Acoma & Laguna Pottery

The publication of this book was made possible
by generous support from the Brown Foundation and
the National Endowment for the Arts.

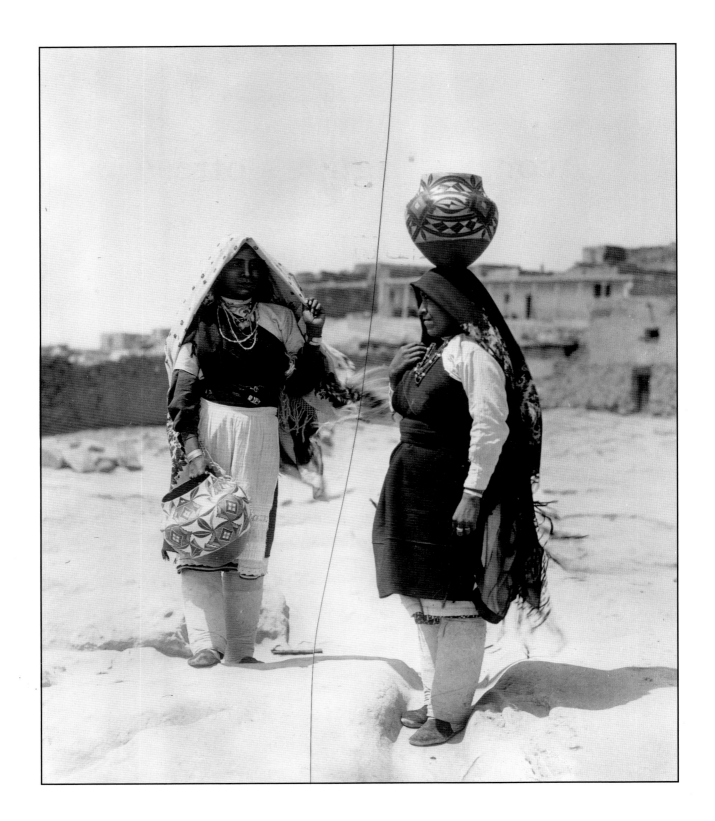

Acoma & Laguna Pottery

Rick Dillingham

With Melinda Elliott

Edited by Joan Kathryn O'Donnell

With a Catalog of the
School of American Research Collection

SCHOOL OF AMERICAN RESEARCH PRESS
SANTA FE, NEW MEXICO

SCHOOL OF AMERICAN RESEARCH PRESS
Post Office Box 2188 • Santa Fe, New Mexico • 87504

Director of Publications: Jane Kepp
Editors: Joan Kathryn O'Donnell, Tom Ireland
Designer: Deborah Flynn Post
Photographer: Herbert Lotz
Indexer: Douglas J. Easton
Typographer: G&S Typesetters, Inc.
Printer: Dai Nippon Printing Co.
Typeface: Adobe Galliard Postscript

Distributed by the University of Washington Press

Library of Congress Cataloging-in-Publication Data:
Dillingham, Rick.
 Acoma & Laguna pottery / Rick Dillingham with Melinda Elliott ; edited
by Joan Kathryn O'Donnell. — 1ˢᵗ ed.
 p. cm.
 "With a catalog of the School of American Research collection." Includes
 bibliographical references and index.
 ISBN 0-933452-31-4 (cloth) : $45.00. — ISBN 0-933452-32-2 (paper) :
$24.95
 1. Acoma Indians—Pottery. 2. Laguna Indians—Pottery. 3. Pottery—
New Mexico—Acoma—Themes, motives. 4. Pottery—New Mexico—
Laguna—Themes, motives. 5. Pottery craft—New Mexico—Acoma. 6.
Pottery craft—New Mexico—Laguna. I. Elliott, Melinda. II. O'Donnell,
Joan Kathryn. III. School of American Research (Santa Fe, N.M.) IV. Title.
E99.A16D55 1992
738.3'089'974—dc20 92-9970
 CIP

Frontispiece: Laguna women with traditional Laguna Polychrome ollas at the
water hole, Laguna Pueblo, ca. 1900. Photograph by William Henry Jackson.
Vertical line through the image is a crack in the glass-plate negative.

Cover: Detail of Acoma Polychrome water jar, ca. 1880–90. Indian Arts
Research Center item no. IAF 682. Photograph by Herbert Lotz.

Printed and bound in Japan

Contents

Illustrations

Preface

My interest in Pueblo Indian pottery and my initial development as a potter go back many years. When I was about twelve, my parents gave me a few dollars to purchase some Indian pots in Tucson, Arizona. These few simple pieces of Acoma, Zia, and Hopi pottery inspired what was to become a lifelong process of collecting, studying, researching, curating, and writing.

In 1981 I was asked to evaluate the collection of Pueblo pottery in the Indian Arts Research Center (IARC) of the School of American Research in Santa Fe, New Mexico. What ensued was a fascinating journey into the evolution of a superb Native American art form. As I went from piece to piece, assessing condition, estimating date of origin, and gathering other pertinent information, I became intrigued with the way form followed function through time. I admired the aesthetic sense of long-vanished potters, who had transformed their everyday work from craft into art, creating items of superb beauty where an object of much lesser refinement would have sufficed. The study taught me much about the essence of pottery making.

After I had looked at more than two thousand pieces of pottery, Michael Hering—then director of the IARC—and I discussed the possibility of compiling detailed catalogs of the research center's collection of Pueblo pottery. Because of my personal knowledge of pottery making at Acoma and Laguna, I was asked to tackle a catalog on those collections. A grant from the National Endowment for the Arts provided the stimulus to move ahead. Additional study, research, analysis, and writing continued for over seven years.

As an Anglo researcher, artist, and frequent visitor at the pueblos of Acoma and Laguna, I have been privileged to have access to many of the potters working today, some of whom I have known for twenty years. They provided an invaluable dimension to what follows. Certain information on pottery is not available to outsiders, of course, and the

reticence of potters on these subjects has been respected. But the voices of the potters themselves are essential to this book.

Many of the potters felt as curious as I about the history of pottery at their pueblos and were eager to learn more about the forms and designs of pots made by their ancestors. Throughout their history, the potters of these two pueblos have incorporated outside influences—Indian and non-Indian alike—into their work. Today their ceramic art is renowned for its beauty of form and design and its technical excellence, whether manifested in "traditional" or innovative styles. The pottery offers an enduring statement of cultural vitality and artistic virtuosity. I am fortunate that so many potters have shared with me their thoughts on the ceramic heritage of their pueblos and demonstrated the meticulous technique and creative ferment that distinguishes their work today.

Although my relationships with Laguna potters are generally more recent than those with Acoma potters, I have known many of them for nearly ten years. Since designs and forms are so similar at Laguna and Acoma, Laguna potters were most interested in helping me search out pottery of definite Laguna origin. Together, we discussed the similarities and differences between the work of the two pueblos. Potters visited me often to see examples of Laguna pottery in photographs I had taken at collections throughout the country. The information and inspiration gleaned from these has been incorporated into their own work.

In this project I have attempted to examine the evolution of pottery at Acoma and Laguna from a scholar's viewpoint but with a potter's understanding. My approach blends anthropology with firsthand contact with contemporary potters, many of whose insights are included in the text. Having long felt that the potter, the weaver, and the woodworker have been shortchanged in the anthropological literature, I have tried here to consider changes in styles and designs from a potter's perspective.

Knowing the craftsperson is intrinsic to understanding material culture. With this publication I hope to place the potters of Acoma and Laguna in context as perpetuators of tradition, initiators of trends, and suppliers of functional and economic needs. My goal is to explore the world and work of potters today as a way of gaining insight into the interior world of potters in the past.

Rick Dillingham

Acknowledgments

Many potters, scholars, and friends have assisted in the research for this project, and my gratitude goes out to each of them. At Acoma Pueblo, I have been particularly fortunate in enjoying a long friendship with Lucy M. Lewis and her family: Emma Lewis Mitchell, Delores Lewis Garcia, Mary Lewis Garcia, and Carmel Haskaya Lewis. Grace Chino, Joanne Chino Garcia, Gilbert Chino, Carrie Chino Charlie, and Rose Chino Garcia have also been exceptionally helpful. Frances Torivio Pino and her daughters Wanda Aragon and Lilly Salvador discussed designs, legends, and contemporary potters' problems with me, and I talked pottery with the late Lolita Concho over a period of nearly eighteen years. The late Stella Shutiva shared warm recollections of her mother, Jessie Garcia, and Shayetsa White Dove offered a valuable perspective on contemporary pottery. I would also like to thank Raymond Concho, former program planner for the Acoma tribe, and writer and poet Simon Ortiz.

At Laguna Pueblo, Evelyn Cheromiah and her daughter Lee Ann Cheromiah gave freely of their time and knowledge. Gladys Paquin followed this project from its outset and contributed valuable insights into the pottery-making process. In Santa Fe, Laguna-born artist Verna Solomon kindly discussed contemporary Native American ceramic arts.

Many others have also contributed their time and expertise. At the Laboratory of Anthropology/Museum of Indian Art and Culture in Santa Fe, I wish to thank John A. Ware, Nancy Fox, Stewart Peckham, and Laura Holt. At the Museum of New Mexico Photo Archives, Richard Rudisill and Arthur Olivas enthusiastically assisted with photographic research. Also in Santa Fe, my thanks to Nora Fisher and Judith Sellars at the Museum of International Folk Art and to Richard Salazar and Alvin Regensberg at the New Mexico State Archives and Records Center.

At the National Museum of the American Indian, Smithsonian Institution (formerly the Heye Foundation) in New York, I thank James

G. E. Smith, Eulie Bonar, Cecile R. Ganteaume, and Brenda Shears Holland. I also want to acknowledge the assistance of Ed Dittert, Arizona State Museum; Ronald L. Weber, Field Museum of Natural History, Chicago; Susan Crawford, Candace Greene, and Felicia Pickering, Smithsonian Institution; Marian Rodee, Maxwell Museum of Anthropology, University of New Mexico; Anibal Rodriguez, Museum of Natural History, New York; George Kritzman, Southwest Museum, Los Angeles; Margaret Hardin, Los Angeles County Museum of Natural History; Grace Johnson, San Diego Museum of Man; Richard Conn, Denver Art Museum; Larry Dawson, Lowie Museum of Anthropology, University of California Berkeley; Rebecca Lintz, Colorado Historical Society, Denver; Lucy Fowler Williams, The University Museum, University of Pennsylvania, Philadelphia; and Mary Hayes of the Royal Ontario Museum, Toronto.

Very special thanks go to Francis H. Harlow, Jonathan Batkin, and David Snow for many years of support and stimulating discussion. Harlow, Batkin, and Snow kindly read and commented on this book in manuscript form.

Other individuals whose help is deeply appreciated include the late Florence Hawley Ellis, Dennis and Janis Lyon, Larry and Alyce Frank, Neva Summer, Bonnie Bibo, Stanley Hordes, Edwina Barela, Bob Gallegos, Maurine Grammer, Nancy Winslow, Lee Marmon, Luther Chavez, Arne Fernandez, Michael Marshall, and Stephen Trimble.

I would also like to acknowledge the staff of the School of American Research, who supported this project from its inception. My thanks to Douglas Schwartz, president, and to Michael Hering, Lynn Brittner-Hutton, Jorge Acero, and Cathryn Miller of the Indian Arts Research Center. At the SAR Press, I am grateful to Jane Kepp, director of publications, for her long-standing support; Peter Palmieri, for his innovative marketing plan; Katrina Lasko for her meticulous illustrations; and Deborah Flynn Post for her elegant book design.

I want to add a special note of thanks to my editor and friend, Joan O'Donnell, for her insight and attention to the many small details that make a book. I am most grateful to Laguna poet and potter Harold Littlebird, whose sensitive Invocation graces this book, and to photographer Herbert Lotz, for his keen photographic eye. And finally, to Melinda Elliott of Santa Fe goes a mountain of appreciation for taking my scattered notes and transforming them into a text.

In memory of

Lucy Martin Lewis

1900(?)–1992

In This Way, Grandchild

Innocence in her curious eyes, a silent, purposeful child approaches her Grandmother.

"*Bah-ba*, teach me to sing the clay."

Brushing silver-stranded hair from her intent face, pausing from her work, she smiles.

"*Amuu, Tza Bah-bah*, come closer and listen. In this way, Grandchild, we have been told to remember . . . "

In a voice slightly more than whisper, she begins to pray.

"*Oh, Mother Clay and Great Creator, hear me. For this young one, my Grandchild, I offer you my breath and once more ask for guidance. From your sacred colored earth, I mix with water, move it in my hands and shape these potteries. Bless them with fire, that the stories of all my Mothers, all my Fathers, be remembered.*"

Taking the child's small hands in hers, she traces the painted lines, lovingly.

"You see, Grandchild, each shape, each design, has meaning in this beautiful life, and Mother Clay helps us on our earthwalk. And for those who came before us, who taught us, we must remember and thank them, all of them. This sacred earth we live upon and share with all its creatures—the rain that wets the earth, making things grow—the sun and fire and its life-giving heat—the green plants for our paints and brushes—the Grandmothers and Grandfathers who showed the people—and you, *Tza Bah-bah*, are part of all this. In this way, Grandchild, we remember . . ."

She picks up the large water jar decorated with many painted symbols, turns it slowly in her ageless hands, and begins to sing:

"*Wa-yo-ho-naaaaha, wha-yo-ho-na-aahaa-aaha-a-yeh*
. . . From over there, way over there
Rain clouds gather
And moving swiftly across broad horizons they come
Dark and heavy
They come dancing
Bringing sweet wet blessings to all my relations . . .
Aahh-eloh-yah-aah, eloh-yah-aha-yeh-ehhhh!"

Harold Littlebird
Laguna-Santo Domingo poet and potter

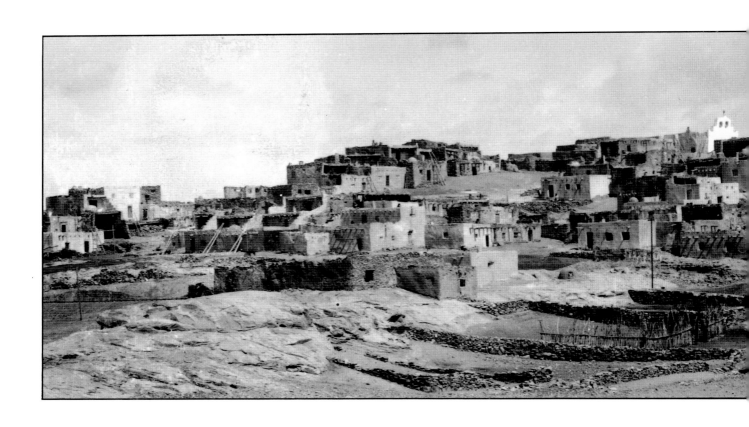

*Figure 1.1. Old Laguna Pueblo, ca. 1900. Photograph by William
Henry Jackson.*

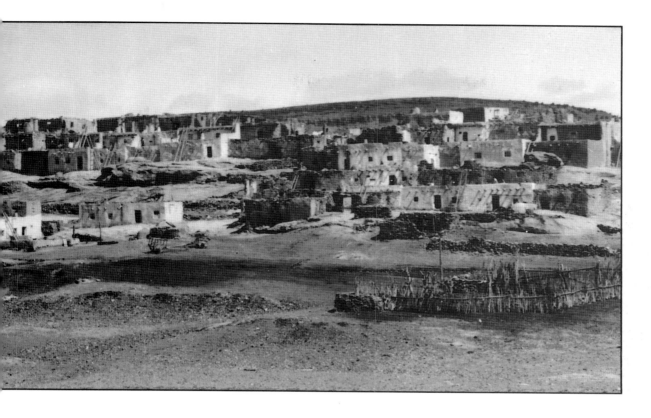

Pots and Pueblos

An Introduction

As one drives along Interstate 40 about forty-two miles west of Albuquerque, New Mexico, a dazzling whitewashed adobe church is visible on a hilltop to the north, small mud houses clustering at its base and spilling down the hillside (fig. 1.1). This is Old Laguna Pueblo, offering a tantalizing glimpse into the world of the Laguna and Acoma peoples, renowned as the creators of exquisite ceramic wares. Acoma Pueblo lies about thirteen miles west-southwest as the crow flies from Laguna. The old village of Acoma, known in the tourist literature as Sky

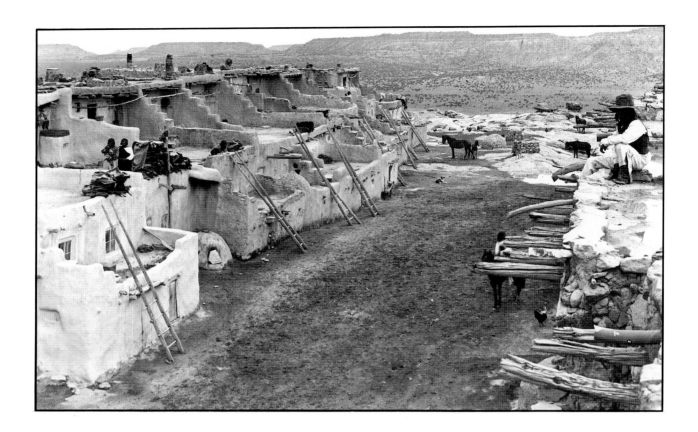

*Figure 1.2. Acoma Pueblo
(Sky City), ca. 1883.
Photograph by Ben Wittick.*

City, is perched high on a mesa in a valley studded with remarkable geologic features (fig. 1.2). It is a startling, powerful, and disquieting landscape, a dry plateau country sculpted with mesas, arroyos, sandstone cliffs, and giant boulders. The two reservations lie at an altitude of over five thousand feet. Nearby, Mount Taylor—sacred to the native peoples of the Southwest—rises through juniper, piñon, and ponderosa forests to a summit more than eleven thousand feet above sea level.

Visitors to Acoma mesa find themselves thrust back in time to a place where everyday activities many centuries old have not been severely altered. Lacking modern conveniences, a potter in the mesatop village will work with the clay much as her ancestors did, using materials gathered from the earth and following a cycle of production based on the seasons, the weather, the natural light. There is sometimes an eerie quiet on the mesatop, offering the craftsperson a sense of limitless time and space within which to create and reinforcing the deep connection between past and present in Pueblo life.

Pottery has always been a central feature of the Pueblo world, serving both utilitarian and ceremonial functions and tying social life to the natural environment in a fundamental way. In centuries past, many vessels were handpainted with elaborate designs, and simple kitchen items—storage jars, pitchers, and ladles, canteens, seed jars, and serving bowls—were executed with the care and creative genius that characterize works of art (fig. 1.3). Like many traditional craftspeople, Pueblo potters have a remarkable ability to instill in a common household object a life and spirit of its own, and the so-called utility wares are exemplars of this quality. Either left undecorated or marked with simple corrugations or unsmoothed exterior coils, these pieces were constructed to withstand heat and abundant use. Less well known than the striking painted wares, prehistoric and early historic utility jars and bowls were plentiful, and they have a subtle beauty of their own.

True utility pottery is virtually nonexistent today. At Acoma and Laguna, as elsewhere in the native world, residents have opted for metal and plastic functional wares. Native American pottery in general has taken on a new role as a work of art, and potters have attained international reputations as fine ceramic artists. Price alone tends to dictate against actually using a bowl; it might break, and a substantial investment would be lost. But an interesting return to a more serviceable ware is taking place at Acoma, Laguna, and other pueblos today, where potters are making and using in their own homes commercially produced and glazed ceramic wares with handpainted designs in traditional style. Easy to produce, inexpensive, and durable, the new slipcast pottery has brought an ancient tradition full circle, so that Pueblo-made pots are again being utilized in Pueblo homes and religious contexts.

Pueblo Indian potters have always created ceramic forms to serve the needs of daily life. Pottery's primary use in history and prehistory was as a container, but clay also served as a medium for ceremonial or symbolic sculpture—the raw material for modeled fetishes and altar figures. A third function, dating to the beginning of the modern period

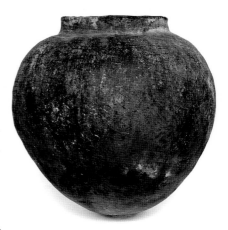

*Figure 1.3. Utility jar, ca. 1880–1900. The short neck and round base of this large jar are reminiscent of Acomita Polychrome. The exterior carbon deposits and absence of decoration attest to its function as a cooking vessel, and the chunky sherd temper opens the clay to prevent thermal shock. IAF 1112. 16" x 16 1/2".**

* Unless otherwise noted, dimensions refer to height x diameter. Sources of pots from collections other than the School of American Research can be found in the Picture Credits section.

and the coming of the railroad, is that of souvenirs or tourist art; most of the pottery created at the pueblos today serves this primarily economic function. More recently still, clay has become the medium for decorative sculpture in the Western fine arts sense—ceramic art works created for the contemporary Indian art market. In this way, too, pottery serves its primary modern function as a means to produce income for the pueblos.

The potter's role in meeting the practical needs of consumers reaches back into prehistoric times, when pottery was traded all over the Southwest. Through time pottery has been a cultural indicator, a vehicle for what is acceptable or even fashionable in form and design. According to Frank and Harlow (1974:13), "Some pueblos depended completely on others for particular types of pottery; Jemez, for example, after about 1700 imported its painted pottery principally from Zia." Pottery was also traded between Laguna and Acoma, historically more often from Acoma to Laguna.

In historic and recent times, Acoma pottery—because of its high quality—has been widely traded, usually for something not readily available at home: jewelry, blankets, or foodstuffs such as chiles. Pottery made at Acoma has found its way via trade to the Rio Grande pueblos, and shelves of pottery—much of it Acoma—can be seen in Santo Domingo, Cochiti, and Jemez homes, where it is used in ceremonial functions or as decoration. Slip-cast ceramic chalices and other vessels, handpainted by Acoma and Laguna artists, are used today in the services of the Catholic church at many of the pueblos.

After Spanish contact, Pueblo potters found themselves with new consumers to supply. Over the centuries, they have made pottery for Spanish colonists and missionaries, European-American settlers, and finally tourists and collectors. Potters at Acoma, for example, sculpted chalices for use in Catholic mass, combining Acoma designs with Spanish forms (fig. 1.4). In the late nineteenth century, Indian craftspeople acknowledged the demands of European-American consumers— "Anglos"—by developing items for sale to tourists brought by the railroad (fig. 1.5). Pottery thus became a source of income rather than a strictly utilitarian product.

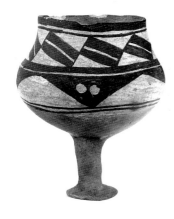

Figure 1.4. Acoma Polychrome chalice, ca. 1875–80. This European-inspired form, perhaps used in Catholic church services, is decorated with traditional Acoma designs. Note the small, probably unstable base. IAF 2555. 5 ¼" x 4".

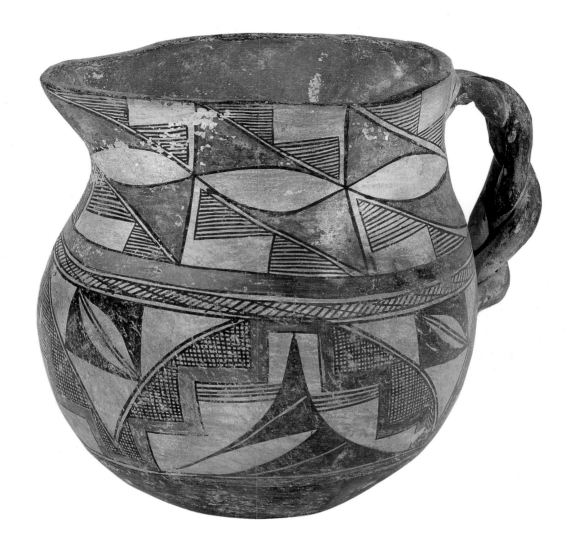

*Figure 1.5. Laguna (?) Polychrome pitcher (four color), ca. 1900–1920.
Though ceramic pitchers existed prehistorically in the Southwest, this form, with its
braided clay handle and modeled spout, is of the more Victorian style that became popular
after the late-nineteenth-century influx of tourists via the railroad. An orange-slip cross
is painted in the interior of the vessel, while the two bands of geometric decoration
on the body are divided around the midbody by a double path-line
band with a capped line break. IAF 1191. 8 ½" x 8".*

Today the consumers of Acoma and Laguna pottery are almost entirely non-Indian, and the role of the potter in Pueblo society has changed accordingly. Many potters have remained with older styles, keeping one foot in the traditional arena, while others have branched out with statements not always grounded in earlier tradition. As the consumers of pottery have changed from Indians to non-Indians, the pottery itself has developed from a functional necessity to a luxury item.

The Spirit of the Pot and the Role of the Potter

Potters and their craft hold a respected place in contemporary Pueblo society and presumably did so in the past. The art of pottery making, while purely utilitarian on a certain level, was and is regarded as an integral and even sacred part of daily life. Despite the changes that have engulfed the Pueblo world, there remains an underlying world view that recognizes a spiritual dimension to every phase of life, to all common objects and everyday activities. This world view is expressed by the still-vital ceremonial calendar and is embodied in items fashioned by hand from the materials provided by the earth. Pottery produced to serve even ordinary household functions therefore has a ceremonial or sacred significance, simply because it was made for use in some life-supporting activity. The old people of the pueblos say that water always tastes better out of an *olla* (pottery water jar), but economics today do not generally allow the luxury of using a pot in this manner. Selling pots to outsiders has in a sense alienated the pots from the people who produce them, and potters look back fondly to the days when the pottery was actually used in the home.

In his 1886 account based on interviews with Zuni potters, Frank Hamilton Cushing (1886:510) mentioned that the pot has a "conscious existence," and forty years later Ruth Bunzel (1929:52) stressed that "among the Acoma . . . there is . . . a strong feeling that each pot is an individual and significant creation." Even today, potters speak of ceramics as having their own spirits, their own lives. Wanda Aragon of Acoma said, "You're always talking to the pot when you are making it—telling it your feelings—and when you finish a pot you blow life into it and it is

given life." At the end of a pot's "life," she continued, "when the pot is killed, like the Mimbres [referring to holes ritually punched in the bottom of painted bowls from the Mimbres culture], the spirit is let go. We still do it that way today, an olla is broken over the deceased and it is buried with them." Laguna potters Evelyn and Lee Ann Cheromiah "talk" to deceased spirits of potters while making new pottery to guide them in their work.

Traditionally, pottery has been viewed as possessing intrinsic power and the ability to take on the attributes of the substance it holds. Water, a sacred element, transfers its power to the pottery vessel that holds it: "Water contains the source of continued life. The vessel holds the water; the source of life *accompanies* the water, hence its dwelling place is in the vessel with the water" (Cushing 1886:511).

The role of the potter was highly regarded in the past for a number of reasons, among them this sense of the sacredness of the enterprise and the essential utility of the product. It is at least as crucial today, and perhaps more so, as the economic significance of pottery to individual families has increased. Modern potters are respected for their work not only because it is traditional but also because it is essential for economic survival: often, potters are the primary wage earners of the family.

Still, a tension exists between the spiritual and the mundane aspects of the craft. Accordingly, two very different approaches to pottery making are evident in the pueblos. As Acoma potter Gilbert Chino told me, "Today the potter is a wage earner. Some have become manufacturers, losing a lot [of the work's spirituality]. Others put a lot of work in it, with spirituality also, with prayer in order to get something really out of it, to really enjoy it."

Learning the Potter's Craft

Specialization in the craft of pottery making usually is handed down within families. There is no separation between this work and daily life, none of the isolation that so often marks "professionalism" in the non-Indian world. Pueblo potters work in their homes, usually in the kitchen, and their children learn through daily exposure to the work. As

Acoma potter John Aragon put it, "I grew up with [pottery making], so it was there. My grandmother and mother encouraged me."

Most children absorb the techniques of pottery making through constant contact with the older potters of the family. Children sometimes make small pieces of pottery or model simple forms such as animals, efforts encouraged by the accomplished potter. Today, because of the voracious market for Native American art, children's work is very saleable (perhaps, as a by-product, creating a false sense of security regarding the marketplace), and categories exist in art exhibits for children's pottery. Although it can take years to develop and refine technique, most potters can create usable pots after only a few months of practice.

Women today—as most likely in the past—constitute by far the majority of potters (see appendix B), and potters at Acoma have told me that all women in the pueblo *should* know how to make pottery. In the twentieth century, though, many men work in all aspects of the pottery-making process. Their participation goes back at least into historic times, although their role in the past was probably not a major one in terms of the volume of production. In 1855, W. W. H. Davis, during a visit to Laguna, saw the pueblo's *cacique*, or religious leader, painting a new storage jar with "rude figures" in black and red (Davis 1938:225, cited in Batkin 1987:20). Though this activity attracted Davis's notice, it must have been acceptable within Pueblo society. Chances are the painting was of a ceremonial nature, and the "rude figures" may have been animal, snake, or insect motifs commonly painted on ceremonial vessels. Men, who have always exercised ritual control in the pueblos, may have painted vessels specifically made for certain ceremonies.

Only select potters are designated to carry out the task of making ceremonial, or kiva, pottery, and the Indians do not reveal how these individuals are chosen. I have been told that an important Acoma potter was struck by lightning in 1964, a profoundly spiritual event that gave her great power and designated her as a "special" potter, qualified to make kiva pottery. Certainly, special status is required for making ceremonial pottery. John Aragon, who is only peripherally involved in religious ceremonies, related that once he "wanted to do a four-stepped bowl, and my mother and aunt said, 'You can't do it. You have to wait for a medicine man to ask you to make it.'"

Figure 1.6. Laguna Polychrome variant jar, ca. 1900. An example of a distinctive group of Zuni-influenced Laguna jars, this piece's typical Zuni design features include the brown base and interior rim, scroll motifs around the neck, and hatched and solid geometric motifs around the body. 11" x 12".

The Potter As Innovator

Although Indian pottery is generally considered a "traditional" art—its materials, methods, and styles handed down from one generation to the next—individual potters have noticeably influenced the development of ceramics at Acoma and Laguna, and, indeed, at all the pueblos. The unique legacies of these potters, whose identities unfortunately are rarely known, are preserved in collections of prehistoric and historic ceramics. These individual pieces do not fit into the established typologies used to define Pueblo pottery, but many of the odd, malformed, miniature, or curiously painted pieces dismissed as "eccentrics" may actually represent steps in the development of new forms and designs. "Such transitional or borderline specimens are thrown into prominence as tangible evidence of continuity in the development of pottery. Without them the evolutionary story of the ceramics . . . would be far less convincing" (Gladwin et al. 1965:169-70).

In the collections of the Museum of Man in San Diego, the Southwest Museum in Los Angeles, and the National Museum of the American

Indian (formerly the Heye Foundation) in New York, among others, is a distinctive group of pots from Laguna that may have been created by one individual or a small group of potters (figs. 1.6, 1.7). Dating roughly between 1890 and 1920, all the pots appear to be unused and may have been made for the market. Their forms are typically Acoma or Laguna, the materials and techniques are Laguna, but the design layouts are Zuni. Because there is no documentation on these pots, we may never know if they were made by migrants from Zuni using Laguna materials or by Laguna potters working in Zuni style. Their characteristic idiosyncrasies, however, identify them as a unique body of work that points tantalizingly to the efforts of an individual artisan.

Unusual as this collection may be, even more unusual is the case in which we have access to biographical information on an individual historic potter. Ruth Bunzel recorded the work of one notable nineteenth-century Laguna potter:

> At Laguna I saw a pot of typical Zuni feeling and treatment, which I first took to be a Zuni pot. My informant, however, assured me that it was an old Laguna piece. Later she remembered that it had been made by her uncle, one of the last men-women of Laguna, a famous potter, now dead, who had once visited Zuni and had been so much impressed by Zuni pottery that he introduced the deer and other typical designs into Laguna. (Bunzel 1929:57)

Figure 1.7. Laguna Polychrome variant jar, ca. 1900–1920. The designs on this Laguna jar are primarily Zuni, except for the split rectangles (far left), which are more commonly found on Laguna and Acoma pottery. 7" x 9".

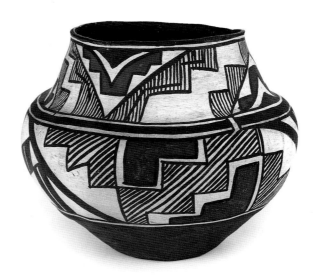

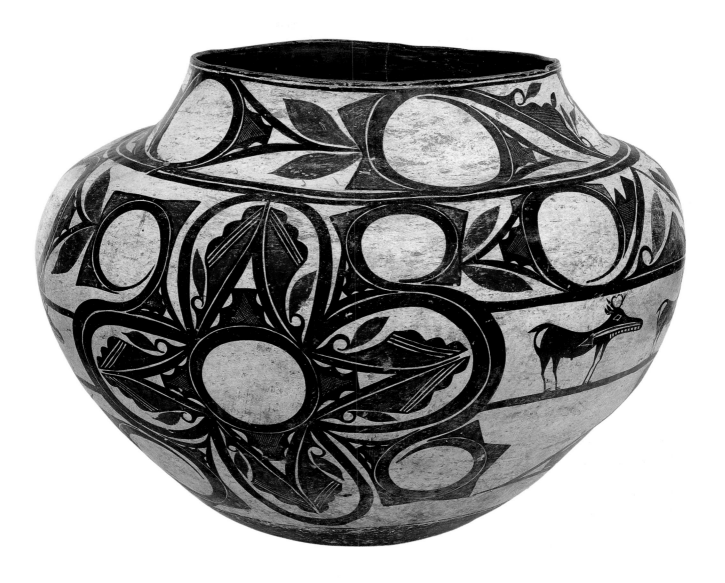

Figure 1.8. Laguna Polychrome variant jar, ca. 1900. This huge jar by the potter Arroh-ah-och has a Zuni-inspired design layout with rainbird motif, elaborate four-lobed medallions, and unbordered chalky red-slipped leaf-like motifs. The body has three bands of design, the upper and lower repeating and the central band featuring unique deer motifs typical of this potter's work. Chapman dated this piece, incorrectly, I believe, ca. 1850. IAF 1026. 19" x 25".

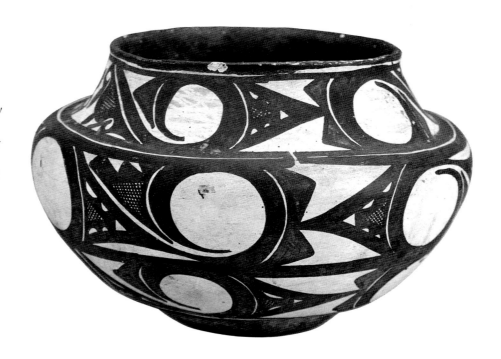

Figure 1.9. Laguna Polychrome variant jar, ca. 1890. This jar, also by Arroh-ah-och, is painted in a banded design with Zuni influence. The catalog card reads "copy of a Zuni pottery jar, Laguna, probably." A chalky red unbordered slip is used for some design elements, and a bold capped spirit break appears at the shoulder. 5 ¼" x 8 ½".

The piece in question may be a jar of exceptional size and beauty purchased in Paguate in 1928 by Kenneth Chapman of the Indian Arts Fund and now in the collection of the Indian Arts Research Center (fig. 1.8; see also fig. 1.9). Chapman noted that the piece was "made as early as 1850 by Arroh-ah-och, a famous Laguna hermaphrodite," but I feel that ca. 1900 would be more accurate. Arroh-ah-och is representative of a traditional, accepted gender-role reversal in Native American culture, known in the anthropological literature as *berdache*. Many of these *amujerados*, or men-women, were potters at the historic pueblos. Whether or not all historic-era male potters were amujerados is unknown; this is not the case today.

Some confusion exists about Arroh-ah-och's tribal identity. He is remembered by many at Laguna as a native of that pueblo; Laguna elders with whom I spoke recalled him as a superb potter. Another scholar (Ed Dittert, personal communication, 1989) has suggested that

Arroh-ah-och originally had his home at Zuni, was trained in pottery making at Acoma, and eventually settled at Laguna. In any case, the exceptional artistry and distinctive treatment of design elements are unique to the work of this potter. His work demonstrates the importance of individual contributions and of interpueblo influences on the development of the pottery tradition, as well as an interest in experimentation and innovation that continues today. In the twentieth century, the importance of the individual artisan to the development of Acoma and Laguna pottery has been abundantly clear, and it is a central theme of the story that follows.

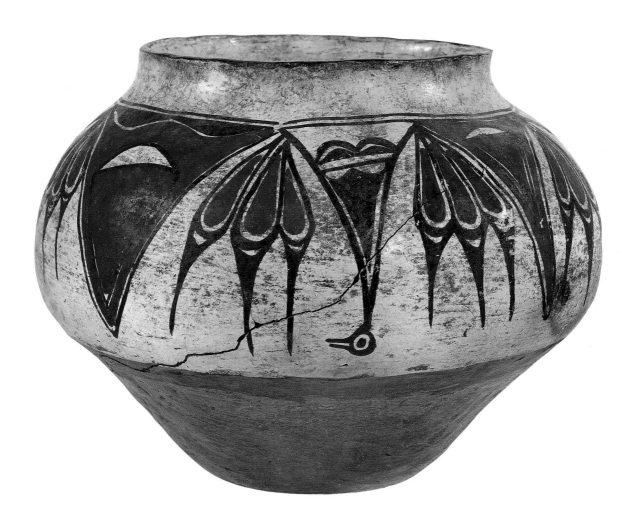

*Figure 2.1. Acomita Polychrome, Laguna variety(?), jar, ca. 1770–90.
At the bottom of the white-slipped design field, this water jar has a red under-
body band of slip, a feature more common among the Rio Grande pueblos than
at Acoma and Laguna. Zia and Santa Ana influences can be seen in the
red areas of design and the upside-down bird motifs pendant
from double upper framing lines. IAF 797. 9" x 11 ½".*

The Study of Pueblo Pottery

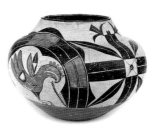

The pueblos of Acoma and Laguna share common boundaries, and both use the small Rio San Jose to irrigate crops and water domestic animals at outlying farming villages. Acoma, Laguna, the pueblo of Zuni in New Mexico, and the Hopi villages of Arizona are known as the western pueblos. Their eastern counterparts, the Rio Grande pueblos, lie in a roughly defined corridor along the northern reaches of that river (figs. 2.2, 2.3).

Despite their geographical proximity, the peoples of the western pueblos speak a number of different languages: western Keresan at Acoma and Laguna; other Keresan dialects at the Rio Grande pueblos of Cochiti, San Felipe, Santo Domingo, Santa Ana, and Zia; and Uto-Aztecan at most of the Hopi villages. Tewa, a language brought by migrants from the Rio Grande pueblos, is spoken at the Hopi villages of Hano and Polacca. The Zuni language is unique to that pueblo.

All of the Keres-speaking tribes, including the Acomas and Lagunas, have myths that trace their ancestral origins to the Four Corners region—and to a people that scholars identify as the prehistoric Anasazi of Mesa Verde (Ellis 1974:11). According to native traditions, these forebears moved south after abandoning their cliff dwellings. The Acomas maintain that their ancestors moved from the Mesa Verde area via Chaco Canyon to their present location, establishing new villages that incorporated Indians who already lived in the area and later colonizing the pueblo of Laguna (Ellis 1974:12, 14, 15).

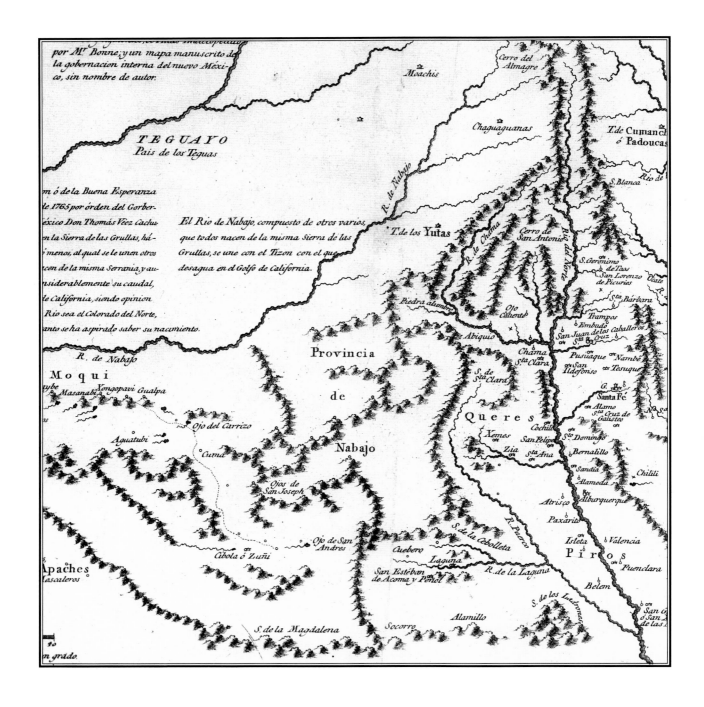

Figure 2.2. Detail of map, *"Nueva Granada ó Nuevo México,"* showing the
Acoma and Laguna area, 1795.

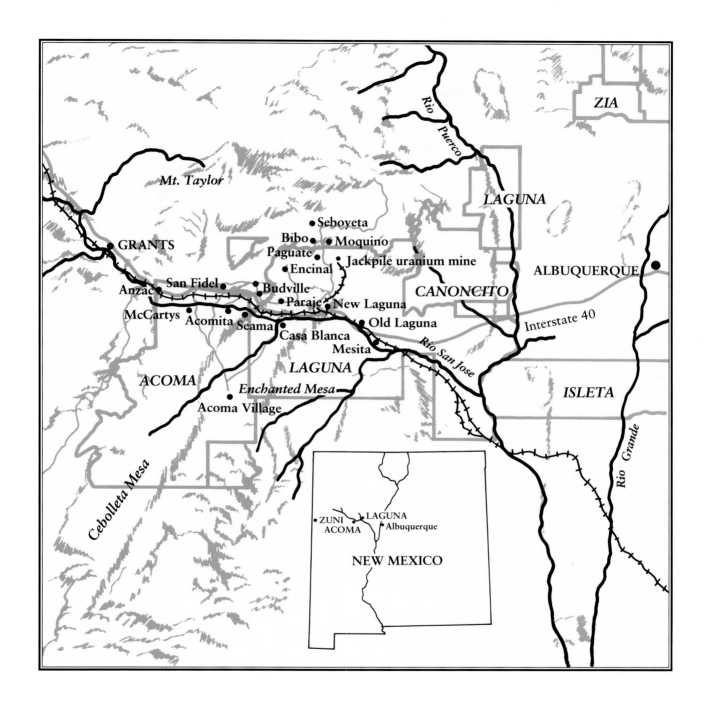

Figure 2.3. The Acoma and Laguna reservations and surrounding area today.

The oral traditions of Laguna, however, suggest that Acoma and Laguna were settled at different times by two distinct groups. Laguna origin stories also represent the ancestors of the Acomas as the first to move south from the Four Corners region, following a westerly route through San Ysidro and Zia and then joining other groups already living in the Acoma area. Later, the ancestors of the Lagunas came through Zia on their own southerly migration (Ellis 1974:12, 13). They camped in the area at the Acomas' invitation and eventually settled in the San Jose Valley, where their descendants live today (Ellis 1974:3, 4; Ellis 1979b:439; Florence H. Ellis, personal communication, 1988).

The migration of the Acomas from the Four Corners area finds some confirmation in the archaeological record, although the date and circumstances of the pueblo's founding are still cloudy—in part because archaeological work is restricted in living villages. Excavations conducted on the mesa in the 1950s indicate that it had been occupied since at least early Pueblo III times (A.D. 1100–1300), and scattered sherds date as early as the Pueblo I period (A.D. 700–900) (Ruppé and Dittert 1952:215). Excavations in the Cebolleta Mesa area southwest of Acoma yielded many sites that show an almost parallel occupation with that of the mesa itself, suggesting a large contemporaneous area of occupation (Ruppé and Dittert 1952:194) that is culturally on the border between the Mogollon to the south and the Anasazi to the north (Ellis 1979b:439).

Whatever the origins of the mesatop village, Acoma was already a venerable site when the first Spaniards arrived. Less certain is the age of Laguna Pueblo. Early Spanish accounts do not distinguish it as a separate settlement, though they do mention the seasonally occupied farming villages distributed along streams and adjacent to springs in the Acoma area. The possible reasons for this omission are spelled out by Ellis:

> Except by tradition and pottery found on old ruins, no one can say where the Lagunas lived before the last decade of the seventeenth century; Spanish historians did not refer to the nuclear tribe because: (1) the Lagunas lived in several villages, none of which were large and imposing, and (2) the early Spaniards confused them with the Acomas, their close relatives,

who spoke the same language and who did have an imposing central village, with subsidiary villages. (Ellis 1974:17)

Many historians date the founding of Laguna between 1697 and 1699, believing it to have been settled by a combination of refugees from Cochiti, Santo Domingo, Jemez, Santa Ana, Zia, and Cieneguilla (a now-abandoned village outside Santa Fe) and some disgruntled Acomas (Ellis 1979b:438). Although Spanish religious officials did not assign Laguna its patron saint, San José de la Laguna, until 1699 (Ellis 1979b:438), it is likely that some sort of settlement existed prehistorically at Laguna and that the Reconquest refugees simply added to it.

The Spanish Conquest

The historic period—and the era of Spanish domination of the pueblos—dawned with the entradas of the mid-sixteenth century. The Acoma area was first entered by a company under the leadership of Fray Marcos de Niza, who came across the large and impressive Zuni village of Hawikuh in 1539. Here Niza heard of the independent province of Acus, with its central village of Acoma (Minge 1976:1). The name "Acoma," a hispanicization of the Keresan word ʔá·k̓ù·m̓é (Garcia-Mason 1979:464), is now used to refer to the entire tribe, its individual people, and the major village, but the Acomas themselves have distinct words for each category.

In 1540, Don Francisco Vásquez de Coronado's lieutenant, Hernando de Alvarado, arrived in Acoma. The conquistadores were impressed by the massive size, structure, and fortress-like quality of the mesa upon which the village was built, "the strongest position ever seen in the world" (Waters in James 1970:7). The chroniclers of the early expeditions commented on the "peaceful nature of the inhabitants," but the lack of anticipated riches brought a temporary end to Spanish activity in the area. Forty years of renewed isolation and relative calm ensued for the western pueblos.

Juan de Oñate established the first Spanish settlement on the Rio Grande in 1598. That same year, after obtaining pledges of submission

from all the pueblos, Oñate sent word to his aide, Juan de Zaldívar, to meet him near Zuni. En route, the young Spanish commander and a number of his soldiers were lured to Acoma mesa and killed (Spicer 1962:157). Oñate quickly dispatched Juan's brother, Vicente Zaldívar, to lead a retaliatory attack on the pueblo. On January 22, 1599, two months after the initial confrontation, the Spaniards laid waste the village of Acoma, killing many of its inhabitants, burning the houses, and taking some five hundred villagers captive. Many other Acomas subsequently fled to the Rio Grande area.

The pace of change in the Southwest accelerated during the seventeenth century, the "Great Missionary" era in New Mexico (Hordes 1986:4). The Catholic religion and Spanish folk arts arguably had the greatest influence on Pueblo lifeways: woodworking and adobe brick making were introduced, along with such architectural innovations as the corner fireplace and the *horno*, an outdoor oven for baking bread. Trade with the Spaniards brought foods that changed Puebloan diet and subsistence patterns and tools that altered construction methods. Sheep and other domestic animals were introduced, and their manure was utilized as fuel for cooking and firing pottery. It burns evenly and slowly, and the ashes retain their initial form and hold the heat of the fire, a significant advantage when firing pottery. Manure firing is still used by the very few potters who fire outdoors today.

The Catholic church suppressed native religion and drove it underground. Burial offerings of pottery were prohibited, as was the kachina cult, an indigenous religious practice

> carried out by several clans and secret societies which are connected to the kivas. The practice of the kachina cult involves the representation of supernatural beings considered to be ancestral spirits and, if properly petitioned, to have the power to bring rain and general well-being to the Pueblo. It includes the celebration of a series of traditional ceremonies whose meaning and significance is a closely guarded secret, but whose emphasis is on fertility and weather control. (Seymour 1979)

No doubt, ceremonial pottery was still made to serve in the now secret rituals, but it would have been guarded from outside eyes.

Although the Acoma-Laguna area was still relatively isolated from the major Spanish settlements along the Rio Grande, its very remoteness spurred the in-migration that would characterize the latter part of the seventeenth century. Indians from other pueblos sought refuge at Acoma for many reasons, among them the desire to preserve a traditional way of life. Spanish discipline was often harsh, and many refugees withdrew to the more distant villages: "Some fled to the Rock of Acoma, reverting to idolatry" (Bloom 1928:366).

Spanish economic policies such as the *encomienda* system and *repartimiento* also affected the pueblos adversely and increased tensions between Indians and Spaniards. These systems functioned from 1600 until 1680, when the Pueblos staged a violent uprising under the leadership of a San Juan Indian named Popé (Spicer 1962:302). Most of the pueblos took part, and the Pueblo Revolt succeeded in driving the Spanish missionaries and colonists out of northern New Mexico to the El Paso district in the south (Simmons 1979a:186).

Acoma's role in organizing the revolt was minor, probably because of its distance from the Rio Grande settlements, but its participation was wholehearted, and all Spaniards residing at the pueblo were killed. Acoma continued to shelter rebellious fugitives after the completion of the Reconquest of the Rio Grande area by de Vargas in 1696; among them were twenty refugees from Pecos Pueblo, east of Santa Fe (Simmons 1979a:187). (It is possible that this influx from Pecos, where glazewares were produced, could have contributed to the elaboration of Hawikuh glazewares at about this time.) Acoma finally submitted formally to Spanish rule in 1699 (Minge 1976:31–32).

Following the Reconquest, more Catholic missionaries were sent to New Mexico from Spain. The friars protected the Indians somewhat from the Spanish colonists, but they also attempted to control their religious ceremonies in ways that aroused continual hostility. The pre-Revolt ban on the "pagan" kachina cult was revived, and the cult again went underground. Protected by secrecy, it has managed to survive to the present day.

But other ancient traditions changed markedly following the Reconquest. Pottery, in particular, underwent one of the most significant changes in its history. Since A.D. 1250, potters throughout the Southwest had made the fine decorated pottery known today as glazewares:

ceramics painted with lead-based pigments that developed a shiny vitreous glaze when the pots were fired. But around 1700 the tradition disappeared abruptly, and potters began decorating their wares with paints that fired to a matte finish, producing the white, black, and red polychromes that are so much admired today.

Civil and religious records for Acoma in the early eighteenth century are sketchy, but they make clear that the period was characterized by regular if sporadic interaction with ethnic groups from beyond the immediate Acoma-Laguna area. There was contact—sometimes tense—with the Spaniards, who remained wary of the Acomas, investigating several rumors of rebellion during the early part of the century (Hordes 1986:10). There were also "alternate periods of violent raiding and suspicious trading" (Hordes 1986:14) with the Apache, Comanche, and Navajo tribes, and occasional participation by Acomas and Lagunas in Spanish military expeditions against these and other "hostile" Indians, particularly peoples of the Plains. Trading very likely affected the development of Navajo utility pottery, which shows direct Pueblo influence.

Pottery Collections and Scholarship

Scholars, historians, anthropologists, writers, artists, and lawyers have studied Acoma and Laguna since the mid-1800s, writing about the culture, land claims, ceremonies, kinship, genealogy, architecture, and arts. The first formal collecting expedition to the Southwest was mounted from 1879 to 1881 by the Bureau of American Ethnology, which sent James Stevenson to gather ethnographic materials from the Pueblos and other tribes of New Mexico and Arizona. Stevenson amassed a rich collection of ceramics and other artifacts. The pottery, including many examples from Acoma and Laguna, is described in his 1883 two-volume publication, *Illustrated Catalogue of the Collections Obtained from the Indians of New Mexico and Arizona in 1879.* These collections are housed in the Smithsonian Institution.

Another important collection of Acoma pottery in the Smithsonian was created in 1884 and 1885 by the brothers Cosmos and Victor Mindeleff. Working for the Bureau of American Ethnology, they

accompanied Stevenson on a number of expeditions to the Southwest. Some of these ceramics may actually have been made at Laguna, but unfortunately the Mindeleffs' records are unclear.

In the early 1900s, philanthropist George Heye purchased a large number of Pueblo ceramics, employing Jesse Nusbaum (among others) to make his pottery acquisitions at Acoma and Laguna. Heye's materials, housed in the Museum of the American Indian, Heye Foundation, and part of the collection of the newly formed National Museum of the American Indian, shed some light on trade patterns among the pueblos, since many of the vessels he obtained were not produced at the pueblo where they were purchased. Until further efforts are made to sort out the origins of these pieces, cataloging of the collection is somewhat unreliable.

The ethnographic study of the potters of Zuni, Acoma, Hopi, and San Ildefonso by Ruth Bunzel, published in 1929 as *The Pueblo Potter: A Study of Creative Imagination in Primitive Art,* remains the classic interpretive work on Pueblo pottery design and a pioneering work in ethnoaesthetics. Bunzel examined the individual potter's role in the Pueblo ceramic tradition, incorporating the potters' own comments and ideas on form and design and focusing attention for the first time on the Indian artist and the creative process rather than on technical detail.

Scholars Harry P. Mera and Kenneth M. Chapman, two founders of the Indian Arts Fund Collection, now in the Indian Arts Research Center at the School of American Research, made contributions that have influenced Pueblo potters and the scholars studying their creations. One of Mera's many publications, *Style Trends in Pueblo Pottery* (1939), established a ceramic typology that is still in use. Chapman's extensive research and publications concentrated on the pottery of San Ildefonso and Santo Domingo pueblos, but his notes on the collections from Acoma and Laguna, on file at the School of American Research, are very useful. According to Acoma potter Lucy M. Lewis, Chapman is at least partially responsible for the introduction of Mimbres motifs into the contemporary Acoma potter's design vocabulary, which has also been adopted by the potters of Laguna.

More recently, Florence Hawley Ellis worked closely with the people of Laguna, developing great familiarity with that pueblo's material

culture. Her 1966 article, "On Distinguishing Laguna from Acoma Polychrome," is a particularly significant contribution, considering the general difficulty that exists in discerning differences between the pottery of the two pueblos.

Other contemporary studies of pueblo pottery that deserve mention are those by Francis H. Harlow (1973) and Larry Frank and Francis H. Harlow (1974), which were instrumental in categorizing the pottery of the pueblos. The works of Betty T. Toulouse (1977) and Susan Peterson (1984) address recent historical events in connection with the development of pottery, and Jonathan Batkin, in his comprehensive 1987 publication, expands and challenges previously accepted ceramic typologies. Ward Alan Minge, in his historical work *Acoma, Pueblo in the Sky* (1976 and 1991), looks at the socioeconomics of pottery making.

These written sources, with the partial exception of Bunzel's work, provide the Western academic viewpoint on Pueblo pottery. Only the native peoples themselves have access to certain information, and they do not share it freely, so much of the culture of the Pueblos remains shrouded in mystery. After centuries of mistreatment by the Anglo-European world, Native Americans have found secrecy their wisest course and sometimes the only means of preserving certain traditions.

Ceramic Typology

The concept of ceramic typology was invented by the people who study pottery, not the potters themselves. Interested in tracing the evolution of ceramics, anthropologists have created typologies to categorize pots for analysis and comparison. Through analysis of materials, forms, and designs, distinctive parameters can be recognized that enable scholars to establish a "type": the repetition of specific combinations of materials, forms, and designs creating a more or less standardized ceramic form. When many potters are working with several different sets of accepted parameters, the resultant diversity in the archaeological or ethnological record can be quite complex. An established typology of ceramic forms helps scholars make sense of that complexity.

From time to time, potters add unique, creative touches to the existing standard types of vessels. These changes are individual and

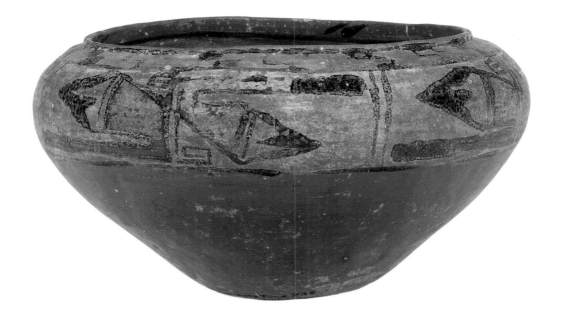

incremental, not made with the knowledge or intention of creating an entirely different style or type. Changes may be introduced to satisfy a consumer or fulfill a specific function, or they may originate out of happenstance or experimentation. If a prehistoric potter decided for some reason to shift to a new kind of clay, centuries later archaeologists might interpret this change as the beginning of a new type, subtype, or local variation. Within the larger Ako Polychrome type, for example, Tecolote Polychrome may be a subtype that developed in response to the materials available at a particular location.

The typologies most frequently used in referring to southwestern pottery were established at a conference of archaeologists held at Gila Pueblo in Arizona in 1930. There, scholars worked out a system of nomenclature for classifying the ceramic types they were finding in the Southwest. The system enabled them to classify broken pieces of pottery, or sherds, and whole vessels. Based on designations for various kinds of prehistoric pottery, the system is used for historic pottery as well.

Following this method, each distinctive type of pottery receives a two-part descriptive name. The first part of the name—such as Tularosa,

Figure 2.4. Hawikuh Polychrome bowl, ca. 1650–1700. This rather heavily constructed bowl has a highly polished red base and red sculpted rim. A white slip, now eroded, is painted around the upper half of the exterior, and a green (copper-bearing) glaze and red slip are used in the feather-motif design. IAF 935. 7" x 12 ½".

Hawikuh, or Ako—is often derived from the geographical location where the type was identified (the "type site"). Alternatively, it may be taken more loosely from the local native language or may be an anglicization of a place-name. The second part relates to some technical attribute associated with the style of construction or painting: corrugated, black-on-white, black-on-red, polychrome, and so on. An example of such a prehistoric type name is Tularosa Black-on-white; other names from historic and recent times are Hawikuh Polychrome and Laguna Polychrome (Gladwin and Gladwin 1930).

The criteria for establishing pottery types also have to do with construction techniques, the composition and density of the clay body, tempering agents, the effect of the firing process on the pot's color, and the pottery forms themselves. All of these parameters are necessary for determining the pottery type of an individual specimen. Ideally, this information can be discerned from individual sherds in the collections studied, whether prehistoric or historic, but this is often not the case. A sherd from the base of an olla, for example, does not always give a clear picture of the jar's other attributes, so a large number of pieces may be required for proper analysis. Occasionally, though, single sherds are so distinctive that they can be very informative.

Other terms used in connection with pottery types are "wares" and "series." A ware is a large grouping that includes types with shared characteristics. A series is a sequence of closely related pottery types that probably represent a chronological evolution of style and form (McGregor 1965:99). Certain wares and series are relevant to the development of Acoma and Laguna pottery. At historic Acoma and Laguna, the chronology begins with glazewares and is followed by a transition to matte-painted wares. Made concurrently with these painted wares are related utility wares. Within the wares are a vast number of types, mentioned here and elsewhere in the literature on Pueblo ceramics. These types can be connected "genetically" to form a series (McGregor 1965:99). Thus an Ako Polychrome (type) olla is part of the Acoma series of matte-painted ware. The existing categorization is by no means complete, and there are several types within the glazeware sequence at Acoma and Laguna that have yet to be named.

Early twentieth-century archaeologist and ceramic authority Harold Colton used the term "style" as a concept that transcends type. For

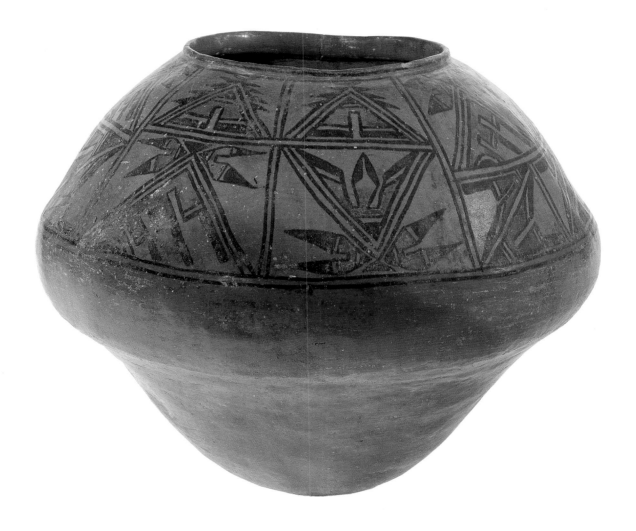

Figure 2.5. Ako Polychrome, Tecolote subtype, jar, ca. 1710–20.
Given a Zia-like appearance by the orange slip on the upper shoulder, this
jar has the local Ako form and fine sculpted rim characteristic of Acoma and
Laguna. It also lacks the diagnostic arcs painted around the lower portion of its
Zia contemporaries. Here, base and bulge are slipped a deep orange-red, as
are the lip and interior of the rim. The paneled design, in a sintered black
pigment, features split-feather motifs common prior to 1720. The sandy
red clay of the jar is atypical for the Acoma-Laguna area.
IAF 1032. 11 ½" x 14 ½".

example, the Sikyatki style of design encompasses the abstracted birds and fluid geometric motifs first developed by Hopi potters and similar designs that appear on Hawikuh pottery at Acoma (McGregor 1965:99). Styles, then, can and do travel among the pueblos. They may be manifest on very different "types" of pottery and perhaps are best thought of as an expression of fashion. Style reflects the potter's sensibilities, which we will probably never be able to analyze successfully or confine within typological categories.

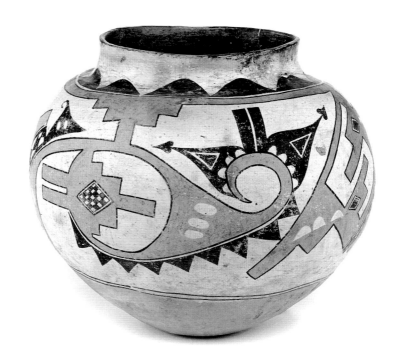

Figure 2.6. Acomita Polychrome, Acoma variety, storage jar, ca. 1800–1820. This large storage jar has a round base, and its finely drawn rainbird-scroll design with unbordered elements is reminiscent of the pottery of Santa Ana Pueblo. The solid arcs around the neck are common after about 1800. IAF 1036. 14" x 16".

The Acoma and Laguna Pottery Types

The term "polychrome," a common type in the Southwest, signifies the use of decorative slips and paints of three or more colors. Most Acoma and Laguna pottery falls into the polychrome category, although there are also many examples of two-colored ceramics, or bichromes. Many polychromes have corresponding bichromes, and it is probable that the

two types were related: that is, they were made during the same period by the same potters. Thus, for example, the bichromes Acoma Black-on-white and Acoma Black-on-red were created contemporaneously with Acoma Polychrome. At all times throughout Acoma and Laguna ceramic history, painted wares and plainwares (utility wares) were made side by side.

For our discussion, the following Acoma-Laguna type names are important: Hawikuh Polychrome (fig. 2.4), a name derived from the Zuni village of Hawikuh, the type site where this glazeware was first identified by excavation; Ako Polychrome (fig. 2.5), from the Acoma name for the central mesatop village of the pueblo; Acomita Polychrome (Laguna and Acoma varieties) (figs. 2.6, 2.7; see fig. 2.1), named after an outlying Acoma farming village; Acoma Polychrome (fig. 2.8), a name taken from the Spanish and English name for the tribe and village; and Laguna Polychrome (fig. 2.9), named for the "village by the lake." Tecolote Polychrome, a type or subtype of Ako Polychrome identified in sherd form from the collection of the Maxwell Museum of Anthropology

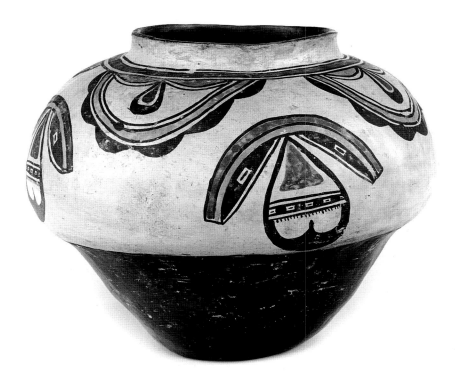

Figure 2.7. Acomita Polychrome, Laguna variety(?), jar, ca. 1760–80. The addition of three painted slips makes this a five-color polychrome. Though the severe construction flexures suggest an early date of manufacture, the short neck indicates a later one; these are good indications that this is an early transitional piece. Half-circle and paddle motifs are pendant from the upper framing lines, and the body displays floating arc and paddle elements with "eyes." IAF 1009. 10" x 12".

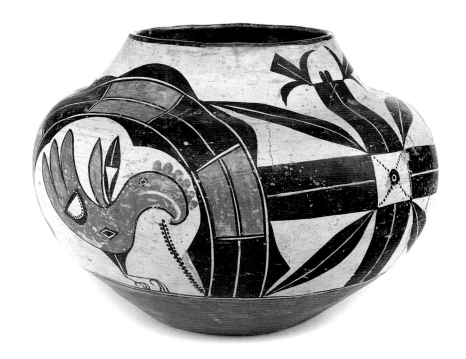

Figure 2.8. Acoma Polychrome jar, ca. 1870. This water jar has a heavy bar style of design, with split rectangles appearing in the prominent cross element and the rainbow band that arches over a parrot motif. IAF 1039. 8" x 11".

at the University of New Mexico, is also noted here (Carroll et al. 1979). It is possible that a very few whole vessels of this type exist, one of which may be the olla in the collection of the Indian Arts Research Center illustrated in figure 2.5.

For both Acoma and Laguna, the established pottery types provide standards that can be used to discern major stylistic changes over the centuries. The sequence of types from Acoma and Laguna, with their approximate dates, is presented here:

Hawikuh Polychrome	1600 to 1700
Ako Polychrome	1700 to 1760–70
Tecolote Polychrome	1700 to 1780?
Acomita Polychrome	1770 to 1870
Acoma variety	1770 to 1850–60
Laguna variety	1770 to 1860–70
Laguna Polychrome	1860–70 to present
Acoma Polychrome	1860–70 to present

Along with the evolution in types, an evolution in the basic form of water jars occurred. These transitions are illustrated in figure 2.10.

A Perspective on Typology

In this study, I minimize the emphasis on pottery types and concentrate instead on ceramic evolution in terms of the process of pottery making and of specific changes in the pottery itself. For my purposes, focusing on rigid typologies limits the ways in which pottery can be examined and discussed.

There are also certain well-known problems with typologies in general. As Florence Hawley Ellis (1977:3) pointed out, "Pottery is certainly one of the keys best fitted to unlock the periods of southwestern prehistory. But the archaeologist desiring to use it has found himself confused with a mass of nomenclature in which there is frequently more than one name for a pottery type yet no adequate description of that type." Another expert on ceramics, Anna O. Shepard, wrote:

> Since the pottery type is a generalization from many fragments and since there may be no individual example including all of its features, it is not infrequently referred to as an abstraction. Also the pottery type is artificial in so far as it is selected to serve as a means of outlining relative chronologies, a purpose that has no relation to the conditions of production or original functions of pottery. (Shepard 1965:307)

The most widely used typology for historic Acoma and Laguna ceramics, established mainly by Harlow (1973), is a helpful tool for studying Acoma and Laguna pottery. As with any typology, however, it must be constantly reevaluated and refined in light of continued research. But the framework provides no way of dealing with the many "eccentric" vessels that are vital to understanding the evolution of pottery over time. Such pieces demonstrate the significance of individual potters, whose experiments and innovations lead to changes in culturally acceptable parameters. These exceptions to the standard types are almost impossible to fit into a typological framework, since types are meant to define a norm, and exceptions simply confuse that norm.

Shepard realized that typology is purely a set of abstractions, devised for the convenience of scholars. "It is indeed strange that pottery should be studied without considering its relations to the people who made it," she observed (Shepard 1965:309–10).

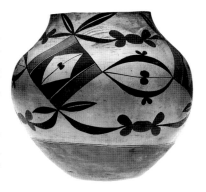

Figure 2.9. Laguna Polychrome (four-color) jar, ca. 1875. Split-leaf, double-dot, and bow-tie motifs accent the major rectangular elements, which are linked with arcs and ellipses. 12" x 12 ¾".

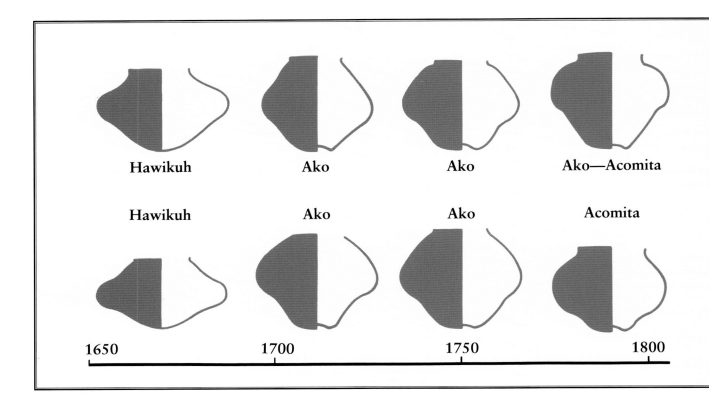

| Hawikuh | Ako | Ako | Ako—Acomita |
| Hawikuh | Ako | Ako | Acomita |

| 1650 | 1700 | 1750 | 1800 |

Figure 2.10. Profiles and cross sections showing the evolution in form of Acoma-Laguna water jars by pottery type and approximate time period.

Pottery is a living entity, and it is important to bear in mind that within Native American culture, ceramic types are meaningless. Ideally, ceramic typology reflects actual, though unarticulated, shifts in culturally accepted stylistic and technical parameters through time. But the fact remains that these categories are imposed by an outside culture and play no role in the conscious act of creating pottery. Individual potters are constantly experimenting and pushing the parameters of the native traditions, and no typology can reflect this vitality of human endeavor.

The Indian potters themselves provide perhaps the best perspective on the relevance of pottery types. Because of their sense of continuity with past, present, and future, their reaction to the vessels now stored in collections often is one of appreciation and calm interest. When they see, for the first time, pots created centuries ago by Acoma or Laguna potters, they respond with pleasure and delight. But their sense of continuity with the past is not derived from the study of the names of types of pottery, given to vessels removed from their pueblos a century or more ago.

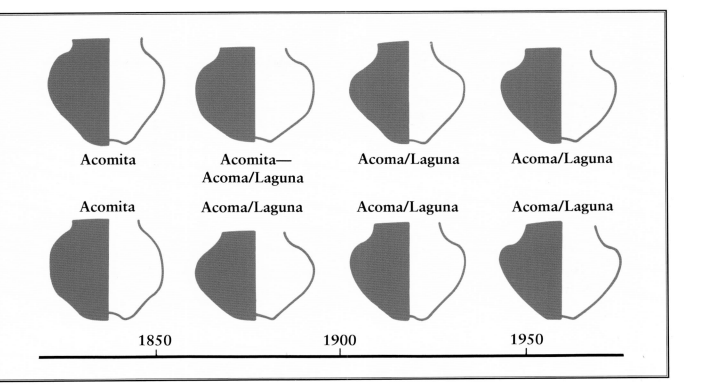

Acomita Acomita— Acoma/Laguna Acoma/Laguna
 Acoma/Laguna

Acomita Acoma/Laguna Acoma/Laguna Acoma/Laguna

1850 1900 1950

Historic and contemporary potters, like artists of any age and place, show a common interest in experimentation. In addition, each potter has a unique personality that is revealed through the pottery. These individual variations become more apparent when transitional pieces, those made between types, are examined. A good new idea, embodied in a transitional piece, might lead to the establishment of a trend or possibly even a type. A modern case in point is the "invention" (or revival) of black-on-black pottery by Maria and Julian Martinez of San Ildefonso Pueblo.

One day I showed Lucy Lewis some photographic charts that traced the evolution of pottery at Acoma and Laguna. Spanning work from the last of the glazewares, Hawikuh Polychrome, to modern pottery, including Lewis's own, the pots ranged from "typical" pieces to unique and decidedly odd examples. I asked Lewis to discuss whatever came to mind as she looked over the photographs, and she efficiently described the pots as follows: "Those are old [the Hawikuh, Ako, and Acomita

polychrome types], and these are new [Acoma Polychrome and examples to the present], and I don't make those [the old types] anymore."

This clear, bare-bones categorization demolished my scholarly struggles to classify—and overclassify?—the pottery. In some amusement and exasperation I protested, "But Lucy, we've spent *years* trying to sort out the pottery and place it in categories for study!"

Unmoved, Lewis answered, "So?"

Figure 2.11. Hawikuh Black-on-red jar, ca. 1650–1700. Entirely red slipped (including the sculpted rim), this jar has a black-glaze paneled design of serrated triangles around the neck and a band of triangles at the base of the neck band. The paneled design around the midbody bulge consists of round-tipped feathers. IAF 996. 11 ½" x 16 ½".

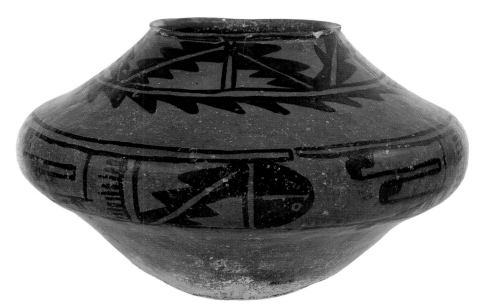

Looking at Acoma and Laguna Pottery Today

My own research, conducted mainly between 1980 and 1991, was designed to trace the development of Acoma and Laguna pottery from about 1680 (fig. 2.11) to the present. This time span covers a major transition in ceramic craftsmanship at the pueblos, the shift from glaze to matte paint. It also covers a remarkable range of pottery styles, from

the superb seventeenth-century glazewares known in the literature as Hawikuh Polychrome to contemporary pieces of ceramic art.

The research focused on the pottery collection housed at the Indian Arts Research Center of the School of American Research (appendix D). This collection, the bulk of which consists of Mera and Chapman's Indian Arts Fund collections, includes over four hundred pieces of Acoma and Laguna pottery and is among the most comprehensive in existence. I also examined pottery (and pottery sherds) housed in other public and private collections around the country.

When possible, I studied whole or nearly whole vessels, but I also examined potsherds when necessary to elaborate a point. Unfortunately, whole examples of some pottery types, particularly the early historic ones, are scarce, and a selection of potsherds is all that is available. Because of their fragile, open forms and the hard use they received, bowls are especially rare. Fortunately, one of the finest collections of extant bowls is in the Indian Arts Fund collection, which also contains several rare ceremonial ceramics, highly valued and closely guarded by those who make and use them (fig. 2.12).

Museum collections of historic Acoma and Laguna pottery contain mainly ollas and storage jars made for everyday use (fig. 2.13). When filled with water or foodstuffs, storage jars became too heavy to be easily moved—they were thus less subject to breakage than other types of pottery. I have selected water jars as the best—and most abundant—indicators of the evolution of pottery form and design over time. They are the basis of much of the typological analysis presented in this book.

The dating of historic Acoma and Laguna pottery is extremely difficult. Well-documented whole vessels are in short supply, and characteristics of shape and design that are particularly time sensitive usually cannot be reconstructed from sherds, which can, however, assist in relative dating. Many of the dates used here are derived by comparing undocumented pots with pieces collected by Stevenson and the Mindeleffs and deposited in the Smithsonian and other institutions where acquisition records are on file. Acquisition dates, however, cannot tell us whether a piece was new at the time of collection or already an heirloom.

Identification of the clay, paint, and other materials used in a vessel can sometimes help to date it, but the data are by no means foolproof.

Figure 2.12. Hawikuh Polychrome bowl, ca. 1650–1700. The interior decoration consists of four dragonflies, a central X, and two flower or medallion motifs. The exterior has a band of geometric and feather motifs and another dragonfly. IAF 1002. 6" x 12".

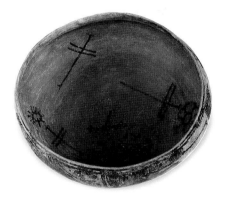

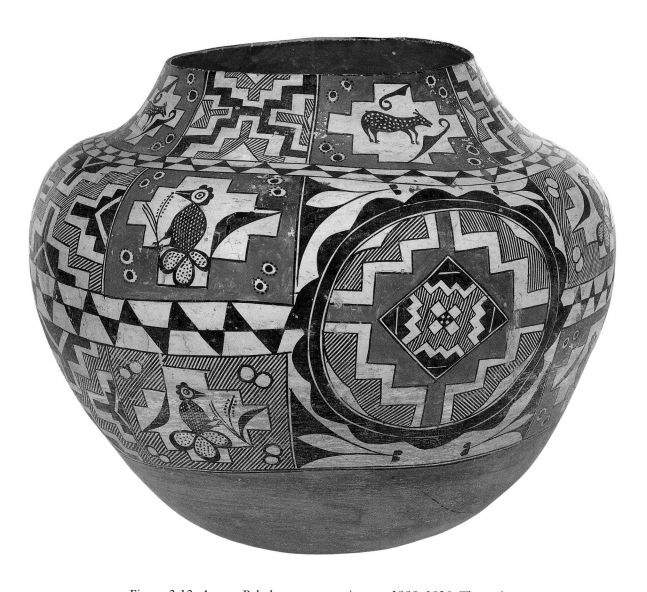

Figure 2.13. Acoma Polychrome storage jar, ca. 1900–1920. The entire surface of this large storage jar is covered with painted designs, characteristic of the allover style of decoration. The Zuni-style layout includes a large rosette, two major bands of design on the body, an intermediate geometric band, and a neck band similar in composition to the body bands. Atypical bird and deer motifs are prominent. IAF 1154. 18" x 21 ½".

The pottery contains so many idiosyncrasies that no tight rules for identification can be formulated, and the "personality" of each piece, within its larger cultural context, is an important part of any pot's history and provenience. Though particles of stone in the clay might at first appear to be rock temper (a nonplastic addition to the clay body), they may instead be bits of the stone mano and metate used to prepare the clay or temper. When ground and added to the clay, colored potsherds will pepper the cross section of a sherd with confusing information. Slips, paints, and designs can tell something about when a vessel was made if it is known when new materials and motifs appeared at the pueblo and when the use of others was discontinued.

The pottery of Acoma and Laguna is so similar in appearance that it is often extremely difficult, and sometimes impossible, to distinguish between the two. Characteristics of clay or temper may help identify the pueblo of origin; examining cross sections of sherds can be revealing in this regard. In the past, some potters at Laguna added crushed rock or sand temper to the clay, in addition to the more common crushed sherds. Florence Ellis describes the Laguna rock temper as "a diabase rock, old volcanic dyke material intrusive at shallow depths, containing feldspar, quartz, magnetite, mica and hornblende" (Ellis 1966:38). Such rock temper was not used in all historic Laguna vessels, but it can be useful in identifying the origin of some. Similarly, on rare occasions Laguna potters used a clay that fired red (some examples exist in the Smithsonian's collection) instead of the gray-white that was and is the norm at Acoma and Laguna.

As a potter, I have also relied on my own knowledge of methods and materials in determining whether Acoma, Laguna, or some other pueblo was the place of origin of a particular pot. Intuition, as well, is a factor not to be discounted in questions of connoisseurship. The "feel" of a pot, its weight and shape, its idiosyncratic personality, are all ingredients to be considered in determining pueblo of origin—and in understanding the characteristic processes of the artist who made the piece.

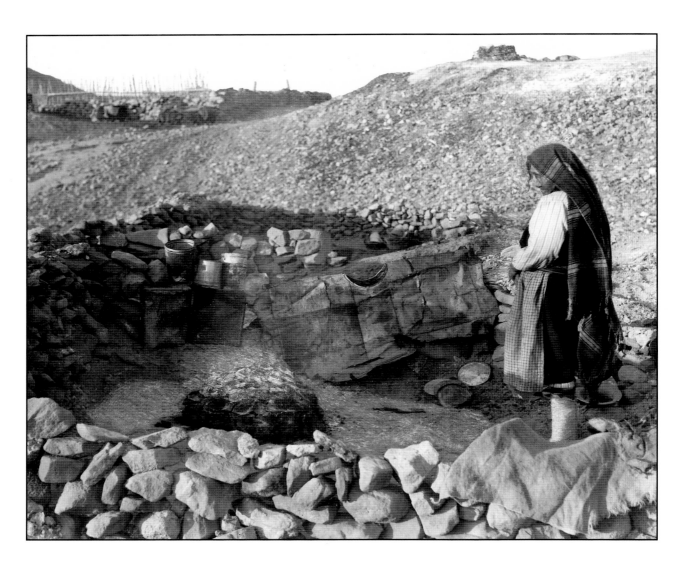

Figure 3.1. "Pottery Burner," ca. 1907. Laguna Pueblo potter dung-firing ceramics in traditional style. The rock wall serves as a windscreen to ensure even firing. Photograph by Herman S. Hoyt.

Making the Pot

Potters working in what we think of as "traditional" style use the most basic materials and very little, if any, modern equipment. Their most powerful tool is their experience, the many years of work that have taught them the art of cooperation with the clay. To watch an accomplished potter deftly molding clay in the kitchen or painstakingly painting intricate designs by the last rays of the setting sun is to experience a sense of the deep satisfaction of the process. When work finally stops at the end of the day because "the light is bad," one can feel the cyclic nature of this enduring act of creation, its ancient and tenacious roots.

The Evolution of the Potter's Technique

Baskets were the first receptacles made by the native peoples of the Southwest. Before the introduction of fired pottery, thick liners of clay tempered with a fibrous plant material were molded around baskets; these may have been attempts to duplicate actual pottery seen by early Native Americans. These receptacles are "semi-fired" and may have been used as parching trays for toasting seeds with hot rocks or as basket liners to extend the life of a worn basket (Peckham 1990:24). An observant potter-to-be may have noticed that heat made these hardened clay liners more durable.

Another possibility is that actual fired pottery was introduced into the Southwest from Mexico. Made along with fired pottery, clay basket liners dating to the fifth century have been found in the Zuni area. Pottery began to supplement the already established basketry containers; it was easier to manufacture and could be placed in a fire to prepare food. More flexible and portable, basketry continued to be made alongside the newly introduced pottery (Peckham 1990:25, 27).

The first true pots were very simple coiled-and-pinched vessels, whose forms resembled natural receptacles such as the rounded bodies of gourds. Coiling with "ropes" of clay is still the basic method for pottery making in the Southwest today: the clay is rolled out by hand into long ropes and then coiled upward beginning at the base. Finally, the junctures between the coils are pinched together to fuse and seal them.

In some areas, a technique known as paddle-and-anvil was also employed: to attach the coils, a paddle was used to press the outside wall against a stone or "anvil" placed inside the vessel. The introduction of simple tools, including sticks and gourds, led to the evolution of the coil-and-scrape method of building: coiling, pinching, and then scraping smooth the junctures. Scrapers enabled potters to expand their repertoire of sizes and shapes, though rounded forms remained the easiest to build. Creating odd-shaped objects with many angles by the coil method was too laborious, and the resulting pots were difficult to fire and are rare. As potters must have learned early on, a continuous curve contributes to successful firing with natural fuels: its surfaces absorb the heat from hot-burning fires more evenly than do angled pots.

Over time, improvements in technique extended the range of forms and designs that the potter could create. The *puki*—a basket, gourd mold, or ceramic dish used to support the bottom of the vessel being created—allowed potters to construct a consistent, standard basal shape.

Until quite recently, in fact, basic techniques of pottery making have changed very little at the pueblos. Most pottery is still constructed by either the coil-and-pinch or the coil-and-scrape method (or both), resulting in aesthetically pleasing if sometimes asymmetrical forms. At Acoma and Laguna, traditional firing methods, though used less often than they were in the past, are also basically unchanged; dried cow and sheep manure have been used since the introduction of domestic livestock by the Spaniards (fig. 3.1).

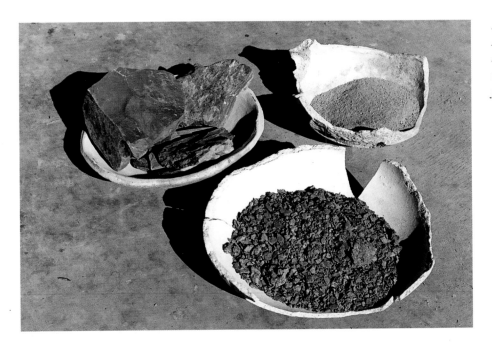

Figure 3.2. Raw clays from Acoma, showing the chunks as they appear after being mined and two stages of finer grinding.

Materials

Earth, water, air, and fire—the most basic of elements—are the raw materials of pottery. The interactions among these materials can appear deceptively simple, but the essence of the potter's art is to understand them at a profound and intimate level. Only with such understanding can the craftsperson produce ceramics of functional value and artistic merit. If the potter tries to dominate the materials rather than to cooperate with them, they can quickly rebel.

Each of the several types of clay used by Acoma and Laguna potters has its special purpose (fig. 3.2). Some clays form the structure—the body—of the pot; others become the slips (clay and water mixed to a creamy consistency) applied to the pot's surface. Certain clays are suited to the creation of large vessels of great strength; others lend themselves to the modeling of small figurines.

The slate-like clays used at Acoma and Laguna are so dense that—with the addition of potsherd temper to prevent them from cracking—vessels made from them remain quite strong through time, even when their walls are molded especially thin. Before firing, Acoma's characteristic

clay is a soft gray color, while some Laguna clay is almost gray-black; both fire to the same white color. There are also a few examples of historic Laguna pottery made with a red clay, which may derive from a special source near the pueblo or one of its outlying settlements. The clays used at both pueblos occur in layers of sandstone formations that occur nearby, but because the mines are considered sacred, their locations are not revealed to outsiders.

"We give our thanks to the Creator with our cornmeal that the clay is there," Acoma potter Lucy Lewis has told me. Potters regard the clay itself as a living thing, which must be treated with respect from the moment it is mined through each step in the making of each pot. Prayers are said and offerings made during mining, while making the pot, and when firing it. Laguna potter Lee Ann Cheromiah says, "We mine the clay in a spiritual way, cornmeal and food offerings are given. Clay is sacred for us. We ask for help and blessings from the clay."

Mining clay is also a social occasion. Children and friends of the potters accompany them to the mine and help them dig the clay, crush the large chunks to a manageable size, and carry them out in gunny sacks. If the clay is mined damp, it must be dried for many days in the sun. When dry, it is cleaned of all extraneous materials such as twigs and rocks, then pulverized and mixed with temper and water.

In prehistoric and historic times, winnowing baskets were probably used to separate the clay from the debris. These are still used occasionally today, but metal screens are more commonly employed. Initial screening of the clay is done at the mine and again at the potter's home. A final screening through a sieve of fine mesh removes most of the remaining impurities. Clay that has not been thoroughly cleaned may contain rocks, bits of white limestone, or organic materials. Organics burn out, leaving impressions in the pot; limestone can cause a pot to pit after firing. Certain veins of local Acoma and Laguna clay contain these limestone inclusions.

Pitting has created considerable difficulty for Acoma and Laguna potters (as well as those at other pueblos), especially since the tourist market has become so important. Pitting occurs when intrusive elements in the clay absorb moisture and expand, pitting or flaking off areas of the surface. When pieces were made strictly for domestic use, pitting did not necessarily detract from the vessel's function. When collectors began

to take an interest in pottery, however, they viewed pitting as indicative of an inferior pot—or potter. As a result, today many potters have resorted to commercially refined clays. Others have developed various methods to reduce the clay's pitting tendency, such as fine-grinding the clay and treating it with chemicals to dissolve the intrusive elements. Potters today have found that the mild acid in vinegar will dissolve limestone and can be used to prepare the clay or soak the pot after firing. Another antidote is the application of a commercial ceramic patching agent to mend the pots after firing. The material is applied in the pits, the surface is repainted, and the piece is then refired in a kiln. Such patches can be detected on close scrutiny.

Actually, in an era when mold-formed pottery made with store-bought clays (slip-cast ware) has become common, a small amount of pitting in a pot is an indication of its authenticity. Although no one likes to see the surface or design of a finely executed pot marred, the pitting does provide proof of local origin of clays and use of traditional production techniques.

"Temper" is the term used for the various stable, or aplastic, materials that are added to clay to reduce excessive shrinkage and cracking when it is dried and fired. At Acoma and Laguna, it is absolutely critical to the making of serviceable pottery, helping to bind the wet clay and allowing the pot to dry evenly, without cracking or warping. When the pot is fired, the temper in the clay holds it together but also allows it to "breathe." The rapid escape of air from pockets in the clay causes a phenomenon called "popping" or "popouts," in which pieces of the pot splinter off, propelled by explosions of steam that build up in pockets in the pot's surface. Temper also helps the pot survive the harsh temperature fluctuations that occur during firing.

Since prehistoric times, potters at Acoma and Laguna (and also Zuni) have tempered their clay with ground potsherds (fig. 3.3). Sherd temper is very durable, and its asymmetrical particles with their many facets serve well as a binder. Created from pottery fragments gathered at nearby ruins or from more recently broken pots, the sherd temper in a modern piece of pottery may be hundreds of years old. There is an undeniable romance in this recycling of ceramic material, in which ancient pots become a vital part of new pieces.

At Laguna Pueblo, ground rock temper was also used for a time.

Figure 3.3. The pot sherds at the bottom of the photograph are ground with the stone in the upper right to yield a powder (temper), which is then introduced into the clay body.

Perhaps introduced by potters from Zia who fled to Laguna during the Pueblo Revolt, rock temper was used by the Lagunas in utility wares such as cooking pots, canteens, large storage jars, water jars, and dough bowls. For smaller, more delicate pieces they continued to use sherd temper, which permitted finer molding of the clay (Ellis 1966:38). Eventually rock temper fell out of favor, and it is not used at Laguna today. Contemporary Laguna potters say that it takes too much work to prepare.

Sand temper has also occasionally appeared in Laguna pottery, but it has rarely—in contemporary pottery, at least—been used at Acoma. I have examined Acoma pots that included sand along with sherds in the temper, but this sand may have originated in the earlier potsherds. Sand temper is readily available, and once in hand need only be screened and added to the clay body. Despite these convenient features, it is used infrequently. From the point of view of the potter, potsherd temper is far more demanding than sand, but it also rewards the artisan with its excellent binding qualities. Traditional potters prefer it, and they often purchase sacks of sherds from local children or visiting Navajos.

The creamy mixture of fine clay and water that decorates the surface

Figure 3.4. Raw and prepared red and white slips. The yellow material will fire to a deeper red.

of many Pueblo pots is known as a slip (fig. 3.4). A white kaolinitic clay made up of very fine particles, similar to those in porcelain clay, is used to create the distinctive stark-white slip of Acoma and Laguna pottery. Properly prepared, this slip leaves a beautifully smooth, luminous surface. It also "grabs" the paints used for the designs very well. The white slips at Acoma tend to be somewhat sandier than those of Laguna, where potters at times apply a thicker coat of white slip that appears "soapy" in texture and can show prominent stone-polishing marks.

As at most pueblos, at Acoma and Laguna mineral pigments and vegetal binders for painting designs and slips are usually mined or gathered locally. Acoma and Laguna potters have traded their desirable, fine white slip with craftspeople from Zuni (and probably other pueblos), so caution must be used in using slips to determine the pueblo of origin of southwestern ceramics.

One instance of such trade is recorded in correspondence between the trader C. G. Wallace of Zuni and Jesse Nusbaum, director of the Laboratory of Anthropology in Santa Fe, who had made inquiries on behalf of ceramic expert Anna Shepard. On February 7, 1933, Nusbaum wrote to Wallace: "For Miss Shepard's information, will you please

inform me as to the location from which the Zunis got their white slip clay such as you sent here for her technical studies? Under the microscope it very closely resembles the slip clay used by the Lagunas, and Miss Shepard is wondering if the Zunis and the Lagunas obtained their white slip from the same source." In his February 9, 1933, reply, Mr. Wallace said that in the previous year, Zuni potters went to Laguna and "fetched back a gob" of white slip which they currently used (letters on file at the Laboratory of Anthropology, Santa Fe; copies provided by Jonathan Batkin). The pottery of Arroh-ah-och that exists in public and private collections shows two different kinds of white slip, one with a surface texture that indicates a Laguna source, the other laced with fine cracks alluding to a different source. Crackling of the surface can also be due to a very thick application of slip or a higher firing.

Many slip colors other than white are used by Acoma and Laguna potters, ranging in their fired state from yellow to deep brick red to a lavender gray and purple-brown (fig. 3.5). The color of a slip in its raw state can change significantly when fired; the polishing of a slip can also deepen its color. The basic slips can be mixed together to produce a seemingly endless palette of colors. The deep red used by Laguna potters frequently has a sandstone rather than a clay base, which lends it a distinctly chalky or sandy appearance and a rough texture. Because of its gritty texture, potters usually leave this slip unpolished. During a nineteenth-century migration, the red Laguna slip was carried to Isleta Pueblo. Along with the basically Laguna design vocabulary, this slip physically connects the painted pottery of the two pueblos.

The matte black paint used in designs on Acoma and Laguna pots combines a mineral substance—natural hematite—with a vegetal material—*guaco*—made from boiled wild spinach (also known as beeweed). At least one potter today, Joe Cerno of Acoma, uses the residue of boiled yucca fruit for the vegetal substance in the mix. The hematite provides the basic colorant, while the guaco serves as the binder that helps attach the mineral pigment to the clay surface. This paint mixture, when fired, can range from deep black to brown-black to gray, depending upon the proportions of each ingredient and the firing atmosphere used. Proper mixing of the hematite, guaco, and water—usually done on a stone palette—is essential. If the mixture contains too much mineral, the paint tends to become powdery after the firing. If too little mineral is used, the watery paint creates a "ghost-like" image.

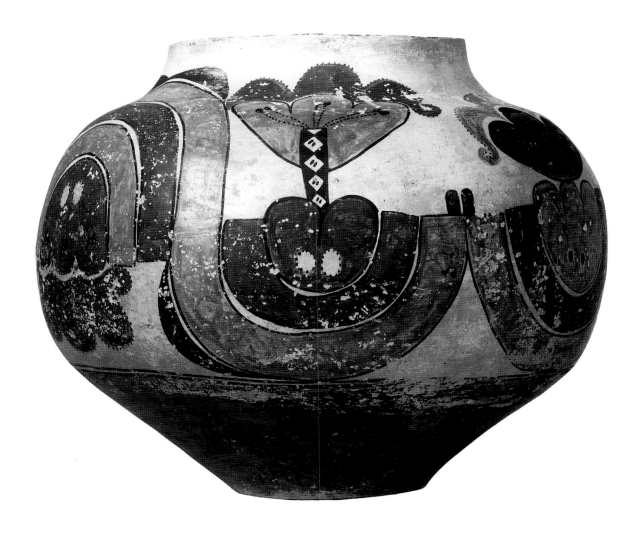

Figure 3.5. Acoma Polychrome jar, ca. 1875. Three colors—brown, orange, and red—appear in the painted design of this jar. Black outlining and a white background slip make it a five-color polychrome, with an unslipped and floated base. The unique design consists of arcs, double dots, and three-lobed motifs with unbordered curvilinear elements. 10 ½" x 14".

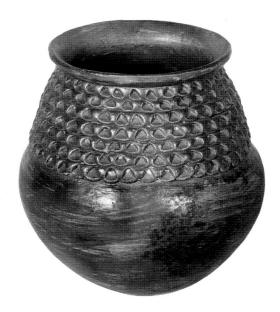

Figure 3.6. Acoma monochrome jar, ca. 1960. Signed Lucy Lewis. A modern copy of the old neck-banded, indented (corrugated) pottery, this vessel is entirely covered with an orange slip that was reduced to brown in the firing. IAF 2789. 6 ½" x 6 ¼".

Traditional and Modern Tools

Traditional tools used in pottery making are simple and multifunctional. The clay is mined with sticks and shovels, ground with stone manos and metates, soaked in large ceramic bowls, and shaped and scraped with tools made from pieces of gourd. Manos and metates are also used to crush potsherds into temper. Sandstone rock and pumice are employed to smooth and sand the dried pieces of pottery. Slips are applied with a piece of wool or soft leather, and stones are most often used to polish the surface.

Like most craftspeople, though, Acoma and Laguna potters have always been extremely versatile in their selection of tools. Today they use both traditional implements and modern items that adapt well to their largely traditional pottery-making techniques. When such items as metal pans arrived over the Santa Fe Trail, for example, Pueblo potters adopted them, and today the list of nontraditional items used in pottery making is endless and intriguing. I have seen old hand-cranked meat grinders used in place of traditional manos and metates to pulverize the clay, and galvanized metal tubs and buckets have replaced ceramic bowls for soaking it. Recently, potters have begun scraping the wet clay with tools made from rubber and stainless steel acquired from commercial

hobby shops or with medical and dental implements such as tongue depressors. After clay passes the "leather-hard" stage (still damp, but no longer malleable), a variety of makeshift scrapers can be used, from old potsherds to corncobs to metal cut from cans. Sandpaper and copper pot scrubbers are replacing natural sandstone and pumice for additional smoothing of the dried pot. Though today some potters still apply slips with a piece of leather, the use of a piece of cloth or a commercial paintbrush is not uncommon.

Potters have shown special versatility in adapting tools for applying designs to their pots. To make the indented pottery inspired by prehistoric corrugated wares, potters use everything from sticks to metal hardware (fig. 3.6); Acoma potter Jessie Garcia used a "church-key" bottle opener. Dentistry tools and X-acto knives are employed to scratch the new cameo-style, or "sgraffito," designs (see fig. 8.6).

Despite the variety of modern artist's brushes available, which are used most frequently to fill in large areas of color, the traditional yucca-leaf brush is still preferred by many potters to apply slips and designs in black paint. The flexibility of these brushes and their ability to adhere to vessel contours makes them much better suited to the exacting work of fineline painting than are commercial brushes. Yucca brushes, made by chewing the ends of small strips of the spear-like leaves of the yucca plant, are prepared in various thicknesses and lengths to accommodate the painter's needs.

Smooth stones of various shapes used to polish the surface of a finished pot are a basic and irreplaceable tool. Favorite polishing stones become "special" to the potter, and some are handed down from one generation to the next like heirlooms. Although most polishing stones are probably found items, potters will occasionally buy stones from a lapidary or other supplier.

Working with the Clay

Potters at Acoma and Laguna rarely work at a steady pace of production, so it is difficult to say how long it takes to make a group of pots by the old methods. A potter will generally have pots in some stage of production in her home at all times; she will work on them for a few days

and then leave them for other matters. Many variables also come into play: how many people are helping with the different tasks, the number of pots being made, the difficulty of the forms and designs, and the type of firing done. If a potter were to work full time, with some assistance, on a group of pots, she might be able to complete the batch in two weeks—including gathering materials and firing pots in the "old style," the traditional outdoor method. Sometimes potters will force the process and create several pots in a week, but this approach is the exception. Working on a group of pots—three or four pieces—rather than a single object at a time allows for a continuous cycle of work, so that the potter can focus on one piece while the others are setting up (drying to the desired hardness). Finally, all the finished pots can be fired together.

Although a more accomplished potter is often responsible for sculpting the shape of the pot and painting the designs, usually a group of people, often members of the same family, work together to produce the pots. In historic times, it is likely that potters worked together to supply pottery needed by the pueblo, although at Acoma in the 1920s, according to Ruth Bunzel, "pottery bees" were not the rule: "Pottery is mostly made in summer at Acomita, a straggling farming village that is not at all conducive to social activities of this kind" (Bunzel 1929:64). Today, although one person's name is usually signed on the bottom of a piece, teamwork is evident in the making of most Pueblo pottery. Production often takes place in a sort of quilting bee atmosphere, with several women in the family participating in different tasks. It is a social activity with time for the exchange of information, gossip, ideas, and laughter. Distractions from children are always a part of pottery making, and the lone potter with babysitting chores tends to work more slowly than the potter in a group, where someone is always available to tend the children.

Today's potters often work in the kitchen or living room, and all parts of a potter's home may be used in some pottery-related function. Clay and tools are stored in garages, or wherever a good place to keep materials dry can be found. The backyard can have buckets of clay soaking and chunks of clay drying on an outspread tarp.

The first task in the preparation of the clay is mixing the clay body—a highly individualistic process. Creating the mixture of ground clay and pulverized potsherd temper can take anywhere from a few hours to many days. Normally the temper and clay are blended in their dry state

first, and then the water is added and the clay body mixed to the desired consistency. Many potters add the water and then step into the mixture, blending it with their feet. Others mix it in buckets and let it "set out," so that some of the moisture evaporates.

With each potter, intuition plays an important role in the mixing process. Some potters prefer a dry clay body, others a wetter compound. Temper is added to the clay by "feel" of the amount of grit in the clay— from experience, the potter knows what will work. The clay-temper mixture is vital: not enough temper and the pot will warp and crack, too much and the plasticity of the clay is lost. The basic proportion is about one-third to one-half temper to two-thirds to one-half clay, but these ratios are not always adhered to. Acoma and Laguna potters are quick to point out that each potter has a different way of doing it.

Different intended functions of the piece also dictate different proportions of clay to temper. If a pot is to be used as an unpainted utility vessel, the potter may prepare the clay body with extra sherd temper, or she may add rock or sand to "open" the clay body and permit air to escape from the pot's surface. This openness allows the pot to withstand the thermal shock of initial firing and later heating over the cooking fire. Extra temper also appears to allow heat to be distributed more evenly throughout the vessel, an important factor if the pot is to be used for cooking.

Clay is among the most versatile of media, but to create a fine pot, the potter must understand the material and its potential and be able to communicate with the clay. The main limiting factors are the characteristics of the particular clay and the talent and ability of the potter. Sometimes potters refer to "bad clay," but this attitude usually indicates that a potter has attempted to mold the material in a way that is inappropriate to its nature. No clay is actually "bad" unless it is riddled with impurities. Many potters who have a "bad" batch of clay, usually from improper blending, will add the appropriate material—temper or clay—to balance the mixture.

Once prepared, the clay body can be used right away; to increase its plasticity, however, it is best to let it age. Molding a batch of four or five pots may take about a day, perhaps longer. Pottery is made year round, with increased production in warmer months. Potters who work in the winter will dry their pots around a fire or heater, but uneven drying in

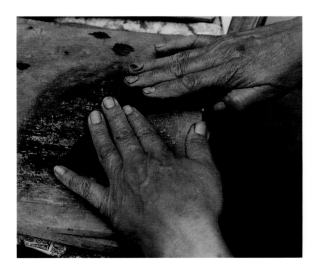

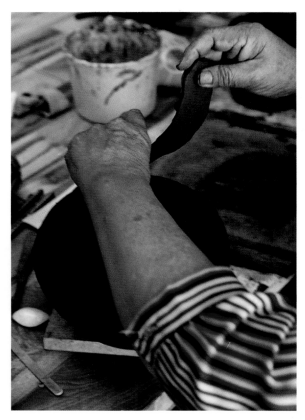

this manner can crack and warp the pot. Many potters complain that cold clay in the winter aggravates cramping in their hands. Room temperature and humidity, which determine how quickly the clay dries, also dictate how quickly a potter works. The interval that elapses between adding each new level of coils may be as short as fifteen minutes or as long as an hour.

To mold the base of the pot, potters use pukis—either the traditional ceramic form, often the base of a broken jar or bowl, or other suitable forms. In keeping with their talent for adapting whatever materials are at hand, modern potters use many types of contemporary materials and forms for their pukis, including china bowls or wooden salad bowls. Recently, I have also seen plastic and metal bowls used as pukis. The puki provides a structural base and facilitates rotation of the

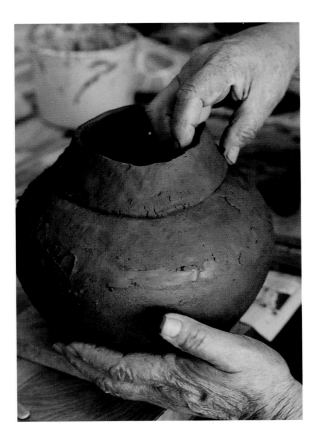

Figure 3.7. Coiling and building the pot. After rolling out a coil (left), the potter flattens it and adds it to the growing vessel (center). The set-up time that elapses between the addition of each coil (right) is essential to prevent the pot from caving in.

vessel during construction to ensure an even vessel wall and overall symmetrical form. Once the base is molded in the puki, the body, shoulder, neck, and rim of the jar are free-coiled to the desired form.

Puki marks, the indentations that occur where wet clay is pressed over the edge of the mold, are noted on pieces created as late as the early 1900s at both Acoma and Laguna. (A puki mark should be distinguished from a "keel," which Harlow [1973:71] defines as "a sharply angular convex flexure" that is not the result of building a pot with a puki.) Stylistic changes in the early 1900s for the most part phased out the puki mark, though occasional examples have been made up to the present day. Potters in the past were not as preoccupied with a perfect surface as they are today. Currently, the emphasis is on a smooth, continuous form, though some potters are adding intentional puki marks in

a revival of the older style. When a contemporary potter adds a puki mark, though, it is almost always well molded—even and clean—unlike the more casual and fluid puki marks of the past.

To begin a new vessel, the potter fills the puki with a small slab of clay or a group of coils, from which she forms the bottom of the new piece. Later, rounded or flattened coils are added on top of the base to form the vessel walls (fig. 3.7). Each coil is pinched together at the joints and scraped smooth. Potters have distinct preferences about the manner of adding coils, some placing the coils on the inside of the vessel walls, others on the outside. The method chosen may depend on the desired shape of the vessel itself. How the coil is placed helps determine the final form of the pot; that is, whether an incurving rim or an outflaring one is created.

The potter builds the vessel in intervals, allowing the clay sufficient time to dry between the addition of wet coils so that the piece does not cave in from their weight. Gourd scrapers, left in a bowl of water to keep a soft edge, or commercial objects of rubber or steel are used to shape the walls. Attention is focused on the stages of dryness: it is difficult to ensure a homogeneous construction if the pot dries out too much between coils. These junctures are likely places for later cracking.

When the final form has been roughed out, it is left to set up to the stage the potters call "leather hard." At this point, the partially finished vessel can be removed from the puki and scraped to the desired thinness. After this initial scraping, the pots today are usually covered with plastic to slow the drying process and then left to set up. They are scraped once more to achieve the final form and then dried. The last step is sanding the pot to even its surface, a process that takes up to an hour for a small olla.

In prehistoric and historic times, the surfaces of many utility wares were left with exterior corrugation, unlike the smoothly sanded surfaces of decorated pots. The surfaces of these utility vessels actually are more difficult to make than those of smooth-surfaced wares because all of the binding done during the coiling process must be executed on the inside of the jar. Potters have a better chance of creating crack-free vessels by smoothing both sides of a jar or bowl. On corrugated jars, coils are pinched just once to join them to keep the exterior surface of the coils fresh looking. It takes great skill to create a corrugated utility vessel

without cracks along the coils' junctures.

The corrugations or unjoined coils on the exterior of a pot may help distribute the heat when the pot is used for cooking. The protrusions seem to "grab" the heat as it rises from the lower surface of the pot, then serve as louvers to hold the heat and spread it over the bottom of the pot. They also keep heat away from the neck, so cooks can handle the rims without being burned.

In the past, many cooking vessels received a special coating after firing with a material that sealed their surfaces and rendered them less porous—the same effect as sealing a wooden bowl with oil. Cushing mentions this seasoning process in describing Zuni pottery, and it was likely used at Acoma and Laguna. After firing, according to Cushing (1886:312), the pottery object was removed hot and the interior coated with the "mucilaginous juice of crushed cactus leaves and piñon gum." The vessel was then refired in "coarser fuel," a process that carbonized the vegetal mixture to a "shining, hard black glaze" (Cushing 1886:312).

Adding Slips and Designs

Slips and painted designs are applied to the pot before it is fired. Slips are used to change the color of the vessel's clay background, alter the pot's surface texture, or both. On ollas made at Acoma and Laguna, bases and rim interiors are usually slipped red or (after the early 1800s) orange, and the distinctive white kaolinitic slip is used over the major portion of the body. The orange slip on the base is often thinly applied, leaving a striated, streaked appearance; occasionally orange slips are used on the entire vessel. Solid white and red slips are used in bowl interiors, red probably being used more at Laguna. Time and use lend most slips a fine patina, and after years of handling, the surface of the pot or bowl has the appearance of fine leather.

In order to build up an even surface, white slip is applied in stages, each application taking a few minutes. The pot is left to dry between applications so the watery slip does not penetrate and weaken the unfired vessel. There are some historic and modern examples of entire pots slipped white, with no basal color used.

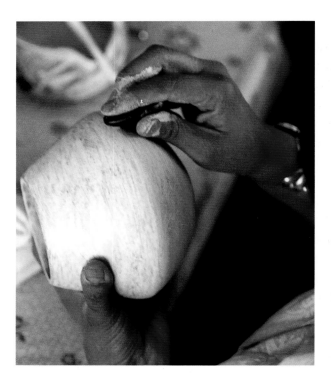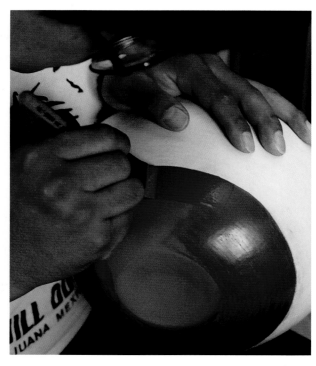

Figure 3.8. After the pot has been scraped, dried, and sanded, the white slip is applied and then polished with a stone (left). The red base slip is applied with a commercial artist's brush (right).

The potter applies the white or red slip—diluted to the consistency of cream—with a brush or a piece of cloth or leather, then most often polishes it with a smooth stone (fig. 3.8, *left*). The polishing "seats" the slip on the clay to make an even surface to receive the painted design. It also seals the surface, creating a protective "skin" on the pot. At this stage, the white slip tends to look streaky, and areas of thin application are evident. Once it is fired, the pot will appear to have an even, overall coating of stark white.

Technically, painting methods today are much the same as they were throughout the prehistoric and historic periods. Materials remained the same until the very recent past, when new commercial products were introduced. If the vessel is to have a decoration, it is painted after the base slip has been polished. Many potters favor particular designs for certain forms; some designs are used for water jars, others for seed jars. Sometimes potters have a design in mind as they are making a pot, and others wait until the pot is done and then decide on something to fit the

form. Each curve of the clay may suggest a particular design.

Many modern Acoma and Laguna potters block out areas of design with a pencil; earlier potters may have used charcoal or slight indentations made with the fingernail to outline their designs. The carbon in lead pencils and charcoal burns out during a high firing, leaving no trace. But an experienced and confident painter can commence her design spontaneously, and I have witnessed many potters working freehand.

After the sketch is completed, the outline is painted with the vegetal-and-mineral mixture. Potters usually start by tracing framing lines around the neck, midbody, and base of the pot to establish design zones. Next, the painter applies vertical panel lines—if they are used—and then goes on to outline the major elements necessary to establish the design's symmetry.

After the basic structure of the design is laid down, decorative slips are painted in the outlined spaces (fig. 3.9). When these have been filled in, the black outlining is sometimes redone to cover areas where the colored slips have spilled over the original lines. When the potter is finished, a typical jar has a washy white appearance, with designs painted in various orange and yellow slips and bordered with the brown-black outlines. Mistakes in drawing are easy to see, as the paint cannot be rubbed off or "erased." Once applied, it permeates the surface of the pot and has to be scraped off. Sometimes these "erasures" are reslipped in white, but often they are left as is.

The time involved in painting the designs varies tremendously, from a few minutes for a simple Mimbres-style design to many days for the elaborate fineline patterns. For the most difficult designs, such as the painstaking fine lines, potters usually work only twenty minutes or half an hour at a time because of the intense concentration, eye strain, and muscular control required.

The colors of the slips and designs will change during firing. The chalky white becomes denser, and the oranges and yellows usually shift to a darker shade; the lavenders tend to remain much the same. Proper firing bonds the pottery slip and design to the vessel, making the entire piece a physically integrated whole.

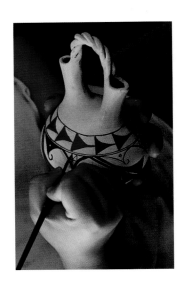

Figure 3.9. Painting the design. Either a traditional yucca brush or (here) a fine commercial brush is used for outlining and detail painting.

Firing

The last step—and ultimate test—in the pottery-making process is firing. Successful firing gives the vessel its hardness and strength, and a very hot, or "hard," firing will render the pot stronger and more functional than a soft firing. Some potters actually refire pieces to make them harder or change their color.

Acoma clay can withstand a very high firing, as can pottery from Hopi, Zuni, and Zia—all pueblos with cultural connections to the pottery traditions of Acoma and Laguna. Pottery from some of the other pueblos, and especially pottery with a high-polished finish, is fired with less heat and is correspondingly softer. Prior to the introduction of domestic animals and their manure, Acoma and Laguna potters used wood for firing. Sheep manure, the favored fuel at these pueblos, has been used for the bulk of the matte-painted wares of the historic period. Both wood and sheep manure burn hot, but sheep manure is more manageable and burns more evenly.

In modern times, the major change in the pottery-making process has been the adoption of the electric kiln by the vast majority of Acoma and Laguna potters since the early 1970s. Most potters take their unfired pottery to ceramic shops in nearby towns or on the reservation; others have purchased their own electric kilns. With them, potters can control the firing temperature and atmosphere more precisely, rendering the entire process more predictable than the dung-fueled outdoor method. "People want perfect pots, and that's one way to do it," says Acoma potter John Aragon. In addition, pottery making is no longer a strictly seasonal task. "My grandmother [Lupe Aragon] worked only in the summer," Aragon continued. "Now it's all year round, and with the weather, you can't always fire outside."

The electric kiln method is clean and relatively simple. The kiln is loaded with pots, which are preheated for two or three hours and then fired for another two hours. About half a day is required to allow the pots to cool down. If necessary, the time for each of these steps can be decreased. Temperatures can be monitored by pyrometric cones, calibrated to melt at a certain temperature, and by timing devices. There is very little variation in the firing temperatures of modern kiln-fired pottery.

The temperature used by most potters today in kiln firing is approximately 1,023 degrees Centigrade, or 1,873 degrees Fahrenheit (Cone 06). It is unusual to reach these temperatures in an exposed outdoor firing. Anna Shepard, recording temperatures of firings at other pueblos, noted that dung-chip fuel reached a maximum temperature of 940 degrees C, while wood peaked at 962 degrees C (Shepard 1965:83). The type of "dung chip" used also has an effect on the firing temperature. The high temperatures reached by Acoma and Laguna potters may be due to the corral-packed slabs of sheep manure they use. Cow manure collected on the open range is more porous, burns more quickly, and has a lighter, less insulating ash than corral manure. Other aspects of manure composition can also affect its efficiency as a fuel. The slabs of corral-packed sheep manure—cut with a hatchet or large knife to appropriate sizes—stack more evenly, burn hot and slow, and leave a dense insulating ash.

Though by far the more common practice today is to use the electric kiln, on special occasions Acoma potters sometimes (though often grudgingly) will fire outdoors in the "old way"—usually in response to buyers who want "old-style" pottery. This ancient process is extremely time consuming and difficult, requiring the participation of several people, so potters tend to charge more for dung-fired wares.

Potters who fire outside set aside special spaces to which they return to do their firing. These areas may be near a potter's or relative's home and may be shared by several potters. A shed is frequently constructed over the area, or it may be covered with tarps or metal to keep the ground dry. The manure must be protected from the weather as well.

The actual firing time is rather short, about an hour or so, but the preparation of an outdoor firing can be a long and tedious process: the fuel must be collected and prepared, the ashes from previous firings disposed of, the equipment (metal pieces and/or sherds to protect new pots from the fuel) checked for damage, the pots and fuel warmed and stacked. Manure is either gathered or purchased, sometimes from Navajos who charge fifty dollars or more for a pickup load of dried manure. Once dried, it is chopped into chunks. When firing conditions are right—the day must be windless, and morning and dusk tend to be favored—some of the dung fuel is stacked, lit, and allowed to burn

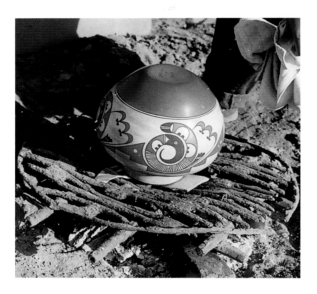

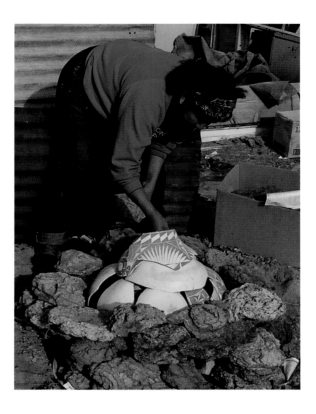

Figure 3.10. Traditional firing at Laguna Pueblo. After building a small fire and allowing it to burn down to a bed of coals, Gladys Paquin places a grate over the coals and rests the pot upside down on several large pottery sherds (left). The coals will ignite the manure (right), which is stacked up around the pot after sherds have been arranged over it as protection from falling fuel.

down to a hot bed of coals. A bed of old potsherds or sheet-metal pieces such as iron grates, corrugated roofing, service trays, or cut-open cans is laid over the coals to prevent the pots from coming in direct contact with the fuel (fig. 3.10, *left*). Some potters have table-like metal frames made to raise the pottery off the coals.

Today the pots are warmed in an indoor stove or oven for a few hours before firing to eliminate moisture. In the past, they were warmed around the firing pit. The preheated pottery is placed upside down on the bed of sherds and covered with more sherds or metal to create a semienclosed "oven." The upside-down pot tends to hold rising heat, adding to the efficiency of the firing. Fuel is then heaped around each pot in a beehive shape to create a self-consuming "kiln," and the underlying bed of coals ignites the stacked manure (fig. 3.10, *right*). If a wind comes up, baffles are placed around the pottery to fend off breezes that would fan the flames and create uneven heat (fig. 3.11, *left*). Any number

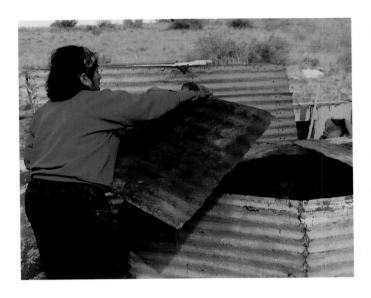

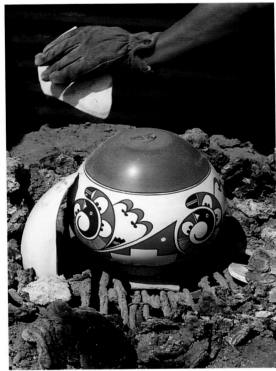

of vessels may be fired at one time, from a single piece to a dozen or more, depending upon the size of fire manageable for a particular potter.

Firings can be characterized as reducing (lacking oxygen) or oxidizing (having plenty of oxygen). Every firing usually begins in a reducing atmosphere (the cooler stage), during which carbon from the initial ignition of the fuel penetrates the vessel walls. Later in the firing, when the temperatures are higher and the fuel is burning cleaner with ample oxygen, much or all of this carbon can be burned out, leaving a gray to white core to the vessel wall (visible only in cross section). The final colors of slips can be used to determine the atmosphere of the fire: most pottery fired in an open fire has a combination of oxidized and reduced areas. This is especially obvious where an orange slip (oxidized) has turned brownish (reduced). Pottery at Acoma and Laguna is generally oxidized, with some examples showing variations in the shades of the orange and red slips that result from spotty reduction. The white slip in

Figure 3.11. Gladys Paquin assembles an elaborate wind-screen around the fire with sheets of corrugated tin (left); *this helps to contain the heat and ensure an even firing. Finally* (right), *the baffles, burnt fuel, and sherds are removed to reveal Paquin's finished piece. Note the difference in the slip colors before and after firing.*

a reducing fire may alter to a gray-brown color. Pottery fired in an electric kiln is thoroughly oxidized: oranges and reds are bright and crisp, with no variation in shades, and whites are true whites.

Once the fire is lit, the process requires constant physical attention. Intense heat and smoke burn eyes and throat. The fire tenders must move rapidly, plugging holes where dung has fallen, in order to keep the fire burning evenly. They need to have great stamina, and when the firing is completed many potters experience total exhaustion.

A successful firing produces a fine, evenly fired surface to the pot (fig. 3.11, *right*), but a small mistake in an instant of inattention to the fire can result in tragedy—the sudden and irreversible loss of some or all of the pots. There are numerous opportunities for disaster to strike. Certain fragile pots, such as large dough bowls, are particularly susceptible to structural cracking, but under undesirable conditions any pot can crack during firing. Stresses can be set in the clay when the pot is handled during any stage of building or painting, and firing will reveal these weaknesses. If a breeze arises and causes uneven heating, the pots may crack. After firing, the tap of a knuckle immediately reveals such cracks: a clean, clear ring means the pot is intact, but a thud or metallic buzzing sound gives away the imperfection. Because of the thinness of construction and dense quality of the clay, the successfully fired pots will produce a high-pitched, bell-like ring. "Pops or cracks," says Acoma potter Wanda Aragon, "show the spirit of the pot has left and the pot has no life. If something bad happened to the potter or she has something bad on her mind or she's unhappy, cracks will happen. When she is making the pot she can talk to it or to other people, but she cannot talk *into* it. If she does, the pot will crack."

Another mark of traditional firing methods is the blemishing of surface color and design. "Fireclouds"—black spots rimmed with gray or other discolorations—are created when chunks of fuel fall onto the pot, cutting off the flow of oxygen to that particular area. Tourists and collectors unfamiliar with the process often consider fireclouds undesirable, though one could certainly argue that they are proof of the "authenticity" of a piece. With the changes in surface color, fireclouds add warmth to a vessel's appearance. Gladys Paquin of Laguna, one of the few potters who continues to fire outdoors, achieves such even firings that fireclouds are unnoticeable. She finds it curious that some collectors find

Figure 3.12. Acoma Polychrome jar, ca. 1959. Signed Lucy Lewis. Steam pockets propelled pieces off the surface of this jar in the firing, causing the popouts which show the sherd temper in the clay. IAF 2778. 6" x 7 1/4".

her rare fireclouded vessels appealing. In general, the market's unwarranted aversion to fireclouds has been an incentive for many potters to switch to kiln-fired pottery.

If a pot is underfired (fired at too low a temperature for maturation), the paint may remain powdery and brush off. If overfired, the paint may crackle. Both manifestations can occur on the same vessel from varied atmospheres and temperatures in the firing.

During the initial stage of firing, moisture in the clay can cause popouts as the pots heat up, forming steam or air pockets in the hot clay that proceed to burst. Popouts give the pot a rough, cratered appearance, which, though unattractive, does not render the pot unusable unless the imperfections go through the vessel wall (fig. 3.12). Unfortunately, in old-style outdoor firing these popouts are a common occurrence. Meticulous vessel construction can help prevent them, however: if the clay is evenly tempered and the initial heating is very thorough and even, existing air pockets will not pop when fired.

Probably no experience is more demoralizing for a potter who has put painstaking hours of thought and labor into the creation of a pot than hearing the dreaded sound of a popout. As Acoma potter Shayetsa White Dove once told me, "It is a very stressful thing to put a lot of time in the pot and [its] design—especially the large ones—and then to hear them pop. It is a waste of time!"

Only when the newly fired pieces are uncovered does the potter know whether or not the firing was a success and if the long hours of preparation, as well as the laborious firing, have brought the desired result. If all has gone well, a beautiful vessel will emerge from the heap of manure and potsherds. When tapped, these pots will ring true.

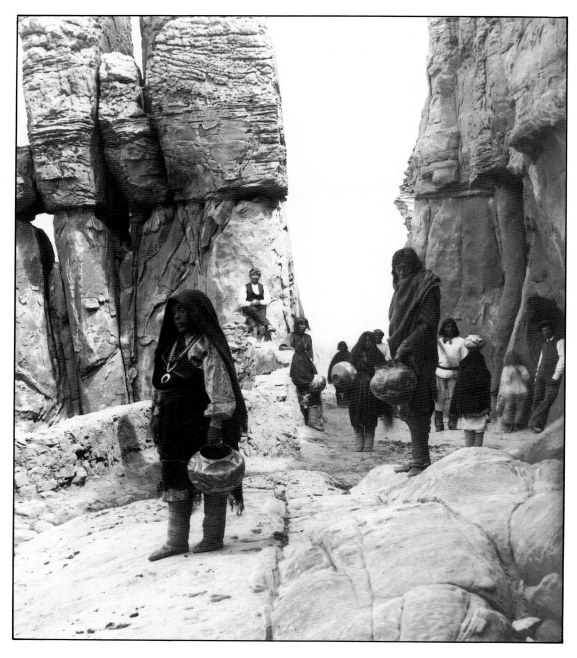

Figure 4.1. "The Water Carriers: Approach to Acoma." Acoma Pueblo, ca. 1884. Photograph by Ben Wittick.

Form and Function

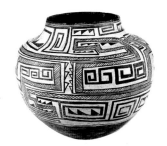

During the four centuries since the Spaniards arrived in the American Southwest, potters have created a vast array of new ceramic forms and painted designs. Yet in the midst of this change and diversity, they have continued to draw on many standard shapes that are solidly centered within the Pueblo cultural tradition.

The traditional olla is perhaps the best illustration of the essential relationship between function and form in Pueblo pottery. To meet the needs of women carrying water to their homes, jars had to be easy to lift and had to balance firmly on the head of the bearer. Acoma and Laguna potters therefore made vessels of a size that would not be too heavy when full—roughly 10 inches tall by 12 to 13 inches in diameter. They formed necks with slight incurving depressions that fit the hand perfectly to allow easy handling when empty, and narrow mouths that inhibited both evaporation and spillage (fig. 4.1). Prehistoric to Hawikuh ollas had rounded bases and were balanced on the head or on the ground with a woven yucca ring. In the early eighteenth century, potters at Acoma and Laguna began to create vessels with concave bases, low centers of gravity, and outflaring shoulders to increase their stability.

Water jars executed in the style known today as Acoma Polychrome have been produced almost continuously since about 1860. This style, which embodies simplicity and grace of line, has served successfully as a utilitarian container and also as an elegant form on which to paint an array of designs (fig. 4.2).

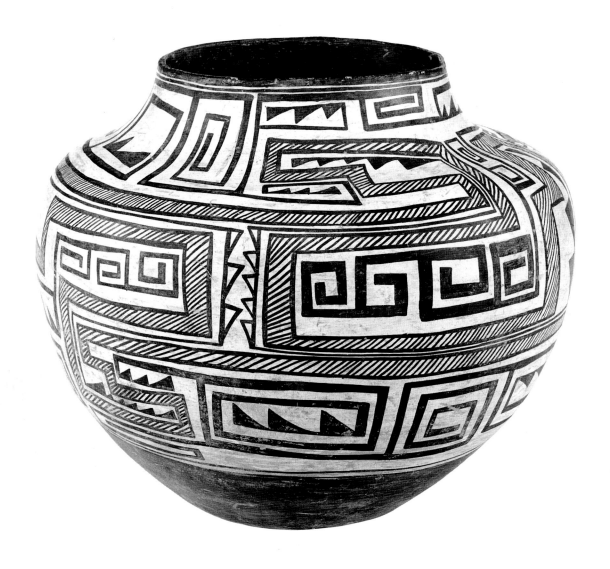

*Figure 4.2. Acoma Polychrome jar, ca. 1880–1900. This piece has a
red base and interior rim and an overall thick white slip. The design is an
elaborate combination of interlocked frets, triangles, and hatching. A continuous,
smooth line of profile, uninterrupted by flexures, is common in Acoma
Polychrome. IAF 1580. 11 ½" x 12 ½".*

The seventeenth-century glazeware called Hawikuh Polychrome was, by contrast, a shorter-lived style. With their remarkably beautiful but exaggerated curves, Hawikuh jars were more difficult to make than the later Acoma Polychromes, and after only a few decades, the Hawikuh style began to give way to a simpler shape. In the test of time, fashion must serve function, and it would appear that potters continued to experiment with the olla's form until they found one that fulfilled both their pragmatic and their aesthetic requirements.

Certain forms made at Acoma and Laguna are common to all the pueblos, including simple bowls in many sizes and large, round storage jars. Some shapes and designs are so ubiquitous that contemporary potters may not be able to distinguish the pueblo of origin of a vessel in a non-Pueblo setting. Acoma potters have asked me if Zia jars were from Acoma. Some shapes, however, tend to be developed into a "trademark" form distinctive of one pueblo. Turn-of-the-century ollas at Acoma are quite unlike those from Cochiti and San Ildefonso, for example: Acoma jars are high shouldered, some San Ildefonso jars exhibit a severe mid-body bulge and tall neck, and Cochiti jars display a rounder, short-necked form. Speculation on the development of these distinct forms ranges from the capacity of the materials (some clays are better suited to some forms) to changing cultural aesthetics to the conscious development of individual styles to make each pueblo's work unique.

Standard forms of painted pottery at Acoma and Laguna in the historic period included practical items such as water jars, storage jars, seed jars, dough bowls, serving bowls, and pitchers; items for personal use such as food bowls (fig. 4.3); and special-purpose items such as vessels to hold minerals and paints for pottery making. Bulbous canteens, with short spouts on top and two handles for attaching a cord, carried water for people traveling, hunting, or laboring in the fields (fig. 4.4).

Painted ceramic bowls ranged in their standard forms from very large dough bowls to smaller vessels for routine food service and preparation. Bowls for preparing *piki* ("paper" bread made from cornmeal) were of an intermediate size—12 to 13 inches in diameter. Smaller bowls, 8 to 10 inches in diameter, were made to be hand-held as dishes for individual food portions at daily meals. Often table settings would include even smaller bowls for native salt or perhaps a separate serving for visiting spirits of deceased ancestors.

Figure 4.3. Acoma Polychrome bowl, ca. 1900–1920. Small food or paint bowl with exterior design of bars and double dots covering the base. Painting across the base may distinguish this as a ceremonial piece. IAF 1485. 4" x 7 1/2".

When the Spaniards introduced wheat and various fruits and vegetables to the Southwest, the Acomas and Lagunas began to need new sizes and shapes of vessels for food preparation and storage. One of these was the large dough bowl—up to 18 inches in diameter, and occasionally even larger—that developed once wheat bread became popular (David Snow, personal communication, 1987). It apparently took some time for such major changes in diet and food preparation to be assimilated, however: dough bowls, now a standard form, probably did not appear at Acoma and Laguna until the mid-1700s (figs. 4.5, 4.6). In the 1920s, Ruth Bunzel (1929:10) noted that bowls were no longer made at Acoma; there has subsequently been some revival of the form, but they

Figure 4.4. Acoma Polychrome canteen, ca. 1880–1900. This cylindrical, double-lobed canteen has a central spout and two constricted areas around which rope was probably tied to hang or carry the container. The design features bordered orange-slipped bands in the depressions connected by bordered orange-slipped ellipses. IAF 1054. 5 1/2" x 9 1/2".

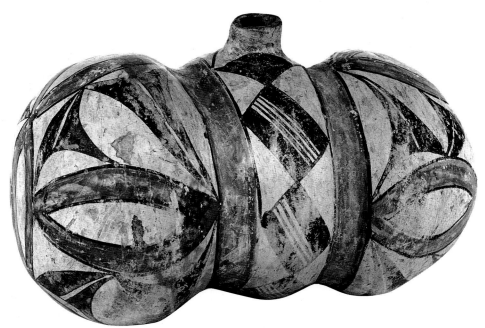

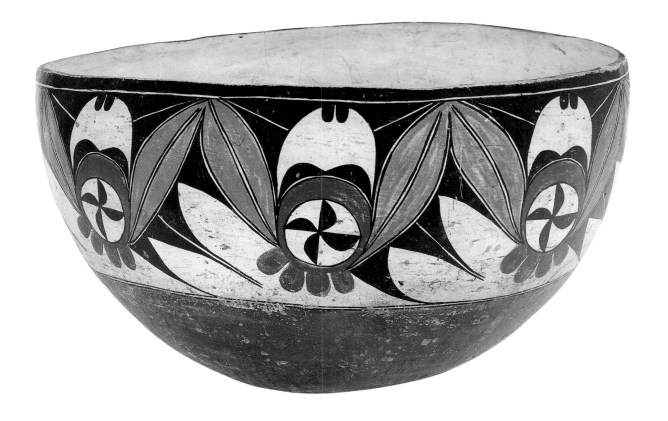

Figure 4.5. Acoma or Laguna Polychrome bowl, ca. 1890.
Four-color polychrome dough bowl with white-slipped interior and
orange and red decorative slips. The pinwheel motif is often used at Laguna,
as is the unbordered red-slipped area with surrounding lobes.
A double-dot design appears around the exterior rim.
IAF 997. 10" x 17–18 ½".

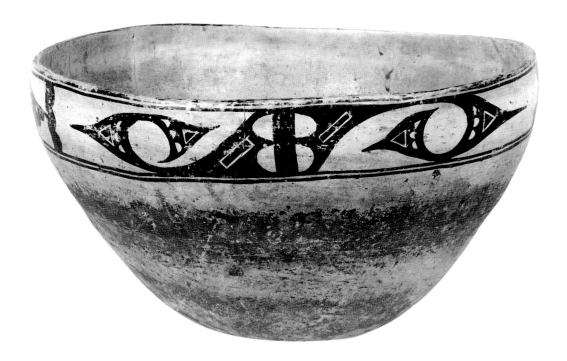

Figure 4.6. Acomita Poly-chrome, Acoma or Laguna variety, dough bowl, ca. 1800. This design, painted in a thin white-slipped rim band, shows strong Zia and Santa Ana influence. The interior has a worn white slip, and the base is either thinly slipped or float-ed. Construction is thick, with rock and chunky sherd temper for strength. IAF 936. 10 ½" x 19 ½".

are very rarely made today. *Tinajas*, large jars for storing wheat or, possibly, loaves of bread, were not common until the early to mid-1800s, and contemporary versions are made by only a few potters.

In recent years, certain types of painted pottery have become standard, even though they serve strictly commercial purposes. Two-spouted wedding vases, miniatures of standard forms, and storyteller dolls (introduced from Cochiti Pueblo) are examples of the standardization of innovative forms. Functional vessels, whether painted or plain, are, with rare exceptions, never made for use today, cooking pots having given way to commercial pots and pans. Traditional ceremonial pottery is still produced, however. This is one of the few applications of pottery for which there is rarely a non-Indian substitute.

Ceremonial Pottery

The distinction between ceramics made for everyday use and those with a ceremonial purpose is not clear-cut in the Pueblo world. All pottery may be said to have broadly religious significance in the sense that it is created for and integrated into Pueblo life, which is considered sacred. But some pieces are specifically made for or used in ritual contexts. Documentation of ceremonial uses is rare; such functions of pottery are as clouded in secrecy as the ceremonies themselves. Because so few examples of ceremonial pottery exist in public collections, my remarks concerning its use must be considered speculative. Some ceramics are used in the kiva, others at communal occasions such as weddings and burials.

Burying pottery offerings with the dead was and is very important. Both standard kinds of pottery and special forms might be placed in a grave. Members of the Lewis family of Acoma have told me that unfired ceramic bowls are "made specially" to be buried with the dead and to accompany the spirit of the deceased. Grace Chino mentioned that specific forms of fired pottery are made for burial with the deceased; canteens for males, and small bowls for females.

Acoma potter Wanda Aragon told me of other customary uses of pottery in burying the dead:

> A water jar full of water that had been prepared [between] the day of death [and] the burial was broken over the grave by the Rain Priest. The water falling over the grave was a symbol of rain and a request for the deceased to ask the spirits to send rain to the pueblo. A canteen was buried with the person to help him on to the next world. After the pot was broken it had done its job and the pieces could be used for other purposes.

Another Acoma potter, Juana Leno, describes the following ceremonial use of a pot. To seal a marriage agreement, the mother of the prospective groom presents a ceramic jar full of ground cornmeal to the mother of the bride. Oral traditions describe Acoma brides and grooms drinking from double-spouted vases during wedding ceremonies, but the practice is unknown in the present day (fig. 4.7). In the late 1800s, this wedding vase form became popular with tourists, and today it is

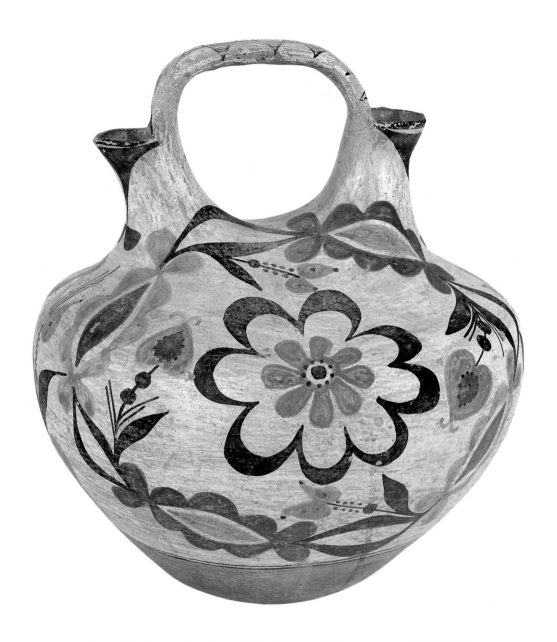

Figure 4.7. Four-color Acoma Polychrome wedding vase, ca. 1900–1920.
Four-color polychrome with floral motifs that may have been inspired by designs on
imported fabric. This two-spouted form has prehistoric precedents, but later examples
may have been inspired by dealers. This large and finely crafted wedding vase
was made for the tourist market. IAF 957. 13" x 11".

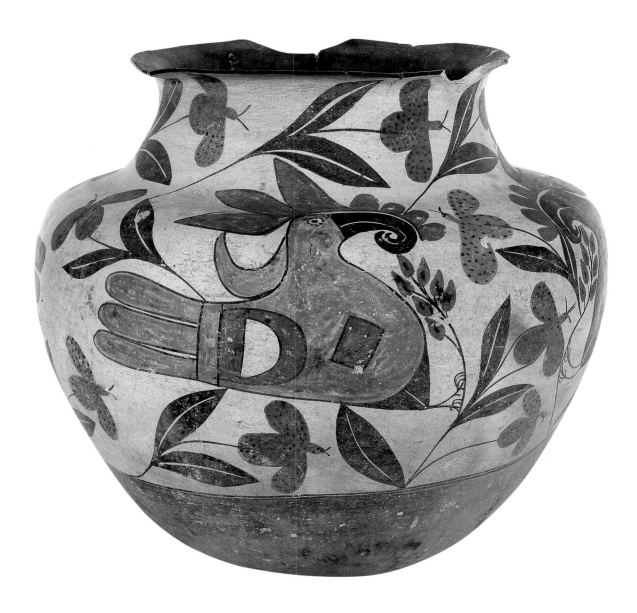

*Figure 4.8. Acoma Polychrome jar, ca. 1880–1900. This large jar may
have been used as a drum. Its round base would fit into a depression in the dirt floor,
and a skin could be tied around the flange of the flaring rim. The elaborate four-color
polychrome design with Acoma parrot and floral motifs has become a classic.
IAF 1148. 15 ½" x 15 ½".*

produced solely for the market. Acoma potters have created magnificent examples, motivated probably by the commercial success Santa Clara potters had with the form.

Ceremonial pottery also includes pots made by specific artisans for the kachinas, who give them to the children at various ceremonies. At Zuni, and perhaps at Acoma and Laguna, large jars with outflaring rims served as bases of drums used in ritual contexts: filled with varying amounts of water, their mouths sealed with stretched skins, they made a variety of rich, resonant tones (fig. 4.8).

Acoma pottery is used today in other pueblos for a multitude of purposes, some of them ceremonial. In many homes, important ritual material is kept in small bowls filled with cornmeal, and ceremonial prayersticks are placed in bowls kept in the home after the death of a family member (Reynolds 1986:287). Acoma jars have been altered by Zunis—to suit either Zuni ceremonial use or the tourist market—by the addition of bone, stone, and feather fetishes and other surface treatments.

It is likely that the clay itself possesses religious meaning, and even unfired clay figurines and vessels may have special significance. During the Christmas season, for example, clay petitions are molded in the form of desired gifts such as foodstuffs, beds, cars, and animals. The petitions are kept in the home and later buried and returned to the earth.

Fired pieces made for use in the kiva sometimes have different shapes from pots made for everyday needs. Some ceremonial vessels are square, some have stepped sides representing clouds or kiva steps, and others can be cross shaped. We can only speculate about the possible functions of some unusual historical forms: composite canteens, for example, with their two bulbous ends joined by open tubes, would not withstand rough handling and might have been only ceremonial. Constructing such elaborate forms demands extra effort on the part of the potter, and the shapes were probably difficult to fire. The special effort itself may be an intrinsic part of producing ceremonial pottery.

Anthropologist Leslie A. White, in his book *The Acoma Indians*, makes reference to ceremonial paraphernalia such as small paint bowls, canteens, refuse bowls, and medicine bowls used in the kiva (fig. 4.9). "The medicine bowls have four terraced sides, they are black and white.

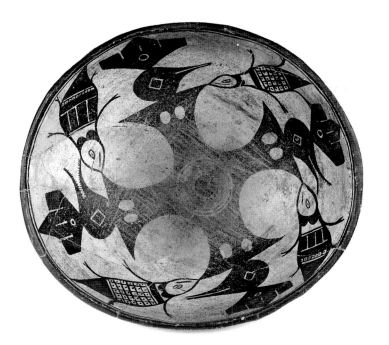

Figure 4.9. Laguna Polychrome bowl, ca. 1880–1900. Perhaps a variation on a traditional medicine bowl, this simple form with floated exterior and white-slipped interior is decorated with ceremonial designs, including a powerful cross element with attached animal and bird-head motifs. The central circle shows traces of red slip. SAR 1980-13. 3" x 8¾".

Bears, snakes, lions, lightning and cloud symbols are painted on the bowls" (White 1932:111). I am aware of some ceremonial bowls made to serve distinct functions. One is a simple form, undecorated, used for cooking pine pitch to make paints, possibly for kachina masks (see White 1932:131). A great deal of carbon has built up on this pot, and the interior is coated with piñon pitch. Another piece is a cross-shaped flat form made around 1900 to 1920 and probably used to prepare herbal medicines. It is white slipped and painted with orange "lions," a black rim, and black framing lines around the orange-slipped base. Two sides of the cross have looped additions, and the other two have higher, stepped sections, perhaps signifying clouds. A third piece is a stepped bowl form with bird, animal, and cloud motifs in black and a red base typical of water jars.

The small bowls used on altars for certain ceremonies are as specific as the ceremony itself. Stirling reports round and square pots with various painted devices; a hemispherical bowl with a scalloped rim is brown outside with a black edge, and white inside with brown concentric lines (Stirling 1942:118, pl. 3). A square, stepped bowl is white with a tan design of stepped clouds and rain; another square bowl is white with tan

design on the exterior and white with a yellow border inside (Stirling 1942:120, pl. 8). A more elaborate color combination, perhaps employing post-fired pigments, appears on a bowl used for sacred cornmeal. It has a scalloped rim and is painted white outside and brown inside, "with designs of the four Mountains of the color directions (yellow, blue, red)" (Stirling 1942:122, pl. 13).

Examples of ceremonial pieces I have seen date to the early part of the 1900s. I assume, however, that ceremonial pottery of various types was made prior to that time, and it certainly continues to be made today. When ceremonial vessel forms are identical to standard forms, individual pieces may be designated for ceremonial use by certain markings, whether obvious or unobtrusive. These designs, in special layouts, are painted and fired on. In the kiva, small bowls with designs painted across the bottom, without delineating a base area, hold the sacred cornmeal or the paints used on masks and bodies. They are also used as special food bowls. The collection at the Indian Arts Research Center includes numerous small bowls of this type.

Other marks or motifs, also fired onto the pot, that might suggest ceremonial use are crescent-shaped bare spots left in the slip applied to the basal areas, X marks painted on the base, and casual drips or swashes of red slip inside pots. I have also seen an hour-glass shape painted on the bottom of pots, which may have ceremonial significance. It is possible that such designs or markings transform these ordinary items into pieces that can be used in the kiva.

Various types of green pigment—piñon pitch with pigments (perhaps copper compounds) or paint—may also be applied to already fired household vessels for ceremonial designation (fig. 4.10). The green pigment may follow patterns already painted on the jar, or it may be applied freely. I have noted this type of painting on jars from Laguna and Zia pueblos as well. It is my impression this marking with green pigments probably could be used on any type of pottery needed to serve the ceremony, even commercial ware. Green pigment, applied in the decoration after firing, was also used to designate gifts exchanged between people of San Ildefonso and Cochiti (Gray 1990:10). Lieutenant John G. Bourke, in his 1881 account of Acoma and Laguna (Bloom 1937:364), noted pieces "spotted and flecked with a green pigment" that he

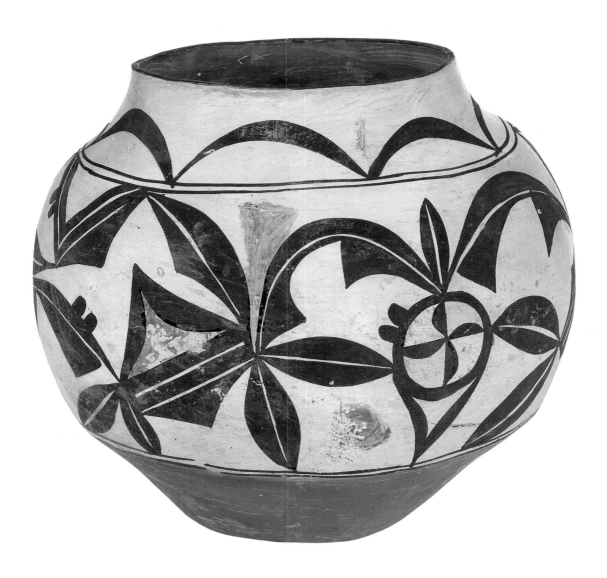

Figure 4.10. Laguna Polychrome jar, ca. 1870. The form and design of this jar
have elements of earlier Acomita Polychrome, with strong flexures in the construction.
The bold bar-style design around the body includes a pinwheel and double dots. A swash
of red slip in the interior and the addition of post-fired green pigment to the
exterior suggest ceremonial use. 12" x 13".

thought was glazing "fused in the fire." I suspect this was not a fired glaze, as I have seen no historic pottery with glaze, but rather a green pigment applied for ceremonial use.

For the most part, one can only theorize about the ceremonial designations of pottery. We may be able to identify forms or designs that appear to be ceremonial, but we do not know what their meaning is. Ceremonial significance is the most closely guarded of all the traditions associated with pottery at Acoma and Laguna, and rightfully so. At Acoma, quasi-ceremonial vessels are made for the commercial market, but they are always altered in some small way so that they are not actual replicas of ceremonial pieces (fig. 4.11). These pieces are also not properly "blessed" by priests. Many such pieces sold today are signed by the potter, but signatures never appear on pottery actually used for ceremonial purposes.

Figure 4.11. Acoma Polychrome jar, ca. 1963. Signed Lucy M. Lewis. Water-jar shape with two modeled white-slipped snakes painted with Xs and two modeled orange-slipped frogs with black design. This quasi-ceremonial jar was made for the tourist market. IAF 2936. 5 ½" x 7 ¼".

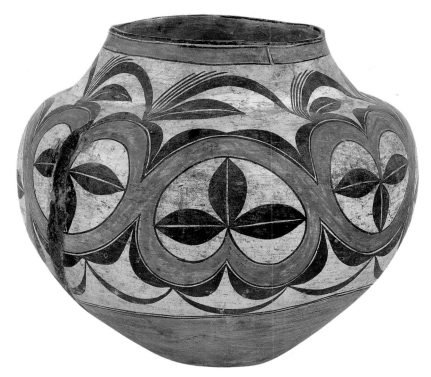

Figure 4.12. Laguna Polychrome jar, ca. 1880–1900. Typical water-jar form with interlocking heart motifs shared by Acoma and Laguna. The crack in the body of the vessel is repaired with piñon pitch. IAF 1674. 10 ½" x 13".

Interchange of Functions

In the literature on Native American ceramics, pottery is frequently classified according to function. Such classifications, however, fail to recognize that vessels often served more than one function, either simultaneously or over the course of their lives. If an olla were not handy, a food storage jar might be used to hold water—and a dough bowl might substitute in a pinch. Similarly, a damaged water jar might be recycled to store food. The need for vessels that could serve interchangeable functions may be one reason that generations of potters kept the forms of their pottery simple rather than elaborating them into more specialized types.

Although the intended functions of a pot certainly influenced the development of its form, form by no means restricted function. In a nineteenth-century household, women probably used their large, thick-walled dough bowls not only for making bread but also as lids to cover

the mouths of big storage jars. Men might have employed such bowls as receptacles for hide scrapings when butchering and skinning a deer. Dough bowls could serve as basins for bathing children, for a newborn's first bath, and for ritual hair washing (ceremonial bowls for these specific purposes also exist). In the twentieth century, a collector who purchases a new bowl might use it in the kitchen for making salads, as a serving dish at a dinner party, or simply as a work of art to be admired. At Acoma and Hopi pueblos in historic times, large canteen forms held the snakes used in certain ceremonies. Acomas have told me of the existence of the snake ceremony at that pueblo in the past, though it is certainly many years since it has been performed; Garcia-Mason (1979:456) dates it to the sixteenth century. The snake dance is still held periodically at Hopi.

Sometimes pots made in utilitarian forms must serve nonutilitarian functions because they are poorly made. Some potters have become lax in construction methods in recent years, and they occasionally make pots with defects such as improperly smoothed coils or vessel walls that are too thick or thin. These pots cannot withstand the rigors of daily use but may be valued by consumers for their decorative quality.

The high regard in which pottery has always been held in Pueblo culture may be seen in the ways in which damaged or broken vessels were recycled into new phases of daily life. The bases of broken pots became pukis (molds) for starting new vessels, large sherds protected new pots during firing, and smaller sherds were ground up and used as temper in new clay. Many cracked prehistoric and historic bowls and ollas were repaired by drilling two holes on each side of the crack and binding them together with fiber or leather—later, metal wire was used. These cracks can be further sealed with the application of piñon pitch (fig. 4.12). Large bowls may have the same binding materials used around the exterior of the opening to stabilize and "pull together" cracks. Popouts from the firing can be patched as well, sometimes with a potsherd and piñon pitch. In a particularly distinctive reuse, large jars—both painted and unpainted—were plastered onto the tops of fireplace chimneys to add height for draught and perhaps to provide visual respite from the monochromatic adobe (fig. 4.13). This sort of reuse expresses respect for the materials and an efficient use of those materials, which require a good deal of effort to obtain.

A potter will sometimes talk about her pots as if they were her children, a part of herself to which she gives life and from which she may have a hard time parting. In these terms we may be able to understand—even from the perspective of a Western world view—that a pot may be said to have a life, or many lives. Its materials and its uses endow it with a significance that is far greater than its "function," narrowly understood.

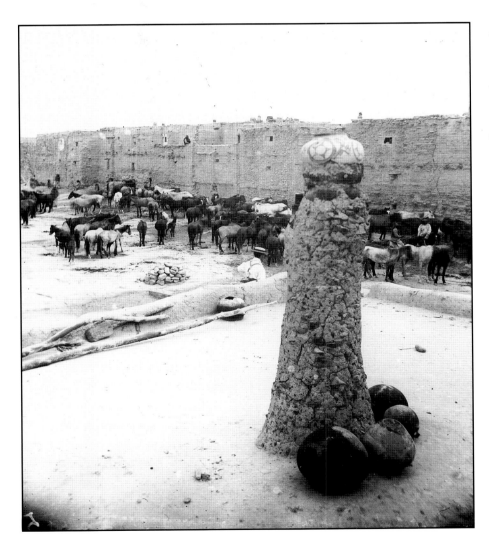

Figure 4.13. Acoma Pueblo, ca. 1884. Photograph by Ben Wittick. The chimney pots, perhaps dating as early as 1850 to 1860, show one method of recycling broken pottery vessels.

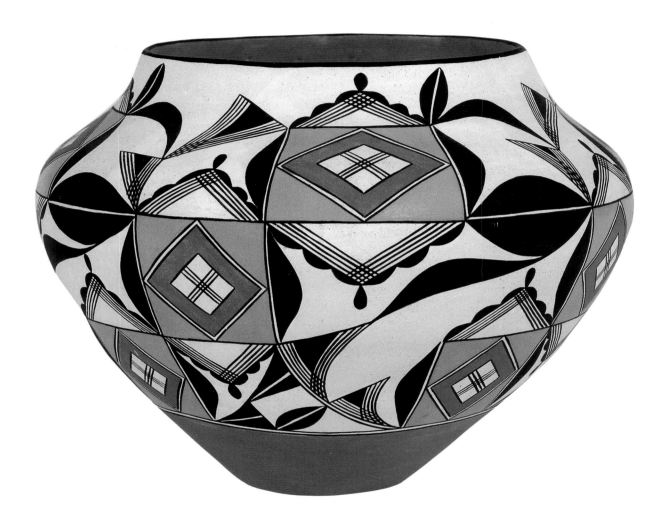

Figure 5.1. Acoma Polychrome jar (four color; kiln fired), ca. 1985. This jar's design is an exquisitely drawn copy of a late-1800's pot seen by the potter in an illustrated book. The polished red base shimmers with mica flecks. The piece is signed "DZINATS'ITUWITS'A, W. Aragon, Acoma, N.M.," and includes Wanda Aragon's cloud-symbol "logo." SAR 1987-5-3. 7" x 8¾".

Design and Surface Decoration

What immediately impresses viewers of Acoma and Laguna pottery is its extraordinary complexity and variety of surface decoration. These superb designs demonstrate quite clearly the maker's intrinsic awareness of beauty and the centrality of aesthetic criteria to the potter's art. The use of colorful slips or fine linework does not improve the vessel's functional qualities, it only renders the pot more beautiful and makes an artistic and cultural statement. Certain design elements can add to the spiritual importance of a vessel. But what are the aesthetic criteria according to which a potter of Acoma or Laguna shapes her work? Aesthetics are both a product and an expression of cultural values and perceptions, and while non-Indians can certainly admire the aesthetic expressed in Acoma and Laguna pottery, they encounter cultural barriers when they try to define it in non-Indian terms.

Perhaps the closest one can come to understanding the aesthetic sensibilities of Acoma and Laguna potters is to listen to their own words. I have asked these artisans many times what qualities they consider "beautiful" in a pot, and their willingness to respond is in itself a bold effort to operate within another conceptual frame. In their own world, these women and men usually do not speak in abstractions about their work, but rather in the visual language of their individual creations, the pots. Their comments are quoted here verbatim, and the cryptic quality

of many of the statements reveals a nonverbal approach that is character-
istic of many visual artists the world over.

According to the testimony of many Acoma and Laguna potters, the
single most important element in creating a beautiful pot is a sense of
harmony between three-dimensional form and two-dimensional design.
When asked what pottery she considered the most beautiful, Joanne
Chino Garcia of Acoma, granddaughter of the late Marie Z. Chino and
daughter of Carrie Chino Charlie, stated that she especially admired
"the large seed jars of Grace [Chino, her aunt], well painted and well
made." Acoma potter Wanda Aragon's response to the same question
was that traditional water jars were the most beautiful "because of their
colors." She says, "I think the pot and the design are one and the same.
I can think of a design and think of a pot with it on it. It's part of it."
When thinking of what is beautiful in pottery, then, these potters envi-
sion the whole pot—the form completely finished and covered with its
characteristic surface decoration. The distinction between form and
design is not clearly delineated (fig. 5.1).

Some potters mention the form of the vessel, which provides the
backdrop or "screen" for a design, as an important element in a pot's
beauty. Potters often visualize their designs in three dimensions: how
they will conform to and wrap around a vessel. Laguna potter Lee Ann
Cheromiah sees form and design as complementary: "If you take your
time and put yourself wholeheartedly in it [making and designing], it
makes it more beautiful. If you rush, it won't come out right. If you're
in the spirit of it, it comes out right. Sometimes the clay will take over
and do what she wants. If she doesn't like the design, it won't work."

Connie Cerno of Acoma speaks of pots "nicely shaped that come up
pretty," referring to well-sculpted forms rising gracefully from the base
to the rim. Shayetsa White Dove, an Acoma potter who lives at San
Fidel, near the Acoma reservation, says she looks for "the overall shape
of the jar with a high, angular, out-more shoulder, tapered base and
tapered in neck. . . . Symmetry in motion, flowing lines" (fig. 5.2).

Form and design are closely intertwined: the lines of a pot may sug-
gest an appropriate decoration, or a traditional design may call up a cer-
tain shape of vessel. As Acoma potter John Aragon says, "I associate the

parrot design with water jars, and when we try to put it on something else it doesn't look right. Some designs suggest certain shapes because they've been around for a long time. I think of a design, and I think of the shape of the pot. I change them when I can. I start in the center and work my way out."

If a primary element that dictates design is the shape of a pot, other considerations include the very pragmatic ones of available time and production deadlines. John Aragon:

> After [the pot is] done, I wait and see what goes on it. How much time you have to work on the piece is also part of the choice of the design. If we're in a rush, we go with simpler designs. With some of my stuff, I do some very intricate and some bigger designs, less detailed. We have deadlines; most are dealer imposed and some are self imposed, and on top of that we do shows where we try to do as many pieces as possible.

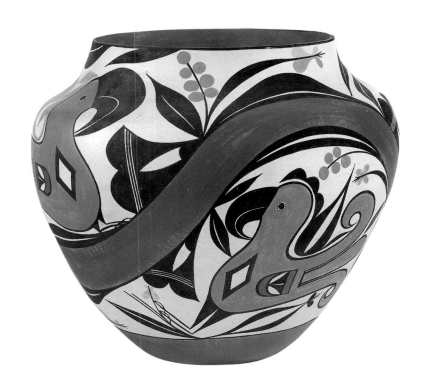

Figure 5.2. Acoma Polychrome jar (eight color; kiln fired), 1988. This potter went to the late 1800s for design inspiration. She writes on the base of the jar: "Shayetsa White Dove, August 8, 1988. Traditional Acoma water olla with Polychrome Rainbow Parrot & floral motifs. Acoma Pueblo, N.M." SAR 1988-13-1. 11 ½" x 12 ½".

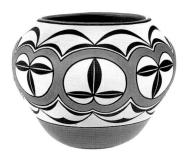

Figure 5.3. Laguna Poly-chrome jar, 1985. This jar, a copy of a late-nineteenth-century Laguna style, is tempered with volcanic tuff. The red slip used on rim and base has flakes of mica. It is signed "SRATYU'WE, G[ladys]. Paquin, '85, Laguna, N.M." SAR 1986-4-1. 9 ½" x 11 ¾".

Laguna potter Gladys Paquin states, "When I'm making them—certain pots—I already know what's going on them. Sometimes I think of the design first, then do the pot. Sometimes when a pot is finished I'm blank, and if I wait a design will come" (fig. 5.3). Lee Ann Cheromiah adds, "When you build [the pot] you already have an idea of what you're going to use, but as you're building another design may come into mind." Gladys Paquin says that when she gets orders to reproduce pots illustrated in books, "I make the shape the same so the pattern comes out right. When I can relax and enjoy making them [the pots], I can wait for a design to come to mind. I sometimes do little bits of designs and wait for separate inspirations."

Design Elements

Although difficult to pin down, the aesthetic of Acoma and Laguna potters can be explored through an examination of specific designs. Two basic design "systems" are used: one is the "allover" covering of a vessel with a design that does not seem to adhere to the structural elements of the pot (fig. 5.4); the other is a banded system in which designs are laid out with reference to the pot's physical structure (i.e., neck, shoulder, or body bands) (fig. 5.5). Bowls, for example, usually have one band of design around the exterior. Designs can be laid out in odd- or even-numbered configurations: four elements of design around the upper shoulder, say, and five around the body. Gladys Paquin says, "Now that I use more Laguna [rather than Acoma] designs, I notice one thing. They're divided into three instead of four. The geometric designs seem to be in fours." (My research has shown the number of elements in design layouts varies in both pueblos.)

The apparent complexity of the more elaborate designs is based on a mastery of simple basic elements from which Acoma and Laguna potters have developed a virtually unlimited design vocabulary. Triangles, scrolls, rectangles, circles, and parts of circles are the basic formal elements, with the line, simplest of all, tying these together. There are a multitude of variations on the line: stripes, crescents, zigzags, cross-hatching. In combination with the popular floral and bird patterns, these geometric motifs create a visual feast. Many potters' designs

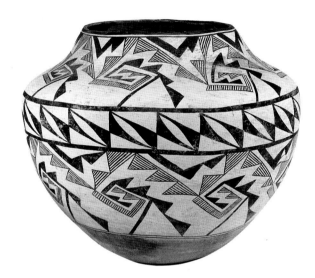

Figure 5.4 (at left). Acoma Polychrome water jar (four color), ca. 1880–1900. This allover design is dominated by an undulating rainbow band with split ellipses and rectangles with hatching and double-dot (raindrop) motifs. The stepped triangular elements at the base of the ellipse motifs are common on Acoma, Laguna, and Zuni jars. IAF 1106. 12 ½" x 13".

vibrate with kinetic energy, and fineline work and other geometrics create a "jam-packed" effect.

Some of the most important and distinctive motifs on Acoma and Laguna pots are framing lines, the spirit break, rainbow bands, bird and floral designs, and deer motifs. Many of them appear, with variations, on the pottery of other pueblos, as well, but certain aspects of their treatment distinguish them when used by the potters of Acoma and Laguna.

Figure 5.5 (above). Acoma Polychrome jar, ca. 1900–1920. The prehistoric-inspired interlocking geometric design is arranged in three bands, with open white areas that conform to the jar's physical structure. IAF 1111. 15" x 17".

Framing Lines

Framing lines are drawn horizontally on vessels to define the area to receive painted designs. On most jars and bowls the juncture of the orange- or red-slipped base and the white upper-body section is further

Figure 5.6. Some of the many variations on framing lines, path lines, and spirit breaks found on Acoma and Laguna pottery.

defined by framing lines, as is the rim section. Many combinations of framing lines have appeared at Acoma and Laguna (fig. 5.6). They may be elaborations of the "path line" (a bordered band of colored slip), sets of narrow lines drawn with a yucca brush, combinations of thin and thick lines, or elements of the decorative design itself. On Acoma and Laguna pottery, fine single or double framing lines are the norm, though the variations just mentioned are not uncommon. Ako Polychrome jars generally have fine double framing lines around the rim and base of the design field (fig. 5.7). Acomita Polychrome types from both pueblos show more elaborate framing lines, with single lines and arcs around jar necks and at the bottom of the design area of bowls,

Figure 5.7. Ako Polychrome jar, ca. 1720–30. This jar has finely drawn double framing lines at the base of the design field, a single line at the rim, and double vertical panel lines. The rim itself is sculpted and has traces of black paint over the red slip, which also covers the base and midbody bulge. Two alternating design panels consist of hooked and feather motifs. Water damage has caused the slip to flake away at the rim. IAF 999. 12" x 15".

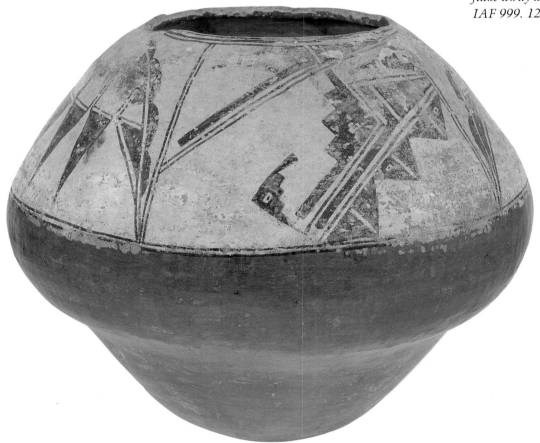

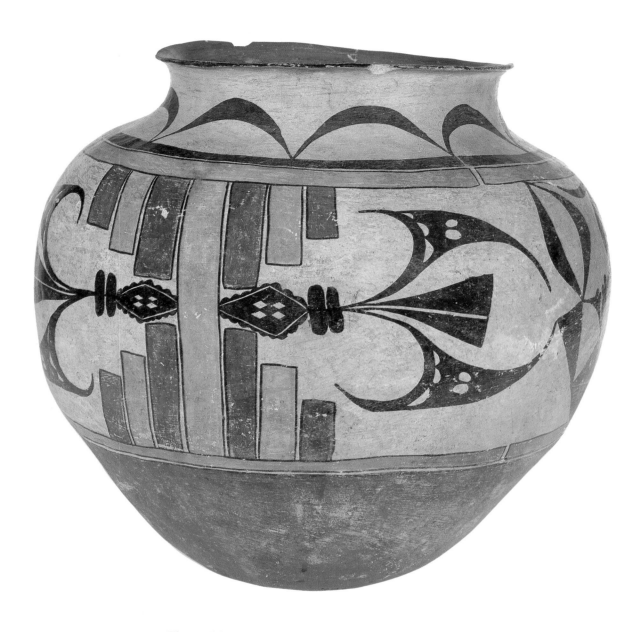

*Figure 5.8. Transitional Acomita–Acoma Polychrome jar,
ca. 1840–60. Around the neck of this large jar is the arc motif associated
with Acomita Polychrome and suggestive of Puname Polychrome from Zia and
Santa Ana. The central design field combines single framing lines at the bot-
tom, a bordered orange path line with a spirit break at top and bottom,
and a thick black framing line at the neck. IAF 795. 16" x 16 ½".*

"capped" double lines, and the incorporation of the path line (fig. 5.8). Later Acoma and Laguna polychromes often lack separate framing lines around the rim; the black rim top may serve the same purpose.

Occasionally the upper edge of the design field itself will act as a framing line, whereas the single or double lines at the bottom of the design field are rarely omitted. On many contemporary pieces in the fineline style, the framing lines are absorbed into the overall pattern. Vertical lines or panel lines can be used to divide the space further.

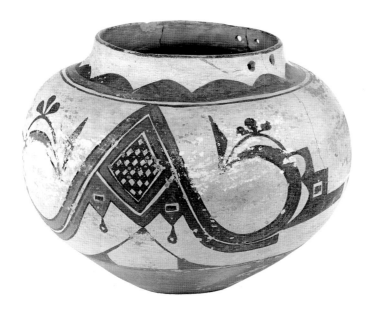

Figure 5.9. Acomita Polychrome jar, ca. 1800–1820. This jar is rounder and has less sculpting than most others of its type. The scalloped band around the neck is combined with a path line and upper framing line as one unit. A diamond-and-scroll motif is accented with round and square "eyes." IAF 1687. 9 3/4" x 12".

Sometimes used on Ako Polychrome wares of the early eighteenth century, and occasionally on later types, they are generally rare at Acoma and Laguna and appear with greater frequency on pottery from Hopi, Zuni, and the Rio Grande pueblos.

Perhaps related to the framing line is the path line (Harlow 1985:25–29), a free-drawn band usually found tracing the perimeter of the design field (fig. 5.9). In prehistoric pottery the path line was quite distinct from the rest of the design. Used on many bowls of the glaze-ware period, it appeared as a floating ring in the center of the bowl.

Over time, it became incorporated into the framing lines or eliminated entirely. On some jars of Acoma and Laguna Polychrome, the path line has been elaborated to become a separate narrow band of simple repeating elements, such as checkerboards or zigzags, around the jar's shoulder.

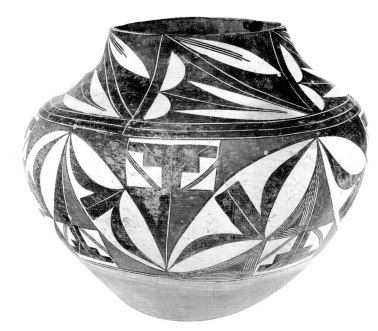

Figure 5.10. Acoma Polychrome jar, ca. 1875–1900. This piece is distinguished by its bold banded design with a capped spirit break in thick double framing lines at the shoulder. IAF 1100. 11 ½″ x 13 ½″.

The Spirit Break

On many pots, framing lines and path lines are interrupted by a small gap called the spirit break, ceremonial break, or simply the line break (fig. 5.10). This feature has occurred with varying frequency in Pueblo pottery for nearly a thousand years and is a major element in prehistoric Hopi pottery and in the early glazewares of the Acoma-Zuni area. Commonly found around the neck, upper shoulders, or base of a jar, the spirit break may appear in many different types of framing lines.

On historic pots, thick framing lines interrupted by a spirit break produce a strong visual impact, and the gap itself becomes a significant

design feature. More subtle spirit breaks include the small, almost imperceptible gap some potters leave in the delicate yucca-brush lines around the base of a pot.

The spirit break is still used by some contemporary Acoma and Laguna potters, usually when they are copying older designs. In the literature and lore of Pueblo pottery, the spirit break has engendered numerous intriguing interpretations. It appears to have a ceremonial basis, but its significance is laced with the personal outlook of the potter.

An early documentation of the motif at Zuni Pueblo comes from Frank Hamilton Cushing:

> I asked the Indian women, when I saw them making these little spaces with great care, why they took so much pains to leave them open. They replied that to close them was . . . "fearful!"—that this little space through the line or zone on a vessel was the "exit trail of life or being." . . . When a woman has made a vessel, dried, polished, and painted it, she will tell you with an air of relief that it is a "Made Being." (Cushing 1886:510)

Cushing wrote that "if encircling lines inside of the eating bowl, outside of the water jar, were closed, there would be no exit trail for this invisible source of life or for its influence or breath" (Cushing 1886:511).

I have been told by Hopi potters that the spirit break is associated with female fertility and that closing it would end a woman's childbearing period. But this is by no means the only native exegesis that has been offered. Lilly Salvador of Acoma says that she uses the spirit break to allow the water to flow in and out of the jar, ensuring that it will always be full. I suspect that the break may also convey a sense of the continuity of life: to finish painting a pot and seal it off or "close" it with a perfect design might leave the potter with a feeling of termination. Leaving the piece in some way incomplete, however, might create a feeling of movement to another piece, a natural flow. Acoma potters have said the break allows the spirit of the jar or bowl to pass into another piece. The break could also signify a metaphorical passage between the

upper and lower worlds embodied in a vessel (Susan Kenagy, personal communication, 1991).

Kenneth Chapman and Bruce Ellis wrote that the break has to do with the woman artisan's health. By including the spirit break in her work, the potter assures herself good health and protects "the group of which she is the perpetuating factor." Chapman and Ellis also state that the persistence of the break may be linked to the Pueblo fertility cult, menstrual cycles, and pregnancy, and to the belief that the circle is a trap or confining element (Chapman and Ellis 1951:283).

Lucy Lewis once mentioned to me that she used the spirit break only on pots she made to be used in the kiva or on pots given by the kachinas to children during kachina ceremonies. These vessels were designed with elements and motifs also commonly found on pots made for sale. Two jars to which Lewis referred also had a splatter of red slip on the inside and a lump of another unidentified white substance in the bottom. To my eye, there was nothing in the design itself that would not have been used in a pot for sale. I tend to think that the line break, the splatter of orange or red (also seen on some historic vessels), and the white substance all designate the pot as ceremonial. I have not seen this white substance on any pottery other than these two pieces by Lucy Lewis.

I have been told by Lewis and her family that pots made for sale or for use in the home do not necessarily require the break, though ceremonial ones do. If this idea is generally held, it may explain the relatively frequent appearance of the spirit break among early vessels found in pottery collections. In general, fewer contemporary pots exhibit the break because most of these pieces are made expressly for the market. The collection at the Indian Arts Research Center is mixed, with about equal numbers of pots exhibiting the break and lacking it.

Gladys Paquin at Laguna has created a version of the spirit break that consists of a bold black framing line interrupted by a small white unpainted rectangle, which appears to be floating within the line itself. Paquin's inspiration for her version of the spirit break comes from the Bible. She explains that the break signifies "eternity. In the sky there's a hole and there's something coming down, something eternal, a never-ending."

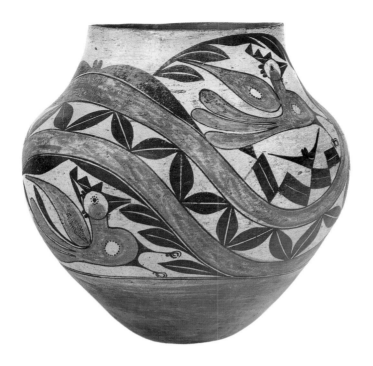

Figure 5.11. Acoma or Laguna Polychrome jar, ca. 1880–1900. A variation of the rainbow band with split-leaf motifs zigzagging between the two black-outlined, orange-slipped bands. Unusual birds with crests of stepped triangles (perhaps more characteristic of Laguna) decorate the unbanded area, and a swash of red slip marks the jar's interior. IAF 226. 11" x 11 1/2".

The Rainbow Band

A curious design element that appears on pottery made at Acoma, Laguna, and some other pueblos—particularly Zia—is the "rainbow band," an undulating stripe that encircles the pot (fig. 5.11). The motif appears in many variations, ranging from single bands in a colored slip bordered by black to double bands in two colors of slip or divided by a central band of geometric elements. Some versions of the band consist of floating and connected single and double arcs.

There are various theories about the origins of this element. If it evolved from the path line, its roots lie in prehistory. If its origins are more recent, it could have developed from the undulating vine used as a border on Spanish *colcha* embroidery. Probably the rainbow band appeared first at Zia, a pueblo close to early Spanish settlements. If so, Zia potters may well have copied the design from a colcha motif. Today at Zia the rainbow band is more elaborated than at Acoma and Laguna, frequently appearing with pendant feathers.

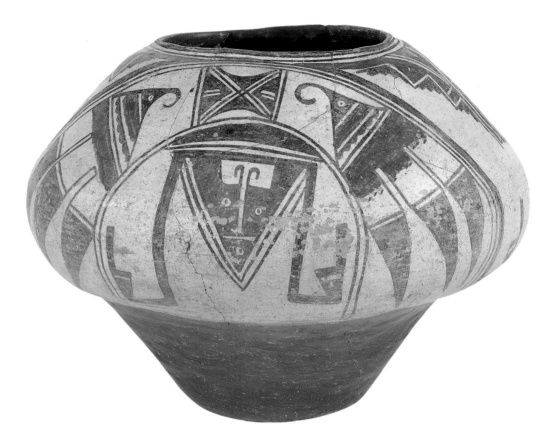

Bird and Floral Designs

Figure 5.12. Ako Polychrome jar, ca. 1700–1720. This stylized bird, with three tail feathers and a hooked beak, preceded the Acoma parrot. The dome-shaped jar has a red-slipped, sculpted rim and a capped spirit break in the framing lines at the neck. IAF 1618. 9 ½" x 13".

Until the nineteenth century, Pueblo pottery had not shown any strong design influence from nonindigenous sources. Beginning around 1850, though, potters at Acoma and Laguna, as well as Zia, began using ornate "parrot," deer, and flower designs, which, like the rainbow band, most likely derived from external sources. These designs were fully elaborated by the late 1800s and continue to be used by potters today. Bird motifs had been popular in all Pueblo pottery since prehistoric times, some of them no doubt inspired by macaws and parrots that were traded in from Mexico. But most were simple line renderings of beaks, feathers, and wings or abstract images of the bird itself. The use of stylized bird motifs reached a peak with Sikyatki Polychrome from the

Hopi area (ca. 1375–1650) and Matsaki Polychrome from the Zuni area (ca. 1550–1650). Hopi-inspired birds appeared on Acoma and Zuni (Hawikuh Polychrome) vessels in the seventeenth century.

Although a realistic hooked-beak parrot-like bird appeared on early Hopi (Sikyatki Polychrome) and Zuni (Matsaki Polychrome) pottery, in the sample I have studied from Acoma a more stylized bird is seen on early glazewares and matte-painted pottery (fig. 5.12). One glazeware jar (in a private collection) from the village of Casa Blanca, now on the Laguna reservation, has square hooked-beaked Rio Grande–style bird motifs horizontally placed around the midbody.

The parrot design popular at Acoma and Laguna since the mid-1800s is characterized by a curved beak, and the bird is often portrayed picking berries from a branch. No two birds look exactly alike, and variations include single or double wings; two talons resting on a branch or on another part of the design; open, unbordered ellipses on the breast or wings; circles or diamonds on the breast; a D-shaped element at the base of the tail; and two or three tail feathers. Although they occasionally appear in multicolored designs, the birds are usually executed in either one or two colors—frequently an orange body with black outlining (fig. 5.13). The birds are usually surrounded by the rainbow band, arcs, or other filler motifs, both floral and geometric.

I have asked many potters if the design represents any particular bird, and they generally respond that it is the "Acoma parrot" (fig. 5.14). Laguna potter Gladys Paquin says, "I think of the parrot as an Acoma parrot because that's where I saw it come from." The parrot-like creature may be identified as Acoma because it resembles somewhat the features of a macaw, and it has been customary to keep live macaws at the pueblo. At Zia, potters call a similar design (which looks somewhat like a roadrunner) the "Zia bird." Along with the distinctive deer motif described below, the parrot-like birds have become trademarks of Acoma and Laguna pottery (fig. 5.15).

There are connections between birds, especially parrots and macaws, and many aspects of Acoma and Laguna ceremony. Whether or not these connections extend to pottery designs is open to speculation. The introduced parrot motif, for example, appears to have taken on ceremonial significance, and its importance may be deduced from the fact that it is featured prominently on the interior walls of the huge Acoma

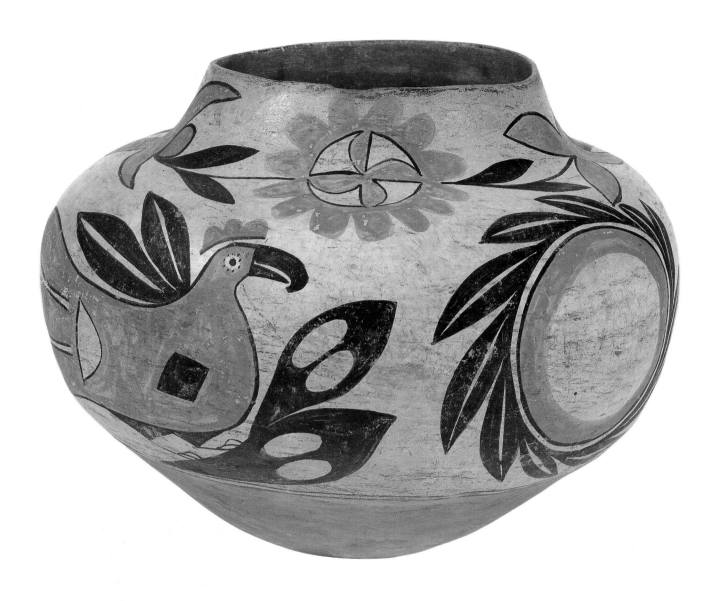

*Figure 5.13. Laguna Polychrome jar, ca. 1870–80. Medallions
with encircling split leaves and pinwheels with unbordered orange petal
motifs are combined with orange birds perched on leaves with open double-dot
ellipses. Among the typical bird elements are a diamond on the breast,
crest on the head, D-shaped element at the base of the tail, and
split-leaf wings. 10" x 12".*

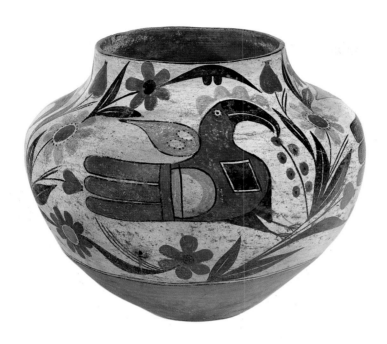

Figure 5.14. Acoma Polychrome jar (four color), ca. 1880–1900. The elaborate floral arrangement, with flowers of many types originating from the same stalk, is reminiscent of Pennsylvania Dutch drawings. The classic Acoma parrot has open circles lined with dots in the wings. IAF 241. 10" x 12".

Figure 5.15. Acoma Polychrome jar (four color), ca. 1880–1900. This thickly painted parrot with a floral branch stands under a rainbow arc, a variation of the rainbow band. Split-leaf patterns also decorate this traditional water jar, which has slight flexures in the construction. IAF 682. 11 1/2" x 13".

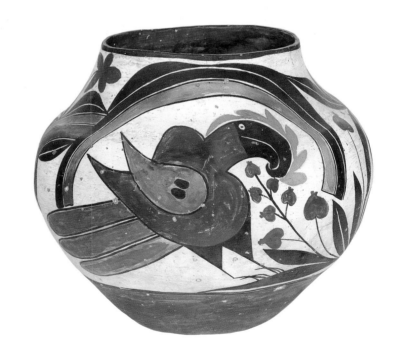

church, used for both Catholic services and traditional Indian dances. Use of the bird motif within the church may exemplify the acculturation of a symbol, or it may represent the assimilation of a completely new idea or design motif into the mainstream of Acoma and Laguna thought.

Bird symbolism was used in Pueblo design for centuries in various forms, and birds of all species play an important role in Pueblo religion. "As signs, birds relate to gods, act as messengers between men and gods, or stand as signals between man and man. As a part of the surrounding world, birds relate to all manner of natural phenomena and to weather control" (Tyler 1979:xii). Because of their brightly colored feathers, macaws and parrots are associated with rainbows and hence with rain (Tyler 1979:16). This symbolism may relate to the use of the bird motif on water jars. Tyler notes that

> macaws, parrots, and parakeets are all exotic birds; none was found in the Pueblo area, although the thick-billed parrot touched southern Arizona and New Mexico. Nevertheless, there is abundant archaeological evidence that imported macaws and parrots were kept in the villages from at least 1100 A.D., possibly earlier, which indicates that their feathers were as important then as in modern ceremonialism where they rank with those from eagles and turkeys. (Tyler 1979:17)

Parrots are also associated with salt gathering and the salt itself: "Because salt is a product of sun and water, salt is also a mediating term between the two, much as is the rainbow, which is linked to the multi-hued parrots" (Tyler 1979:31). At Acoma, the Parrot clan is in charge of salt gathering; at Laguna, the Parrot clan participates in the journeys to collect salt (Tyler 1979:31). The parrot design on pots may also have been a "prayer" for salt, a necessary dietary staple.

The Deer Motif

The deer motif also raises questions of external influence. Like the parrot, as a pottery design it may have been inspired by imported cloth. Cartoon-like deer figures, easily distinguished from the Zuni-style

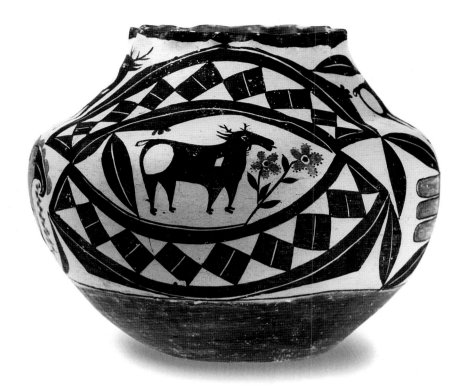

Figure 5.16. Acoma Polychrome jar, ca. 1880. One of the earliest examples of the heartline deer at Acoma, this design employs a curious blend of bird, floral, split-leaf, and other motifs that may be derived from colcha embroidery. The rim is fluted or crenellated, and a red X is painted on the jar's base, perhaps designating ceremonial use. 9 ½" x 12".

heartline deer with its bold line extending from the animal's mouth to its heart, have been used at Acoma since the late nineteenth century; I have seen the deer on pottery dating from the 1880s on. It may have appeared this early at Laguna as well, although I know of no documented examples. As with other designs probably taken from colcha embroidery, this motif seems to have migrated to Acoma and Laguna by way of Zia.

One particularly distinctive deer figure commonly used at Acoma was inspired by the unique heartline deer of Zuni, a hunting symbol with spiritual significance (fig. 5.16). The original Zuni design is basically a flat rendering of a deer, with or without antlers, seen from the side. The animal is depicted with a variety of head and leg features and usually has a white spot on the rump. A red or black line runs from the mouth to the midbody area, where it ends in a red or black "heart," usually triangular.

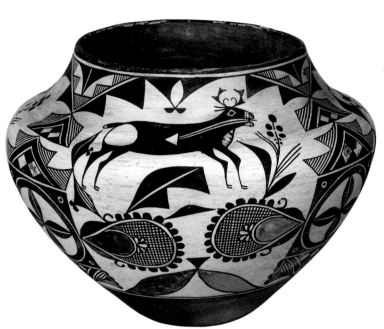

Figure 5.17. Acoma Polychrome jar, ca. 1900–1920. This jar exhibits an interesting combination of design motifs: a pinwheel, geometric elements with hatching, paddle shapes, a Zuni-style heartline deer with a white heart, and a floral branch. IAF 313. 10" x 12".

Figure 5.18. Acoma Polychrome jar, ca. 1900–1920. The form of this water jar is typical, but its decoration is unusual, combining seven atypical deer motifs (one without a heartline), three realistic butterflies (one with red-spotted wings), and a mixture of floral elements. IAF 1156. 9" x 11 ½".

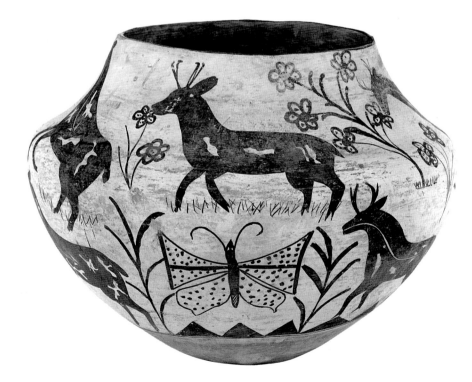

There is little doubt that the heartline deer was borrowed from Zuni: it is found earlier on Zuni pottery than on Acoma pottery (fig. 5.17). Many potters not familiar with the older work recall its commercial introduction at Acoma by Lucy Lewis in the 1950s. Lewis apparently tried the design at the suggestion of Gallup, New Mexico, Indian art dealer Katie Noe, after anthropologist Frederick Dockstader brought it to Noe's attention. Lewis added that she did not adopt the motif until receiving the Zunis' permission to do so (Kenagy 1988:14). In earlier uses, the heartline deer was usually surrounded by other design elements (fig. 5.18); today it tends to be set starkly on a white background or surrounded by a few simple motifs.

Potters at Acoma offer differing versions of the heartline deer's origins. Grace Chino has said that Lucy Lewis was the first potter to use the heartline deer at Acoma in contemporary times, but other potters disagree, some claiming that it was a traditional Acoma design. Lewis herself has said that earlier Acoma potters used the motif (Kenagy 1988:109), and Wanda Aragon has told me that the heartline deer is "mostly Zuni," but that Acoma did traditionally have a deer with a heartline, though Zuni inspired. Aragon also believes that "Grandmother Teofilo Toribio [the mother of potter Frances Torivio] used the deer design probably in the 1910s." Marie Z. Chino, another Acoma potter noted for her early use of the heartline deer, recognized it as a Zuni motif. Grace Chino, Marie's daughter, stated that her mother altered the motif slightly to make it more Acoma and more personal. Grace remembered that her mother would get a chuckle out of looking at the design after outlining it on a pot.

Although the heartline deer does not carry traditional ceremonial significance at Acoma, as it does at Zuni, some potters feel that the elements of the design do have meaning. The heartline itself is said to represent life. "There is a spiritual connection [of the design] to deer, and going hunting for the deer is special," says Wanda Aragon, adding that "the deer design is a prayer for deer." Lucy Lewis and her daughters, Emma Lewis Mitchell and Delores Lewis Garcia, agree that the deer design has a spiritual connection and symbolic association with the hunt.

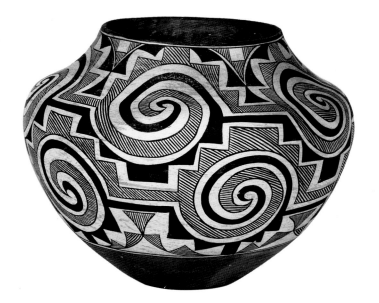

Figure 5.19. Acoma Polychrome jar, ca. 1920. Tularosa-inspired spiral-and-stepped design with solid and hatched fill. This jar's design is copied from prehistoric sources, perhaps from potsherds used as temper. IAF 655. 10 1/2" x 13".

Fine Lines and Bold Designs

Elaborate, tightly drawn, fineline designs are much in favor today among collectors of Acoma and Laguna pottery. Usually painted in black, these contemporary designs contain such elements as repeated triangles, concentric squares, and spiraled squares and triangles. Although the motifs are distinctly contemporary innovations, they were inspired by designs on prehistoric pottery, particularly the spiral motifs from the Mogollon Tularosa Black-on-white wares and Anasazi Chacoan ceramics (fig. 5.19). Vibrating optical effects are common on pottery made for today's marketplace.

Lucy Lewis and her daughters told me that in the late 1950s they made a visit to the Indian Arts Fund collection in Santa Fe. During that visit, Kenneth Chapman showed them the designs on Mimbres pottery, which they began to use in their own work. Mimbres-inspired designs offered potters a unique "Indian style," which has also appealed to tourists and collectors (fig. 5.20). Perhaps potters used it, in part, as a respite from the more difficult traditional designs. As the market accepted these novel styles, potters began searching for new and exotic sources of inspiration. Today Mimbres designs are used by potters at many

pueblos, including Laguna, though they are most closely associated with Acoma.

Although the Acoma and Laguna people had been grinding up prehistoric pottery for temper for centuries, they did not begin experimenting with hatching and other geometric motifs prominent on prehistoric pottery until the late 1800s. Several more decades passed before today's successful contemporary fineline designs were developed.

Potters focused their attention on fineline designs beginning sometime in the late 1940s. In 1950 Lucy Lewis received an "Overall Excellence" award at the Gallup Inter-Tribal Indian Ceremonial for one of her fineline pots, an award that marked a sort of watershed in the commercial success of the style. The popularity of fineline pottery increased steadily during the 1950s, when much of it was handled by Katie Noe.

Figure 5.20. Three contemporary seed jars inspired by prehistoric designs: left, *Acoma Black-on-white, ca. 1960, signed Marie Z. Chino. Mimbres design used on top of a seed jar rather than inside a bowl. IAF 2831. 4 ¾" x 7";* center, *Acoma Black-on-white, ca. 1958, signed Lucy M. Lewis. Prehistoric Chacoan-inspired lightning design. IAF 2780. 5 ⅞" x 8";* right, *Acoma Black-on-white, ca. 1961, signed Jessie C. Garcia. An old form of seed jar with a modern Mimbres-style grasshopper motif. IAF 2842. 3 ½" x 9 ¾".*

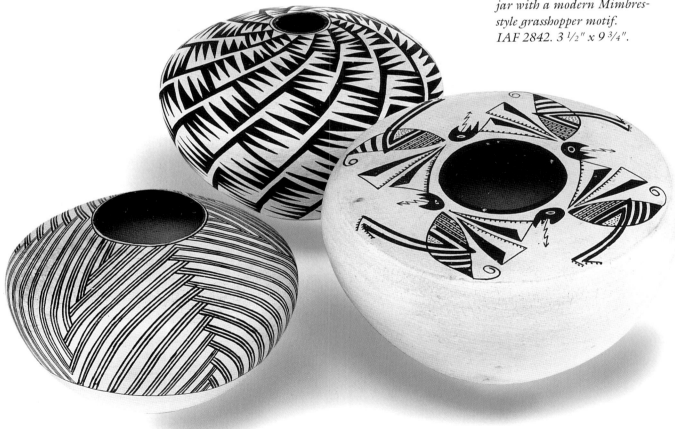

The Potter's Design Signature

Often potters develop a unique style based on their personal interpretation of traditional Acoma and Laguna designs, a style that reveals their particular aesthetic sensibilities. Certain types of designs or design elements—as well as individual technical abilities—serve as a personal signature or trademark. Potters can usually recognize work done by family members and other potters by the form and design of the vessel.

There is a certain amount of "family ownership" of designs. Each member of the Lewis family of Acoma, for example, has a preferred design. For Lucy Lewis, Chacoan fineline designs and the heartline deer motif are trademarks. All the other designs used by the family have their roots in Lucy's work. Among Lucy's daughters, Emma Lewis Mitchell is partial to Mimbres designs; Mary Lewis Garcia states that "polychrome" is her favorite, referring to the traditional orange-and-black design on white slip done in a variety of traditional motifs; and Carmel Lewis, Lucy Lewis's youngest daughter, uses Chacoan and Mesa Verdean designs.

An exception to the "design trademark" rule is Delores Lewis Garcia, who claims to have no particular preference, saying that she lets each pot "decide" what design to use. Other potters, such as Grace Chino and Rose Chino, have achieved success with several designs. Many collectors purchase both their tightly drawn geometrics and their bird-motif pots.

Personal designs are important to their "owners," and part of a potter's artistic development is finding a design system or set of motifs that she individualizes and then uses repeatedly. Copying a potter's individualized designs is frowned upon within the pueblos, as anthropologist Ruth Bunzel learned at Laguna early in the twentieth century. Bunzel's informants said they did not copy the ideas of other potters, although they learned by observing: "I never copy other women's designs . . . I used to watch my aunt while she made pottery because she was such a good potter. That is how I learned to paint" (Bunzel 1929:51–52). The distinction between learning traditional designs and copying the individualized execution of those designs is a fine one, about which the potters are quite clear. As another Laguna potter told Bunzel, "I make up *all* my designs and never copy. I learned this design from my mother. I

learned most of my designs from my mother" (Bunzel 1929:52).

Acoma potters also talked with Bunzel about their respect for each other's creativity and individuality, as expressed through design. As Bunzel wrote, "The condemnation of copying the designs of other women is unanimous. All women denied copying from other potters, and most of them disclaimed repetition of their own designs" (Bunzel 1929:52).

The last statement clearly does not apply to today's potters at Acoma and Laguna, who tend to use repeatedly certain designs which have become their identifying "signatures" in the marketplace. Bunzel, too, noted the importance to the potters of the design signature. "Every potter," she wrote, "claims that she can distinguish readily between the work of her fellow artists" (Bunzel 1929:64–65). "All the women use different designs," said one potter, and another maintained, "I can always tell by looking at a jar who made it." One Laguna potter stated, "I don't have to use any mark on my bowl," because her design was recognizable to herself and others (Bunzel 1929:65).

I have heard similar comments in my own conversations with potters. However, many distinguish between sharing designs and copying them. Artists tend to alter each design, making their version of it their own. As Delores Lewis Garcia told me, "It doesn't matter if you copy because it's never the same, you can't pick up [other potters'] techniques." Still, design innovations introduced by renowned potters such as Lucy Lewis and Marie Chino tend to be heavily copied when they first become popular. In the 1950s, the fineline designs initiated by these two potters were widely adopted by potters seeking to establish themselves commercially.

Symbols

The question of symbolism in Pueblo pottery designs has long fascinated scholars and collectors. The conservative Pueblo Indians have adhered tenaciously to many ancestral traditions, so it is not surprising that pottery decoration contains frequent reference to the multivalent symbols of native religion. Some designs are said by the potters to be symbolic; others suggest symbolic meaning by their similarity to designs

of known religious significance. The tri-lobed motifs seen on some pots, for example (see fig. 3.5), are remarkably similar to designs on prayer-stick headdresses which are said to signify early spring leaves (Stirling 1942:123, pl. 17).

According to contemporary Acomas and Lagunas, many design elements do have specific meanings. Feathers (birds), hatching (rain), stepped motifs (clouds), double dots (raindrops), and other symbols pertaining to natural phenomena—including mountains, lightning, thunderclouds, and the moon—reveal a vital connection to the natural world. Potters have told me that certain designs symbolize the yucca plant, spiderwebs, porcupines, "starbursts," arrowheads, turtle shells, and even three-story buildings. Colors may also have significance, such as orange for the sun and white for the earth.

It is difficult, however, to maintain that all designs have symbolic meaning, and some scholars have concluded that no meaning at all is attached by the potters to their designs. According to Ruth Bunzel, "At Acoma there is no trace whatever of symbolism in design." She quotes one potter saying, "We have only three names for designs, red, black and striped. The designs do not mean anything" (Bunzel 1929:71). Today, elaborate stories about designs do not seem prevalent at Acoma and Laguna, and for the most part designs have names relating to the style of decoration rather than to specific symbolism: "fineline," "Mimbres," and so forth. Many potters tend to describe their designs simply as either bird, floral, or geometric, without expanding upon their meaning.

At Acoma and Laguna, European pottery forms were adopted in historic times, but I have not come across specifically Christian symbols on historic pottery. The figures of saints, for example, are noticeably absent until very recently (see figs. 8.1, 8.3), even on ceramics created well after the arrival of the Spanish missionaries. Crosses do appear, but crosses exist in the prehistoric Pueblo design tradition as well.

To some extent, traditions are changing along with the changing economic function of Pueblo pottery. Buyers want "primitive" art to have symbolic meaning, so today some potters may add tales of symbolism to give an exotic flavor to their work. At the same time, the contemporary marketplace has diluted the symbolism of pottery of the past. Many designs—especially the tightly structured, dazzlingly fine geometric designs—are created for strictly commercial purposes. Most designs

created for the modern market cannot be said to be symbolic, but to some Pueblo people the ancient designs copied from traditional pottery still do have meaning.

Designs on ceremonial vessels are in an entirely different category, and in some cases may be more important than the physical objects themselves. These designs do have specific meanings, most of which are associated with fertility. Motifs include frogs, tadpoles, dragonflies, serpents, and other natural manifestations relating to water. Ceremonial pottery from Acoma and Laguna is very rare in collections outside the pueblos because the Pueblo people value it highly and guard it closely, but on the few genuine ceremonial pieces that I have seen, the design elements are similar to those on ceremonial pottery from other pueblos which is accessible in public collections.

Because of their inherent conservatism, Acoma and Laguna potters have been reluctant to use any sort of ceremonial designs on pottery made for use in the home or for sale. Such designs do make pottery more exotic and attractive to buyers, though, and in recent years they have begun to appear more frequently. These pseudo-ceremonial vessels lack some essential ceremonial elements, or include unrelated elements, and are not properly "blessed," so that they are rendered "not ceremonial."

Distinguishing Acoma from Laguna Designs

Without documentation as to pueblo of origin, it is very difficult and frequently impossible to determine whether a particular pot came from Acoma or Laguna. In most collections, therefore, pots of the Acoma-Laguna style tend to be lumped under the heading of "Acoma." Sometimes technical criteria (such as the constitution of the paints used on a piece) may help determine pueblo of origin, but even these are not always definitive. Materials such as the black guaco/mineral mixture can vary considerably from pueblo to pueblo and from potter to potter—or even from one batch of pottery to the next when made by the same potter.

Design is even less diagnostic than materials and technique. In general, what is done at Acoma is also done at Laguna, and vice versa.

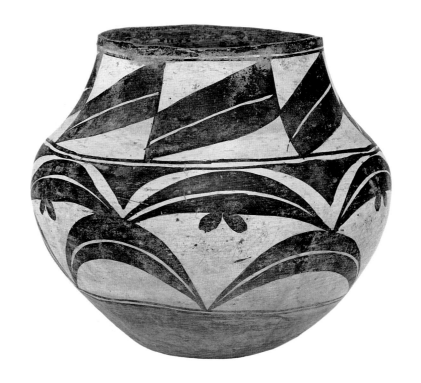

*Figure 5.21. Laguna
Polychrome jar,
ca. 1880–1900. Typical
water-jar form with two
bands of design: split par-
allelograms on the upper
shoulder and split arcs
with double dots on the body.
The movement of connected
elements suggests a Laguna
origin; "Paguate" is penciled
on the base. IAF 959.
9 ½" x 10 ½".*

Gladys Paquin of Laguna said when she took her pottery to stores, buy-
ers said they were done in Acoma designs, "So I tried to do different
designs, I tried to stay away from Acoma designs." Laguna potter Lee
Ann Cheromiah commented that Acoma pots are "so busy with
design—busy is messy—and Laguna pots are less busy, more spacious.
Balanced. You have to balance the pot and balance the design so the
design does not take over the pot." The tendency to cover the jar or
bowl with profuse design does appear to be more an Acoma trait,
although it is also seen at Laguna.

Certain minor variations in design at each pueblo can be noted,
though there are always exceptions to these generalizations. An open
"chain-link" patterning, sometimes with a heart-shaped motif or other
central element, is characteristic of Laguna and creates a sense of move-
ment or flow around the central portion of the jar (fig. 5.21). From the
mid-1800s to around 1930 a more spacious quality of design is typical
of Laguna pots, as are bolder elements connected with split-leaf (arc)

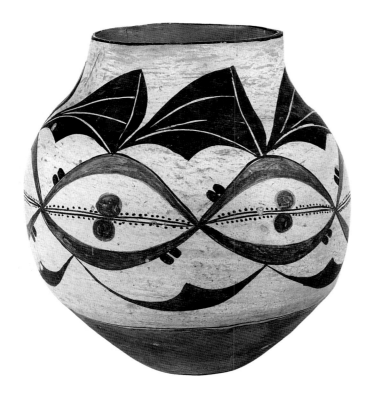

Figure 5.22. Laguna Polychrome jar, ca. 1870–80. The central band of open ellipses on this jar is bisected by lines and rows of dots. In the center of each ellipse is an unbordered red double-dot motif; smaller black double dots appear on the exterior. Dark triangular elements with fine white "lines" and simple arcs connect with the ellipses to form a single band of design. The spacious quality and sense of movement suggest a Laguna origin. 11½" x 11".

patterns and dots drawn as tracks across the design field. The lines of dots most often have near their center two lateral larger dots; these may signify raindrops (fig. 5.22).

Although previous literature has attributed a more casual—even crude—application of design to Laguna pottery (Frank and Harlow 1974:133), the relative fineness or crudeness of design cannot be used to distinguish between the two pueblos. Some Acoma vessels are crudely painted, and some Laguna pots are rendered with exquisite precision and grace.

Zuni and Zia Designs

Both Zia and Zuni designs appear at Acoma and Laguna. From roughly 1890 to 1915, a potter or group of potters at Laguna produced wares that appear to be attempts to replicate Zuni designs and materials (especially slips) directly (fig. 5.23). With such historic borrowings taking

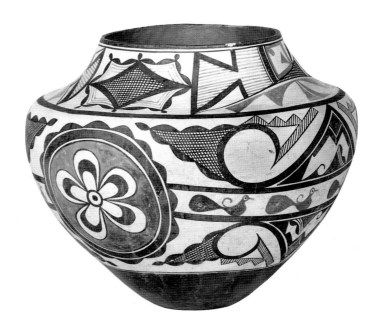

Figure 5.23. Acoma Polychrome jar, ca. 1920. Typical Zuni olla design layout employed at Acoma, showing rosette and banded design with intermediate band of small red birds. Orange interior rim and base (rather than the usual Zuni brown) are typical of Acoma. IAF 257. 12" x 14½".

place, it remains extremely difficult to establish firmly a Laguna or Zuni origin for a particular piece of pottery.

Although all six Keres pueblos share a common language, Acoma and Laguna pottery has more in common with that of Zia and Santa Ana than with that of Cochiti and Santo Domingo. It may be that language is less important than geography and history in determining similarities in material culture. Designs moved rather freely between Zuni, Zia, Santa Ana, Acoma, and Laguna, no doubt due to their geographical proximity and probable historic connections (fig. 5.24). The bold triangular patterns of the Santo Domingos are more commonly found in the work of their Tewa-speaking neighbors, the San Ildefonsos, than in that of their language affiliates at Acoma and Laguna (Henry Walt, personal communication, 1989).

An example of a design used by Acoma, Laguna, Isleta, and Zia potters but not by others is the "double-dot" motif, already mentioned as a rain symbol (fig. 5.25). This design has a few different forms: double ellipses left open in a solid area of design, two dabs with a dotted line between them connected to other elements, or two dabs attached to

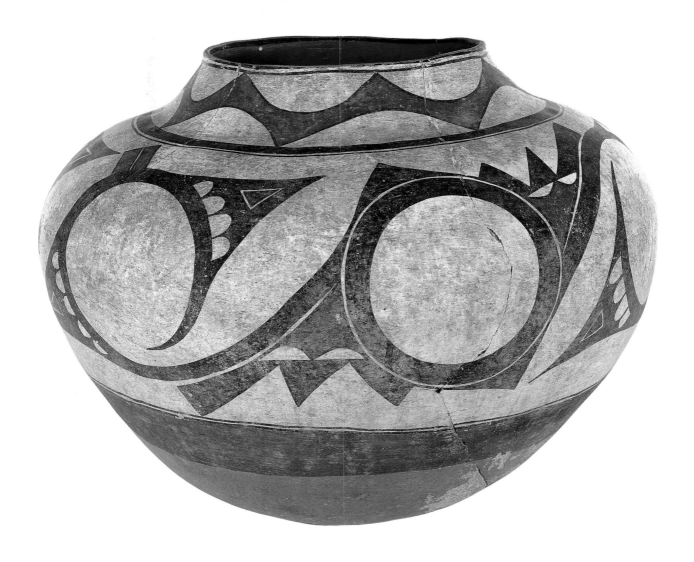

*Figure 5.24. Laguna Polychrome jar, ca. 1880–1900. Strong Zuni
(rainbird) and Zia (solid red zigzag around the neck) elements dominate the
design on this large storage jar. The unusual red underbody band is more common
along the Rio Grande and has been used on at least two Laguna vessels.
IAF 792. 16" x 21".*

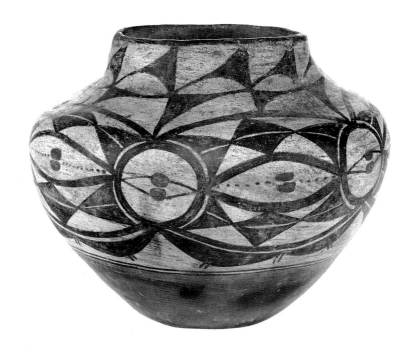

Figure 5.25. Zia Polychrome jar, ca. 1880. This jar exhibits design elements shared with Laguna and Acoma. The clay is a rock-tempered red, as opposed to the sherd- (and sometimes rock-) tempered white Acoma or Laguna clay. IAF 445. 10" x 11 ½".

another design element. Filling in areas of design with cross-hatching is a popular technique also shared by Acoma, Laguna, Isleta, Zuni, and Zia.

Fifty years ago, Ruth Bunzel noted that "a number of typical Zuni designs are current in Acoma, but the Acomas claim to have originated them. The claim is by no means valid. The designs are traditional at Zuni, but are found only on comparatively recent Acoma pots" (Bunzel 1929:57). Acoma potters often reproduced the Zuni designs verbatim but always rendered them in the bright oranges and reds of Acoma rather than the deeper Zuni reds. Use of Zuni designs began at Acoma in the latter part of the 1800s, a time of increased tourism that probably stimulated Acoma potters to borrow and experiment to see what would be most marketable. Zuni pots would have been readily accessible, being sold at the railroad stations at Gallup and elsewhere. Most of the examples of Zuni-style pottery I have seen are in excellent condition, an indication that they were probably made for sale rather than domestic use.

History and Design

The reasons certain motifs developed and became identified as regional or village designs may be found in the events and societal pressures of the early post-contact period. According to Henry Walt (personal communication, 1989), before the Pueblo Revolt of 1680 and the ultimate Reconquest of 1696, many design motifs were shared among the pueblos of the Rio Grande and the Acoma-Zuni area, suggesting broad cultural connections. The most prevalent of these was the feather motif, used with minor local variations by each pueblo. Following the Revolt, designs began to become more locally differentiated, perhaps in response to the decreased geographical mobility of Indians fearing Spanish reprisals.

Alliances between various pueblos and the Spaniards may also have intensified divisions within Pueblo culture and contributed to the development of a more "nationalized" corpus of designs. Other external pressures, including the 1780 smallpox epidemic, substantially decreased the native population and may have resulted in smaller, more protected, and more isolated villages—and fewer potters. With fewer potters, more individualized designs may have come to the fore and altered the identifiable design elements at each pueblo (Henry Walt, personal communication, 1989).

Language groups also blended in response to Spanish occupation, and Keres-speaking Zia, Santa Ana, Acoma, and Laguna showed stylistic connections to the Zuni. Closer to Spanish strongholds, Keres-speaking Cochiti, Santo Domingo, and San Felipe were stylistically more similar to their Tewa-speaking neighbors (Henry Walt, personal communication, 1991).

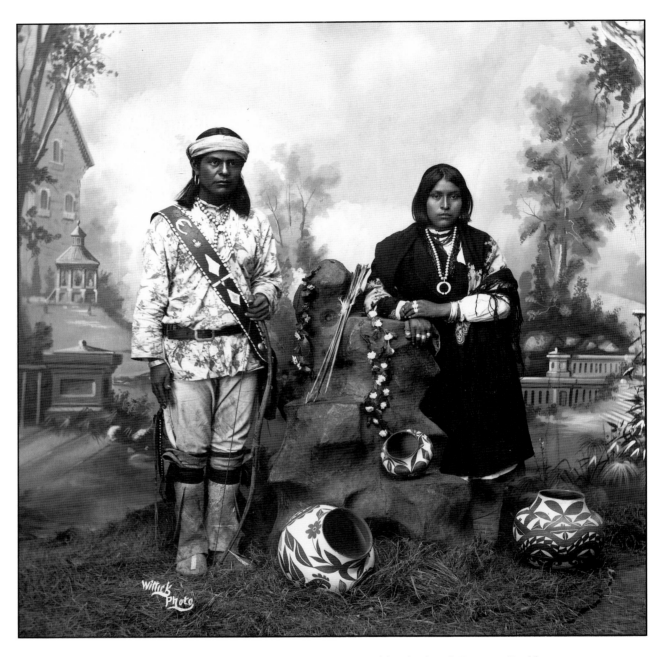

Figure 6.1. Wedding portrait of Tzashima and her husband, Laguna Pueblo, ca. 1883. Photograph by Ben Wittick.

The Prehistoric and Historic Periods

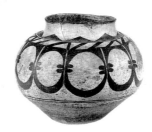

Indigenous populations lived in the Southwest for centuries prior to the arrival of the Spanish conquistadores, and in the Acoma and Laguna area a wide spectrum of prehistoric pottery styles preceded the development of elaborate glazewares, whose production ended rather abruptly around 1700. Black-on-white, black-on-red, and, later, polychrome types were common, along with the virtually timeless unpainted utility wares. Anasazi pottery such as Lino Gray ware (A.D. 200–500) is widespread in the Acoma area, suggesting that it was occupied at a very early period. Pottery from the Mesa Verde area, including Mesa Verde Black-on-white (A.D. 1200–1300), has been found on Acoma mesa (Ellis 1974:37), lending some support to the local myths that trace Acoma origins to that source.

Examples of Socorro Black-on-white and related types appeared sporadically from around A.D. 1050 to 1150, while the more consistent glaze sequence in the western pueblo region began with St. Johns Polychrome (A.D. 1175–1300) and its regional variant, Zuni Heshotauthla Polychrome. The Rio Grande version of Heshotauthla Polychrome, introduced perhaps from Zuni visitors, is called Los Padillas Polychrome (Peckham 1990:82, 86). These early glazewares evolved into distinct local types in the Acoma-Laguna and Zuni areas (David Snow, personal communication, 1989).

Tempering materials indicate that two areas of prehistoric pottery manufacture existed in the Acoma region: in the volcanic area north of the Rio San Jose, an eroded diabase rock was used as temper in combination with ground sherds; plain ground sherds with sand were more commonly used in the sandstone-cliff area south of the river (Ed Dittert, personal communication, 1990).

In the lowest level of a test trench dug at Acoma by Ruppé and Dittert, a small sample of Pueblo III pottery types dating between A.D. 1100 and 1300 was found, among them Tularosa Black-on-white (A.D. 1100–1250) (in its northern variant); Northern Gray Corrugated (Ruppé and Dittert 1952:215) (also known as Kowina Corrugated) (A.D. 1050?–1325) (Ed Dittert, personal communication, 1990); Pinedale Polychrome (A.D. 1275–1350); and Los Padillas Glaze Polychrome (a rare imitation in the style of late St. Johns Polychrome from the Rio Grande area, A.D. 1175–1300) (Ellis 1977:80; Snow 1982:251). In pre-contact levels of the test trench, intrusive sherds from middle Rio Grande types appeared. Higher in the fill, Hopi types, including Sikyatki Polychrome (A.D. 1375–ca. 1625), were noted. Most of the pottery recovered, however, was locally made.

After the 1300s, Acoma pottery developed in relative isolation, though some outside influences are evident (Harlow 1985:73)—particularly in the Zuni-type bowls that occur in Dittert's sample (Harlow 1985:77). The forms of rims, along with general typology, are used to distinguish the chronology of pieces in the glazeware sequence, beginning with simple squared-off treatments in early examples and later becoming sculpted like Hawikuh polychromes. Designs, too, evolve over time, from prominent interior designs with simple exterior motifs, to equal interior and exterior treatment, to exterior decoration with no interior painting (Harlow 1985:76). Slips are combinations of red and white: white interiors with red exteriors, and vice versa (Harlow 1985:78).

The mineral-based paints used in these prehistoric glazewares have lead as a fluxing agent (a vehicle to allow melting), present in sufficient quantities to vitrify the material and render it glasslike. Oxides of minerals (e.g., manganese, iron, and copper) provide the color spectrum; other trace minerals affect the color and quality of the glaze, as do the firing atmosphere and colors of the slips beneath the glaze. Oxides present in the decorative slips sometimes bleed into the vitreous glaze and alter its

color. Copper, a fluxing agent and colorant, is a diagnostic element in the glazes of the west and is responsible for the distinctive greens seen on Acoma and Zuni glazewares.

Prehistoric potters probably developed their process for making glazewares by noting the different qualities of materials gathered at various locations and observing the results of accidents that occurred during the firing process. The difficulty of controlling the use of glaze paints cannot be overstated. The glaze might separate or "crawl," leaving a blotchy appearance, or a ghost-like image might appear where the carbon paint penetrated the clay surface and the glaze ran off (Shepard 1965:46–47). Various paint mixtures would produce a wide array of results, from a fairly viscous glaze to a thin, runny one. A shift in the wind during firing could result in one side of the pot heating more than the other, warping the jar and causing the glaze to run haphazardly, with gravity doing the designing. Many bowls and jars display this runny glaze effect, more common along the Rio Grande than at Acoma and Zuni.

A cooler fire would keep the glaze in a sintered state, a stage in the vitrification process that leaves the glaze somewhat rough and gritty, midway between a flat matte and a glossy sheen. Glazes when molten might also pick up ashes from the fuel, producing a rough surface. Through trial and error, however, prehistoric potters eventually were consistently able to produce elaborate and well-fired glazed decoration showing great technical and artistic control.

Acoma glazewares were very similar to those of their close neighbors, the Zunis, and early ceramics from the two pueblos resemble each other so closely that they are sometimes indistinguishable. Continued research may demonstrate that Zuni and Acoma varieties of the same glazeware type are distinguishable by the addition of the diabase temper either directly (at Acoma) or via crushed sherds already made with diabase temper (at Zuni) (Ed Dittert, personal communication, 1990).

Glazeware was made continuously in the Acoma area from roughly A.D. 1300 until around 1700, while at Zuni, the glaze sequence was interrupted around 1550 by a matte-painted, yellow-slipped "Hopi-style" polychrome (Matsaki Polychrome) similar to Sikyatki Polychrome (Ed Dittert, personal communication, 1990). There is some speculation that this yellow-slipped pottery may have evolved separately at Zuni

Figure 6.2. Hawikuh Polychrome jar, Acoma (?), ca. 1680. *This design, which appears to represent kachina figures, is painted with a green-black glaze and red slip in a style reminiscent of Sikyatki Polychrome. The underbody slip is deep red, and a streaky tan slip covers the upper shoulder and bulge area. An unrepaired hole in the base caused by a popout during firing suggests that the pot served a nonutilitarian purpose. 9" x 14 1/2".*

from northern Mexican influences (Carlson cited in Snow 1982:253).

The Acoma jar form of the style referred to as Hawikuh Polychrome, with its distinctive midbody—or "spare-tire"—bulge, may have been developed after contact with the Rio Grande pueblos following the Zaldívar massacre of 1599. Rio Grande wares of the time featured pronounced bulges, and the new form also shows up in some of the Hopi-style Matsaki pottery at Zuni, becoming standard in Hawikuh jars at both Zuni and Acoma.

At the time of the initial Spanish contact in 1540, Acoma's long-established pottery tradition was strong and flourishing. By 1850, however, interaction among the Acomas, the Spanish settlers, and other native ethnic groups during the period of Spanish dominion would affect virtually all aspects of pottery production, resulting in new techniques and forms as well as changes in various design elements.

It is perhaps no coincidence that the pottery of the turbulent period from 1599 through ca. 1700 was most elaborate in both form and design. The designs on Hawikuh Polychrome jars and bowls in some cases have almost mythical content: kachinas in the Hopi (Sikyatki) tradition, intricate stylized birds, and other geometric forms (fig. 6.2). Is it

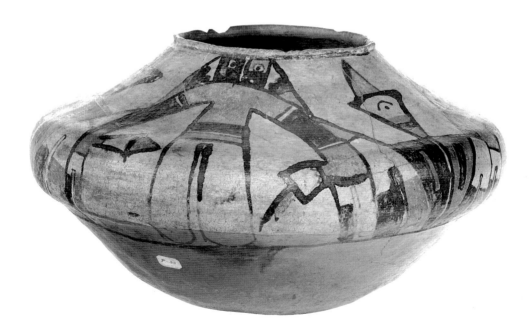

possible that these exceptional ceramics were made as offerings to the deities, a religious or ritual response to the chaotic conditions engulfing the known world of the Pueblos? Certainly, whether symbolically or not, they reflect the ferment of the times.

Early Historic Ceramics

Beginning in the late sixteenth century, as Spanish settlers moved into the Rio Grande valley, the prehistoric glazewares of Acoma and Zuni were evolving technically. Known to archaeologists as Hawikuh Polychrome and Hawikuh Black-on-red (Smith, Woodbury, and Woodbury 1966:138–39), these new ceramics were produced until the end of the seventeenth century. Very few whole examples of Hawikuh pottery exist; five are in the collection of the Indian Arts Research Center in Santa Fe, four of which are probably from Acoma. Others are housed at the Laboratory of Anthropology in Santa Fe, the National Museum of the American Indian (Heye Foundation), Cambridge University in England, and in private collections.

The type was first identified in Frederick Webb Hodge's 1917–23 excavations of the prehistoric Zuni pueblo of Hawikuh (Smith, Woodbury, and Woodbury 1966), but some authorities believe that Hawikuh Polychrome originated at Acoma and was picked up by Zuni potters at a slightly later date (Ed Dittert, personal communication, 1989, 1990). At present, though, archaeological evidence from the Acoma area is scant and inconclusive.

Whatever its origins, Hawikuh Polychrome demonstrates the close ties between Acoma and Zuni prior to the Reconquest. It also represents a significant step forward in pottery form and design, marking an artistic and technical peak in Pueblo glazewares. Hawikuh Polychrome and its related bichrome—Hawikuh Black-on-red—were the last glazewares produced at Acoma and Zuni prior to the change to matte-painted wares at about the time of the Reconquest.

Hawikuh Polychrome jars, in particular, have received a great deal of attention from scholars and collectors. Their form is unique and difficult to construct, the glaze paint is consistently applied in rich, warm tones, and the designs include elaborate geometric and life forms. Although

concave bases were common on jars from the Rio Grande pueblos at this time, they did not make their appearance in the Acoma area until after glaze paints had been replaced by matte paints, around 1700 (Harlow 1985:22). All Hawikuh jars have rounded bases, from which outflaring walls rise to meet an exaggerated and diagnostic bulge around the midsection of the jar. Above the bulge, a gracefully incurving upper shoulder joins the sculpted rim, which has an interior molded band and a slight exterior flare. In addition to the famous jars, Hawikuh Polychrome bowls, canteens, and other forms were produced.

My examination of existing Acoma and Laguna pottery—including glazewares—from the historic period in general (i.e., from the first Spanish settlement in New Mexico in 1598 to the arrival of the railroad in 1880) revealed a marked scarcity of whole bowls. The hard daily use to which the bowls were subjected made them particularly vulnerable to breakage; the Acomas may also have cultivated less wheat than did other pueblos and thus utilized fewer dough bowls.

The clay of Hawikuh Polychrome pottery was probably much like that used by Acoma-Laguna potters today: a fine paste tempered with the crushed sherds of broken (and sometimes ancient) pots. The different firing atmospheres characteristic of the different types—reducing in Hawikuh times, more oxidizing later—result in post-fired clays of different colors. The walls of both jars and bowls are usually very thin. Glaze paints ranging in color from green to purple to deep brown or black were used in conjunction with slips of a red-orange or a white-buckskin color. Bichrome pieces with a red overall slip and a deep brown-black glaze are called Hawikuh Black-on-red (fig. 6.3).

The same glaze can vary from a transparent green when applied over a white slip to a deep black when painted over red. Such color variations are also due in part to the firing atmosphere. Most Hawikuh pottery was fired in a reducing atmosphere (briefly oxidizing at the end of the firing), which results in deep, rich surface colors and a characteristic dark cross section visible in the sherds. A glaze containing copper will turn a bright green when the firing ends with a clean oxidizing atmosphere, while in a reduction firing, this glaze will go to a purple-black. A halo-like purple bleed can occur where the edge of the glaze meets a white slip. Brown appears where the glaze is painted over a red slip or the firing is on the reducing side, creating a surface luster.

Design layout on Hawikuh Polychrome and bichrome jars usually consists of a band of simple geometric elements around the neck; this band can become more elaborate and cover the jar's upper shoulder. Frequently, a design band is also drawn around the midbody bulge of jars and the upper exterior section of bowls. On jars, this design is quite separate in feeling from the upper shoulder band, and often is divided into panels with repeating design elements. Bowl interiors are usually left undecorated.

The designs themselves consist of relatively few simple geometric elements that appear complex when repeated. Other common designs, which show strong Hopi influence, are stylized bird and abstracted kachina motifs. Some Hawikuh pieces have an allover design on the upper shoulder and bulge area which is akin to the Hopi wares. The red and white slip application on jars has at least two major configurations: the red basal area can extend up over the midbody bulge, with white on

Figure 6.3. Hawikuh Black-on-red jar, ca. 1650–1700. A deep red slip painted over the entire jar has taken on the patina of fine leather. A band of hooked elements in black glaze is painted around the neck, and an outlined path line encircles the jar at the upper shoulder. The midbody bulge area has a paneled band of geometric design. IAF 1185. 9 1/2" x 15".

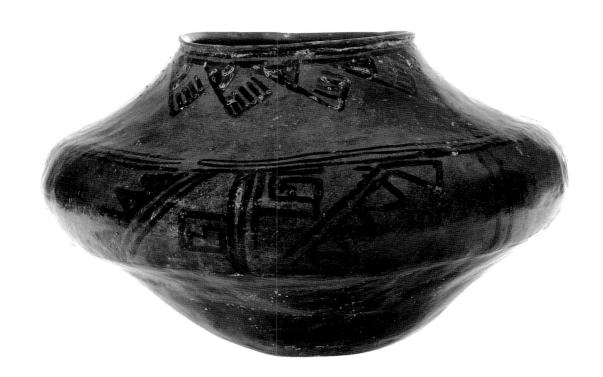

the upper shoulder, or white can extend down from the rim over the bulge. Some examples have both red and white on the upper shoulder, usually dividing the jar in half—the glaze design then follows the colored fields. Red slips, polished and unpolished, are also used as a paint over a white-slipped area. Rims are red, as are bases on polychrome pieces.

The path line, which seems to have originated in the thirteenth century, appears around the upper shoulder of some jars. It is generally a thick band of black paint, or sometimes of red slip edged in black, that in the Acoma-Laguna-Zuni area often exhibits the ceremonial or spirit break. The path line may also anchor pendant designs such as stepped figures or hooked elements (Harlow 1985:26).

In general, Acoma and Zuni pottery of this period shows much crossover in design with the Hopi-area wares created from about A.D. 1375 to 1625 (Sikyatki Polychrome). Elaborate feather motifs more commonly associated with Hopi are notable on Acoma and Zuni seventeenth-century wares. After various feather patterns were adopted by the Acoma, Laguna, and Zuni potters, the designs then migrated east and were absorbed by the Rio Grande potters.

An Evolution of Form

Prehistoric potters, like their modern descendants, no doubt expressed their creative imagination by devising unique pieces. Cultural parameters may dictate basic forms and designs, but within these confines experimentation can and does take place. Any long-term changes are likely to have begun with the innovations of a single potter, which were then adopted outright by others or which stimulated further experimentation.

We can speculate about the reasons that certain forms evolved in Pueblo pottery. Consider the pre-seventeenth-century glazeware water jars, round-bodied and small-mouthed, whose short vertical necks could easily be grasped by the rims. When full, the ollas' heavy bodies were likely to break off from their fragile rims, dashing to pieces on the ground. Both users and makers of these jars would demand a solution to such a problem, a solution that did develop over time.

First, potters tried molding indented, self-contained handles, providing two points of stability that could be grasped while bearing full jars on the head. But two discrete handles could easily be missed when reaching up quickly to steady a jar, so further improvements were added. The diagnostic spare-tire midbody bulge may have evolved to provide a continuous handle, easily grasped when the jar was fully weighted with water. In the Indian Arts Research Center, one particularly interesting transitional jar (probably from Zuni) has both the spare-tire bulge and the two indented handles (fig. 6.4).

Figure 6.4. Hawikuh Polychrome jar, Zuni area, ca. 1650–1700. Note the innovative use of the midbody bulge and indented handles for easier carrying. The feathery painting around the rim appears to be a Zuni trait. IAF 2757. 8 ¾" x 15".

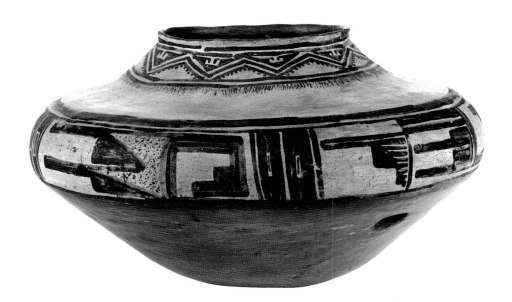

The midbody-bulge form freed the potter from the tedious task of fashioning separate handles. While not difficult technically, construction of the handles interrupted the potter's flow of motion as she coiled the clay to build the jar form. Constructing the bulge allowed the potter to mold jars and bowls inside a puki up to a certain point, and then do free coiling. When the clay had filled the mold, it spilled out over the top.

The potter then worked with this exaggeration, incorporating it into a graceful vessel form.

The bulge in jar forms developed in the Tewa area along the northern Rio Grande earlier than it appeared in Acoma and Zuni pottery. But Tewa potters molded the bulge in the bottom third of the pot, creating a shallower puki flexure, while at Acoma and Zuni it was formed at the approximate midbody.

Attempts by contemporary Zuni potter Randy Nahohai to replicate this form demonstrate the technical challenges. The potter must make many shifts in structural direction while molding the midbody bulge; especially tricky is the shoulder-to-rim section, which tends to crack. In addition, clay that is too heavy and thick or too wet can cause the jar to cave in.

Such difficulties may be one reason that the midbody-bulge jar form was relatively short-lived, although it continued to appear in a modified form in the Ako Polychrome pottery created at Acoma around 1700 and eventually evolved into more of a dome form, or mushroom shape. This new form was easier to construct, it had a more stable concave base, and early examples show the sculpted rim common on its predecessor.

The End of the Glazeware Tradition

The glazeware tradition at Acoma and the other New Mexico pueblos may well have been brought to a close by a specific historical circumstance. It is probably no coincidence that the florescence of glazewares ended abruptly at about the time of the Reconquest, when lead mining was suspended by the pueblos because of competition for the material from the Spaniards. Although lead was a crucial ingredient of the traditional glazes, Pueblo miners may have decided not to contest Spanish control of the lead mines, or they may have been forcibly barred from using them.

Lead was most likely employed by the Spaniards in the manufacture of bullets, used primarily to fight hostile nomadic Indians. It was thus a valuable resource, and one that might have been kept from the native population for strategic reasons (Goodman and Levine 1990:27). The Spaniards may have also used lead in solder for tools and weapons.

The unsettled conditions after the Pueblo Revolt and the granting of land and mining claims to the Spaniards in the Rio Abajo (middle Rio Grande valley) also played a role in the shift to matte-painted pottery among the Rio Grande pueblos (Snow 1982:260). The lead mines in the Cerrillos area (the Mina del Tiro and Bethsheba mines) (Goodman and Levine 1990:23) and at Las Huertas, south of Cerrillos near present-day Placitas (Goodman and Levine 1990:27), had been exploited for pottery production by the pueblos along the Rio Grande. Whether or not this material was traded to the Acomas and Zunis is not known; it is possible that Rio Grande glazed pottery initially was painted with pigments derived from the Zuni area until more local lead sources were discovered (Peckham 1990:86).

Acoma and Laguna potters today seem to be unaware of the existence or locations of lead mines in their region. One eighteenth-century document states that the Acomas had both lead and jet mines, but that the Indians would not divulge their whereabouts (Minge 1974:169). Most of the early Spanish commentaries on mines in the Acoma and Zuni area mention silver and other ores, but say nothing about lead, which can be found in conjunction with silver. Espejo's narrative on the Acoma area states that "the mountains thereabout apparently give promise of mines and other riches, but we did not go to see them as the people from there were many and warlike" (Bolton 1930:183).

It seems highly unlikely that potters would have abandoned such a well-developed ceramic technique without some sort of external pressure. But then the obvious question arises: Why didn't the Pueblo potters return to glazewares after tensions with the Spaniards settled down? Whatever the answer, the fact is that matte-painted pottery making began at this juncture and continues at Acoma and Laguna today. By the standards of change common to Pueblo pottery, the switch from glazeware to matte ware, or from Hawikuh Polychrome to Ako Polychrome, happened virtually overnight. By the year 1710, the new matte paints were well in place as the norm.

Pottery from Acoma and Zuni was still very similar at this time. The matte ware produced at both pueblos was called Ashiwi Polychrome by H. P. Mera (1939). Several decades later, Francis Harlow (1973) noted sufficient differences to divide the type into Ashiwi Polychrome at Zuni and Ako Polychrome at Acoma. Ako Polychrome was made at Laguna

also, though it is difficult to distinguish Acoma from Laguna ceramics until the onset of Acomita Polychrome in the later 1700s (Harlow 1985:100).

Like the glazes, matte paints have a mineral base, but because they lack the fluxing agent, lead, they produce a nonshiny finish. The mineral base consists of rock containing hematite, which has a high content of both manganese and iron and yields colors ranging from warm red-browns to cool brown-blacks, depending on the specific paint mixture and firing atmosphere used. Potters scraped the hematite-bearing rock on a stone palette to obtain a residue that was then mixed with the vegetal material, guaco, to adhere the paints to the clay. This method of preparing mineral paints was known throughout the prehistoric period in the Southwest and is still used today.

Early records throw some light on eighteenth-century sources for Acoma paints. A 1782 description of Acoma Pueblo written by Fray Juan Agustín de Morfi, based on a 1779 manuscript by Governor Jean Bautista de Anza called "Resumen de los padrones y noticias del Nuevo Mexico," states that "there is . . . in the environs of said pueblo a mine of very rich jet, of which the Indians make crosses and many other curiosities. There are also mines of black, yellow and red earths, with which they paint their houses and pottery" (Rands 1974:248, 251). Concerning Laguna, de Morfi wrote the following: "To the north there is a mine of yellow and black colors that serve to paint their houses and their earthenware that they make for their use, which is very coarse, all of which is found in the Sierra Cebolleta" (Rands 1974:258).

From the aesthetic point of view, matte paints provided potters one important advantage: delicate and intricate designs could now be drawn with precision and were not subject to the runniness of glazes that could obliterate the painted patterns.

Eighteenth-Century Forms and Designs

Although the eighteenth-century Ako Polychrome jar shape is reminiscent of that of the earlier glazed pottery, the new style is taller and has a less pronounced midbody bulge. The upper flexure of the bulge is eliminated, resulting in what some experts have called a mushroom-like form

(Harlow 1973:60–62). Vessels of this period have underbodies that are narrow at their concave bases and flare outward to the juncture of the bulge.

The evolution of the earlier midbody bulge to an overall domed or mushroom shape eliminated the need for the difficult construction of the insloping shoulder and upper body. From a potter's point of view the new shape required considerably less work, and over time an even simpler, more rounded form evolved. Potters continued to elaborate the puki flexure at the base, and this feature was very severe in early Ako Polychrome pieces.

The Ako Polychrome jar also sported a concave base. With its many points of contact, this base offered greater stability on the head of the bearer and on a flat surface, and easier handling overall. It probably was introduced by Rio Grande potters, specifically the northern Tewa, who had utilized similar bases since before 1500.

Early Ako Polychromes exhibit sculpted rims similar to those found on Hawikuh Polychrome jars, but gradually the rims became more squared off. Many of the vessels are shaped without a neck, though in later examples the rim is raised slightly to form a short neck. Over time, the neck elongates and becomes a diagnostic trait in the succeeding type of pottery at Acoma and Laguna, Acomita Polychrome.

Slip treatment of Ako Polychrome pottery is very similar to that of the Hawikuh wares. Deeper in color than that used on its Zuni counterpart, Ashiwi Polychrome, the Ako red slip is painted over the entire base and polished with a stone. The slip can extend to the beginning of the midbody bulge or cover the bulge entirely. The Ako white slip begins on the upper section of the piece and extends downward, sometimes over the bulge. It has a soapy texture and tends to blister. The clay itself is strong, however, and does not erode easily with use. This is due to the dense quality of the paste, which lacks impurities and is very durable when highly fired.

Besides adapting to matte paints, potters at Acoma, Laguna, and Zuni developed new designs in their pottery during the eighteenth century. The design field on a jar generally consisted of a wide band set off by framing lines at the borders of the white slip on the neck and body, and sometimes separated by vertical panels. The band might also be

made up of "floating" elements not pendant to the framing lines. One set of framing lines usually exhibits the ceremonial or spirit break.

Until around 1730, the rims of Ako Polychrome jars were slipped red; by the mid-1700s, potters began to paint them with black mineral paint. The rim of at least one jar has black paint applied over a red slip.

Because of their limited exterior design area, bowls were painted in a band with panels. Occasionally, a zigzag line is drawn around the bowl's interior rim, which might be sculpturally exaggerated to accommodate the design. Large dough bowls, whose manufacture probably began in the mid-1700s at Acoma and later at Laguna, were rarely painted inside because the painted design would erode with use; instead, they were simply slipped in white or red. (In contrast, dough bowls at Zuni usually bear interior designs, many now badly worn.)

Directly after the shift to matte paint was made, pottery at Acoma, Laguna, Zia, and Zuni began to display a profusion of feather motifs, both the naturalistic, gracefully curving Hopi-inspired plumes and the more angular and delicate feathers with triangular caps characteristic of the Puname pueblos of Zia and Santa Ana. Geometric elements such as stepped sections and triangles were common, and open "eyes" appeared on some pieces in solid design areas. Arc motifs also were used; these may show Puname influence as well.

Three interesting examples of jars from this period are in a private collection: an Ako Polychrome jar from Acoma, a Puname Polychrome jar from Zia, and an Ashiwi Polychrome jar from Zuni that bear almost identical designs. It is impossible to determine which jar was made first, but they demonstrate a definite stylistic connection among these pueblos.

Interpueblo Connections

Trade among the western and the Rio Grande pueblos was ongoing both before and after the Pueblo Revolt, and it can be assumed that the western pueblos used their pottery for barter with the Spaniards as well, perhaps in return for domestic animals. Little imported Spanish pottery

has been found in New Mexico, and certainly the highly serviceable and readily available Pueblo ceramics lessened the need for imports from Europe or Mexico. Various types of Mexican majolica did make their way to New Mexican Spanish settlements from the early 1600s through the mid-1800s, but these wares remained a luxury. Inventories from the seventeenth century note that one box of pottery from Puebla, Mexico, was sent to the northern missions every three years (Lister and Lister 1976:120).

There is considerable evidence from the eighteenth century that entirely new pottery forms introduced by the Spaniards were created by Acoma and Laguna potters, some of which were adopted for Indian use. These include soup bowls, candlesticks, chalices, and footed wares (with a modeled ring on the base). Surprisingly, though, given the rich heritage of Spanish ceramics, colonial documents make very little mention of Pueblo pottery.

Contacts between the western pueblos and the peoples of the Rio Grande and Plains regions may have been facilitated by the trade fairs held at Taos, Picuris, and Pecos, but in general, contact between Acoma-Laguna and the eastern pueblos was sporadic. It probably did not have as great an effect during this period as did the actual presence of groups of people from the eastern pueblos at Acoma and Laguna. Other continuing influences were the trading-and-raiding Navajo and Apache tribes and the Acomas' always closely associated neighbors, the Zunis.

Acoma and Laguna potters were also influenced by the Puname pueblos of Zia and Santa Ana (Harlow 1973:51). The clay body used at these two pueblos is similar in color (brick red, orange, buff) and texture, but the temper differs. Zia pottery characteristically has pulverized basalt added to the clay, so that in cross section a Zia pottery sherd has a black-speckled appearance. It is possible that ancestral Zia potters at Laguna introduced the use of ground-rock temper to that pueblo. Santa Ana pottery is generally tempered with fine, river-worn sand.

During the eighteenth century, potters at Acoma and Laguna created a few unusual ceramics that resemble the pottery of the Puname pueblos. Made from red clay and tempered with sand and crushed rock,

this Puname-influenced pottery has been identified by Michael Marshall as Tecolote Red ware. It includes the type or subtype Tecolote Polychrome (Carroll et al. 1979), which describes a number of existing pieces, mostly sherds, that (though stylistically similar) do not fit comfortably into the Ako Polychrome type or its counterpart, Puname Polychrome, under which they were previously grouped.

Marshall has dated Tecolote Polychrome to the late 1700s (Carroll et al. 1979:sect. 5.3.4), and red clay appears later. A probable example of the type in the collection of the Indian Arts Research Center suggests an earlier date. This jar, an intact olla of the mushroom shape (Ako style), appears from its form, design elements, and overall design layout to have been made between 1710 and 1720 (see fig. 2.5).

Partially covered with sintered black paint, this vessel had reached a phase in the firing that occurs before vitrification of the glaze. Though Mera (1939:138) termed the paint a glaze, Harlow (1974:xix) considered it a matte: actually, it falls somewhere between the two. It appears to be a unique example, perhaps painted with an old stash of glaze paint or with pigments from an odd source, not connected with more organized lead mining. This sintered surface mineral, along with the red clay body and sand temper, may indicate that the jar was made at a location other than Laguna or Acoma, though the pot is generally identified with those pueblos because of its distinctive shape.

Unlike the related Zia and Santa Ana wares, which were generally fired in an oxidizing atmosphere, the sherds of Tecolote Polychrome studied at the Maxwell Museum of Anthropology at the University of New Mexico showed many gray cores that result from a reducing, or partially oxidizing, fire. The Tecolote sherds also tend to be thicker (more like Zia) than the Acoma-Laguna ceramics. There was a significant eighteenth-century settlement of Rio Grande Keresans at Laguna, an association that suggests that this red ware may be more closely tied to Laguna than to Acoma. As Marshall states, "Tecolote Red Ware materials appear to represent a link between the Puname and Laguna ceramic industries, being the apparent result of Puname provenience immigrants in the Laguna region" (Carroll et al. 1979:sect. 5.3.4).

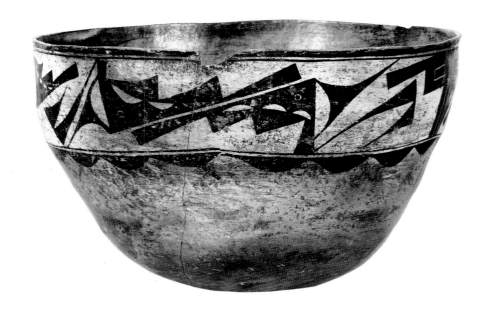

Figure 6.5. Acomita Polychrome bowl, ca. 1800. A large, heavily constructed dough bowl with floated underbody, white interior, and white band of slip with geometric design in black. A band of scallop motifs around the base of the design area is typical for the type, though more common on jars. IAF 1575. 11" x 18".

Harbingers of Change

For about sixty to seventy years, potters created the mushroom-shaped pottery described above. But in the later 1700s at Acoma and Laguna a downward shift in construction quality began, and pottery of a heavier, more rounded form evolved, with a short neck developing from the earlier sculpted rim. The type name Acomita Polychrome has been given to this unusual pottery, which was made at Acoma and Laguna from about 1770 until the mid-1800s (fig. 6.5). The earlier Ako and later Acoma polychromes show much greater finesse in manufacture and design, and the reasons the less-adept Acomita type developed and persisted remain a mystery. The evolution from Ako Polychrome to Acomita Polychrome is quite abrupt, with form, design, construction quality, and design application changing almost simultaneously.

With reference to major events that changed Pueblo pottery—the arrival of the Spaniards, the Pueblo Revolt, and later the railroad—Ross

Frank offers another event that may have altered pottery form and design. This "middle period" (Frank 1991:282), dating from 1780 to 1820, affected all pueblos with active pottery traditions and includes the Acomita Polychrome type at Acoma and Laguna. The shift in quality, form, and design may be related to a more active New Mexican economy beginning around 1785 and increased trade from New Mexico south to northern Mexico. Frank proposes that after Comanche and Apache raids were stopped (and the Spanish-Comanche treaty alliance was established in 1785), trade opened to northern Mexico, and Pueblo pottery was made for export. These pots, reflecting Spanish tastes and the growing dominance of Spanish society in late-colonial New Mexico, had short necks reminiscent of Spanish-style pottery being made in Mexico. "The pueblos replaced clouds, feathers, and other formal design elements with complex abstractions, less formally organized decorative spaces, and new active, stylized shapes. Finally, in a number of pueblos the new types exhibited a marked degradation in the quality of their output consistent with increased production for trade" (Frank 1991:293). The more casual approach to construction and design, with short necks on jars, can be noted on Acomita Polychrome from Acoma and Laguna.

The typical Acomita jar is heavy in construction and very thick, with a short neck, squared-off rim (which was easier to make than the earlier sculpted rims), short outflaring underbody, and convex base. In many cases, rim exteriors are decorated with a simple open or solid scalloped arc motif. A strong puki flexure is common, giving way to a smoother profile in the later phase of the type (1840–60); the puki flexure is used as the demarcation between the underbody (base) and body (area of design field) of these vessels.

There is greater variety in the form of Acomita jars than in that of their predecessors: they may be squat, round, or tall in profile. The squat form follows the transition from Ako to Acomita, while the other two shapes are typical during the later manifestations of the type. Earlier examples carry over the domed or mushroom shape, though with time, the dome shifts to a lower center, and a rounded or squared profile prevails. A primary distinguishing feature of Acomita jars is their

short vertical—or occasionally outflaring—neck, clearly an evolution of the vertical lip on late Ako Polychrome jars. As a rule, rims are black, but rare exceptions with red rims do exist.

The thicker construction of the Acomita type was well suited to large bowls, which are rendered quite sturdy by the addition of rock or chunky sherds as temper. Many bowls also exhibit a puki flexure and have flat bottoms, perhaps for added stability. The rims on bowls and jars of this period are squared off or rounded and lack the fine sculpting of earlier Ako pieces.

On early Acomita Polychrome jars, the neck is undecorated, and framing lines are painted at the juncture of neck and body. These can be two fine black lines, a red unbordered band of slip, or heavy black bands. By about 1800, the neck was most often decorated with a band of solid arc or triangle motifs, which may have been inspired by the Zia and Santa Ana wares. Solid arc motifs also appear on some large bowls, encircling the juncture of the base slip and the white design band. Later Acomita Polychrome jars are more fluid in profile and have fewer flexures in the construction. They also tend to be less heavy, and their necks are taller and slope inward toward the mouth. The arc motif continued to be used up until the transition to early Acoma Polychrome.

In design, Acomita pottery undergoes a development from the strong Puname influence apparent in its early phase to the carefully rendered geometric patterns of the later phase. Early Ako-Acomita transitional pieces have simple modified feather patterns with scroll elements; later pieces feature the bird motifs commonly associated with later Acoma pottery. In earlier examples, the white-slipped area is used as a field for decoration and much "negative" space is left undecorated; in the later examples, geometric designs divide and redivide the space until they completely absorb the design field, making the white-slipped areas a design element in themselves. On early Acomita wares, red-slipped areas contain unbordered design elements such as ellipses, half-circles, circles, and crescents, which are strongly associated with the pottery of Santa Ana, and the "rainbird" motif, an elaborate scroll, makes a vigorous appearance (see fig. 2.6).

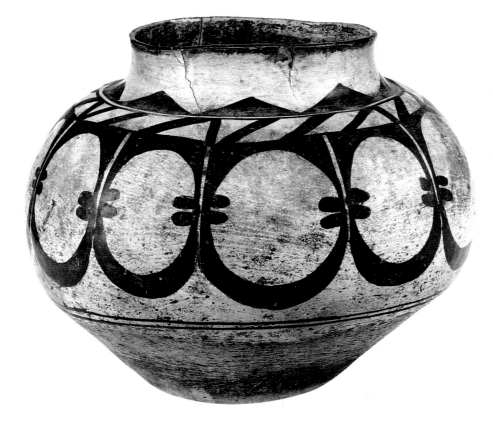

Acomita Polychrome, Laguna Variety

Again in Acomita Polychrome, elements that would determine origin at Laguna are difficult to define. Laguna designs tend to have a chain-link feel to them, with elaborately connected elements, but this characteristic is not strongly diagnostic (fig. 6.6). At both Acoma and Laguna, Puname-influenced design motifs and puki flexures occur; Frank Harlow (personal communication, 1991) suggests that the latter appear more at Laguna toward the end of the Acomita Polychrome period. Both pueblos commonly use more than one shade of orange in the design. The presence of rock temper in the jars can be an identifying element—it is used more at Laguna than at Acoma—but not until roughly 1870 can a fairly clear distinction be made between the work of the two pueblos.

The distinguishing features include construction (heavier), design (more open), and firing atmosphere (more reduced). Still, the use of pottery for trade can confuse the issue, since some pots found at Laguna may well have been traded from Acoma.

A Rio Grande-style red-slipped underbody band at the base of the design field occurs on at least two examples of Laguna pottery. These pots may have been made by Rio Grande migrants to the pueblo or by Lagunas imitating a Rio Grande style. The basal slip used on Acomita Polychrome at Laguna does show some characteristic idiosyncrasies: on some Laguna examples, the concave bottom portion of the jar is left unslipped or is very thinly washed with slip. On many jars, the base is simply floated (polished without a slip) and often shows stone marks.

Floating brings up fine clay particles and seals the surface with a "skin" that can look like an applied slip. When polished, the raw paste will change in texture and sometimes color. Because they reflect light rather than absorb it, polished surfaces appear "harder." The sealed surface also stains easily (from contact with skin oils or other discoloring substances). On many Acomita Polychrome vessels, white slip is applied on the interior rim or neck surface, and most often the bowls are slipped white on the interior surface as well.

The Indian Arts Research Center (IARC) houses a fine collection of large bowls dating from around 1800 to 1900. The Acomita Polychrome pieces are particularly interesting, displaying a thick and sometimes casual modeling that gives them an organic quality, further enhanced by the use of simple designs limited to a narrow band around the bowl's exterior. Interior designs and red slips are rare, and all the bowls in the IARC collection show the deep patina of long use, most likely from the penetration of lard used in bread dough preparation.

Designs on bowls closely resemble those on jars, but they usually are simpler and rarely utilize a red slip. The same scallop or arc motifs are occasionally repeated at the bottom of the design band on the bowls, the bases of which are sometimes slipped red. Many bowls and jars have been floated or polished, without the addition of a slip; with age, they take on a patina that suggests a slip.

Toward the end of the Acomita phase at both Acoma and Laguna, thinness returns to pottery construction, along with a more graceful

profile from the base of the jar to its rim and a greater effort to cover the entire design field with design. With these developments, Acomita Polychrome gives way to Acoma Polychrome and all its variations, which persist into the modern period.

The Nineteenth Century

In 1821, Mexico won her independence from Spain and inherited dominion over the territory known as Nuevo México. The Mexican administration had little effect on the geographically remote Acomas and Lagunas: some of the old Spanish laws were changed, but otherwise life went on according to age-old patterns and the native peoples continued to live off the produce of the land (Minge 1976:42).

A predominant concern for Hispanics and Indians alike during the Mexican period was the threat of Navajo raiding for slaves, crops, and livestock. The Navajos harassed all the pueblos, but because of their location, Acoma and Laguna were particularly plagued (Hordes 1986:17), and both pueblos contributed men to serve as auxiliaries with Mexican soldiers in fighting the raiders (Minge 1976:49–51).

Mexican rule ended in 1846, when the United States annexed the territory of New Mexico. That year, one recently arrived American, Lieutenant James William Abert of the United States Army Corps of Topographical Engineers, observed that the Acomas appeared to have remained very pure in their ways and showed little or no Spanish influence—in fact, only one or two Acomas spoke the Spanish language (Minge 1976:52).

With the arrival of the Americans, however, change overtook the pueblos at an ever-increasing pace, and the isolation that the Acomas and Lagunas had enjoyed eroded rapidly. Traders, government agents, and more missionaries arrived, and with the arrival of the railroad in 1880 (Robertson 1986:177), Acoma and Laguna were thrust squarely into Anglo-dominated territorial life (Hordes 1986:18).

Population surveys at Acoma and Laguna indicate that groups of immigrants from the Rio Grande pueblos continued to arrive even after United States annexation of the territory. American settlers, as well,

made their way to the Acoma-Laguna area in the 1850s, and the establishment of Fort Wingate between Gallup and Grants in 1862 led to considerable Indian migration within the western pueblo region (Hordes 1986:17–18).

American government reports of the nineteenth century, like those of the Spanish before them, unfortunately make little reference to Pueblo pottery, so our knowledge of pottery making of the time is derived from the study of public and private collections and from the spoken recollections of contemporary potters. Although their materials remained the same, potters during the first half of the nineteenth century showed demonstrably less control in construction than during the previous two centuries, and the pottery was thicker and at times more casual in construction than earlier wares. This period stands out as a marked exception in the evolution of Acoma and Laguna pottery, which characteristically tends to be fine, thin, and elegantly formed.

In the mid-1800s, during the shift from Acomita Polychrome to Acoma and Laguna Polychrome, thinner, more careful construction is common, perhaps showing that pottery was no longer made hastily for export (Ross Frank, personal communication, 1991).

The specific cause of this decline in Acoma and Laguna potters' skills and techniques is not clear. Some fine pottery was made during this period, though technically it is not as daring as previous types. Still, the apparent casualness in construction lends an aesthetic warmth that is frequently absent in later pottery. In any event, the pottery of the last part of the eighteenth and first half of the nineteenth century can be regarded as anomalous within the Acoma-Laguna sequence.

Nineteenth-Century Designs

The introduction of new designs into a traditional art form is a complex mix of individual innovation, borrowing, and gradual evolution. If an individual potter invents or incorporates a new design, its sudden first appearance may appear to be an aberration, but if it is accepted and imitated it becomes absorbed into the cultural vocabulary and evolves into a form that will, in time, be identified as "traditional."

During the 1800s, designs at Acoma and Laguna became bolder, reflecting increased trade influences and closer connections with the Puname pueblos of Santa Ana and Zia. By the mid-1800s, Pueblo pottery designs showed strong outside influences, both Indian and Anglo, most likely spread to the western pueblos from the Rio Grande villages. Spanish and Mexican goods continued to enter New Mexico, but as had been true since the Spanish Conquest, pottery was rarely imported, and Pueblo ceramics continued to serve the colonists' needs. At the same time, the Pueblo potter's repertoire was enriched by the arrival of a vast array of new designs on pottery, cloth, and other items that came to the frontier via the trade routes from the south and east.

Among the designs that appear around the mid-1800s is the Acoma parrot, now strongly identified with the pottery of Acoma and Laguna. The motif appears suddenly (the earliest example I know of dates to about 1850 to 1860), with no evidence of an evolution from preexisting designs. Potters had used bird motifs prior to the mid-1800s, but this sudden arrival of an entirely new bird form, accompanied by novel floral motifs and design layouts, suggests external influences. With probable increased trade from the east via the Santa Fe Trail after the annexation of New Mexico by the United States, eastern folk arts must have made their way to New Mexican colonists and then to the native population. The introduction of the Acoma parrot may coincide with this eastern trade after Mexican independence (Ross Frank, personal communication, 1991). The parrot motif may have been borrowed from Pennsylvania Dutch designs, Spanish colcha embroidery, or both, as were various floral motifs.

Some of the trade cloth arriving in New Mexico early in the 1800s, including the popular cotton chintz fabrics from India, may have been carried on the Manila galleons that operated between the Philippines and Acapulco from 1565 to 1815 and then traded from Mexico to Spain's northern territories in the New World. It is remarkable that individual potters working at these remote pueblos gained access to designs from places as distant as the Orient. The connection between these imported motifs and Pueblo bird and floral motifs was brought to my attention by Lawrence E. Dawson of the Lowie Museum of Anthropology at the University of California, Berkeley. The curious mix

of designs that characterizes the original chintz fabrics had a strong influence on Mexican and Spanish New Mexican folk arts.

Another authority speculates that Spanish women on the New Mexican frontier began copying designs from imported chintzes for their colcha embroidery in the early 1800s (Fisher 1979:161–62), designs that were also employed in Spanish New Mexican weaving, woodworking, and leather work (fig. 6.7). Gradually, the Pueblo Indians began to use the Spanish embroidery designs and other folk art motifs in their pottery. It is also possible that Indian servants in Spanish homes, who had direct access to the imported designs, took them to the pueblos.

Other motifs that appear to derive from colcha embroidery include a curious "bow-tie" design, an organic floral form, the floating C element, and a paddle-like motif. These designs are noted on Acoma pottery from the mid- to late 1800s. The new motifs were used in combination with traditional designs already in place, including the split-leaf pattern, split rectangles, triangles, ellipses, arcs, parallelograms, and various combinations of these.

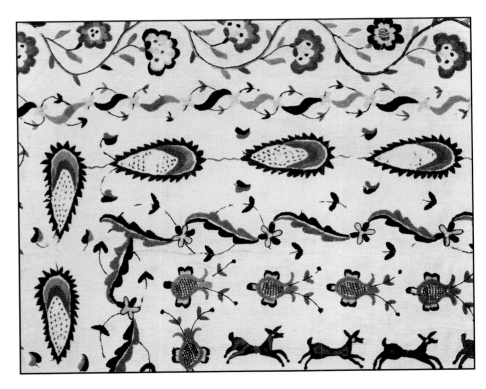

Figure 6.7. Detail of wool-on-cotton New Mexico colcha embroidery, ca. 1850–65, showing deer, flower, leaf, paddle, and undulating vine elements similar to those found on Acoma and Laguna pottery.

The "tree of life" design, in which a branching vine produces a myriad of flowers and berries and hosts an assortment of birds and animals, is another popular motif taken from the imported chintzes that appears clearly in Acoma, Laguna, and Zia pottery. The undulating single or double band on the pottery from these pueblos may also have been inspired by the sinuous branches bordering many imported fabrics, in combination with the traditional path line.

Although it is clear that many things are independently invented by different cultures—as is the case with canteen, pitcher, and mug forms in the Southwest—in order to explain the quite rapid development of a new design system during a period of intensified and expanded trade networks, it is useful to look outside the existing Native American design repertoire. A possible source of some of the new Acoma designs is Pennsylvania Dutch culture. Many of the design motifs mentioned above are staple elements in the iconography of the German (Deutsch) immigrants known as the Pennsylvania Dutch. Bird and floral designs were used on painted furniture, illuminated manuscripts (called *Fraktur* writings) (fig. 6.8), slipware and sgraffito pottery (fig. 6.9), and other

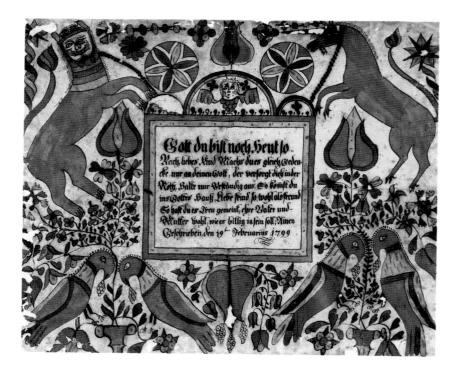

Figure 6.8. Pennsylvania Dutch Fraktur. *Anonymous religious text, 1799, probably from Northumberland County, Pennsylvania. Hand-drawn, lettered, and colored on woven paper, this drawing has a multitude of elements that can also be seen on pottery at Acoma and Laguna: animals in flat style, birds, berries, and distinctive floral motifs.*

household items. From their European homeland, these motifs were "transplanted to colonial Pennsylvania, adapted and rejuvenated in typical American fashion" (Shelley 1961:2).

The Pennsylvania Dutch designs most likely made their way first to colonial New Mexico and then to the Pueblo potters. The similarities between the specific design elements are too close to be coincidental, though the motifs have been adapted and reworked to suit Pueblo tastes. The rich Pennsylvania folk art decorative style was based on standard flower, bird, and animal forms, which were altered by the artists to reflect their daily surroundings (Shelley 1961:82–83)—much as the Pueblo potter altered and adapted the designs. The Acoma parrot, in particular, has parallels both in design and in reality with its use in Pennsylvania Dutch folk art (fig. 6.10). As Shelley points out, the "fantastic" and unrealistic birds of the Pennsylvania Dutch were "removed from reality" and impossible to associate with actual species (Shelley 1961:84). Although the Carolina parakeet, with its curved beak and brilliantly colored plumage, did range up to Pennsylvania and could have served as a model, the Pennsylvania Dutch parrot seems to be no more representative of an actual bird in the immediate environment of the artist than is the Acoma parrot.

Another nineteenth-century design source brought to New Mexico over the Santa Fe Trail was crewelwork from the East Coast. These elaborately stitched designs also employed patterns inspired by Indian chintz. There is a suggestion of crewel influences in an embroidered cloth made for a New Mexican family chapel about 1865 by José Delores Durán at Llano de Santa Barbara, east of Peñasco, New Mexico. As Nora Fisher notes: "The floral borders, the flowers themselves, the sinuous and continuous curve throughout the full length of the embroidery, and the stylized birds and insects—all of these elements serve to illustrate the relationship of the wool-on-cotton *colcha* embroideries to eastern American crewelwork" (Fisher 1979:163). These floral and faunal elements are also typical of Acoma, Laguna, and Zia pottery of the time.

Deer, in particular, are prominent on American crewelwork (Fisher 1979:163–64), and the semirealistic deer motif became very popular on Zia pottery in the mid- to late 1800s, and to a lesser extent on the pottery of Acoma and Laguna. Zia potters may have adopted the new

Figure 6.9. Molded Pennsylvania Dutch redware plate, ca. 1808, attributed to Andrew Headman. The bird on this sgraffito plate is surrounded by branches with various flowers, much like the treatment of this motif on Acoma and Laguna pottery.

Figure 6.10. Pennsylvania Dutch bookmark, anonymous artist, southeastern Pennsylvania, ca. 1830. Hand-drawn and colored on woven paper, the elements of this bird motif parallel those of the Acoma parrot: delineated head, curved beak, separate wing, and fan tail.

design elements first because they lived closer to Spanish settlements, and the designs may have then migrated west to Acoma and Laguna. Curiously, the colcha-inspired designs do not appear at Zuni Pueblo.

Lawrence Dawson states:

> It is not yet possible to say whether the several pueblos independently took up the flowers, birds and deer, or a single pueblo started the trend and was copied by the others. There is some evidence for the latter interpretation from an examination of existing pottery: early Zia pots have designs much closer to European textile examples than do the pots of the other pueblos, which also lack the variety seen on Zia vessels. (Dawson 1980:3)

The avenues through which new designs migrated to New Mexico appear almost numberless. For example, designs appear on Acoma, Laguna, and Zia ceramics of the late 1800s that are almost identical to a type of Majolica pottery unearthed in Mexico City, called La Traza Polychrome, which exhibits designs found on trade cloth and other motifs that are clearly inspired by Spanish and Italian sources (Lister and Lister 1982:21). Forms of jars and bowls of Mexican origin probably had their impact on the Pueblo potter as well, among them Mexican jars with high rounded shoulders and short vertical necks that may have influenced Acomita Polychrome (Batkin 1987:27).

From Jars and Bowls to Trinkets

After 1860, transitional and "eccentric" pieces are common, and many unite a wide diversity of styles. Potters created ceramics with thinner walls, in many cases having taller, more gracefully sloping necks. Other pieces hark back to earlier types, with short necks or incurving rims. Generally, the vessels have few structural flexures. Various shades of orange and red are used in the designs, which display the distinctive new bird and floral motifs. Exquisitely drawn geometric patterns, some mixed with floral elements, cover entire jars without attention to structural features. Imported and indigenous designs blend to create a unique statement in Pueblo pottery.

Between 1860 and 1870, potters introduced a painting style I call the "bar" type, which features heavy geometric designs painted in bold black bars, along with other simple geometric shapes (figs. 6.11, 6.12). The jars are very dark in appearance, due to the heavy application of black paint, and white lines running among the black elements create a strong graphic statement. Many of these pieces have clear puki marks and shoulder flexures, a structural throwback to earlier types. I know of no bowls decorated in this style, which was very short-lived and may have been produced by only a few individual potters at Acoma.

The graceful, tall-necked jars that originated during this transitional period continue to be made today, as do jars painted with allover decoration. Some designs in the early Acoma Polychrome period are very similar to, if not direct copies of, designs done at Zia, and vice versa. The Zia-style and bar designs are two new styles that appeared during this period. Clearly, potters were incorporating new ideas, and the pottery is remarkable both technically and aesthetically.

Interchange among pueblos continued during this period, as it does today, in part as a result of various interpueblo migrations during the late nineteenth century, including movements of Rio Grande peoples. But the interchange has deeper, social-structural roots as well, since

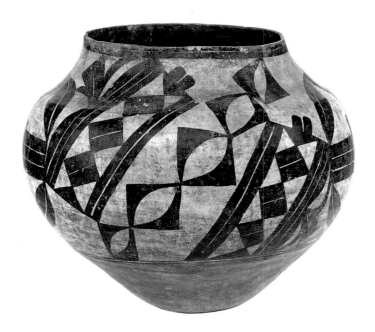

Figure 6.11. Acoma Polychrome, ca. 1870–80. The potter has not attempted to tailor the allover bar-style design of dark split rectangles, triangles, and arcs to the structural features of this fine jar. IAF 2720. 11 1/4" x 13 5/8".

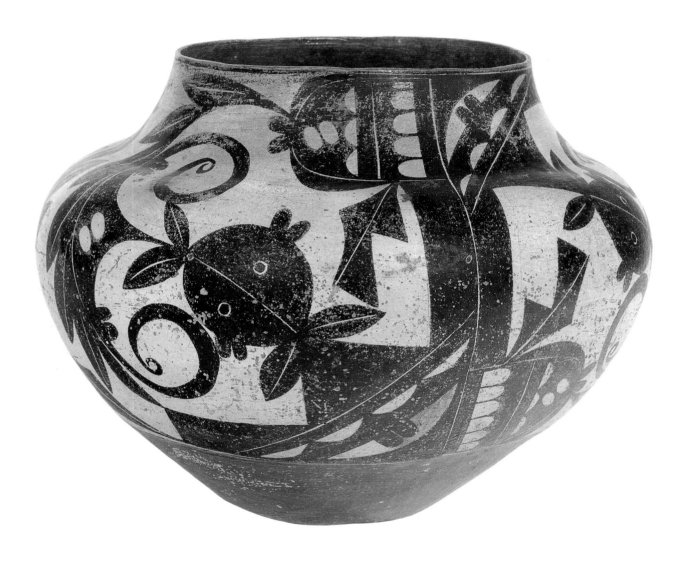

Figure 6.12. Acoma Polychrome, ca. 1875. A variation on the bar style, the heavy black painting on this pot utilizes open ellipses, "eyes," scrolls, and split-leaf patterns. Split circles with attached double dots take on the appearance of a face. IAF 227. 10" x 13".

"tribes" among the pueblos are not clearly defined, and many intertribal or pantribal connections exist in the form of clans, medicine, religion, and so on.

There are so many variations in form and design of bowls and jars during the late nineteenth century that the exception becomes the rule. Form, in particular, followed a burgeoning array of new functions, as potters responded to changing economic demands with a range of experiments that showed tremendous versatility. Fine water jars of great technical and artistic merit were made alongside simple tourist pots, as increased participation in a cash economy led to the creation of non-functional pottery for buyers from outside the pueblo.

Tourist pieces were less labor intensive than the traditional function-al pots, and many potters may have welcomed the opportunity to make them. Tourist pottery was an outlet through which beginners could sell their work, and it allowed experienced potters to earn cash and embark on productive careers.

Animal and bird figurines experienced a short-lived commercial pop-ularity at this time, and many of the Acoma and Laguna figurines are very similar to those from Zuni. These ceramic deer, antelope, owls (especially popular at Zuni), and other bird forms may have been made for ceremonial purposes earlier in Pueblo history, but in the nineteenth century they made their way into the tourist market (figs. 6.13, 6.14). The figurines are modeled in semirealistic fashion on white-slipped bases; some are slipped in two shades of orange and decorated with black mineral paint. Designs are similar to those used on pottery, though many of the animal forms include large open areas slipped in bold colors.

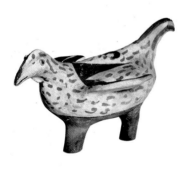

Figure 6.13. Laguna Polychrome bird effigy, ca. 1880–1900. Bird figures were also made at Zuni and Acoma. This one is thickly constructed, with a chalky red slip in the design. 4 ½" (h) x 7 ½" (l) x 4 ½" (w).

The Smithsonian Institution's collection of historic Pueblo pottery includes an unusual group of Acoma ceramics made ca. 1870 to 1875. The style of these pieces is clearly copied from eighteenth-century pot-tery, but these "archaics" are all in excellent condition and appear to be unused. It is not uncommon for Pueblo potters to make pots in historic or prehistoric styles, and many examples of this tendency are noted at Acoma and Zuni. One Acoma jar in the Smithsonian collection, made around 1875 (fig. 6.15), is a close copy of the "authentic" ca. 1750 Ako Polychrome jar illustrating the cover of Frank Harlow's book on matte-paint pottery (Harlow 1973).

Figure 6.14. Acoma Polychrome (four color), ca. 1880–1900. Rounded bird effigy with modeled tail and painted detailing. The painted wings have open D-shaped elements lined with dots. IAF 1056. 7" x 7 1/2".

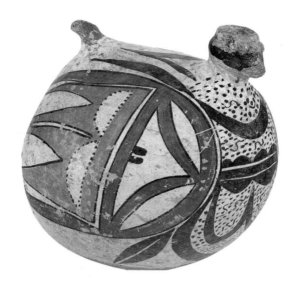

One possible reason for the enormous variety and high number of eccentric pieces in the pottery of the late 1800s may be the depletion of the "pottery library" at the pueblos (see also Batkin 1987:30). As institutions such as the Smithsonian began to buy up the finest examples of old pottery, many of the potters' best models of form and design were removed. Potters had to rely on memory, odd bits of pottery remaining at the pueblo, models from other pueblos, or innovation and imagination.

Laguna pottery itself bears the stamp of the pueblo's many contacts with other groups. The settlement in Laguna of many refugees from other pueblos during the late seventeenth century began the acculturation process, which continued in the later 1800s as large numbers of outsiders arrived. Apparently, the Lagunas were very open to these settlers, for the pueblo became a unique mixture of Indians, Hispanics, and Anglos—a sort of southwestern melting pot. By 1870, 1,856 non-Indians occupied areas surrounding the Laguna and Acoma reservations, compared with 644 in 1860 (Hordes 1986:18). During the 1870s, non-Indians continued to move onto Laguna land, and their arrival drastically changed the earlier way of life.

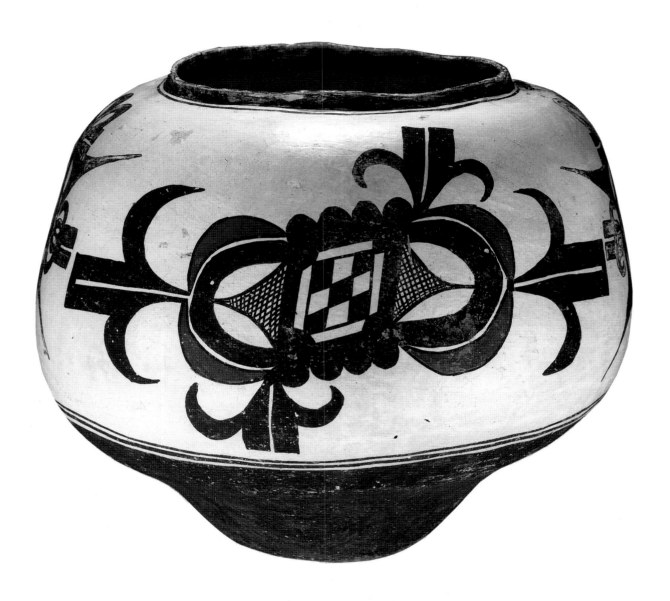

Figure 6.15. Acoma Polychrome, ca. 1875. This jar appears to be a later version of an Ako Polychrome piece, ca. 1750, which illustrates the cover of Francis Harlow's Matte-Paint Pottery *book (1973). 10 ½" x 12 ½".*

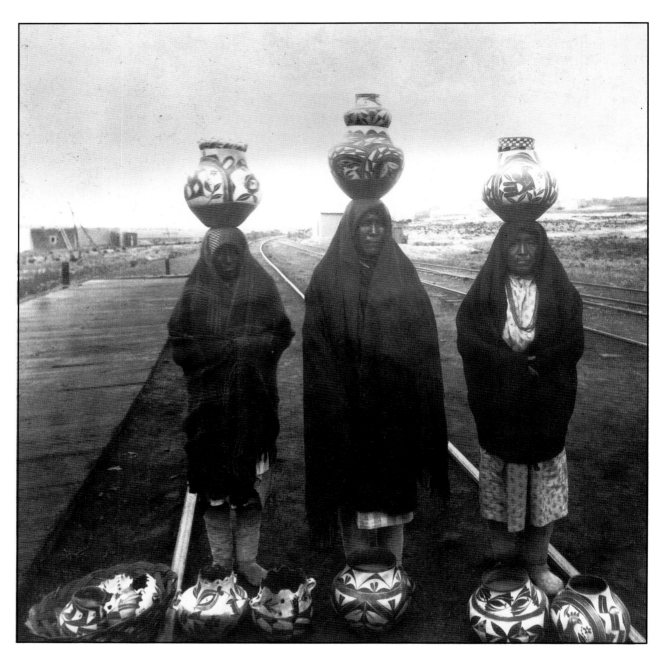

Figure 7.1. Laguna Pueblo women with ollas at the train stop, Laguna, New Mexico, ca. 1890. Large traditional water jars are offered for sale alongside more tourist-oriented wares. Photograph by F. H. Maude.

Trade and Tourism in Modern Times

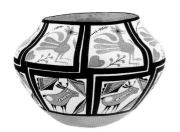

The first entrepreneurs to look at Pueblo crafts as items for the cash market were the American traders who set up shop in New Mexico in the mid-1800s. Previously, the Acoma and Laguna peoples had bartered their wares to the Spaniards and Mexicans—and this continued to be a viable part of their economy—but now pottery could also be sold for cash. The expanded system of outlets set up by the traders introduced the workings of a money-based economy, and the railroad stops at Laguna and at McCartys on the Acoma reservation became another important market for pottery and other crafts (fig. 7.1).

Traders to Acoma and Laguna potters never achieved the degree of control Thomas Keams had over Hopi pottery or traders to the Navajos had in the late 1800s over weavers, to whom they dictated not only styles and designs, but even the materials to be used. The earth, not the trader, supplied the potter with her essential materials, and traders concentrated on selecting, buying, and selling the Indians' wares rather than trying to influence directly their manufacture and design. Traders in Navajo weavings also took a more energetic role in marketing, and some prepared extensive catalogs of rugs for buyers on the East Coast. Pottery traders apparently assumed a less active approach, ordering items by quantity and size rather than specific design.

The difficulty of transporting the fragile Pueblo ceramics undoubtedly was a limiting factor in the nineteenth-century pottery trade. By comparison, rugs and blankets were easy to ship nationwide, giving traders an incentive to develop and exploit that commerce to the fullest. Even twentieth-century traders are influenced by these considerations. Neva Summer, the sister-in-law of trader Phil Bibo, nephew of the prominent nineteenth-century trader to the Acomas, remembers the old Bibo family trading post near Acomita (an enterprise that was sold to the Acoma tribe in 1983). Rather than commissioning pots by shape and design, she recalls, the Bibos took what was brought to them and preferred to resell the pottery to other traders who would manage the shipping (Neva Summer, personal communication, 1988).

A better understanding of the interactions between Anglo traders and the Indians of Acoma and Laguna comes from examining the activities of two prominent trading families: the Bibos at Acoma and the Marmons at Laguna. These families offered the potters an outlet for their work and a source of income, and they were the only local suppliers of necessary goods to the potters and their families. The traders would then take on the role of provider and could personally attach themselves to the people of the pueblos.

The Marmons and Bibos became integrated into Pueblo society, marrying Pueblo women, serving as pueblo governors, and in the case of the Marmons, introducing a constitution and voting procedures to Laguna Pueblo (Ellis 1979b:446–47). Their participation in village life was part of the complex interaction between the Anglo and Pueblo cultures that had a profound impact on the pueblos' economy and society.

Laguna, in particular, felt the traders' influence. The Marmons were devout Protestants with an intense desire to remove all aspects of Laguna's native religion, and their proselytizing efforts helped generate the religious split that divided the Lagunas into two factions: conservatives, who opposed the Marmons and their ideas, and progressives, who supported them. The conservative faction finally left the pueblo, first establishing residence in the satellite village of Mesita. The migrants later headed east toward Sandia, but en route were persuaded to stay at Isleta Pueblo, south of Albuquerque, where they settled in 1879 (Parsons 1928:602). A side effect of this split was the export of the Laguna pottery style to Isleta.

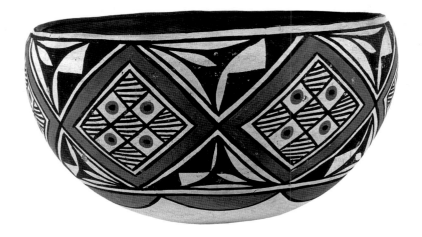

Figure 7.2. Isleta Polychrome food bowl, ca. 1900–1920. Made by Emily Lente. The Laguna potters and their descendants who migrated to Isleta continued the Laguna polychrome tradition. This Isleta example uses a sandy buff clay; the white and chalky red slips were probably brought from Laguna. IAF 279. 6" x 8 ½".

Until this time, Isleta pottery had been plain, sand-tempered, red and brown ware. After the arrival of the Laguna migrants—who also introduced Laguna rituals to Isleta—the polychrome style typical of Laguna and Acoma was adopted, and a new style and type, Isleta Polychrome, evolved (fig. 7.2). In this pottery, a white slip served as background for a red sandy slip and brown-black mineral paint designs. The paste used was sand tempered and buff in color. The Isleta potters, as of Parson's writing in 1928 and up to the waning of the style in the 1940s (Ellis 1979b:448), continued to buy their paints from the Lagunas, who obtained the white and red slips from locations near old Laguna and the black mineral paint from the Rio Puerco (Parsons 1928:604–5).

Most Laguna-style pottery produced at Isleta during this period was geared to the tourist market. Many eccentric forms were made, including bird effigies and baskets with twisted handles. Since utilitarian pottery from Isleta was traditionally undecorated, potters there had no repertoire of designs on which to build, making it easier to adapt to Laguna-style pottery manufacture and design.

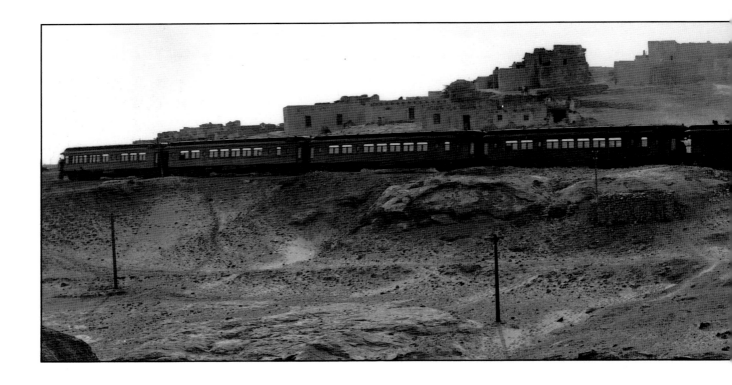

The Beginnings of the Tourist Market

Figure 7.3. The California Limited passing through Laguna Pueblo, ca. 1900. Photograph by William Henry Jackson.

The Anglo influx catapulted Pueblo culture into new and strange realms, and with the change came drastic alterations in pottery and the reasons for making it. Once the potters began to shift from pottery production for home use and barter to production for cash sales, they entered the era of the tourist curio market—their first step toward today's highly sophisticated Indian art market.

In the 1880s the transcontinental railroad brought the tourist market directly to Laguna's doorstep (fig. 7.3). The "kitschy" ceramic forms noted from the railroad period of tourism (ca. 1880 to 1920) consist mainly of small ceramics, easily transported by travelers. Many are quite elaborate and appear to mimic American and European decorative glasswares and pottery.

Examples of construction taken from imported glasswares are fluted rims of jars and bowls that appear in Acoma and Laguna pottery of the period (these can be seen in fig. 7.1), and the circular "feet" attached to

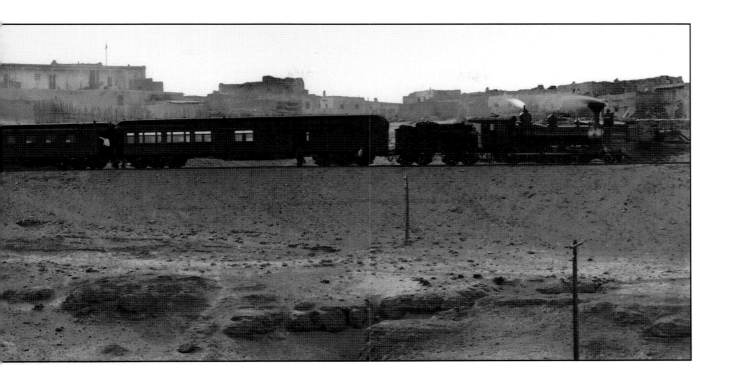

the bases of bowls and pitchers. These vessels and trinkets of Anglo inspiration were painted with native designs. Overall quality waned, and in most of the pueblos pottery technique hit a low ebb by the 1920s and 1930s. Efforts to "revive" native pottery were undertaken mainly by Anglo-Americans concerned about the degeneration of traditional crafts.

Although potters were kept busy meeting tourist demand, they continued to produce many fine large water vessels after the arrival of the railroad. Some of these jars were certainly for home use, but others were sold at the railroad stops. A balance of finely crafted work and tourist objects was maintained into the early part of the twentieth century, when the tourist wares began to overshadow functional pottery and the art market became a major influence on pottery production.

After the turn of the century, when porcelain dishes and metal cookware had become increasingly popular in the pueblos, traditional pottery was no longer needed for many everyday functions. The potter's craft might have died out entirely had it not been for the growing numbers of tourists traveling through the Southwest by rail and automobile. A

fascination with the Indian way of life and the mystique of the Wild West translated into the desire to own an "authentic" piece of Indian craftsmanship. Tourism was a significant contributor to the perpetuation of the art of Acoma and Laguna pottery, even though the objects purchased by the tourists were often of inferior quality. It was in part the experience gained in selling their ceramics in the early tourist market that enabled potters from Acoma and Laguna to participate successfully in the Indian art market that was to develop later in the century.

Potters felt free to try out new ideas on the tourists that they might not have experimented with otherwise. Some of these experiments were more successful than others, of course, as Indian craftswomen strove to make what the tourists seemed to want to buy. Potters frequently copied Victorian ceramic forms—pitchers, vases, dishes—and made them "exotic" by adding native designs.

The fact that the non-Indian visitors were generally looking for easily transported souvenirs affected the scale of tourist wares, and potters began to create miniature forms. Though the prices charged were very modest, usually well under a dollar per item, the extra money earned by the potters was important to the economy of the pueblo.

Inevitably, the role of both potter and pottery was transformed with the advent of tourism. For some potters, their work became simply a job, a source of income. For others, a sense of the age-old significance and spiritual dimension of pottery making was retained. As the twentieth century progressed, this rift between the commercial craftsperson and the traditional artist grew, with results that have been both liberating and problematic for producers, collectors, and students of Pueblo pottery.

1900 to 1920

From the arrival of the railroad in 1880 through about 1920, large jars and bowls were produced for home use and the tourist trade. Elaborate and skillfully crafted items such as wedding vases decorated in bird and floral motifs were made, along with more casual pottery baskets and small dishes. Many of the large ollas from this period that are preserved

in museums and private collections show no signs of wear associated with functional use—neither chipped rims nor the exfoliated slips and paints caused by the clay's absorption of water. The condition of these jars suggests they were made solely for sale outside the pueblo.

Consumer demand drastically affected the forms of pottery made at Acoma and Laguna, expanding the potters' repertoire (figs. 7.4, 7.5). At the same time, it brought about an overall decline in quality and a standardization of styles and designs. Nonutilitarian knickknacks—trinkets, basket forms, ashtrays, and miniatures—appealed to the tourist trade, and designs became less inspired, simpler, and more repetitious. By the 1920s, elaborate, multicolored polychromes had given way for the most part to more common three-color polychromes. Many pieces have a washy orange slip and a profusion of bird motifs in various styles; at Laguna, simple allover checkerboard designs were also common.

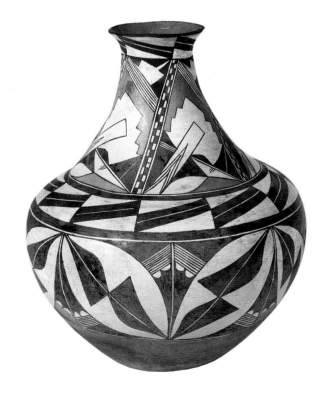

Figure 7.4. Acoma Polychrome vase, ca. 1900–1920. To make their wares appeal to tourists, potters adopted many introduced forms such as this tall-necked vase. IAF 3010. 13 ¾" x 11".

Figure 7.5. Acoma Polychrome bowl, ca. 1900–1920. This flat-bottomed, vertical-walled "cake-pan" form suggests an external influence, though vertical-walled ceremonial vessels do exist. IAF 1063. 3 ½" x 11".

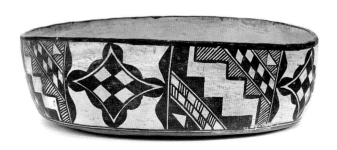

Smaller ceramic items were often virtually mass-produced, probably at the behest of Indian traders, who might order dozens of them to market wholesale. Such orders were good for the potter's income, but the repetition must have become tedious, and a more casual product resulted. Bulk orders also standardized and depersonalized pottery making, preventing the potter from indulging her individual tastes and largely destroying the spiritual element that was inherent in traditional pottery making. This remains a dilemma for many potters, who try to retain a sense of the spiritual nature of the work while they produce a commodity for the cash economy.

Traders bought this pottery in bulk according to size specifications. A letter from Lem A. Towers, superintendent of the Southern Pueblos Agency in Albuquerque, to Mrs. Marion S. Norton of Germantown, Pennsylvania, dated July 18, 1932, typifies these standard classifications. Towers wrote:

> I am listing below the names of some of the Indians of this jurisdiction who make the best type of Acoma pottery, and also the size in which they specialize:
>
> | Small | 6 to 8 inches |
> | Medium | 8 to 10 " |
> | Large | 10 to 12 " |
> | Extra Large | 12 to 18 " |
>
> | Mrs. Torivio Haskaya | Small |
> | Mrs. Marie Aragon | Medium |
> | Mrs. Luciano Chavez | Large |
> | Mrs. Andres D. Vallo | Extra Large |
> | Mrs. Santiago Vallo | Small, Medium and Large |
> | Mrs. Juan E. Garcia | Large |
> | Mrs. Jose A. Sandoval | Large |
> | Mrs. Nicolas Lucardio | Medium |

"All these Indians," Tower went on to say, "can be reached at Acomita, New Mexico" (Archives of the Pueblo Cultural Center, Albuquerque, New Mexico). Mrs. Torivio Haskaya, incidentally, is Lucy M. Lewis.

Along with the standardization of sizes and styles, the inception of the tourist market stimulated the introduction of new designs at Acoma and Laguna. Around the turn of the century, potters sometimes began

to crowd a great deal of decoration onto the pot's surface, so that the white background no longer predominated. Hatching became popular as filler. After about 1910, the Acomas and Lagunas developed a motif—perhaps inspired by the Hapsburg double-headed eagle—that became the popular design known today as the "thunderbird" (fig. 7.6).

The latter-day appearance of this motif is curious, since the double-headed eagle had been present in Hispanic New Mexico on locally made and imported items since the early days of Spanish presence. Members of one family of Acoma potters, the Lewises, have said that the design is a form of the rainbird motif, uninfluenced by European models. In any event, the figure has been used on all types of Acoma and Laguna pottery, from small dishes to large storage jars, and has become a trademark motif.

Figure 7.6. Acoma Polychrome jar, ca. 1920. Water-jar form with elaborate double-headed thunderbird with large wings composed of geometric elements. IAF 1368. 8 ½" x 11".

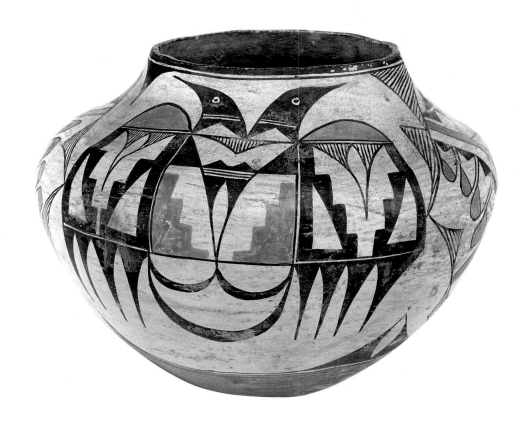

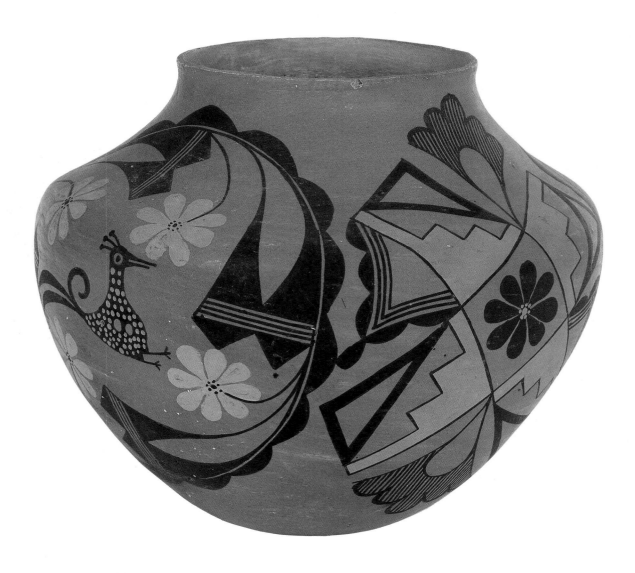

Figure 7.7. Acoma Polychrome variant jar, 1931. Made by Mary Histia.
A revival of earlier allover red-slipped pottery, this jar has a design that includes
two large medallions with bird and floral motifs and geometric fill elements. The
white spots painted on the bird have been common at Laguna and Isleta since
the advent of the tourist period. IAF 2104. 8 ½" x 10 ¼".

Anglo encouragement of traditional crafts at Acoma and Laguna occurred only sporadically during the first two decades of the century. One of Acoma's great potters, Mary Histia (1881–1973), did much of her work in traditional Acoma style prior to the significant Anglo-inspired revival efforts of the 1920s and later (fig. 7.7). Once the revival styles became popular, Histia adopted them as well, and her descendants continue to make pottery in these styles today.

In the early decades of the twentieth century, Laguna pottery making almost died out. Francis Harlow says that "the manufacture of pottery at Laguna Pueblo came nearly to an end in the early 1900s" (Harlow 1977:81). The first railroad track was laid right through Laguna, and many Lagunas became employees of the railroad. Entire families moved off the reservation as a result of this employment, and towns along the railroad line such as Winslow, Arizona, and Richmond, California, became satellite Laguna communities. The people of Laguna thus had less reason than their neighbors to rely on tourist sales of native crafts, though the original train station offered potters a built-in market. Laguna became an increasingly acculturated commercial center, and Acoma pottery was traded to Laguna in return for commercial products. Primarily Acoma wares were sold at the station to the visiting tourists.

In 1910, in an effort to promote the manufacture of marketable pottery at Laguna, Josephine Foard, an Anglo potter from the East, built a kiln and introduced commercial glazes to enable the Lagunas to make tiles. There was some effort made to combine local pigments with commercial glazes, but the latter consumed and absorbed the traditional pigments. Eventually, the tiles had to be made using commercial pigments exclusively (fig. 7.8). Even so, the enterprise was largely unsuccessful (Toulouse 1977:43).

Figure 7.8. Laguna commercial-ware tile, ca. 1910–30. Yamie Leeds, potter. Greenish decoration and yellow commercial glaze on commercially prepared tile blank, produced as a result of Josephine Foard's efforts to revive Laguna pottery. IAF 1457. 6" x 6".

1920 to 1950

After World War I, the railroad relocated its line north of Old Laguna, and the station in the village itself was closed (Gill 1976:110). In the 1930s, Route 66 was built along the path of the old railroad, offering potters a place to set up stands to sell pottery (figs. 7.9, 7.10, 7.11). But

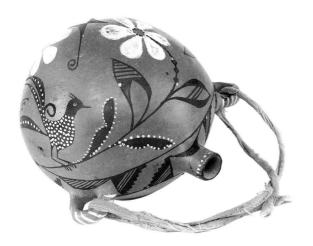

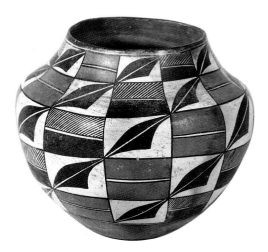

Figure 7.9. Acoma Polychrome, red-slipped variety, canteen, ca. 1930. This modern canteen by Delores Ascension (signature penciled on base) has prominent black and white bird and floral motifs. A band of geometric design encircles the piece, including the handles and spout. IAF 1428. 6 ½" (h) x 9" (l) x 7" (w).

Figure 7.10. Acoma Polychrome jar, ca. 1920–40. Tourist water jar in an overall checkerboard pattern with split solid and hatched squares and split arcs and triangles in alternating squares. IAF 1074. 11" x 12".

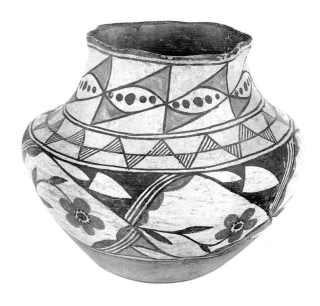

Figure 7.11. Laguna Polychrome jar, ca. 1900–1920. This tourist vessel has a fluted rim, most likely introduced from imported wares. The simple floral motifs, common on tourist pottery, almost float in the large expanse of white slip. IAF 1109. 7 ½" x 9".

after World War II the road too was moved, making it difficult for potters to find a ready market (Gill 1976:110). In 1929, Ruth Bunzel wrote about Laguna pottery:

> Here we have a dying art, now uttering its last feeble gasps. It has succumbed to commercialism, complicated by the removal of the market when the Santa Fe railroad removed its tracks and built a new station three miles from the pueblo. The women are all hopeless about the state of their art. They would say, "We don't make good pottery here any longer. Why don't you go to Acoma? When we want pottery, we buy it from the Acomas." A few women still make small pieces which they peddle on the road, but not only are they inferior in workmanship, but the old style has completely disintegrated, and the products show a wearisome repetition of a few elements without any apparent sense of order or of style. (Bunzel 1929:64)

By this time, the Acomas also had train stations. Acomita, McCartys, and Anzac are all listed as stops on a March 1928 timetable (AT&SF Railway 1928). Potters began to develop identifying marks for their wares, and beginning in the 1920s, a fired-on "Acoma, N.M." or "Laguna, N.M." commonly marked the bottoms of pots (fig. 7.12); only later were personal signatures added.

But not only the tourist trade flourished during this early part of the century: a brisk intertribal trade continued, as it had since prehistoric times. Indeed, the potters of certain pueblos, Acoma among them, increasingly supplied the functional, ceremonial, or decorative pottery needs of pueblos in which the craft was dying out. At Laguna, large vessels were no longer made at all, and Evelyn Cheromiah recalls that the Acomas would bring their big pottery items to Laguna for sale or trade at the traditional dances and feast days. Florence H. Ellis reported, "Laguna women remember Acoma women coming as far north as Paguate [a Laguna village] with their burros laden with large vessels slung from each side of the animal. Laguna people had more commercial goods, cloth, and such things, and were glad to exchange such items for pottery" (Ellis 1974:84).

Figure 7.12. Acoma Polychrome bowl, ca. 1950. A tourist piece with modeled bird heads, this small bowl is typical of the inexpensive souvenirs sold along Route 66. The potter painted "Acoma N.M." on the base prior to firing. IAF 2451. 1" x 4 1/4".

Trading was and is common between the Acomas and Lagunas, and much of the pottery collected in the past at Laguna may actually have been made at Acoma. This pattern of potters from one pueblo creating wares for people at neighboring pueblos can be seen elsewhere: Zia pottery, for example, was traded for crops from the fertile Jemez area, and many of the great Zia jars have been collected at Jemez Pueblo.

Agriculture became gradually less important at the pueblos during the first half of the twentieth century, and the share of income derived from other types of work grew. The importance of agriculture at Acoma and Laguna is closely related to the ongoing struggle to protect pueblo land rights. From the late 1700s on, Acoma in particular has had problems with encroachment upon its lands: first from the raiding Navajos and Apaches, and later from Hispanic and Anglo settlers. The Acomas have also had conflicts with Laguna over their territorial boundaries. These difficulties were amplified by Acoma's need to produce more food to feed a growing population, such that by the late 1800s and early 1900s, the population was overusing the pueblo's agricultural lands (Reynolds 1986:282).

Pottery making and other crafts, then, played a minor but increasingly significant economic role: when other sources fell short, many Indians relied for survival on their arts and crafts sales. Since much of this alternative income came from the work of women, their economic role in the pueblos began to grow. The tendency to use crafts-related earnings to take up the slack increased steadily over time, and by the 1950s and 1960s, arts and crafts emerged as a major source of income.

The Great Depression and drought of the 1930s hit the pueblos hard, affecting agricultural production and prices, and no doubt hurting pottery sales as well. Still, agriculture contributed up to half the cash income at Acoma in 1935 and 1936, while pottery and other craft items, such as silver jewelry and beadwork, contributed only 9 percent (Reynolds 1986:285).

A certain amount of government sponsorship took place in the 1930s, and the work of prominent Acoma potter Mary Histia was distributed to United States embassies and government offices by John Collier of the Indian Arts and Crafts Board (Grammer 1987). Much of Histia's work of this period features realistic bird motifs; a piece now in

the University of New Mexico's Maxwell Museum of Anthropology bears an eagle design and the letters "NRA," for National Recovery Act (fig. 7.13) (Batkin 1987:138). A piece in the Smithsonian Institution, made for President Roosevelt, is decorated with a yellow bird with wings outspread and the words "our President Franklin D. Roosevelt" written in native paints.

Early orange- and red-slipped wares were "revived" in the 1920s and 1930s (fig. 7.14), and occasional (though rare) examples crop up through the present day. In 1928, Kenneth Chapman commissioned a revival-style Hawikuh Black-on-red jar at Acoma made either by Delores Ascension or (according to Marie Z. Chino) Santana Sanchez (fig. 7.15). The original Hawikuh Glaze-on-red piece, also purchased at Acoma in 1928 by Chapman, was the obvious model for the later pot, in both shape and design.

At Laguna, small bowls frequently carried an unpolished red slip on the interior, with checkerboard patterns, scrolls, flowers, and dots as typical decorative elements. An unbordered chalky red slip is also very common and provides a distinguishing element of Laguna wares. (Lagunas

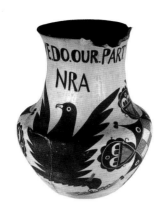

Figure 7.13. Acoma Polychrome jar, ca. 1930. Made by Mary Histia. Painted on the jar before firing is the motto, "We do our part—NRA" (National Recovery Act). 11 ½" x 8 ¾".

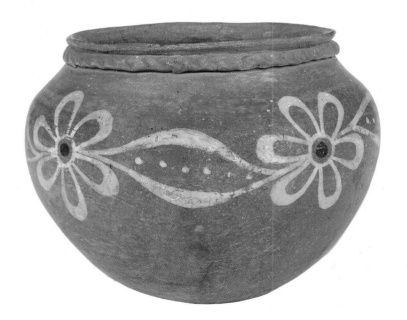

Figure 7.14. Acoma Polychrome variant jar, ca. 1920–50. This utility jar combines several distinct styles, including an indented rim that also appears on Navajo utility pottery, a red slip, and a painted decoration of white and brown floral motifs. IAF 2490. 5 ⅞" x 8 ½".

living at Isleta at the time used the same slip, imported from their home pueblo.)

A major trend from the 1920s through the 1940s was the institution of special events and competitions to encourage the production and sale of high-quality Indian arts and crafts. The Southwest Indian Fair, forerunner of today's Santa Fe Indian Market, was first held during the Santa Fe Fiesta in 1922. Organized by Rose Dougan of Richmond, Indiana, and endorsed by Edgar L. Hewett, director of the Museum of New Mexico and the School of American Research (Toulouse 1977:34–36), the fair offered ribbons and cash prizes. In response to this competition, potters began to use designs that were to become recognized as individual trademarks.

Another important event, the annual Inter-Tribal Indian Ceremonial in Gallup, New Mexico, was inaugurated in September 1922. Intended to offer a "look into the life of the Indian," the ceremonial's original

Figure 7.15. Acoma Black-on-red jar, ca. 1925–28. Made by Delores Ascension or Santana Sanchez, this jar is a copy of IAF 996, a Hawikuh Black-on-red jar (see fig. 2.11). It may have been commissioned for the Indian Arts Fund by Kenneth Chapman. IAF 1031. 10″ x 13 ½″.

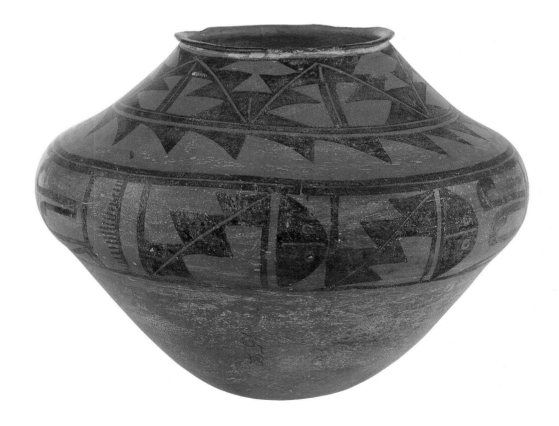

emphasis was on the Navajo culture. It has subsequently expanded to include a fine exhibition of Pueblo pottery, in which many Acoma and Laguna potters take part (Toulouse 1977:49–50). In 1933, the Southwest Indian Fair Committee merged with the New Mexico Association on Indian Affairs to promote and encourage "authentic" arts and crafts. This merger became the Southwestern Association on Indian Affairs (SWAIA), which now sponsors the annual Indian Market in August in Santa Fe (Toulouse 1977:48) and offered a winter market in Santa Fe in 1989.

The New Mexico State Fair, held each fall in Albuquerque, began competitions in Indian arts and crafts in 1938. By 1946, the event offered potters such categories as "decorated bowl under fifty inches in circumference" and "decorated canteen, any size." Prize money at the fair in 1946 included awards of $2.00 for first place, $1.00 for second, and $.75 for third in each ceramic category. These competitions have continued through the present day, with ever-increasing prize monies offered. Each year, many Acoma and some Laguna potters participate, showing both commercial and traditional wares (New Mexico State Fair Offices, premium lists, 1939 and 1946; Edwina Barela, personal communication, 1990).

1950 to 1970

The post–World War II period through the 1960s saw the potters of Acoma move from the realm of cottage industry to the beginnings of a competitive art market dominated by dealers and gallery owners as well as collectors. Three Acoma potters who made particularly important contributions to the art of pottery making during this period were Marie Z. Chino, Jessie Garcia, and Lucy M. Lewis. Lewis and Chino had made pots since the 1920s, and each helped to set a trend that flourished at Acoma during the 1950s: the revival of prehistoric design motifs. All three women became matriarchs of well-known pottery-making families. Although they created pottery for income, they also found time to fulfill the tribe's need for traditional domestic and ceremonial pottery.

One of the first to work with prehistoric designs, Marie Z. Chino had been a potter since the 1920s, as had her sister, Santana Sanchez.

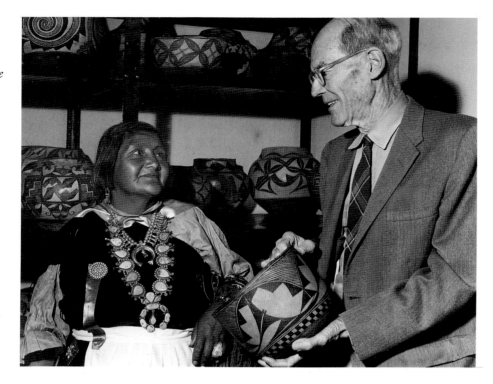

Figure 7.16. Lucy M. Lewis and Kenneth M. Chapman in the Indian Arts Fund collection, then housed at the Laboratory of Anthropology in Santa Fe, 1958. Photograph by Laura Gilpin.

Some of her pieces were among the prizewinners at the first Southwest Indian Fair in 1922 (Toulouse 1977:81). Chino's first experiments with old designs were inspired by the ancient potsherds she used for temper; later, she added personal touches to the prehistoric motifs. Adaptations of prehistoric designs were created to fit individual ceramics, and a design from a Mimbres bowl interior might be transferred to the exterior of a seed jar. Chino and other Acoma and Laguna potters used these prehistoric designs by themselves or in combination with traditional motifs.

Lucy M. Lewis pioneered the introduction of Mimbres (Mogollon) and Hohokam designs at Acoma. In 1958, photographer Laura Gilpin took Lewis to the Laboratory of Anthropology in Santa Fe to meet Kenneth Chapman, the Pueblo ceramics scholar (fig. 7.16). Chapman showed Lewis pottery from various prehistoric cultures, including Mimbreño, Chacoan, and Mesa Verdean examples (Dutton in Peterson 1984:207). All of these influences later showed up in Lewis's highly skilled work.

Today, many Acoma and Laguna potters use the old designs revived and adapted by Lewis and Chino. Jessie Garcia, Anita Lowden, Juana Leno, Lolita Concho (fig. 7.17), and Frances Torivio also were important in the perpetuation of traditional and revival-style designs. Leno, a potter who uses very traditional methods, continues to fire much of her work in outdoor firings. Sisters Lolita Concho (who died in 1989) and Frances Torivio have worked with a variety of designs, ranging from prehistoric sources to more contemporary multicolored, elaborate bird and floral motifs.

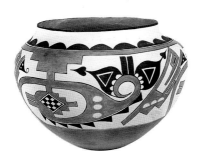

Figure 7.17. Acoma Polychrome jar, ca. 1979. This jar, signed Lolita Concho, is a copy of IAF 1036, an Acomita Polychrome storage jar. Concho's version employs the water-jar form common in the 1970s. The piece was fired in a kiln and then refired with manure to obtain the fireclouds. 10" x 14".

During these decades, as the reputations of some Acoma potters grew, signing the work became more common. According to Emma Lewis Mitchell, individual signatures began to appear around 1950; other potters have mentioned slightly earlier or later dates. Grace Chino of Acoma says her mother, Marie, signed her pottery when she and Lucy M. Lewis began to do exhibitions at Window Rock, Arizona, in the late 1940s. Maurine Grammer of Albuquerque was given a pot by Mary Histia at the Santo Domingo feast day in 1952, which Histia had signed with a scratched-on, rather than painted and fired-on, signature. In spite of the increasing number of signatures, the main hallmark of a fine potter remained, as it had been since prehistoric times, the mute "signature" visible in individual touches in vessel form and design.

At Laguna during these two decades, however, pottery making continued to suffer. Working on her pottery at the kitchen table one autumn day in 1989, with a horror movie on the television in the background, Evelyn Cheromiah commented on the advent of the railroad and highway and their relationship to the decrease in pottery making at the pueblo: "People got lazy. The husbands brought in the money [by] working on the train. Others moved to Winslow, Gallup, and California [to work with the railroad], and later men worked at the uranium mines. The highway moved outside the pueblo and slowed sales in the late 1960s, [while] the Acomas lived at Sky City and still had tourism."

The opening of two uranium mines on the Laguna reservation in the early 1950s presented new job opportunities to local residents, but again had the side effect of diluting efforts in pottery making. Both Acomas and Lagunas worked in these mines and others in surrounding areas. Another source of local income was the firm Omnitec, which closed in

the late 1960s (Ellis 1979b:448). Laguna Industries, started up in 1985, now employs many Lagunas in the manufacture of high-tech electronic goods (Arne Fernandez, personal communication, 1991).

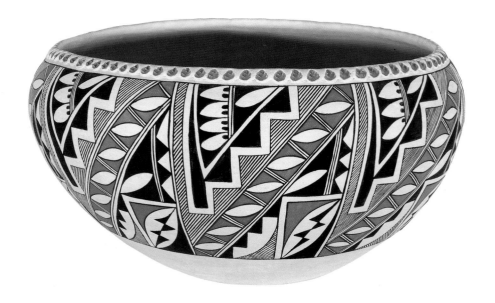

1970 to 1990

Figure 7.18. Acoma Polychrome jar, 1985. A rare contemporary example of a large dough bowl, signed "Grace Chino, Acoma, New Mexico." The added rim coil is indented, and the indentations are filled with an orange slip that was more common in the early part of the century. Like most modern pottery, this bowl was kiln fired. SAR 1987-5-1. 10 ½" x 18 ½".

As the decades passed, the people of Acoma and Laguna had to remain flexible in the face of continually changing sources of income. In the mid-1970s, many of the uranium mines closed, and unemployment climbed in the Acoma-Laguna area. As a result, many families became more dependent on the money earned by their potters.

An innovation of the 1970s and 1980s that may have been related to the closing of the mines and the need to develop new and less labor-intensive sources of income was the adoption by some potters of commercial slip-casting methods, which enabled them to mass-produce ordinary domestic items such as plates and mugs. These slip-cast ceramics, produced from commercially prepared materials, are painted with both old-style and contemporary designs. Relatively inexpensive and dishwasher-safe, they enabled potters to increase their output and

exploit the market for inexpensive souvenirs. They also allowed experienced and inexperienced potters, both young and old, to produce large numbers of saleable items. These wares in the future may take on the kitsch appeal that poster-painted wares from Jemez and Tesuque, made between 1910 and 1940, now have with collectors.

Despite such modern innovations, the Acomas and Lagunas continued to perfect their fine pottery, made by mostly traditional methods, as the market for this kind of work expanded to include ethnic art collectors in other countries. Today's Acoma and Laguna potters represent the culmination of centuries of fine pottery making at those pueblos (fig. 7.18). Their art still plays a central role in Acoma and Laguna society, and their economic contribution to pueblo life has become equally important.

Since the 1970s, Native American "craft" has increasingly been looked upon as "art," and as general interest in Indian cultures began to increase, a stronger Indian art market developed. Indian Market in Santa Fe, for example, grew from a small local event to a national and international media circus. As a result, there are large financial rewards for the makers of the finest pottery today. Though welcome, these monetary returns are accompanied by certain problems. In a society oriented toward group consensus and sharing, jealousies can erupt when one potter attains more success in the marketplace or is viewed by the outside world as having more talent than others.

Laguna did not begin to reap the benefits of the Indian art market until quite recently. In 1973 Nancy Winslow, a native New Mexican concerned that traditional pottery making had died at Laguna and was waning at other pueblos, began a project to offer assistance to people interested in reviving traditional techniques. Encouraged by the enthusiasm of Evelyn Cheromiah, Winslow applied for funding through the Manpower Development and Training Act. This act offered financial assistance to enable people to earn a small wage without conventional employment while learning a trade. Winslow was able to set up an "arts and crafts" project that lasted for two four-month sessions in 1973 and 1974. Winslow was project coordinator. According to Cheromiah, twenty-two students attended the first class, eleven the next.

Winslow's original students included Evelyn Cheromiah, Regina

Figure 7.19. Illustrations from the 1972 pamphlet Traditional Laguna Pottery Designs, *produced by the Laguna Pottery Project which was funded by the Manpower Development and Training Act and directed by Nancy Winslow.*

Pino, Louise Mae Toledo (deceased), Jennie Sanshu, Josephita Cheromiah, Edith Lorenzo, Frances Lorenzo, Josephine Poncho, Mabel Poncho, Josephine Kie, Agnes Weeker, Katherine Romero, Rita Romero, Delores Earle (deceased), Marie Kasero, Rose May Scott (deceased), Mary Duncan, Bertha Riley, Elsie Chereposy, Lupe Lucero, Emily Alonzo, and "Paraje" (a woman from the Laguna village of Paraje). The women were given technical training, and they were also taken to Santa Fe's Laboratory of Anthropology and School of American Research to study examples of historic pottery.

When offered photographs of the pieces they were studying, many of the students said they already carried the designs in their heads. Nevertheless, a ten-page pamphlet was made up with drawings of historic Laguna pottery designs to serve as patterns (fig. 7.19). Emphasis was placed on the reintroduction of traditional methods of pottery manufacture and design.

In general, Laguna potters have not followed the Acoma potters in reviving and developing prehistoric designs, tending instead to use a more recent polychrome geometric style. Laguna potters today are becoming more conscious of the past and may use it as a foundation for contemporary expression. Gladys Paquin, for example, has researched Laguna pottery in the literature and visited the Indian Arts Research Center to study old examples of Laguna pottery. In 1988 she told me that she enjoyed the traditional designs and used them as a way of establishing a different look for her pots. Recently, Paquin has painted the rims of her pieces red with black outlining to capture the flavor of eighteenth-century wares.

Throughout this century, Laguna has depended far less on pottery making than has Acoma. As has been alluded to earlier, the economics of the pueblo may in part account for this. As Ellis has written,

> More than half (2,900 in 1975) of Laguna's members live in the six major villages of the 420,000-acre reservation; 2,500 live elsewhere. Less than one-fourth depend on agriculture, cattle, or sheep, and the transition to wage economy is alleviated in part by the public works program provided by tribal funds. Thanks primarily to the energy of its leaders and to its mineral wealth, all but a small proportion of which is set aside

for investment and improvements rather than being distribut-ed to individuals, Laguna in the 1970's stands as the wealthi-est and probably the most acculturated of all the New Mexico Pueblo tribes. (Ellis 1979b:448)

Perhaps because of this "wealth," the women of Laguna have not relied as heavily on pottery making as did their counterparts at Acoma, where the craft has been almost essential to making a living. Tracing population accounts at Acoma and Laguna is difficult, but according to early records, Acoma was larger than Laguna until around 1776. Beginning in the early 1800s, Laguna's population began to overtake that of Acoma, and by the mid-1800s Laguna was roughly twice the size of its neighbor. Today Laguna is almost three times as large (Simmons 1979a:185; Simmons 1979b:221), but Acoma has many more potters.

Commercial and Traditional Potters

Among the more than 375 potters working at Acoma today, most create commercial pottery, including slip-cast ceramics, pottery made with commercial clay, and pots decorated with commercial paints. Few pot-ters work in a strictly traditional mode, and almost all Acoma pottery is electric-kiln fired. Many potters make both traditional and commercial types of ceramics, and their works include hand-built pottery made with native materials. At Laguna, only about 30 potters are active as of this writing. They produce work in styles ranging from traditional to sgraffi-to (see appendix B).

The potter's traditional craft is still necessary at the pueblos to pro-vide certain vital types of ceramics, such as pottery employed in the kiva, given by the kachinas to children, and used domestically. I have seen water jars being used, though perhaps more for fun or to honor the past than from convenience or need. Clearly, though, the main function of pottery is for sale, and at the annual Indian Market in Santa Fe the casu-al buyer, souvenir collector, or art connoisseur can see a fine cross sec-tion of work from all the pueblos.

Many collectors want to own something that they consider to be "grounded in roots," so traditional or semitraditional pots are valuable

in the marketplace. Particularly appealing to some buyers are quasi-ceremonial wares—such as kiva-water and prayermeal bowls—made to resemble, but not precisely replicate, actual vessels. Until very recently, the conservative Acomas would not have painted a ceremonial figure on an item made for sale, but today a signature on a "ceremonial" vessel indicates that the piece was produced strictly for sale. Some authentic ceremonial items from Acoma and Laguna have also made their way into the marketplace, often as a result of unethical practices.

Craftspeople who create slip-cast wares have clearly left the realm of traditional ceramics behind, but even potters who create handmade "traditional" wares have benefited from the artistic freedom resulting from technological innovations and the fact that their pots no longer need to be functional. Traditional potters today have more technical options: some build their vessels by hand with native clays but use commercial paints for designs; others use commercial materials entirely and fire in an electric kiln. Most of these new methods seem to have been introduced at Acoma and later moved to Laguna.

Acoma potter Carrie Chino Charlie is one of a large group of potters producing ceramics of traditional form, design, and materials, made with native clay and painted with natural pigments but fired in an electric kiln. Her work is a sophisticated blend of centuries-old methods and materials and twentieth-century ingenuity. When I asked Carrie to identify a pot she considered traditional, she pointed to one of her own pieces decorated in the noted fineline design—a twentieth-century innovation (fig. 7.20).

The mobility provided by cars and pickup trucks has contributed to changes in pottery manufacture in recent years. In the past, potters were generally restricted to those materials closest at hand: clay, in particular, was laborious to mine and heavy to transport, so potters relied almost exclusively on local deposits. Today, they have the option of obtaining clays and other materials from a multitude of sources. Laguna potter Gladys Paquin, for example, incorporates a volcanic tuff or "sand" more commonly used by Tewa potters in her clay mixture, instead of ground potsherds. Until she found a suitable material at Mount Taylor, near Laguna, she drove some two hours to Pojoaque, New Mexico, north of Santa Fe, to obtain the fine volcanic tuff.

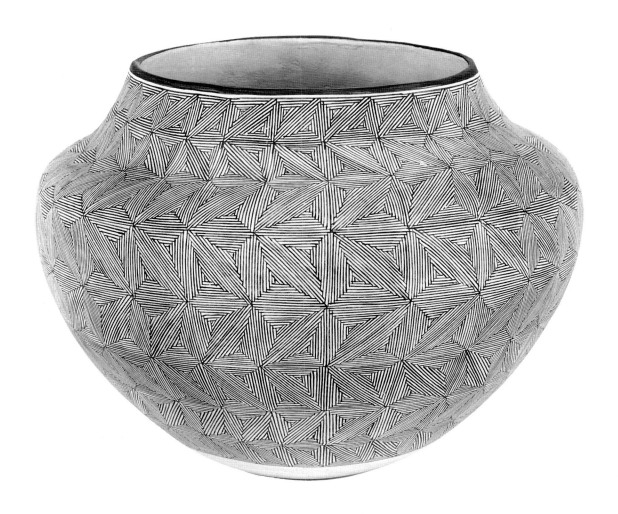

Figure 7.20. Acoma Black-on-white jar, ca. 1985. Signed Carrie [Chino] Charlie. Elaborate fineline decoration based on prehistoric designs covers the entire jar. 8 ¼" x 11 ¼".

As has been mentioned, slips were traded between pueblos in the past, and trade of materials goes on today, as potters try to gain an edge in the marketplace by introducing new colors to their work. Acoma potter Rose Chino Garcia has used a deep maroon slip that she acquired on the Hopi reservation, and Hopi potter Helen Naha and Cochiti potter Ada Suina have used an orange slip obtained on the Acoma reservation.

The Production of Slip-Cast Wares

Slip-cast ceramic wares, the production of which continued to increase during the 1970s and 1980s, are made in the home or in a commercial hobby shop, giving the shop dealers a good deal of influence over the potters. The social atmosphere—many people working together, talking and sharing ideas—is reminiscent of the past, when instead of working in isolation in front of the television, potters often gathered in groups at one person's house on Acoma mesa or in Old Laguna.

Indeed, the influence of the hobby-shop dealers on potters is far stronger than that of the nineteenth-century Indian traders. Entire ceramic shops have been geared to selling materials to potters who want easy, fast methods of creating pottery. In the early 1990s, one such enterprise exists on the reservation at Acomita. Luther Chavez operates a large shop in Cubero; at least two more are located in nearby Grants, another in San Rafael.

At these shops, liquid clay slip is poured (slip cast) into plaster molds, and the unfired blanks, or "greenware," are sold to craftspeople who sand the surfaces and decorate and apply commercial glazes to the forms (fig. 7.21). This can be done in the hobby shop or at home. The pieces are then fired in electric kilns. The molds are used so skillfully that it is very difficult for a novice buyer to distinguish mold-made from handmade wares. In recent years, plaster molds of traditional pottery forms have been developed: the molded pot then bears the uneven qualities of a handmade piece. While damp, these pieces can be altered slightly, giving each one a unique, handmade appearance. Painting and finishing of the pieces are frequently done in the hobby shop itself, which is set up with tables so that many potters can work simultaneously.

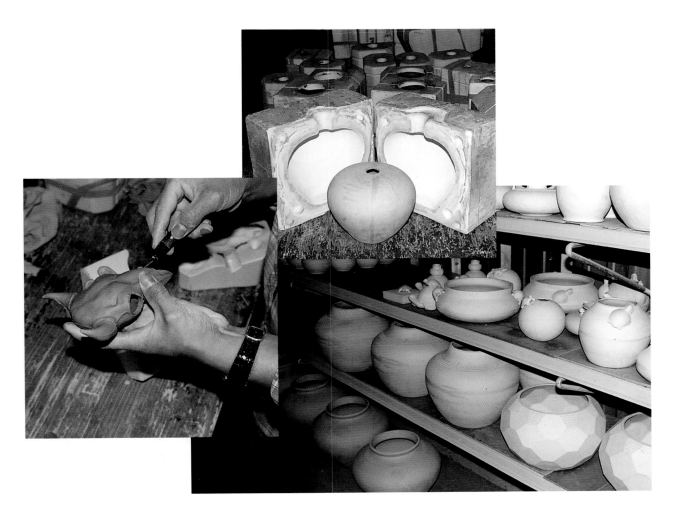

Molds can be made in virtually any shape. Molds for simple forms consist of two pieces; other forms, such as animals and more complicated figures, require more than two. These pieces are assembled and tied together, usually with large rubber bands or parts of inner tubes, and a slip (liquid clay) is poured to fill the mold. The plaster mold absorbs water from the clay slip, leaving a solid, built-up film—which becomes the wall—at the point of contact with the plaster. The excess slip is then poured out, and the piece is left to set up. When it is leather hard, the mold can be removed and the piece left to dry. At the junctures of the pieces of the mold there will be raised seams: these are cut and sanded

Figure 7.21. Making slip-cast pottery at Luther Chavez's shop in Cubero, New Mexico: top, *simple two-piece mold and greenware pot. Strapped molds have been poured with clay slip that is setting up;* left, *trimming a freshly cast cow skull;* bottom, *stacks of greenware ready for finishing.*

to disguise the item's molded origin. This part of the process is done by the hobby-shop employees. The dried forms are then purchased by individuals who will paint and finish them, and finally fire them in the shop's kiln.

To finish the piece, commercially prepared ceramic pigments as well as vitreous glazes are used. Often potters paint fineline or other traditional designs on the slip-cast commercial wares in an array of colorful commercial pigments. The sight of traditional Acoma and Laguna designs rendered in vibrant greens, blues, and turquoise may be shocking, but potters use the colors because they are appealing to both potter and consumer. (See appendix C for a discussion of signs of commercial origin in Pueblo pottery.)

Typical slip-cast pieces that can be found in curio shops today include functional bowls, cups, plates, teapots, sugar bowls, and cream pitchers, as well as knickknacks such as cowboy hats, religious figurines, animal figures, and the like (see figs. 8.3, 8.4). Another recent trend in Pueblo pottery is sgraffito carving, found mainly on slip-cast ware. Matte-painted designs and sgraffito techniques are done on greenware. A bisque firing is then done to fix these pigments; overall glazing requires a second firing. Glaze painting of the sort done on Hawikuh pottery is not seen today. In sgraffito, the greenware is painted with various underglazes (commercially produced matte finishes), and designs are scratched through the color to the clay itself, creating a sort of cameo design. The sgraffito style became popular in the Northern Tewa region in the late 1960s and was adapted to the commercial pottery of Acoma and Laguna in the 1970s (see fig. 8.6)

The Modern Potter's World

Many elements of traditional lifestyle have persisted at the pueblos, and tilling the ancient fields and raising livestock still play a part in the subsistence economy. But members of the pueblos also work in the nearby towns of Grants and Albuquerque; they hold jobs as miners, railroad workers, retail store employees, and teachers. Many, although by no means all, of those commuting to work in the towns are men; more

women have managed to maintain occupations such as pottery making as a major source of income.

But pottery making demands a great deal of time. Even when the craft has brought them added—and sometimes substantial—income, many potters have chosen to work "regular" jobs with "regular" hours. When jobs lead potters to other cities, their pottery production most often takes a back seat to their other commitments. Still, some potters who live away from the pueblos do produce old-style pottery. Lucy Lewis's daughter, Anne Lewis Hansen, has lived in California since the 1970s but continues to make and sell Acoma-style wares. Mary Ann Hampton made pottery at both her Albuquerque residence and her home in Skyline Village on the Acoma reservation; she now resides solely at Acoma.

Even if it is done in a traditional manner and at the age-old location, pottery making and its context have changed considerably. Contemporary potters face the monthly pressures of car payments, utility bills, and the need for cash to cover school supplies, medical expenses, and so on. This has had an effect on the process, with potters sometimes arranging their production schedules so that they can meet their various payments. And television and radio have become part of the daily setting of Pueblo craftsmanship: a potter may use her TV set as "company" while she is coiling or painting, or as a diversion for her children while she works.

Changes are evident in everything: styles, functions, methods, and materials. Commercial materials and technology, such as the electric kiln, make it possible for potters to take technical shortcuts, and there is a general movement away from painstakingly handmade pots toward mass-produced commercial items.

At the contemporary pueblos of Acoma and Laguna, pottery is made in all sorts of locations, from ancient homes on Acoma mesa to modern trailers within view of passing traffic on Interstate 40. Most families maintain a home in the old villages, which they use during ceremonies, but live much of the year in more modern homes in outlying settlements.

Most potters do not have a separate room for making pots but work at the family dining table all day. The table is cleared for the evening

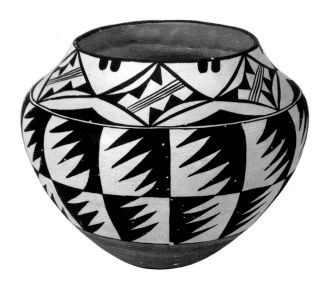

Figure 7.22. Acoma Polychrome jar, ca. 1970. This traditional water jar by Frances Torivio has banded designs on the neck and body. The pitted surface is caused by impurities in the clay. IAF 3115. 7 ¾" x 9".

meal, and after supper the pottery-making paraphernalia goes back onto it. It is only in recent years, and due to the great demand for their work, that some potters have arranged separate workrooms or storage areas to facilitate constant production.

The esteem in which traditional pottery is held at the pueblos is seen in the fact that pottery vessels appear in many of the potters' homes. Although most older pieces find their way to the marketplace, a few items are always kept within the family. In modern Pueblo homes, pottery can be considered a three-dimensional vehicle for conveying cultural nostalgia, reminding people of their heritage and of much-loved craftspeople in the family. Many pieces seen in potters' homes are flawed in some way and not marketable, but such flaws are unimportant if the essence of the pot remains intact—that is, if the damage has occurred as part of the organic, traditional process of pottery making.

The individual and family lives of today's potters reveal longstanding dedication to their craft. Eighty-five-year-old Frances Torivio has been potting since the 1920s (fig. 7.22). She and her sisters, Mamie Ortiz and Lolita Concho, have made both traditional and slip-cast work (see fig. 8.1). Torivio's daughters Lilly Salvador and Wanda Aragon are recognized for their superb miniature replicas of older pots, as well as for their innovative contemporary ceramics.

Evelyn Cheromiah has successfully revived the making of large ollas at Laguna, and her daughter Lee Ann Cheromiah also works in older styles. Evelyn has been potting for nearly twenty years. She says that after "looking at my mother's pottery-making tools, I got the urge of going back to making pottery."

Trends in Contemporary Pottery

Experimental forms constantly appear in the marketplace. Clarice Aragon, daughter of Wanda Aragon, has made small ceramic versions of hot-air balloons, decorated with old-style Acoma designs and small human figures in the gondola, an ingenious response to Albuquerque's International Balloon Fiesta.

In spite of the numbers of potters employing the newer techniques, older methods persist, and old-style pottery forms remain popular. Water jars, bowls, canteens, seed jars, and so forth are available, as are individual "eccentric" pieces. Many potters continue to make small tourist dishes, easily potted, with various designs in the center. Contemporary versions of water jars conform to styles of the past, with individual variations. Other items, such as decorative animal forms of owls, turkeys, and chickens, have roots in the early twentieth-century tourist market (fig. 7.23). Lucy Lewis and her family continue to make small, solid roadrunner figures of the same style that she originally made for trade fairs, and for decades, Mabel Brown of Acoma has made cream pitchers in the form of a cow.

Since the mid-1970s, many potters have displayed a tendency toward technical perfection in form and painting. Thin vessel walls, a longtime characteristic of Laguna and Acoma pottery, were elaborated to an almost eggshell thinness. These ceramics would have been totally unacceptable for functional purposes, but because their only function is decorative, their fragility has become acceptable and desirable. As competition accelerated, potters began to create vessels so delicate in construction and intricate in design that, like a Fabergé egg, they are useless except as a tour-de-force of technical and artistic virtuosity. This is an extreme development in the general correlation between the rise of the tourist market and the reduction of functional utility in Pueblo pottery.

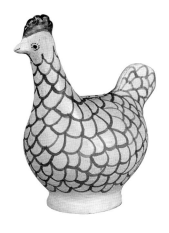

Figure 7.23. Acoma Polychrome, ca. 1960. Animal forms have been adapted for the tourist market at many pueblos, especially Zuni, Acoma, and Laguna. This chicken figure has a slot cut in the back for coins. SAR 1982-7-16. 7" (h).

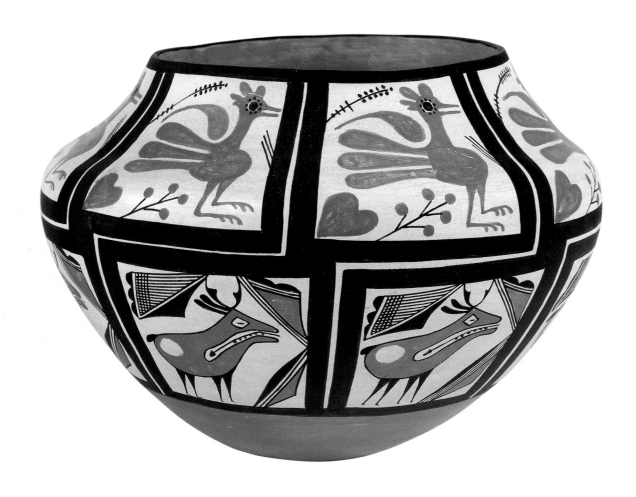

*Figure 7.24. Acoma Polychrome (kiln-fired) jar, 1985. Made by
Rose Chino Garcia. Although the shape is different, the design on this jar is an
almost identical copy of IAF 1042, which Garcia saw published in* American Indian
Art Magazine *in 1977. She has since made many versions of the design.
SAR 1985-9-1. 9" x 12".*

The spirit of older pottery continues to inspire potters, and revivals of prehistoric and historic designs are popular. Wanda Aragon of Acoma has faithfully copied designs from actual historic examples; when it is known, she marks the date of the original model on the base of the new pot. Rose Chino Garcia has also been enthusiastic about reviving classic styles. In 1977, I illustrated a ca. 1900 Acoma jar in the School of American Research collection (IAF 1042) in an article in *American Indian Art Magazine* (Dillingham 1977). Garcia copied the old jar's unusual bird and deer motifs from the photograph and has since made many versions of it. I was able to acquire her first copy for the School of American Research collection (fig. 7.24).

Because most pottery today, even vessels in traditional forms, has no utilitarian function, the potter is free to perfect and exaggerate form and decoration with no practical constraints. Small functionless seed jars, for example, are made by the hundreds. These elliptical "flying saucer" forms serve more as vehicles for intricate painting than as ceramic statements. Made purely for art's sake, they have no accessible opening and are usually crowded with Mimbres, Hohokam, and other geometric design elements painted in various commercial colors (see fig. 8.6).

The variety of designs and materials used in today's Acoma and Laguna pottery is dazzling and represents a genuine florescence of the craft. Allover checkerboard fineline designs are generally very elaborate; painted in native or commercial pigments, they display true virtuosity and are the result of intense effort. Potters can work on them for only a few hours at a time because of the muscular control needed to draw the straight, even lines and the terrific eye strain that develops. Banded designs, laid out in patterns conforming to the physical structure of the jar, continue a style that began around the turn of the century; they too have become more complex and tend to cover the entire surface of a pot. Yet another recent trend is the use of intricately interwoven lines and geometric elements to create optical illusions on the surface of the pot. Mimbres designs are more popular than ever (fig. 7.25), the Acoma parrot motif has enjoyed a strong revival, and potters generally feel free to copy old versions of designs, transform traditional designs in their own way, or create entirely new styles of decoration. There is no indication that this creative ferment has yet reached its peak.

Figure 7.25. Acoma Polychrome (kiln fired), ca. 1977. Seed jar with Mimbres motifs made by Barbara and Joe Cerno. SAR 1989-7-294. 2 ⁵⁄₈" x 3 ¼".

Figure 8.1. Acoma commercial ware. These two pieces by Acoma potter Mamie Ortiz (d. 1990) are typical of the commercial slip-cast pottery done today at Acoma and Laguna. Ortiz made both traditional (though kiln fired) and commercial work in her later years. These two pieces have underglaze pigments, a clear overglaze, and fired-on decal transfers. Left, SAR 1987-13-4, 9 ¾" (d); right, SAR 1987-13-5, 10 ⅛" (d).

Native Artists and the Marketplace

Contemporary Acoma and Laguna potters are faced with new issues and challenges that arise from their position as members of two very different social universes. Are they ceramic artists who just happen to be from an indigenous culture? Or are they traditional ethnic artists who are forced by a hard-driving marketplace to create contemporary statements—statements with which they are essentially uncomfortable? Native American artists today must try to balance the pressures, constraints, and opportunities of two worlds. This commentary explores some of the issues that confront them and the ways in which the potters of Acoma and Laguna pueblos adapt and change as they move into the future (fig. 8.1).

The potter's need to stand out in the competitive marketplace has led to innovation, experimentation, and wide variations in the quality of ceramic work being done, ranging from the sublime to the mundane to pure kitsch. Potters feel intense pressure to come up with original ideas, and many buyers want to be able to say, "I have the only piece like this." To keep up with trends, young potters in particular often pattern their work after innovative nontraditional pieces they see in galleries and shops. In the best cases, the development of well-defined individual styles results from these influences. One of the negative effects of market pressures, however, is the development of the "big name" syndrome.

The Big Name Syndrome

From prehistory to the present, individuality has been an element of the potter's craft. But during the twentieth century the importance of the individual potter has escalated to such an extent that a personal signature not only adds value to a pot but may be more important in the market than the quality of the piece itself. In this sense, at least, Pueblo pottery has crossed the line from a traditional craft to a contemporary form of fine art, from a product that is desirable in and of itself—and, even more so, because of its cultural associations—to one identified with a recognizable artist, whose name alone can sell a piece.

Besides individual "stars," certain families of potters have attained high status and financial clout in the art world. In 1974 I assembled an exhibition for the Maxwell Museum of Anthropology at the University of New Mexico that traced the genealogies of seven families of potters in four pueblos. The show and catalog, entitled *Seven Families in Pueblo Pottery* (Maxwell Museum of Anthropology 1974), demonstrated how designs and forms are handed down within families from one generation to the next. Needless to say, many families of talented potters were not included in the catalog, and many other families have done exceptional work. But the attention focused on these seven families, particularly the Lewises and Chinos of Acoma, catapulted them to prominence among buyers and collectors. The unfortunate result is that many equally talented potters were overlooked.

The drawbacks to the art market's "star system" are many for the Pueblo potter. Some fine potters go unrecognized because their marketing approach is too low-key, their output is too small, or their work has not been published. But as the demand for output increases, the quality of work of even a big-name artist may suffer. Famous potters also risk falling into a creative rut: once known for a particular type of pottery—a certain shape or design—a potter may be hesitant to experiment or alter the work. Ironically, once the marketplace is saturated with that particular style—unless it becomes a "classic"—the demand for it can slow or stop.

For the younger artist there is particular danger in creating too deliberately for the marketplace. Despite the superficial emphasis on

tradition, fads and trends play an important role in the world of Indian art, and careers can be made and broken within a single season. Just as in the high-stakes fine arts market, dealers in the Native American art market can create monsters by spotlighting and promoting novice artists before they are ready to handle the accompanying personal and artistic pressures. For the sake of both artist and buyer, it is preferable that an artist develop a history of credible, high-quality work so that reputation does not outstrip the ability to create.

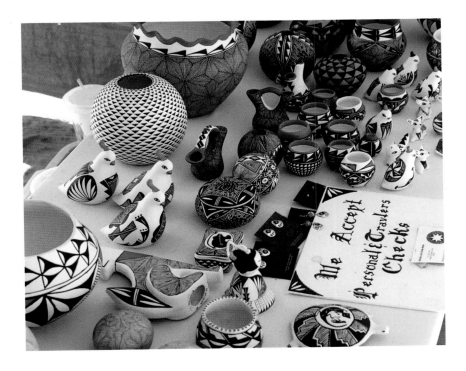

Figure 8.2. A pottery booth at the visitors' center, Acoma feast day, September 2, 1991. Both commercial wares and old-style pottery are offered for sale.

Twentieth-Century Commercialism

A promotion-oriented, almost carnival-like atmosphere prevails at times in the Pueblo pottery marketplace. Potters vie at competitive fairs and other events, entering their work in highly differentiated categories created to fit virtually every type of ceramic work (fig. 8.2). Some potters find refuge in these minute categorizations and can comfortably work within such confines. But fixed categories can also stifle experimentation

and variation and severely limit the artist's creative freedom. An argument could be made for allowing the work to stand on its own merit apart from such classifications, which exist primarily for the convenience of the buyers and sellers of Indian art.

As increasing numbers of potters employ modern technology and commercial methods and materials to speed their output and simplify the production process, tension has developed between commercial craftspeople and the few conservative potters making old-style pottery. Some potters have complained that the large supply of commercial, and especially slip-cast, ceramics flooding the market decreases the number of buyers for painstakingly made traditional wares (figs. 8.3, 8.4).

Many conservative potters are adamant about not doing "commercial" work—the term the potters use for wares produced with non-native materials and techniques. These potters are quick to point out individuals who they believe are taking shortcuts, using store-bought paints and materials and representing them as traditional. This is the main source of tension between potters today. As Lee Ann Cheromiah of Laguna Pueblo says, misrepresenting commercial work is "not fair, not right. I get angry that a lot of them are selling theirs as traditional and they're not." Lee Ann acknowledges that she has made commercial ceramics herself, creating utilitarian pieces such as lamps, but emphasizes that she has never signed or misrepresented these items. Even so, she is chided by her mother, potter Evelyn Cheromiah: "You're a traditional potter, and you're doing these kinds of ceramics!"

I respect the pride that traditional potters take in the old ways, but I don't disdain slip-cast ceramics as long as they are not represented by the potter or the dealer as being totally handmade. As Native American culture changes, potters will naturally change their methods in order to survive. Collectors and buyers need to be aware that a "traditional" style may no longer have any meaning for the potter, except to the extent that it is valued by the consumer. To demand that Pueblo potters preserve an old ceramics style is as offensive as expecting native peoples to retain an antiquated lifestyle. Contemporary Native Americans do preserve certain enduring traditions, of course. In most cases these are integral to their changing culture; in others, they may represent the reincorporation and reinterpretation of archaic elements that are deemed valuable by the buyers of their work.

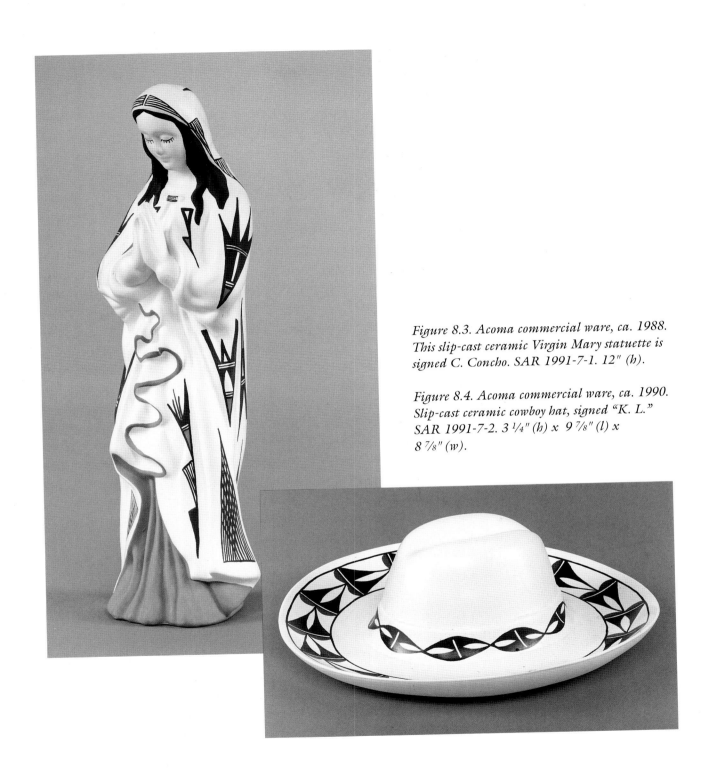

Figure 8.3. *Acoma commercial ware, ca. 1988. This slip-cast ceramic Virgin Mary statuette is signed C. Concho. SAR 1991-7-1. 12" (h).*

Figure 8.4. *Acoma commercial ware, ca. 1990. Slip-cast ceramic cowboy hat, signed "K. L." SAR 1991-7-2. 3 ¼" (h) x 9 ⅞" (l) x 8 ⅞" (w).*

For the novice potter, or a potter constrained by finances to produce substantial quantities of ceramics as quickly as possible, working with the less labor-intensive commercial products may be not only convenient but necessary. Pueblo potters live in the same world as the rest of us, they have the same obligations and confront the same pressures. Borrowing and adapting tools, techniques, and styles has always been a part of every culture and contributes in a very basic way to the vitality of human expression.

But the relative ease of manufacturing commercial wares may in fact motivate some potters to learn the techniques of the past or to experiment with other methods that may find a place in the future of Pueblo pottery. I identify with these potters; I too began my ceramics career in a hobby-shop situation making slip-cast wares. I have no doubt that many commercial potters will be inspired to look more deeply into the medium, and that some will become serious artists.

Dealers, Collectors, and Institutions

Prices in today's international marketplace for Acoma and Laguna ceramics range from a few dollars for a small tourist pot to many thousands of dollars for the work of a fine potter—and many thousands more for fine historic pottery. As high-end prices have risen, buying has become a more serious proposition, and the interface among Indian artists, dealers, collectors, and institutions has become increasingly complex.

One problem in these transactions occurs when work is misrepresented to the dealer, and then in turn misrepresented by the dealer to the buyer. Some modern blends of commercial and native pigments can fool even an expert, and the technical characteristics of a pot also can be difficult to ascertain.

Certain idiosyncrasies in pots made by traditional methods are perfectly acceptable, however. Slight pitting or fine cracks on a well-made, century-old pot may not have been considered flaws by dealers or collectors in earlier times, and today certain technical deficiencies may be offset by a potter's creative ability. The later efforts of an elderly potter

with a long and exemplary history in the craft may lose an element of precision or control, but the artistic soul of the creator remains present and strong in the work.

Some dealers attempt to manipulate the market in older pottery, placing a greater emphasis on age than on aesthetics and embellishing their descriptions of a pot to lead a buyer to believe that it is older than is in fact the case. The word "traditional" has itself become a marketing device in recent years. Used appropriately to describe pottery made the old way, the term is often misapplied to newer styles to create an impression of age that will influence the buyer.

Strictly speaking, traditional pottery was made to supply domestic and ceremonial needs at the pueblo. In this sense, there is little traditional pottery being made for sale today. The term "old style" is actually more appropriate to describe the modern Acoma and Laguna pottery that is made and decorated in older styles. Today these old-style forms are made strictly for sale. As far as I know, for example, there are no jars made for use in Pueblo homes to store water, although many such "water jars" are made for the market.

The competitive marketplace and the influence of the dealers' marketing strategies cause artists to create highly diversified styles and have led to the faddish and trendy quality of some Native American art today. The gimmick that a would-be artist hits upon to gain attention and entry into a gallery may experience only short-lived popularity, but even established artists are strongly influenced by trends, which have a substantial effect on pricing. For a time, a newcomer's innovation may command a great deal of money, while prices for the work of a potter with fifty years' experience remain relatively fixed. Today's constantly changing trends are regulated to some extent only by the discrimination of the dealer and the buyer. Of course, if there were no market for faddish ceramics, they would not be produced.

In recent years the output of Acoma and Laguna potters has also been affected by collectors who demand very high quality in the technical aspects of the work, a demand that has led to creations so "perfect" as to be visually monotonous. Other collectors buy at the opposite end of the spectrum, selecting pieces according to their surface appearance, without concern for workmanship or materials.

Potters feel pressured to satisfy the demands of both types of buyers: those who demand technical perfection and those who buy with less knowledge and discrimination.

Museum professionals exercise a special type of influence in the world of Native American art, using historical, ethnographic, and stylistic criteria to select their acquisitions. Their decisions may be based on the desire to create for posterity a record of various styles, materials, and innovations that occurred during the evolution of the craft, whether or not the pieces can be considered great art. Even so, these institutional purchasers are important tastemakers, influencing what styles become favored by commercial buyers.

There is, of course, an ironic element to the commerce in Pueblo pottery. To make a living, Native Americans produce for non-Indians products that are icons of a traditional culture that no longer exists—indeed, that was destroyed by the ancestors of today's consumers. The potters themselves often consciously seek and expound this association with their own past, as in the work of Wanda Aragon, who has created replicas of historic Acoma pots and inscribed the dates of both the original and the "reproduction" on the base of the new piece.

The Human Factor

Potters are people, and the human factors that go into the creation of their work help to explain some of the contemporary developments in Pueblo pottery. Potting all day can be tiresome work (if not outright drudgery), and it is understandable that potters will look for ways to reduce their workload and increase sales. If potters make unexceptional pottery to sell to the tourist trade they cannot be condemned for it. A thriving market for such work exists, and there is no disgrace in producing ceramics simply to make a living.

Potters who do put a lot of time into well-crafted work will, as a result, have fewer pieces available for sale. Many potters begin saving work months in advance for the annual Indian Market in Santa Fe to realize the higher prices they can generally charge there. Their work proceeds under intense pressure up until the last minute, and it is not

uncommon for potters to bring pots to the market fresh from that morning's kiln or outdoor firing.

Understandably, some artists resent the marketplace. It places them in the position of selling personally and culturally meaningful items to outsiders who may have no understanding of the work or the culture from which it came. When sales involve heirloom pieces, the issues involved can be quite emotional. On selling heirloom pottery to collectors, Wanda Aragon told me, "If the person wants to sell whatever artifact they have it's up to them, but they don't understand the value of it, they understand money. They think it's old and outdated . . . and don't know the value. Maybe if they started making pottery they would realize the value of it, or at least the tradition behind it."

Hard-working artists may also resent the fact that less fastidious craftspeople can easily sell inferior products. As these disenchanted artists discover, "Those guys will buy anything." Why work hard for buyers who don't appreciate the extra effort? Even artists who have a profound commitment to producing classic statements of old-style art, grounded in history and a deep respect for the past, may become disillusioned. The art market does not address the internal, personal workings of an artist, and a vast gulf stretches between the person who creates the work and those who purchase it. This is the inevitable, though unfortunate, trade-off involved in doing something primarily for money: no marketplace—whether art or industry—is concerned with the inner life, the spiritual needs, of the laborer.

A further impact of the selling of Indian culture has been the introduction into Pueblo society of overt competition, a fact of life in the new economic environment. One of the more benign forms this competitive spirit takes is the potters' efforts to elaborate and perfect their chosen styles. Fineline designs, in particular, have become a test of skill in which potters aim to best each other with ever more complex, delicate, and intricate designs (fig. 8.5).

Perhaps the most prominent characteristic of the Acoma and Laguna potters I know is their resilience in the face of change and the pressures of the modern world. This resilient spirit, imbued with cultural pride, artistic skill, and a great sense of humor, enables them to adapt to the needs of the marketplace without losing their cultural identity. Humor

Figure 8.5. Slip-cast seed pot with ultra-fineline design by Merlinda Miller, Acoma, 1991. LSAR 1991-2-3. 5" x 5".

in particular has always played a crucial role in my relationships with the potters, and laughter continues to ease personal and cultural tensions and strengthen our communication and friendship.

Preserving and Challenging Tradition

The challenge facing twentieth-century Acoma and Laguna potters (and Native American artists in general) is how to blend traditions with the need for sales. If an artist is consciously searching the past for ideas and creating statements based on the past, the traditional style may well satisfy his or her need for artistic integrity—and even provide "food for the soul." But a contemporary artist may equally well avoid tapping the past, preferring instead to use tradition only as a reference point while moving on to more experimental work. A further difficulty may arise, though, as the artist attempts to reconcile artistic freedom with the need to market the work.

Today most stylistic changes come about through individual decisions, and the old way of incorporating change by slow, gradual consensus is disappearing. Some traditional potters at Acoma, motivated by economic concerns and heavy competition in the marketplace, have recommended that the tribal government intervene to set standards for pottery, requiring that pieces be labeled either "ceramic" (commercially produced) or "traditional" (made with old-style methods and materials). An informed buyer, it is presumed, would value handmade over mass-produced pottery, thus creating informal price regulation (see appendix C).

The potters' struggle to define and label their works in terms of these two categories is an indication that the cultural glue of tradition in Acoma and Laguna pottery has begun to break down. But traditions in pottery will inevitably change, expand, and breathe with time (fig. 8.6). The eccentric animals, baskets, and trinkets of the early tourist period have now taken on the status of "traditional" tourist wares, and today's slip-cast wares are just as likely to become established as tomorrow's traditional pieces. Twenty years from now, will they be considered kitsch or classic? Twenty years from now, will the electric kiln be an old-style technique?

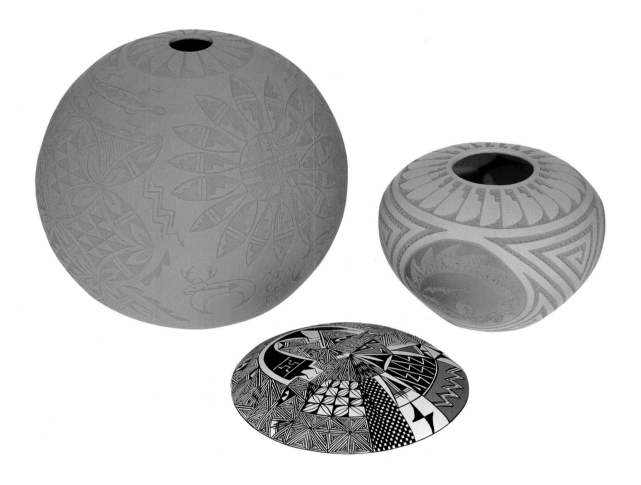

Figure 8.6. Acoma commercial ware: left rear, *sgraffito seed jar
in red clay with blue underglaze. Gertrude Poncho, 1991, LSAR 1991-2-4,
7" x 7 ½";* right rear, *slip-cast jar in red clay with painted blue and yellow under-
glaze and sgraffito design. Keith Chino, 1991, LSAR 1991-2-2, 4 ¼" x 5 ½";*
front, *painted seed jar with post-fired pigments. Sheila Concho, 1991,
LSAR-1991-2-1, 2" x 5 ½".*

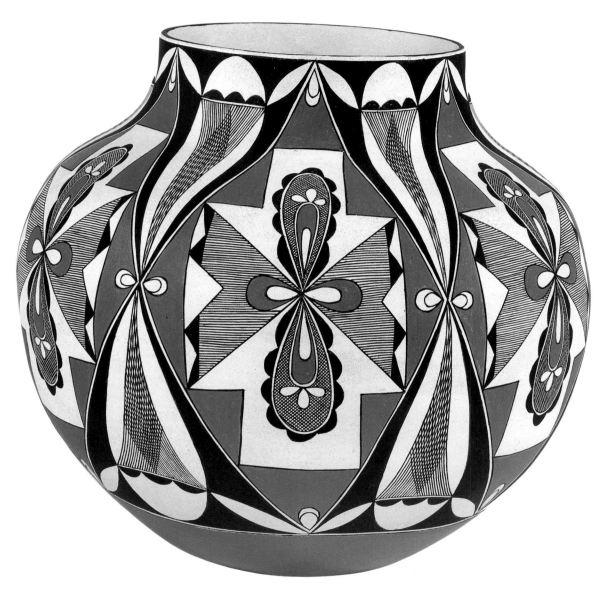

*Figure 8.7. Laguna Polychrome (kiln-fired) jar by Evelyn Cheromiah, 1991.
Tightly drawn overall geometric pattern with paddle motifs and delicate hatching
on a contemporary olla. 11 ¼" x 11 ½".*

When Native American potters visit my ceramic studio in Santa Fe, they express in many ways their constant quest for a balance between tradition and individual expression. Eager to communicate about the craft, to question me about experimentation, they are at the same time restrained by a way of life that stresses continuity, conformity, and dignified forbearance from asking questions. Their capacity to create under the tensions imposed by these conflicting cultural influences is remarkable.

Today as in the past, many collectors lump Acoma and Laguna pottery together, usually under the Acoma designation. Both historic and contemporary ceramics from Acoma have generally overshadowed Laguna pottery, the former being both better known and more highly regarded. In fact, however, in recent times Laguna potters have created ceramics equal in technical skill to those of Acoma. Numerous outstanding potters live and work at Laguna (see appendix B), among them Evelyn and Lee Ann Cheromiah and Gladys Paquin. These three women have already established what promises to be a strong and continuing tradition of fine Laguna ceramics, creating wares that are an inspiration to younger potters (fig. 8.7).

Acoma pottery has achieved greater popularity and publicity for three primary reasons: Acoma's very ancient tradition of exceptional ceramics, a tradition that has continued unbroken for centuries; the far greater quantity of documented pottery available from Acoma; and the fact that Acoma has been the home of many well-known pottery-making families in the twentieth century. The work of these artists, publicized nationally and internationally and appearing widely in galleries and exhibitions, fuels buyers' interest in that pueblo's pottery.

Anglo Influence

European-American, or "Anglo," involvement with Pueblo pottery—as collectors and dealers, as promoters of competitions and arts events—has been both a source of encouragement and sustenance and, at times, a cultural intrusion. There is a vast difference between supporting the arts of a native people and interfering in the creation of those arts, and Anglos have on too many occasions been guilty of meddling.

When people from Anglo society, which encompasses the majority of collectors, buy Native American art, they purchase along with the object an intangible value, a "piece" of the culture. In order to validate the exotic nature of the piece, the collector sometimes demands that the artist who made it play a role—in particular, maintain an outmoded "traditional" lifestyle to live up to the "Indian" image. When collecting takes on this character of patronizing the artist or the culture, a review of the ethics of the situation is in order. In cases such as the possession by non-Indians of ceremonial material necessary to the life of the culture, collecting becomes tantamount to cultural rape.

Despite the tendency of some Anglo collectors, scholars, artists, and philanthropists to meddle with pottery styles, forms, and designs, the potters of Acoma and Laguna have been able to absorb Anglo ideas while maintaining the continuity of their traditions. New ideas have been flexibly incorporated into the potters' existing traditional processes in such a way that the resulting pottery remains distinctively Acoma and Laguna.

When James Stevenson began collecting for the Smithsonian in 1879, he was "meddling" in the sense that he removed large quantities of valuable art from the pueblos of origin. But had he not carried out this mission, we would not have the priceless legacy of pottery available to both Indian artists and the public today. Instead, many of the ceramics he helped to preserve would have been damaged by use and met their traditional fate: they would have been thrown on the trash heap—by no means a disrespectful gesture in a culture that honors all materials that came from and are returning to the earth.

From the Anglo and institutional point of view, the collecting done by early visitors to the pueblo—Stevenson, Heye, the Mindeleffs, and others—may have saved many fine pieces from extinction. But the potters' attitude may be more ambivalent, combining recognition of the valuable role of museums with a desire to repossess their own cultural heritage. As Acoma potter Wanda Aragon has said of institutional collections, "I think it's good that [ceramics] are saved at museums, and someday I want them home. But right now there's no place safe to put them. Someday I would like to see them back at Acoma."

Like other potters, Aragon appreciates the preservationist role museums have played:

> I always think about the designs of my ancestors. They had these special designs. They are different even from what my mom [Frances Torivio] was handed down by her mother. They are just different, and I can find these designs in the collections. The good thing about it is [scholars] can kind of date them and they can be studied. They make all kinds of tests to tell more about [the pots].

Interchange of ideas and commodities is a vital part of cultural process, and it would be absurd to argue that Native American culture in the twentieth century is in any way pristine. Ever since their ceramics became a saleable commodity, Acoma and Laguna potters have been influenced by individuals such as Nancy Winslow, Katie Noe, and others. As a potter first, a collector second, and a dealer last, I have access to potters and their work in a number of ways, and I have offered ideas to potters that may well have affected the styles and designs they produce. Perhaps my experience will illuminate the fine distinction between taking a legitimate interest in the creative process of the Pueblo potters and meddling in pottery making.

When Native American potters ask me for ideas, I am quick to offer help based on my knowledge of old Indian pottery. I also make suggestions to contemporary potters stuck in creative or technical ruts or stymied by the demands of the marketplace, if I believe my opinion will be of assistance. The information I give in these conversations stems from my own journey through the art world; I provide feedback and ideas out of a sense of camaraderie in craftsmanship and to help potters generate new ideas to increase their sales.

This is an exchange among equals, a dialogue among colleagues; yet even so I sometimes ask myself if it is appropriate to offer this information or feedback. Does my influence on an artist's work compromise its "authenticity"? Am I creating an undesirable sense of dependency? Or am I, as I believe, engaged in a legitimate give-and-take among peers? I feel that any interpretation other than the last is patronizing toward

Native American artists and assumes that they should be strictly limited in their expression to what the dominant society feels is traditionally "Indian."

Today Acoma and Laguna potters participate and interact with Anglo scholars and dealers in ways that decrease the meddling aspect of Anglo–Native American communications. I have been fortunate to have had the active assistance of a number of potters in my own research. Gladys Paquin, for example, who knew of my interest in putting together this book, has helped me by collecting and saving historic and ancient sherds that she found and knew would assist the research. At the same time, these sherds have served as inspiration for her own work. Indian artists today apply for grants to study art history, the history of their crafts, and other related fields that will enhance the depth and appreciation of their work. As potters become more self-sufficient and confident in their interactions with Anglo individuals and society, the problem of undue Anglo influence will recede.

Acoma and Laguna Potters in the Future

Research on Acoma and Laguna pottery today spotlights the wide range of new directions in which Indian potters may move. Some potters have not only researched the history of their own pottery but have also experimented with techniques of potters from cultures throughout the world. The modern Acoma or Laguna potter may ask a client, "Do you want Mimbres style, Chaco style, traditional Acoma or Laguna style, or would you prefer an innovative, contemporary product?"

The versatility of the modern potter creates identity questions unknown to earlier Indian craftspeople. Is all pottery made by Indians Indian pottery? Many potters have crossed over into nontraditional styles and techniques. The marketplace defines most pottery made by an Indian as Indian pottery, but it remains an open question whether this label is really valid. A lot of Anglo potters are making "Indian-style" pottery to compete in the same marketplace, and Native Americans are increasingly competing in the fine arts market.

"Everybody's changing," says Laguna-born potter Verna Solomon. But despite changes, the values that Acoma and Laguna potters adhere

to today are encompassed by Pueblo tradition, which recognizes established ways of doing things while providing the flexibility necessary to adapt to circumstances. Tradition is a living concept and experience, a state of mind and being that evolves with time and in response to cultural needs. In his book *Lost and Found Traditions*, Ralph T. Coe sums up tradition thus:

> The Indian view is that tradition, like time, cannot be measured. It exists within everything, a sort of wholeness or all-ness that man touches, or establishes contact with, at every point, but particularly when he is in a ritualistic state. It is more than custom, belief, or myth. It is an essence that explains to Indians what they are psychologically. It manifests itself at different levels. Though it can be expressed, finally, by dance, ritual, or symbols, it is none of these things. It is something Indians step into in order to be themselves. (Coe 1986:46)

Potters use this awareness of tradition to create ceramics that gracefully encompass the old and the new. For the Pueblo people, tradition involves using the past to ground the present and to serve as a bridge for moving into the future. "I like change," says Verna Solomon, a ceramic artist, teacher, and museum curator, "but I also like tradition. I have both in me and I try to show it in my art." Solomon's work exemplifies the many different currents influencing Native American art today. Trained in traditional techniques by a well-known potter, Blue Corn of San Ildefonso, and in other methods by Anglo and Native American teachers, Solomon works in stoneware (hand-built and wheel-thrown), low-fired earthenware, and raku, a Japanese technique, as well as traditional Laguna style. But as she emphasizes, "All the ideas I've ever had in my pottery have kept the Native American elements I keep in me. With the raku I've used turquoise stones or modeled kiva steps, representations of nature and some part of my southwestern upbringing" (fig. 8.8).

In a matter of only five centuries, Acoma and Laguna pottery has been transformed. Starting from the exceptional glazewares of the late 1600s, it has developed through the great variety of elaborated forms of the 1700s and 1800s, to early twentieth-century tourist and commercial pottery, and finally to glazewares of commercial manufacture and the

highly individualized artworks of contemporary artists. But even in the innovative wares of today, a strong undercurrent of tradition prevails. Most of the forms found in the marketplace have been handed down—or rediscovered—and they are still widely respected by Pueblo people as the best way of shaping a pot. About such ancient forms potters will say, "This is the old way, the way my mother did it."

"It is good to keep tradition so it won't die out," maintains Verna Solomon, "but we also want the children to express themselves. If we are going to compete with non-Indians in contemporary art, we have to go with the flow." For the future of pottery making, the attitudes of young Native Americans are crucial. I have no doubt that the buoyancy, pride, and humor of the potters of Acoma and Laguna, along with their tremendous technical skill, creative talent, and aesthetic sensibility, will continue to inspire the coming generations of Pueblo youth to practice, develop, and transform their native artistic traditions in ways that reflect the past and embrace the future.

Figure 8.8. "Buffalo Spirit," 1991. This mixed-media mask by Laguna artist Verna Solomon combines earthenware fired in the raku technique, pheasant and macaw feathers, coral, silver, bone, and straw in a nontraditional contemporary statement.

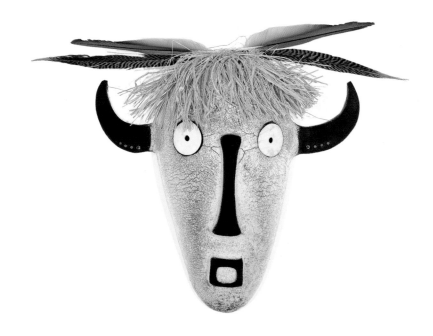

Potters at Acoma, Laguna, and Nearby Villages in 1910

In 1910 the thirteenth annual census of the United States was conducted at Acoma and McCartys villages by Leopold Bibo. The census listed a total of 76 individuals as potters by occupation (New Mexico State Archives, Call T624, Roll 919); the lists are reproduced here as recorded in the state archives. In the same year at Laguna Pueblo, census-taker Walter K. Marmon identified only one person, Yamie B. Leeds of Seama, as a potter.

Potter	Age	Potter	Age	Potter	Age
ACOMITA VILLAGE (62 potters)		Soledad Berendo	60	Teodorita Matai	60
		Grace Ziutie	35	Maria Toribio	35
		Santana Koowakami	40	Lupita Louis	55
Doloritas Martin	60	Maria Poncho	38	Juanarita Serna	50
Consepsion Valle	25	Annie Miller	45	Consepsion Watzai	65
Luisa Victorino	40	Maria Cooyaitie	65	Candelaria Cajero	77
Doloritas Victorino	30	Keyteayai Yamoon	65	Lupy Sarrasino	55
Consepsion Antonio	20	Lupe Toribio	65		
Juana Antonio	70	Consepsion Juachonpino	65		
Consepsion Victorino	55	Lorita Juachonpino	55	McCARTYS VILLAGE (14 potters)	
Lupe Chino	43	Manuelita Sanches	45		
Maria Antonia Chino	75	Maria Corai	45		
Maria Beuina Antonio	50	Rosita Pujacante	50	Andrea Miller	50
Juanita Chino	30	Mariantona Lola Hishi	40	Lupe Miller	70
Juanarita Layo	55	Marcelina Sanantinio	65	Rufina Salvador	55
Juana Maria (?) Poncho	50	Dolores Scaiseloh	65	Tulis Platero	40
Lupita Siemaniowie (?)	49	Maria Coowai	45	Juana Maria Teakamai	40
Juanita Dolores Estevan	40	Lupita Schutio	45	Lupy Garcia	55
Consepsion Zuni	50	Juana Maria Schutio	35	Dolores Garcia	65
Lores Bicente	60	Pablita Waniehe	65	Maria Platero	25
Juanarita Rontzi	45	Pablita Waniehe (daughter)	28	Lupy Andres	60
Consepsion Waitie	45	Juana Waneih	50	Maria Seitemai	65
Juana Maria Antonio	45	Albina Payatiamo	30	Pabla Yaca	35
Rosita Garcia	35	Juana Pasqual	45	Juana Maria Yaca	65
Marcelina Shawrutie	45	Juanarita Sea-atie	60	Juan(a) Maria San (listed as female)	65
Maria Payatiamo	39	Rosita Edwards	35	Dolores Garcia	41
Consepsion Haskea	50	Juanita Johnson	25		
Lorencita Juachonpino	35	Maria Zuni	50		

Appendix B

Potters Working at Acoma
and Laguna Pueblos in 1991

I assembled the following list of potters from Acoma and Laguna between 1986 and 1991, collecting names and information at pueblo feast days, the New Mexico State Fair, shops and galleries, and the annual Indian Market in Santa Fe. Lists supplied by Raymond Concho from Acoma and Ward Alan Minge were cross-referenced with the potters I came in contact with. Because so many of today's potters work in a variety of styles and materials, no attempt has been made to distinguish those working in a more traditional mode from those creating commercial "ceramic" wares. (For another listing of Acoma "artisans and trainees" in pottery, see Minge 1976: appendix 6.) Potters deceased since this list was compiled are noted with a (d) following their names. As of this writing, some 345 Acoma and 30 Laguna potters are active. My apologies to those whose names are not included in this list.

ACOMA PUEBLO

Abeita, Tamra L.	Aragon, Clarice	Castillo, Irene	Chino, Gilbert
Abenita(?), Fernando	Aragon, Daisy	Cerno, Annie	Chino, Grace
Abeyta, Pauline	Aragon, Delores	Cerno, Brenda	Chino, Iona
Albert, Cedric	Aragon, Edna	Cerno, Connie O.	Chino, Jeffrey
Amos, Louise	Aragon, Florence	Cerno, Joe and Barbara	Chino, Keith
Analla, Kathryn	Aragon, John	Charlie, Ann	Chino, Laura V.
Antonio, Blanche	Aragon, Karen	Charlie, Carrie Chino	Chino, Marie Zieu (d)
Antonio, Daniel	Aragon, M.	Charlie, Connie	Chino, Maurus
Antonio, Dora	Aragon, Mary	Charlie, Isabel	Chino, Myra
Antonio, Hilda	Aragon, Rachel	Charlie, LaVerne	Chino, Myrna
Antonio, Josephine	Aragon, Wanda	Chavez, Clara H.	Chino, Nellie
Antonio, Louis	Armijo, Phyllis	Chavez, Elvira	Chino, Terrance M. and
Antonio, Melissa	Arnold, Rachel	Chavez, Rose Leno	Colleen
Antonio, Mildred	Ascencio, Margaret	Chavez, Sam	Chino, Velma
Antonio, Randy and	Augustine, Christopher	Chavez, Vanessa	Concho, Adeline
Frederica		Chino, Becky	Concho, Angela
Antonio, Santana	Barreras, Joyce	Chino, Corrine J.	Concho, Carolyn
Antonio, Steven and Diedra	Boren, Ruth	Chino, Debbie	Concho, Celeste
Antonio, Toni	Bradley, Helen	Chino, Donna	Concho, Daisy
Aragon, Alice	Brown, Debbie	Chino, Edna	Concho, Isidore and
Aragon, Bernadette	Brown, Fae	Chino, Emmalita	Frances
Aragon, Bernie	Brown, Mabel	Chino, Everett	Concho, Lillian

Concho, Lolita (d)
Concho, Lorianne and Cyrus
Concho, Pablita
Concho, Pat
Concho, Rachel
Concho, Rebecca
Concho, Santana
Concho, Sheila
Correa, Prudy (lives in Isleta)

Davis, Darla
DeLorme, Bryan

Edwards, H.
Edwards, Josie
Emanuel, Jerilyn Lowden
Engle, Tina Garcia
Estevan, Charlene

Faustine, Conception

Gallegos, Viola
Garcia, Aaron
Garcia, Arlene
Garcia, Beatrice
Garcia, Bert
Garcia, Christopher and Loretta
Garcia, Connie
Garcia, Corrine
Garcia, Delores Lewis
Garcia, Elizabeth
Garcia, Jessie (d)
Garcia, Joann Chino
Garcia, Josephine
Garcia, Lita
Garcia, Margaret
Garcia, Marie
Garcia, Mary Lewis
Garcia, Nina
Garcia, Pauline
Garcia, Peggy
Garcia, Regina
Garcia, Robert
Garcia, Rosemary Chino

Garcia, Sally
Garcia, Sarah
Garcia, Sharon
Garcia, Virgie
Garcia, Virginia
Garcia, Wilfred, and Sandra Shutiva
Garcia-Cerno, Gail S.
Garcia, Nellie

Hansen, Anne Lewis
Hayah, Angela
Hayah, Esther
Hayah, Mavis
Henderson, Marilyn
Hepting, Cecelia
Histia, Bennett Greg, and Jackie Shutiva
Histia, Daisy
Histia, Eva
Histia, Jackie
Histia, Margaret

Iule, Pat

James, Rachel
Jim, Priscilla
Joe, Loretta
Johnson, Florence
Johnson, Lois
Juanico, Brenda
Juanico, D. M.
Juanico, Lucy
Juanico, Marie
Juanico, Marietta
Juanico, Phyllis
Juanico, Rita

Keene, Juanita
Kim'a'aits'a
King, Juanita
Kohlmeyer, Reina L.

LaBelle, Gloria
Leno, Bonnie
Leno, Juana
Leno, Vina and Joseph

Leon, Julie
Leon, June
Leon, Philip
Lewis, Alvin, Jr.
Lewis, Andrew
Lewis, Carmel Haskaya
Lewis, Cynthia
Lewis, Daisy
Lewis, Diane
Lewis, Germaine
Lewis, Grace
Lewis, Katherine
Lewis, Lucy Martin (d)
Lewis, Sharon
Liptow, Emma
Louis, Carmen
Louis, Carrie
Louis, Corrine and Gary
Louis, Ervin
Louis, Jessie
Lowden, Mary
Lowden, Virginia
Lucario, Caroline
Lucario, Jennie
Lucario, Juana
Lucario, Rebecca
Lucero, Nelda
Lukee, Mary
Lukee, Nancy Ann
Lukee, Remalda

Mahkee, C.
Maldonado, Irma
Malie, Rita
Martinez, Stephanie
Martinez, Evelyn
Martinez, Harold (d)
Martinez, Margaret
Martinez, Sarah
Miller, Barbara
Miller, Karen
Miller, Marie
Miller, Merlinda
Miller, Sharon
Mitchell, Emma Lewis

Natseway, Charmae Shields (husband is Laguna potter Thomas Natseway)

Ortiz, Chuck and Carla
Ortiz, Evelyn
Ortiz, Ida
Ortiz, Juanalita
Ortiz, Mamie (d)
Ortiz, Norma Jean
Ortiz, Viola M.

Paisano, Elizabeth
Paisano, Lee and Liz M.
Paisano, Michelle
Pasqual, Juana
Pasqual, Laura
Pasqual, Roseanne
Pasquale, Aurelia
Pasquale, Camille Sanchez
Pasquale, Katerina
Pasquale, Ramalda
Pasquale, Rita
Patricio, Darrell
Patricio, Doug
Patricio, Francis
Patricio, Israel
Patricio, Joyce
Patricio, Leo
Patricio, Michael
Patricio, Myron P.
Patricio, Patrick and Doris
Paytiamo, Alice
Pedro, Agnes
Peters, Ella
Phillips, Santana
Pino, Edna
Poncho, Adella
Poncho, Gertrude R. (Shdiya'araits'a), and Richard L. Martinez (from Laguna)

Ramirez, Betty
Ramirez, Nadine
Ray, Joselita

ACOMA PUEBLO

Ray, Lydia
Ray, Rose
Ray, Sandra
Reid, Luann
Reid, Magdeline
 (Maggie)
Rodriguez, Pam
Romero, Aaron and
 Cynthia
Romero, Gertrude Ann
Romero, Greg and
 Mary
Romero, Juanita
Romero, Pat
Romero, Patricia and
 Albert
Routzen, Bear
Routzen, Devine
Routzen, Elsie
Routzen, Katherine
Routzen, Mae
Routzen, Marcie
Roy, Adrian

Salvador, Darlene
Salvador, Gary
Salvador, Gloria
Salvador, Lillian
Salvador, Veronica
Sanchez, Dale
Sanchez, Dorothy
Sanchez, Earline
Sanchez, Josephine (Jo)
Sanchez, Mary
Sanchez, Monica
Sanchez, Selina
Sandee, Mary
Sandoval, Cecelia
Saracino, Mildred
Sarracino, Edwin and
 Minerva
Sarracino, Faith and
 Zelda
Sarracino, Francis
Sarracino, Jolene
 "Mickey"

Sarracino, Leona
Sarsina, Juanita
Scissons, Sandra
Sena, Daisy
Sena, Margaret
Seymour, Christopher
Seymour, Lois
Seymour, Margaret
Seymour, Mary
Seymour, Vivian
Shields, Ethyl
Shields, Judy
Shroulote, Ilene and
 Warren
Shutiva, Jackie
Shutiva, Regina Leno
Shutiva, Sandra
Shutiva, Stella (d)
Stevens, Irene
Stevens, Sharon
Stevens, Virginia
Suazo, Dale

Toribio, Edna
Toribio, Edwin Francis
Torivio, Brenda
Torivio, Dorothy
Torivio, Frances
Torivio, James
Torivio, Katherine
Torivio, Lambert
Torivio, Lena
Torivio, Marie
Torivio, Mary
Torivio, Mike and
 Jackie
Trujillo, Adrian
Trujillo, Merlinda
Trujillo, Yolanda
Tuttle, Anita
Tuttle, Tina

Valdo, Margie
Valdo, Pearl
Valley, Dorothy
Vallo, Darlene

Vallo, Delilah
Vallo, Elizabeth
Vallo, Ergil
Vallo, Eva
Vallo, Florinda
Vallo, Genevieve
Vallo, Helen (d)
Vallo, Jay
Vallo, Jenny
Vallo, Juana
Vallo, Lee and Jo
Vallo, Lilly
Vallo, Lucita
Vallo, Mabel
Vallo, Pearl
Vallo, Santana (d)
Vallo, Simon and Marie
Vallo, Susie
Vallo, Velma
Vicente, Gordon and
 Star R.
Vicente, Regina
Vicente, Santana
Victorino, Bernadette
 (Bernie)
Victorino, Beverly
Victorino, LaDonna
Victorino, Sandra
Victorino, Virginia

Waconda, Debra
Waconda, Elizabeth
Waconda, Florence and
 Fred
Wanya, Billie
Wanya, Elma
White Dove, Shayetsa
Wilkinson, Martha
Wilson, Nora

LAGUNA PUEBLO

Cheromiah, Evelyn
Cheromiah, Josephita
Cheromiah, Lee Ann
Cheromiah, Mary
Curtis, Molly
Davis, Miriam
Early, Max (Paguate)
Garcia, Sally
Koyona, Ruth
Littlebird, Harold
Lucario, Art
Lucario, Paul, Jr.
Martinez, Richard
 (works with wife
 Gertrude Poncho
 of Acoma)
Mooney, Josephine
Natseway, Robert
Natseway, Thomas
 (works with wife
 Charmae at Acoma)
Padilla, Andrew Jr.
Padilla, Danny (d)
Paisano, Michelle
Pancho, Mabel
Paquin, Gladys
Pedro, Sherrel
Pino, Claire and
 Lambert
Pino, Regina
Pino, Romona M.
Romero, Anthony and
 Linda
Sarracino, Jeanette
Sarracino, Myron
Smith, Tim (Hopi
 style)
Whitmore, Bernadette

Signs of Commercial Origin in Pueblo Pottery

Certain criteria can assist the buyer in determining the difference between slip-cast ceramic wares (formed by pouring a clay slip into a plaster mold), handmade pottery made with native materials, and handmade pottery using commercial materials (clays and paints). Some of the more diagnostic characteristics of slip-cast and commercial wares are discussed below.

FORM:
- Forms of mold-made pieces vary greatly, from old-style or utilitarian items such as simple pots and wedding vases, to spoon holders and decorative bric-à-brac. Many animal forms are made. Lamps, mugs, and plates meet modern standards of utilitarian pottery. Shops carry many examples of the same form, made unique with the application of different designs.
- The surfaces and thicknesses of slip-cast wares generally show a high degree of uniformity, unless the mold from which they were cast was taken from a handmade piece. When still wet, molded wares are sometimes altered by hand to give them a less uniform, more handmade look.
- Drips from excess slip may be visible inside the slip-cast piece.
- If the mold markings or seams have not been sanded smooth, they may be visible on the outside of the piece.
- Commercially prepared clay can also be used to hand-build pottery.

SLIPS:
- Commercial slips used to make ceramic pieces vary from one hobby shop to the next, but usually are extremely white ("too white"). Occasionally, native clay may be made into a slip and used in the molds. Colored clays may also be used, and red is a current favorite.

FIRING:
- Commercially made pottery is fired at high temperatures, and the ring of the pot can be like that of bone china. Since kiln-fired native clay also rings very high, this trait is not necessarily diagnostic.

SURFACE DECORATION:
- Commercial paints yield very even colors and textures; native paints show greater variation.
- Underglaze colors such as green, blue, and purple are used in commercial ceramic wares. Underglazes and "one-stroke" are commercially prepared pigments made from a mineral base and used to paint designs on unfired greenware. Underglaze needs two or three coats; one-stroke only one. Synthetic-based "bisque stains" are also used as post-fired decoration, yielding very bright colors.

 Certain commercial treatments, for example, orange and yellow underglazes, can very closely match the native slips. After the piece is given a bisque, or initial, firing to set the painted design, a vitreous glaze can be applied to render the pot waterproof. The piece is then fired again to mature the glaze.
- Ceramic decals of realistic figures, flowers, religious personages, and so forth are often used as decoration on slip-cast wares, as are fired-on gold, silver, copper, platinum, and various opalescent finishes.

SIGNATURES:
- On mold-made pieces, the signature is usually that of the painter and is generally identified as such. Pieces made by hand usually bear just one signature, that of the potter who both coiled and decorated the pot. Collaborative pieces may be signed by both artists. Some pieces today may also carry a notation that the pot is handmade.

Appendix D

Catalog of Acoma and Laguna Pottery in the Indian Arts Research Center, School of American Research

The Indian Arts Research Center at the School of American Research (SAR) contains over four hundred pieces of pottery from Acoma and Laguna pueblos, the majority of which were donated to the School by the Indian Arts Fund (IAF). Founded in 1922 as the Indian Pottery Fund and incorporated in 1925, the IAF was established to collect and preserve fine examples of historic southwestern Indian art and to keep that art from leaving the Southwest. The collection was deeded to the School of American Research starting in 1966. In 1978 it was deposited in the newly constructed Indian Arts Research Center (IARC) at the School.

This appendix lists the pottery from Acoma and Laguna pueblos housed in the Indian Arts Research Center and cataloged before September 1991. The pottery is organized according to the time periods during which the pieces were made, which correspond roughly to the major pottery types. These chronological divisions are 1650–1750, late 1700s–1860, 1860–80, 1880–1900, 1900–1920, 1920–40, 1940–60, and 1960–91. Within each time period, pieces are listed numerically by accession number.

By far the largest number of pieces of Acoma and Laguna pottery (226) date to the period between 1880—the coming of the railroad—and 1920. A great number of these were collected for the IAF by Kenneth M. Chapman in 1928. Pottery made earlier than 1880 was rare even at the time Chapman was collecting; still, the School's collection is one of the finest in existence for the early historic and historic periods.

For each piece in the collection, the following information is provided: acquisition number (IAF or SAR, marked with an asterisk if illustrated); page number of photograph; tribal affiliation and type of vessel (water jar, canteen, dough bowl, etc.); pottery type; maker (if known); a brief description of the piece, including information on form, construction, slip colors, and design motifs; dimensions in inches (height x diameter); date; collection data where available; name of donor; and date of acquisition.

1650 to 1750

IAF 333. Acoma bowl, Ako Polychrome. Band of black split-feather motifs on a floated(?) pink surface; feather pattern similar to IAF 1032. 2" x 6 ½". 1700–1740. Gift of John G. Evans; purchased at Acoma, 1924.

IAF 628. Acoma or Zuni jar, Ako or Ashiwi Polychrome with unusual constricted neck. White slip with black and red feather motif and pinkish-red underbody slip. 8 ½" x 5". 1700–1750. IAF purchase, Acoma, by K. M. Chapman, 1926.

IAF 935. Acoma bowl, Hawikuh Polychrome. Band of four opposing feather and fret designs in red slip and (eroded) green glaze on white slip. Red-slipped underbody. 7" x 12 ½". 1650–1700. IAF purchase, Acoma, by K. M. Chapman, 1928.

*IAF 996 (p. 36). Acoma jar, Hawikuh Glaze-on-red. Two bands of design: neck, stepped zigzags and band of triangles; bulge, band of geometric motifs including split half circles with "eyes" and feathers. Thin, with sculpted rim. 11 ½" x 16 ½". 1650–90. IAF purchase, Acoma, by K. M. Chapman, 1928.

*IAF 999 (p. 91). Acoma jar, Ako Polychrome. Classic domed (mushroom) form with sculpted rim. White-slipped upperbody with two panels of feather motifs and two with hooked fret motifs with "eyes". Red-slipped base. 12" x 15". 1720–30. IAF purchase, Acoma, by K. M. Chapman, 1928.

*IAF 1032 (p. 29). Acoma or Laguna jar, Ako or Tecolote Polychrome. Characteristic domed top and concave base. Red sand-tempered clay with orange upperbody slip and deep red basal slip. Paneled split-feather design in sintered paint. 11 ½" x 14 ½". 1720–30. IAF purchase, Acoma, from Gladys Chavez by K. M. Chapman, 1928.

IAF 1037. Acoma(?) jar, Little Colorado Glaze Polychrome (Mera 1939). Round form with short vertical neck. White-slipped upperbody and red-slipped base. Stylized birds in red slip and glaze with floating Xs. Appears to be sherd temper. 8 ½" x 14". Pre-1600(?). IAF purchase, Acoma, from Concepcion Mariano by K. M. Chapman, 1928.

*IAF 1185 (p. 125). Acoma jar, Hawikuh Black-on-red. Well-potted form with severe midbody bulge and sculpted rim. Entirely red slipped; painted with deep black glaze in a six-panel design around the bulge. 9 ½" x 15". 1650–90. IAF purchase, 1929, from B. A. Reuter, who bought it at Acomita.

*IAF 1618 (p. 98). Acoma jar, Ako Polychrome. Domed form, sculpted rim and concave base. White-slipped bulge and upperbody with two arched feather motifs and stepped

fill elements. 9 ½" x 13". 1700–1720. IAF purchase, Acoma, from Concepcion Tsinatay, 1931.

Late 1700s to 1860

IAF 645. Acoma jar, Acomita Polychrome. Probable floated or thinly slipped base (yellowed with time) and white-slipped upperbody. Short undecorated vertical neck. Two major red design elements with possible Santa Ana influence. 11" x 11 ½". 1780–1820. IAF purchase, Acoma, by Leslie A. White, 1926.

*IAF 795 (p. 92). Acoma jar, Acomita or Acoma Polychrome. Large white-slipped jar with decoration in red, orange, and black. Arc decoration around the neck and an outflaring rim. 16" x 16 ½". 1840–60. IAF purchase from Frank G. Applegate, 1927; collected at Acomita.

*IAF 797 (p. 16). Laguna(?) jar, Acomita Polychrome, Laguna variety. Unusual underbody band in polished red slip (reminiscent of Zia and Santa Ana) with a floated, concave base and short undecorated neck. White-slipped upperbody with large areas of deep red (a Zia and Santa Ana trait) and an upside-down bird motif. 9" x 11 ½". 1780–1800. IAF purchase from Frank G. Applegate, 1927; collected at Acomita.

*IAF 936 (p. 72). Acoma or Laguna bowl, Acomita Polychrome. Thick construction with rock temper; white-slipped interior and exterior design band; traces of red slip on base. Triangular appended scroll (rainbird) in thin band. 10 ½" x 19 ½". Ca. 1800. IAF purchase, Acoma, by K. M. Chapman, 1928.

IAF 960. Acoma jar, Acomita Polychrome. Round body with concave base and short vertical neck. Red-slipped base, unslipped bottom; orange-red in the interior rim. Scalloped neck band. Elaborate red-and-black geometric and curvilinear stylized bird. 9" x 10". 1840–50. IAF purchase, Acoma, by K. M. Chapman, 1928.

IAF 1001. Acoma or Laguna bowl, Acomita Polychrome. Thick, uneven construction with flat base. Smudgy red-slipped interior, lighter orange base, white exterior band. Stepped scroll-key design in black mineral paint with open three-lobed motifs. 11" x 20". Ca. 1800. IAF purchase, Acoma, by K. M. Chapman, 1928.

*IAF 1009 (p. 31). Laguna(?) jar, Acomita Polychrome. High domed form reminiscent of Ako Polychrome; short undecorated vertical neck and concave base. Four-color polychrome with floating arc and paddle motifs. Red rim, deep red base. 10" x 12". 1760–80. IAF purchase, Acoma, by K. M. Chapman, 1928.

IAF 1028. Acoma or Laguna bowl, Acomita Polychrome. Flat bottom; floated base with orange patina (possibly a thin orange slip) and wide band of black design on white slip. Floral "pomegranate" motif and curved-edge triangles. 10" x 18 ½". 1800–1820. IAF purchase, Acoma, by K. M. Chapman, 1928.

IAF 1029. Laguna or Acoma bowl, Acomita or Laguna/Acoma Polychrome. Medium-sized bowl with puki marks and squared-off vertical rim. Four design panels on white slip; white interior. 7" x 10 ½". 1820–60. IAF purchase, Acoma, by K. M. Chapman, 1928.

IAF 1034. Acoma jar, Acomita Polychrome. Bulbous body, concave base, and tall vertical rim. Diagonal design layout has brown-black geometric elements with open circles and small curls. Band of solid arcs at neck. 10" x 12 ½". 1800–1820. IAF purchase, Acoma, from Juanita P. Edwards by K. M. Chapman, 1928.

*IAF 1036 (p. 30). Acoma jar, Acomita Polychrome. Large storage jar with a round body and slightly flattened base. White-slipped with black-and-orange design; Santa Ana influence seen in scrolls with pendant triangles and open circles. Band of black scallops at neck. 14" x 16". 1800–1820. IAF purchase, Acoma, by K. M. Chapman, 1928.

IAF 1059. Acoma or Laguna bowl, Acomita Polychrome. White-slipped exterior band with simple black geometric design in panels; red interior and base. Heavy construction with squared-off rim and flat base. 6 ½" x 13 ½". 1820–50. IAF purchase, Acoma, 1928.

IAF 1151. Acoma or Laguna jar, Acomita Polychrome. Large storage jar with flat base. Elaborate curvilinear design in bordered red slip of scroll and two- and three-lobed forms. Scallops around the slightly outflaring neck. 17" x 17". 1800–1840. IAF purchase, Acoma, by K. M. Chapman, 1928.

IAF 1199. Acoma or Laguna jar, Acomita or Acoma/Laguna Polychrome. Transitional jar with Acomita Polychrome traits (short neck and scallops); other attributes (short, incurving neck and tight design) suggest a later date. 8 ½" x 11 ½". Ca. 1850. IAF purchase from Pete Alarid, 1929.

IAF 1571. Acoma jar, Acomita Polychrome. Squat, with tall vertical neck and concave base. Four-lobed medallions in orange and red make a four-color polychrome. 10" x 12 ½". 1800–1840. Gift of Andrew Dasburg, 1931.

*IAF 1575 (p. 135). Acoma or Laguna bowl, Acomita Polychrome. Large unevenly constructed bowl with outflaring walls and squared-off rim. Band of triangular motifs is divided into two panels. Tall underbody has traces of deep orange slip. 11" x 18". 1800–1830. IAF purchase, Acoma, by K. M. Chapman from Santana A. Garcia, 1931.

*IAF 1638 (p. 138). Laguna(?) jar, Acomita Polychrome. Bulbous body with concave base and short neck. Design band of interlocked oval elements with double-dot motifs around the body; band of solid triangles at neck. 11" x 13 ½". 1800–1840. IAF purchase from Concepcion Haweya, Acoma, 1931.

IAF 1675. Acoma or Laguna bowl, Acomita Polychrome. Large, flat-based bowl with round body and outflaring rim. Geometric design with red slip: diamond within a square, open "eyes," elongated triangles. Thin orange slip on underbody; white interior. 10" x 20 ½". 1830–50. IAF purchase from Maria Garcia, Santa Fe, 1931.

*IAF 1687 (p. 93). Acoma jar, Acomita Polychrome. Four-color polychrome with two diamond motifs and pendant scrolls with rainbird elements. Orange base and interior rim. 9 ¾" x 12". 1800–1830. IAF purchase from P. G. Sanchez, 1931.

1860 to 1880

*IAF 227 (p. 148). Acoma jar, Acoma Polychrome. Well-formed and -painted jar with bold black design: two major bilaterally symmetrical elements with split circles, "eyes," double dots, and open arcs in solid black areas. Slight construction flexures. 10" x 13". 1865–75. Gift of Col. R. E. Twitchell, 1924. Given to Twitchell by Román A. Baca of Providencia (San Mateo), NM, who owned it for many years.

IAF 332. Laguna(?) bowl, Laguna Black-on-red. Unusual form with concave upper rim. Eroded red-slipped interior and worn red-slipped exterior. Black geometric design bands on neck and body. Large white inclusions in the paste. 9" x 16". 1870–80. IAF purchase, Acomita, by K. M. Chapman, 1924.

IAF 992. Acoma jar, Acoma Polychrome. Unusual neckless form (seed jar?) with short, black-painted rim (reminiscent of Ako). Design consists of six ovoid units. Rough-scraped, red-slipped base and interior rim. 7" x 10 ½". 1865–75. IAF purchase from Mrs. Charles Haynes, 1928.

IAF 995. Laguna(?) bowl, Laguna Polychrome(?). Flat-based, open bowl with red-polished interior and base. White-slipped exterior with curvilinear triangle motifs. Large chunky inclusions in the paste. 9" x 15 ½". 1860–80. IAF purchase, Acoma, by K. M. Chapman, 1928.

*IAF 997 (p. 71). Laguna or Acoma bowl, Laguna or Acoma Polychrome. Large bowl with white interior and wide exterior design band in black, red, and orange. Lobed "pinwheel" motifs linked by split-leaf elements. 10" x 17–18 ½" (warped). 1870–80. IAF purchase, Acoma, by K. M. Chapman, 1928.

IAF 1000. Acoma or Laguna bowl, Acoma or Laguna Polychrome. Large bowl with curving high walls, squared-off rim, and puki marks. Bold geometric design with open "eyes" and triangular motifs. White interior and red base. 9" x 17". 1860–80. IAF purchase, Acoma, by K. M. Chapman, 1928.

IAF 1027. Laguna or Acoma bowl, Laguna or Acoma Polychrome. Flat base with puki mark; widely outflaring walls. Five D-shaped elements with double dots. 9" x 17". 1850–70. IAF purchase, Acoma, by K. M. Chapman, 1928.

*IAF 1039 (p. 32). Acoma jar, Acoma Polychrome. Squat form with bold bar-style elements and two elaborate parrots in arcs of alternating orange and black split rectangles. 8" x 11". 1870–80. IAF purchase by K. M. Chapman, 1928.

IAF 1040. Laguna jar, Laguna Polychrome. Very chunky paste with some rock inclusions. Five orange geometric units have Santa Ana-style open arcs, and pinwheel motifs with large double-dots. 9 ½" x 11 ½". 1870–80. IAF purchase, Acoma, from Marie Romero by K. M. Chapman, 1928.

IAF 1060. Laguna or Acoma bowl, Laguna or Acoma Polychrome. Hemispherical form with flat base. Three ellipse motifs appear in connecting geometric elements painted in bordered orange and heavy black. 8" x 13". 1875–90. IAF purchase, Acoma, 1928.

IAF 1067. Laguna or Acoma bowl, Laguna or Acoma Polychrome. White-slipped interior and exterior with flat, red-slipped base. Repeating bold geometric design with curvilinear triangles. 7" x 12 ½". 1860–80. IAF purchase, Acoma, 1928.

IAF 1085. Laguna jar, Laguna Polychrome. Tall-necked form with split-ellipses and double dots in three interlocked units. Chunky paste with red inclusions (rock, tuff, or sherds). 13" x 15". 1860–75. IAF purchase, Acoma, 1928.

IAF 1090. Laguna or Acoma jar, Laguna or Acoma Polychrome. Squared-off body with strong puki mark at the base and tall vertical neck. Four diamond motifs with split ellipses in the centers. 8" x 9". 1870–75. IAF purchase, Acoma, 1928.

IAF 1448. Laguna(?) bowl, Laguna Polychrome(?). Shallow, heavily constructed bowl construction and strong puki mark at base. Red floral motifs with black connecting "leaves." 7" x 15". 1870–75. Gift of Seligman Brothers, 1930.

IAF 1578. Acoma or Laguna canteen, Acoma or Laguna Polychrome. Rounded vessel with two handles (one broken) and red base. Orange and red bird-and-heart motifs. 12 ½" x 10". 1870–75. IAF purchase, Acoma, from Lupita Sanchez, 1931.

*IAF 2720 (p. 147). Laguna or Acoma jar, Laguna or Acoma Polychrome. Heavy construction with puki mark at base and flexure at the upperbody-neck junction. Two bold bar-style crosses; diagonal bands of geometric elements. 11 ¼" x 13 ⅝". 1870–80. Gift of R. M. Tilghman.

IAF 2917. Acoma jar, Acoma Polychrome. Wide form with incurving neck and squared-off rim. Banded design in bold bar style with split-leaf and double-dot elements. 10" x 12 ½". Ca. 1870–75. A tag on the base reads "110132 Acoma N.M. Stevenson Bur Ethnology". IAF purchase from Mrs. Ernest T. Love.

1880 to 1900

IAF 44. Acoma jar, Acoma Polychrome. Four-color polychrome; four medallions, attached geometric elements, much open space. 8" x 10". 1890–1900. IAF purchase from J. F. Collins, 1923.

IAF 46. Laguna or Acoma jar, Laguna or Acoma Polychrome. Banded design of stepped and hatched geometric elements. Heavy construction, indented interior rim. 10" x 12". 1890–1910. IAF purchase, Southwest Arts and Crafts, Santa Fe, 1923.

IAF 47. Acoma jar, Acoma Polychrome. Four diamond motifs with crosses in the center. Rawhide repair at neck. 9 ½" x 11 ½". 1890–1900. Gift of Theodore Wagner, 1923.

IAF 52. Laguna jar, Laguna Polychrome. Banded design in black on thick white slip. The body design consists of linked stepped elements with triangular elements as filler. 11" x 12 ½". 1890–1900. IAF purchase from Wesley Bradfield, 1925.

IAF 54. Acoma jar, Acoma Polychrome. Three vertical panels of repeating design with a central diamond in each. Panel dividers are thin vertical hatched zigzags. 12" x 13". 1890–1900. IAF purchase from Wesley Bradfield, 1923.

IAF 136. Acoma jar, Acoma Polychrome. Tall-necked form with elaborate allover pattern of split triangles, hatching, and terraced elements. 12" x 13". 1890–1900. Gift of Albert Sievers, 1924.

IAF 137. Acoma jar, Acoma Polychrome. Allover design. Two major squares with four scrolls at each corner; two minor opposing squares with diamond filler. 12" x 13". Ca. 1900. Gift of Albert Sievers, 1924.

IAF 163. Acoma jar, Acoma Polychrome. Zia-style design of central diamonds connected by filled arcs. The jar is bound in rawhide and repaired with pitch. 9 ½" x 11 ½". 1890–1910. IAF purchase from B. J. O. Nordfeldt, 1924.

IAF 165. Acoma jar, Acoma Polychrome. Tall-necked form with concave base. Neck and body bands of design in four-color polychrome. 12" x 13". 1880–1900. IAF purchase from B. J. O. Nordfeldt, 1924.

IAF 218. Laguna or Acoma jar, Laguna or Acoma Polychrome. Allover design has banded "feel" but lacks definite framing lines at the neck-body juncture. Unbordered orange elements and checkerboard patterns. 11 ½" x 13". 1880–1900. Gift of Alice A. Atkinson, 1923.

IAF 223. Laguna(?) jar, Laguna Polychrome(?). Heavy construction, some rock in the paste. Four allover design units with open "eyes" and triangular motifs. 12" x 12 ½". 1880–1900. Gift of H. P. Mera, 1924; purchased from A. F. Spiegelberg, 1905.

*IAF 226 (p. 97). Acoma or Laguna jar, Acoma or Laguna Polychrome. Tall-necked form with an interior swash of red slip. Unusual birds with terraced crests and "open" heads; undulating rainbow band is divided by a band of split leaves. 11" x 11 ½". 1880–90. Gift of Col. R. E. Twitchell, 1924.

*IAF 241 (p. 101). Acoma jar, Acoma Polychrome. Classic bird and floral motifs in red, orange, and black on white slip. Multiple flowers on single stalks; open "eyes" in the birds' wings; D-shaped tail elements. 10" x 12". 1880–1900. Gift of H. P. Mera, 1924. (A picture of this pot was used on a U.S. postage stamp in 1977.)

IAF 242. Acoma jar, Acoma Polychrome. Tall-necked form with the widest point at midbody. Black and red two-part band of decoration with diagonal rectangular motifs. 10 ½" x 12". 1870–80. Gift of H. P. Mera, 1924.

IAF 326. Acoma jar, Acoma Polychrome. Four-color polychrome. Two major opposing geometric and curvilinear panels; two minor panels with diamond in between. 11" x 13 ½".

1890–1910. IAF purchase, Acomita, by K. M. Chapman, 1924.

IAF 328. Acoma jar, Acoma Polychrome. Four-color polychrome with three bands of design separated by bold framing lines. Neck and body bands with realistic flowers repeat; narrow shoulder band has split parallelograms. Rim and neck eroded from use. 11" x 13". 1880–1900. IAF purchase by K. M. Chapman, Acomita, 1924.

IAF 330. Acoma Jar, Acoma Polychrome. Four-color polychrome; four bird motifs in orange and red; four types of flower on single stalks. 10 ½" x 12". 1890–1910. IAF purchase, Acomita, by K. M. Chapman, 1924.

IAF 417. Laguna jar, Laguna Polychrome. Small jar with tall neck and concave base. Heavy, casual painting with Navajo feel: scrolls, dots, and arcs. 6 ½" x 7". 1880–1900. IAF purchase, Encinal, 1925, by K. M. Chapman from Juana Ahmie, who claimed she made it.

IAF 420. Acoma jar, Acoma Polychrome. Unusual water-jar form with high shoulder, flat upperbody, and short neck. Elaborate four-color design with panels of central diamond motifs. 10" x 12". 1880–1900. IAF purchase from Carrie Poncho, Acomita, 1925.

IAF 473. Laguna jar, Laguna Polychrome. Banded design, neck and body bands repeat: triangular elements with open "eyes" and floral elements. Shoulder band is a checkerboard pattern. Interior swash of orange slip. 10" x 11". 1890–1900. Gift of James L. Seligman, 1925.

IAF 578. Acoma jar, Acoma Polychrome. Stepped zigzag in red with black geometric elements, including a double-bar motif. Much white space. 11" x 13". 1890–1900. IAF purchase from Juan Olivas, 1926.

IAF 579. Acoma jar, Acoma Polychrome. Tall-necked form; three bordered orange framing lines, three bands of geometric design. 11" x 12". 1890–1910. IAF purchase from Juan Olivas, 1926.

IAF 581. Acoma jar, Acoma Polychrome. Allover design with a central square; zigzag and triangular fill elements. 11 ½" x 12 ½". 1890–1900. IAF purchase from Juan Olivas, 1926.

IAF 627. Acoma jar, Acoma Polychrome. Four-color polychrome. Bold geometric design with bar motifs, diamonds, and arcs. 10" x 11 ½". 1890–1900. IAF purchase, Acoma, by K. M. Chapman, 1926.

IAF 644. Acoma jar, Acoma Polychrome. Tall-necked form with expanded geometric bird motif, hatching, and a three-lobed element. Four-color polychrome. 12 1/2" x 12". Ca. 1880. IAF purchase by Leslie A. White, Acoma, 1926.

IAF 646. Acoma jar, Acoma Polychrome. Elaborate allover pattern with three-lobed motifs, checkerboard, scrolls, and triangles. Fluted rim. 11" x 12 1/2". Ca. 1900. IAF purchase, Acoma, by Leslie A. White, 1926.

IAF 667. Laguna or Acoma jar, Laguna or Acoma Polychrome. Heavy construction and some rock in the paste. Two unusual bird motifs with geometric elements. Rim is eroded from use as a water jar. 11 1/2" x 13". 1880–90. IAF purchase from Spanish and Indian Trading Co., 1926, collected at San Mateo, NM.

IAF 678. Acoma jar, Acoma Polychrome. Thinly potted, tall-necked form with shoulder flexure. Four-color polychrome design of four bird motifs and floral elements. 10" x 12 1/2". 1880–1900. IAF purchase from W. B. Prince collection, 1927.

IAF 681. Laguna jar(?), Laguna Polychrome(?). Boldly painted two-banded design with linked arcs and curved triangles. Black and red double-dot motifs. Paste appears to have some red tufflike material. 10" x 13". 1880–90. IAF purchase from W. B. Prince collection, 1927.

*IAF 682 (p. 101). Acoma jar, Acoma Polychrome. Boldly drawn four-color polychrome with two parrots and floral motifs. Double arcs around the birds connected by double bands. 11 1/2" x 13". 1880–90. IAF purchase from W. B. Prince collection, 1927.

IAF 683. Acoma jar, Acoma Polychrome. Parallelograms around the neck; orange zigzag with triangular fill elements around the body. Red underbody and interior rim. 11" x 12". 1890–1900. IAF purchase from W. B. Prince collection, 1927.

IAF 685. Acoma jar, Acoma Polychrome. Four-color polychrome with deep red, orange, and black design of four repeating units on white slip. 8 1/2" x 11". Ca. 1880–90. IAF purchase from W. B. Prince collection, 1927.

IAF 686. Laguna jar, Laguna Polychrome. Tall-necked form; two bands of design divided by bordered orange framing line. Four-color polychrome. 9 1/2" x 10". 1890–1900. IAF purchase from W. B. Prince collection, 1927.

IAF 724. Acoma jar, Acoma Polychrome. Four-color polychrome with a deep red zigzag around the body, pendant scrolls, and three-lobed motifs. 11 1/2" x 13 1/2". 1880–1900. IAF purchase from Spanish and Indian Trading Co., 1927.

IAF 772. Laguna jar(?), Laguna Polychrome(?). Extremely intricate fret design in hatched and solid elements based on a swastika form. Paste has abundant red tufflike material. 11" x 12". 1890–1900. IAF purchase from Ambrosio Salazar, 1927.

*IAF 792 (p. 115). Laguna storage jar, Laguna Polychrome. Large jar with Zia- and Zuni-style motifs. Polished red underbody band is common on Zia pottery but extremely rare on Laguna jars. Rainbird motif on body; red-filled zigzag around neck. Rock-tempered paste. 16" x 21". 1880–90. IAF purchase, Southwest Arts and Crafts, Santa Fe, 1927.

IAF 796. Acoma jar, Acoma Polychrome. Four-color polychrome. Three elaborate parrots with orange bodies; row of curvilinear triangles; rows of dots and double dots around the neck. Puki flexure. 13" x 15". 1890–1900. IAF purchase, Acomita, by Frank G. Applegate, 1927.

IAF 894. Acoma jar, Acoma Polychrome. High-shouldered, round-bodied form with stepped elements and arcs of split parallelograms (also seen at Zia). 10" x 12". 1890–1900. IAF purchase from Matthews Antique Shop, Albuquerque, 1928.

IAF 895. Acoma jar, Acoma Polychrome. Four-color polychrome. Three square units with attached geometric elements, including a red, black, and stippled three-lobed paddle motif. 9" x 12". 1890–1900. IAF purchase from Matthews Antique Shop, Albuquerque, 1928.

IAF 930. Acoma or Laguna jar, Acoma or Laguna Polychrome. Water jar with six diamond-shaped motifs joined with geometric elements and double dots. Red base and interior rim. 11 1/2" x 13". Ca. 1900. IAF purchase, Laguna, by K. M. Chapman, 1928.

IAF 931. Laguna(?) jar, Laguna Polychrome. Large jar with pronounced puki mark. Two design bands: neck band with red flowers, body band with zigzag of open ellipses. 15" x 18". 1880–1900. IAF purchase, Laguna, by K. M. Chapman, 1928.

*IAF 959 (p. 112). Laguna jar, Laguna Polychrome. Heavy construction with thick white slip. Neck band of split parallelograms; body band of linked split arcs with double-dot motifs. 9 1/2" x 10 1/2". 1880–90. IAF purchase, Paguate, by K. M. Chapman, 1928.

IAF 961. Acoma or Laguna bowl, Acoma or Laguna Polychrome. Shallow, heavily constructed bowl with puki flexure and incurving rim. Design of stepped triangular motifs with arcs of scallops. 6" x 15". 1880–90. IAF purchase, Acoma, by K. M. Chapman, 1928.

IAF 998. Acoma bowl, Acoma Polychrome. Large bowl with round base, slightly incurving walls, and squared-off rim. Band of triangular motifs. 8" x 16". 1880–1900. IAF purchase, Acoma, by K. M. Chapman, 1928.

IAF 1007. Acoma jar, Acoma Polychrome. Two arcs filled with hatched frets, two heartline deer, floral elements. Red base and interior rim. 11 ½" x 13". Ca. 1900. IAF purchase from Southwest Arts and Crafts, Santa Fe, 1928.

*IAF 1026 (p. 13). Laguna jar, Laguna Polychrome variant. Large storage jar by Arroh-ah-och. Banded design, typical Zuni layout, with two elaborate four-lobed medallions and a row of deer motifs. Thick construction supports the large form. 19" x 25". 1890–1900. IAF purchase from Locario K. Chavez, Paguate, by K. M. Chapman, 1928.

IAF 1033. Laguna(?) bowl, Laguna Polychrome(?). Tall form with washy red-orange base and washy red interior. Four-color polychrome with diagonal geometric design. 7" x 12 ½". 1880–1900. IAF purchase, Acoma, from Joe Lino by K. M. Chapman, 1928.

IAF 1041. Acoma jar, Acoma Polychrome. Wide jar; elaborate four-color polychrome and hatching lend a dark appearance. 10 ½" x 12". 1890–1900. IAF purchase, Acoma, from Santiago Pascual by K. M. Chapman, 1928.

IAF 1042. Acoma jar, Acoma Polychrome. Unusual paneled treatment that appears to be a banded design. Unique heartline deer motifs around the bottom and bird motifs around the top. 11" x 12". 1890–1900. IAF purchase, Acoma, from Juan Estevan Sarracino, 1928.

IAF 1043. Laguna or Acoma jar, Laguna or Acoma Polychrome. Two design bands: open elongated triangles at neck; floral and bar motifs around body. 9 ½" x 11". 1890–1900. IAF purchase, Acoma, from Rose Garcia by K. M. Chapman, 1928.

IAF 1044. Acoma jar, Acoma Polychrome. Allover triangular meander design in red and black. Tall insloping neck; red underbody and interior rim. 10" x 11". Ca. 1890–1900. IAF purchase, Acoma, by K. M. Chapman, 1928.

IAF 1047. Acoma canteen, Acoma Polychrome. Round form with two handles and spout. Bold geometric design with central checkerboard. 4 ½" x 5 ¼". 1880–90. IAF purchase, Acoma, by K. M. Chapman, 1928.

IAF 1049. Acoma canteen, Acoma Polychrome. Round form with two handles and spout. Central diamond with pendant bars and scrolls. 10 ½". 1890–1900. IAF purchase, Acoma, 1928.

*IAF 1054 (p. 70). Acoma canteen, Acoma Polychrome. Three-lobed form with short vertical spout in center. Black and orange design, with bands in the depressions between lobes. 5 ½" x 9 ½". 1890–1910. IAF purchase, Acoma, 1928.

*IAF 1056 (p. 150). Acoma bird effigy, Acoma Polychrome. Canteen form with spout modeled in the form of a bird head; modeled tail. Four-color polychrome with random dots and bold geometric design suggesting wings. 7" x 7 ½". 1875–90. IAF purchase, Acoma, 1928.

IAF 1061. Laguna or Acoma bowl, Laguna or Acoma Polychrome. Tall bowl with red-slipped base and red inclusions in the paste. Band of four rectangular motifs connected by open ellipses with double-dots. 7 ½" x 12 ¼"–14 ½" (warped). 1875–85. IAF purchase, Acoma, 1928.

IAF 1068. Laguna or Acoma bowl(?), Laguna or Acoma Polychrome. Thick construction with rock fragments in the paste and a washy red X in the interior. Orange zigzag with triangular fill design. 6" x 11 ½". 1880–90. IAF purchase, Acoma, 1928.

IAF 1070. Acoma jar, Acoma Polychrome. Three bands of design in red, orange, and black on a white slip. Neck and body bands are similar; narrow shoulder band has split parallelograms. 11 ½" x 13". 1880–1900. IAF purchase, Acoma, 1928.

IAF 1086. Acoma jar, Acoma Polychrome. Tall-necked form with narrow mouth. Four connected flowers around the neck; eight bird motifs, four on each side of a double undulating rainbow band. 10 ½" x 13". 1880–90. IAF purchase, Acoma, 1928.

IAF 1091. Laguna jar, Laguna Polychrome. Casual checkerboard design around the upper shoulder and neck. Split leaves, triangles, double dots, and rows of dots make up the body band. 10" x 13". 1890–1910. IAF purchase, Acoma, 1928.

IAF 1094. Acoma jar, Acoma Polychrome. Tall-necked form with thick white slip. Unusual design layout with bird, floral, and bar motifs in orange and red. 10 ½" x 12". 1880–90. IAF purchase, Acoma, 1928.

*IAF 1100 (p. 94). Acoma jar, Acoma Polychrome. Water jar with banded design in bold black and deep red. Washy orange slip on base and interior rim. 11 ½" x 13 ½". 1880–1900. IAF purchase, Acoma, 1928.

IAF 1102. Laguna or Acoma jar, Laguna or Acoma Polychrome. Two bands of design with heavy black painting and red details; split curvilinear triangles, bars, and rectangles. Sharp upper shoulder. 1 ½" x 14". 1880–90. IAF purchase, Acoma, 1928.

*IAF 1106 (p. 89). Acoma jar, Acoma Polychrome. Four-color polychrome with undulating rainbow band in orange and red; three-lobed motifs of split leaves. 12 ½" x 13". 1880–1900. IAF purchase, Acoma, 1928.

*IAF 1112 (p. 5). Acoma jar, Acoma utility ware. Large jar with olive-shaped body and short vertical neck. Heavily constructed of chunky paste; round base and no decoration. 16" x 16 ½". 1880–1900(?). IAF purchase, Acoma, 1928.

IAF 1113. Acoma jar, Acoma utility ware. Round body with short vertical neck and round base. Heavy construction, chunky paste, no decoration. 14" x 13 ½". Ca. 1880–1900(?). IAF purchase, Acoma, 1928.

IAF 1119. Acoma bowl, Acoma Polychrome. Small bowl; geometric design of hook elements and checkerboards in a zigzag layout. Slightly outflaring rim. 4" x 8". 1890–1900. IAF purchase, Acoma, 1928.

*IAF 1148 (p. 75). Acoma jar, Acoma Polychrome. Large jar with round base, sharp shoulder flexure, and thin outflaring rim, possibly used as a drum jar. Floral and bird motifs in an allover pattern in orange, red, and black on white slip. 15 ½" x 15 ½". 1880–90. IAF purchase, McCartys, by K. M. Chapman, 1928.

IAF 1150. Acoma jar, Acoma Polychrome. Large storage jar with flat base. Black geometric design of central rectangular motifs flanked by elaborate triangles and scrolls. Simple band of triangles at neck. 14" x 18". 1890–1900. IAF purchase, McCartys, by K. M. Chapman, 1928.

IAF 1152. Acoma jar, Acoma Polychrome. Large high-shouldered jar with double rainbow band filled with a band of split rectangles. Two bird motifs in four-color polychrome. 15 ½" x 15 ½". 1880–90. IAF purchase, Paguate, by K. M. Chapman, 1928.

IAF 1153. Laguna or Acoma jar, Laguna or Acoma Polychrome. Large jar with flat base. Three design bands with narrow shoulder band of geometric elements. 15 ½" x 15 ½". 1880–1900. IAF purchase, Paguate, by K. M. Chapman, 1928.

*IAF 1154 (p. 38). Acoma jar, Acoma Polychrome. Very large storage jar with a multitude of design elements, including medallions, geometric motifs, "eyes," hatching, deer, and birds. 18" x 21 ½". Ca. 1900. IAF purchase, Acoma, by K. M. Chapman, 1928.

IAF 1183. Acoma jar, Acoma Polychrome. Large jar with flat base and round body. Two major rectangular motifs with pendant scroll, leaves, "eyes," and hatched elements. 18" x 17 ½". 1880–1900. IAF purchase, Acoma, by K. M. Chapman, 1928.

*IAF 1191 (p. 7). Laguna(?) pitcher, Laguna Polychrome(?). Heavily constructed pitcher with braided handle and spout. Four color polychrome in two bands with double solid framing lines at the shoulder. Orange cross painted in the interior. 8 ½" x 8". 1890–1900. Gift of Jane B. Evans, 1929.

IAF 1202. Acoma bowl, Acoma Polychrome. Medium-sized bowl with nine repeating design panels; open double dots in orange, red, and black on white slip. 7" x 13". Ca. 1880–1900. IAF purchase, Maisel's, Albuquerque, 1929.

IAF 1367. Acoma jar, Acoma Polychrome. Water jar. Undulating, bordered-orange rainbow band has pendant bordered-orange split leaves. 9" x 11 ½". 1890–1910. IAF purchase from D. M. Bacalski, Navajo Trading Post, Albuquerque, 1929.

IAF 1411. Laguna or Acoma jar, Laguna or Acoma Polychrome. Four-color polychrome in three unframed, linked design bands, each different. Paste appears to have rock inclusions. 13" x 14 ½". 1880–1900. IAF purchase from Hugh B. McGill, 1930.

IAF 1425. Acoma canteen, Acoma Polychrome. Bulbous form with central spout and two handles. Bold geometric and floral design with central four-lobed split-leaf motif. 7" x 8". 1890–1900. IAF purchase, Acomita, by K. M. Chapman, 1930.

IAF 1427. Acoma jar, Acoma Polychrome. Water jar with red base and interior rim. Three bands of design; neck and body bands repeat. Open white parallelograms or black triangles in narrow shoulder band. 11" x 13". 1890–1900. IAF purchase, Acomita, by K. M. Chapman, 1930.

IAF 1477. Laguna(?) jar, Laguna Polychrome. Spacious neck design with open white areas and hatching. Body band has unbordered chalky red double-dot elements and linked diamonds. Five-color polychrome. 10" x 11". 1890–1900. IAF purchase from W. B. Prince collection, 1930.

IAF 1479. Laguna(?) canteen, Laguna Polychrome(?). Small round form with two handles and spout. Central pinwheel in black with surrounding orange "wreath." 4 ½" (h) x 6" (l) x 4 ½" (w). 1880–1900. IAF purchase, Acoma, by K. M. Chapman, 1930.

IAF 1573. Acoma jar, Acoma Polychrome. Elaborate four-color polychrome; three bird motifs in a deep maroon slip with surrounding chains of linked diamonds. 11" x 14 ½". 1880–90. IAF purchase, Acoma, by K. M. Chapman from Paulita Sanacino (Saracino?) in 1931.

*IAF 1580 (p. 68). Acoma jar, Acoma Polychrome. Very similar to IAF 772 (attributed to Laguna), showing possible cross-over of design. Hatched and solid elements based on a swastika motif. 11 ½" x 12 ½". 1890–1900. IAF purchase, Acoma, from Concepcion Antonio, by K. M. Chapman, 1931.

IAF 1581. Acoma bowl, Acoma Polychrome. Large bowl with red base and washy white interior. Four major hatched diagonal stepped elements with split leaves, small hooks, and half circles. 8 ½" x 14 ½". 1890–1900. IAF purchase, Acoma, from Concepcion Antonio by K. M. Chapman, 1931.

IAF 1590. Acoma Jar, Acoma Polychrome. Tall-necked form in four-color polychrome. Two alternating design units with split leaves, hatching, and a lobed fanlike element. 11 ½" x 13". 1890–1900. IAF purchase from Jose Lino Vallo by K. M. Chapman, 1931.

IAF 1603. Laguna or Acoma jar, Laguna or Acoma Polychrome. Small, squat, four-color polychrome jar with two pairs of two different bird motifs. One bird pair is more chicken-like; the other, more elaborate pair has open, crested heads. 6 ½" x 9". Ca. 1900. IAF purchase, Acoma, by K. M. Chapman, 1931.

*IAF 1674 (p. 81). Laguna jar, Laguna Polychrome. Bold red-bordered band with capped spirit break at the neck. Allover design of linked red heart-shaped motifs with arcs and split leaves. 10 ½" x 13". 1875–90. IAF purchase from Maria Garcia, Santa Fe, 1931.

IAF 1694. Acoma jar, Acoma Polychrome. Four medallions with pinwheel centers and radiating bar motifs; four square panels in between. 12 ½" x 14". 1890–1900. Gift of Margaret McKittrick from Ida Raub collection.

IAF 2002. Acoma bird effigy, Acoma Polychrome. Hollow bird form with the jar's mouth forming the beak. Red washy slip on the body, white head, black facial details. 3 ½" (h) x 5" (l) x 3" (w). 1880–90. Gift of Alice Corbin Henderson, 1929, excavated on William P. Henderson property, Santa Fe.

IAF 2057. Laguna or Acoma jar, Laguna or Acoma Polychrome. Strong puki mark at base. Heavy application of white slip with prominent stone marks. Banded decoration in red and black on white slip consists of flowers and geometric elements. Bold neck and shoulder framing lines. 10 ¾" x 12". Ca. 1875–90. Anonymous gift.

IAF 2177. Acoma jar, Acoma Polychrome. Allover band of design with no division; central rectangles and medallions. Interior has a swash of red slip. 12" x 13 ⅜". 1880–1900. Gift of Mrs. E. Dana Johnson.

IAF 2382. Acoma jar, Acoma Polychrome. Four-color polychrome with orange hourglass motifs and hatching on neck; vertical bands of hatching and split rectangles on body. 9" x 11". 1890–1900. Given in memory of Dr. David Knapp by Dr. LeGrand Ward, 1950.

*IAF 2555 (p. 6). Acoma chalice, Acoma Polychrome. Small footed chalice with simple geometric design in two bands. Collected by Stevenson, 1879-80; marked "111040 Acoma NM Stevenson Bureau of Ethnology Exchange." 5 ¼" x 4". 1875–80. Gift of Byron Harvey III, Fred Harvey Indian Department, Albuquerque.

IAF 2565. Acoma jar, Acoma Polychrome. Water jar with red, orange, and black bird and floral motifs. The rainbow band over the birds is divided by a row of split parallelograms. 11 ½" x 12 ¾". 1880–90. Gift of Amelia E. White.

IAF 2721. Acoma jar, Acoma Polychrome. Tall form with unusual "archaic" feather patterns in red, orange, and black, more common on Ako Polychrome. 12 ½" x 11 ½". 1890–1900. Gift of Mrs. William Lippincott.

IAF 2796. Acoma vase, Acoma Polychrome. "Victorian" form with long neck, fluted rim, and two handles (one broken). Elaborate geometric and floral decoration in red, orange, ochre, and black on a white slip. 14 ½" x 10 ¼". 1890–1900. Gift of Roberta Robey, 1959.

SAR 1978-1-150. Acoma jar, Acoma Polychrome. Four-color polychrome with neck band of triangular elements, body band of central medallion with paddle motifs. 11 ½" x 13". Ca. 1900. Amelia White estate, 1978.

*SAR 1980-13 (p. 77). Laguna bowl, Laguna Polychrome. Small shallow ceremonial bowl. Floated exterior with many stone marks; white interior with central Maltese-cross element, crested bird heads, and pendant animals forming a swastika. Eroded red central circle. 3" x 8 ¾". 1880–1900. Gift of Dennis Lyon, 1980.

1900 to 1920

IAF 45. Laguna jar(?), Laguna Polychrome(?). High-shouldered, with short vertical neck. Neck band of triangles; four large Tularosa scrolls on body. Red tufflike material in the paste. 11" x 12 ½". 1900–1910. IAF purchase from Southwest Arts and Crafts, 1923.

IAF 51. Laguna or Acoma jar, Laguna or Acoma Polychrome. Tall-necked form; two repeating bands of design divided into panels with filled zigzag elements. 11 ½" x 12". 1890–1910. Gift of H. P. Mera, 1923.

IAF 53. Acoma jar, Acoma Polychrome. Interlocked step-fret design around neck and body in solid and hatched elements. Shoulder band of triangles or white parallelograms. 10 ½" x 11". 1910–20. IAF purchase from Southwest Arts and Crafts, 1923.

IAF 123. Acoma jar, Acoma Polychrome. Round with modeled vertical ribs. Four-color polychrome with yellow and orange hatching. 7 ½" x 9". 1890–1910. Gift of Olivia Pope, 1924.

IAF 125. Acoma jar, Acoma Polychrome. Complex combination of design elements in four-color polychrome: birds, paddle elements, hatching, leaves, triangles, and "eyes". 11 ½" x 14". 1900–1920. Gift of Olivia Pope, 1924.

IAF 158. Acoma Jar, Acoma Polychrome. Banded design in solid and hatched elements. Red base and interior rim. 10" x 12 ½". 1900–1910. IAF purchase, Laguna, by K. M. Chapman, 1924.

IAF 162. Acoma jar, Acoma Polychrome. Tall-necked form with two design bands. Body band has hatched and checkerboard split rectangles with scrolls and double dots. 11 ½" x 12 ½". 1890–1910. IAF purchase from B. J. O. Nordfeldt, 1924.

IAF 180. Acoma jar, Acoma Polychrome. Single orange-bordered undulating rainbow band with bird motifs along the top and bilaterally symmetrical stepped-scroll motifs along the bottom. Mixed fill elements. 12" x 13 ½". 1900–1920. IAF purchase from B. J. O. Nordfeldt, 1924.

IAF 220. Acoma bowl, Acoma Polychrome. Tall-sided bowl with outflaring rim. Four design panels painted on the base with four triangular fill panels. Penciled inside, "Delores Ascencione;" she is listed as the maker. 4" x 9". Ca. 1920. Gift of O. S. Halseth; purchased at Acoma in 1924.

IAF 230. Acoma wedding vase, Acoma Polychrome. Large body with two narrow spouts (connecting handle broken).

Medallions and double arcs with rectangular "eyes." 14" x 13". 1900–1920. Gift of Mrs. Thomas Curtin, 1924.

IAF 236. Acoma jar, Acoma Polychrome. Central diamond motifs with geometric fill elements including stepped frets. 8" x 10". 1900–1910. Gift of K. M. Chapman, 1924.

IAF 254. Acoma jar, Acoma Polychrome. Three separate design bands in geometric motifs with a large comma-like element on the neck. 10" x 12". 1910–20. Gift of H. P. Mera, 1924.

IAF 287. Acoma bowl, Acoma Polychrome. Small bowl in four-color polychrome with modeled rim. Stepped scroll motifs. 4" x 7 ½". 1910–20. Purchased at Paraje by K. M. Chapman and given by him in 1924.

*IAF 313 (p. 104). Acoma or Laguna jar, Acoma or Laguna Polychrome. Geometric, paddle, floral, and heartline deer elements predominate. Green paint may be ceremonial; recorded as "gift jar." Said to have been made by a Laguna woman living at Isleta. 10" x 12". 1900–1920. Gift of Frank G. Applegate, 1924.

IAF 325. Acoma or Laguna jar, Acoma or Laguna Polychrome. Unusual layout with atypical design elements in two opposing areas, each with banded and panelled sections. 10" x 11". 1900–1910. IAF purchase, Acomita, by K. M. Chapman, 1924.

IAF 327. Acoma jar, Acoma Polychrome. Complex design of stepped frets, scrolls, and geometric motifs. 9 ½" x 12". 1900–1920. IAF purchase, Acomita, by K. M. Chapman, 1924.

IAF 329. Acoma Jar, Acoma Polychrome. Five diamonds and attached geometric elements in black. Red base and interior rim. 10" x 12". 1900–1920. IAF purchase, Acomita, by K. M. Chapman, 1924.

IAF 331. Acoma jar, Acoma Polychrome. Sharp-shouldered jar with three design bands, neck and body bands repeat. Narrow shoulder band of hatched zigzags. 9 ½" x 12". 1910–20. IAF purchase, Acoma, by K. M. Chapman, 1924.

IAF 348. Acoma jar, Acoma Polychrome. Allover pattern based on four red flowers and surrounding square configuration. Four-color polychrome. 10" x 13". 1915–20. Gift of James H. MacMillan, 1925.

IAF 374. Acoma seed jar, Acoma Polychrome. Bowl form with severe incurving rim. Tularosa spiral motifs in black. Red underbody. 6" x 11 ½". 1910–20. Gift of Carlos Vierra, 1925.

IAF 391. Acoma jar, Acoma Polychrome. Tall-necked, sharp-shouldered form; allover design with central triangle and scroll motifs. 10" x 11 ½". 1910–20. IAF purchase, Encinal, NM, 1925.

IAF 395. Acoma or Laguna canteen, Acoma or Laguna Polychrome. Small, round form with two handles and central spout. Band of hatched zigzags from spout to base. 6 ¾" x 7". 1910–20. IAF purchase, Laguna, 1925.

IAF 430. Laguna(?) bowl, Laguna Polychrome(?). Stone-stroked, red-slipped interior with white exterior. Geometric design on the diagonal. 3 ½" x 7". 1910–20. IAF purchase, Acomita, 1925.

IAF 559. Acoma canteen, Acoma Polychrome. Two handles and central spout. Design in four quadrants with stepped-scroll motifs. 5 ½" x 5 ½". 1900–1920. Gift of Wesley Bradfield, 1926.

IAF 580. Acoma jar, Acoma Polychrome. Heavy construction, uneven form; four-color polychrome with banded design. 10" x 12". Ca. 1900. IAF purchase from Juan Olivas, 1926.

IAF 606. Acoma jar, Acoma Polychrome. Tightly drawn three-banded decoration; neck and body bands repeat. Wide checkerboard shoulder band. 10 ½" x 12". 1900–1915. IAF purchase by James H. MacMillan at Hopi House, Grand Canyon, 1926.

IAF 626. Acoma jar, Acoma Polychrome. Allover zigzag design with balanced solid, hatched, and white areas. 11 ½" x 13". Ca. 1900. IAF purchase, Acoma, by K. M. Chapman, 1926.

IAF 650. Acoma jar, Acoma Polychrome. Two diamond motifs with geometric fill elements. 7" x 8". 1900–1915. Gift of Ernest Seligman, Domingo, NM, 1926. Purchased by him at Santo Domingo Pueblo.

IAF 674. Laguna bowl, Laguna Polychrome. Small open bowl; slipped white inside and out; interior and exterior geometric decoration in black and red. 3" x 7". 1910–20. Gift of H. P. Mera, 1926.

IAF 692. Laguna jar, Laguna Polychrome. Tall-necked form; two design bands. Paneled neck band of simple stepped elements; body band has rows of dots with double dots and connecting elements. 7" x 7". Ca. 1900. IAF purchase from W. B. Prince collection, 1927.

IAF 732. Acoma jar, Acoma Polychrome. Balanced form with three design bands; neck and body bands repeat. 11" x 13 ½". Ca. 1900. Gift of K. M. Chapman, 1927; purchased at Seama, 1924.

IAF 776. Acoma canteen, Acoma Polychrome. Round form with two handles, vertical spout, and flat base. Bold black and orange bands of design, horizontal and vertical. 8 ½" x 7 ½". 1900–1910. IAF purchase from Spanish and Indian Trading Co., 1927; collected at Isleta Pueblo.

IAF 956. Acoma jar, Acoma Polychrome. Large jar with flat base. Four major medallions with four filler elements. Reinforced by two rawhide ties. 14" x 19". 1900–1910. IAF purchase, Paguate, by K. M. Chapman, 1928.

*IAF 957 (p. 74). Acoma wedding vase, Acoma Polychrome. Round body with two short necks and connecting handle. Four-color polychrome with elaborate floral design. 13" x 11". 1900–1920. IAF purchase, Paguate, by K. M. Chapman, 1928.

IAF 958. Acoma wedding vase, Acoma Polychrome. Body and two spouts with connecting handle. Design section on top between spouts. Band around body contains zigzag and geometric fill elements. 13" x 9 ½". 1910–20. Gift of K. M. Chapman, given to him by governor of Paguate.

IAF 969. Acoma jar, Acoma Polychrome. Two large unbordered orange flowers and paddle motifs with other geometric elements. 10" x 12". 1915–25. Gift of E. L. White, 1928.

IAF 1030. Acoma wedding vase, Acoma Polychrome. Two-spouted form; one spout is a modeled bird head. Geometric and curvilinear design on the body. 11 ½" x 9 ½". 1900–1920. IAF purchase, Seama, by K. M. Chapman, 1928.

IAF 1038. Laguna(?) bowl, Laguna Polychrome(?). Unusual red clay with sherd and stone temper. Red-slipped interior with unslipped triangle in center. Exterior has band of split parallelograms. 5" x 10". 1910–20. IAF purchase, Acoma, by K. M. Chapman, 1928.

IAF 1048. Acoma canteen, Acoma Polychrome. Two loop handles (one broken) and spout. Central diamond with checkerboard and unbordered orange areas. 4" (h) x 5 ½" (l) x 4" (w). 1910–20. IAF purchase, Acoma, 1928.

IAF 1050. Acoma canteen, Acoma Polychrome. Typical form; hatched zigzag center band with geometric elements, double dots, and ellipses. 5" (h) x 7" (l) x 5" (w). 1900–1920. IAF purchase, Acoma, 1928.

IAF 1051. Acoma canteen, Acoma Polychrome. Typical form; four-color polychrome with diagonal band of split triangles and bordered orange scrolls. 7" x 8". 1910–20. IAF purchase, Acoma, 1928.

IAF 1052. Acoma canteen, Acoma Polychrome. Round form, flat base, two loop handles, and spout. Central square with scrolls and squared scrolls. 9". 1910–20. IAF purchase, Acoma, 1928.

IAF 1053. Acoma canteen, Acoma Polychrome. Round form, flat base, spout, and two lug handles. Six-pointed medallion in center with bold geometric elements. 6 ½" x 8 ½". 1900–1910. IAF purchase, Acoma, 1928.

IAF 1055. Acoma canteen, Acoma Polychrome. Unusual form with five hollow "fingers," two loop handles, and spout with central square motif and hatching. 3 ½" (h) x 6 ½" (l) x 5" (w) (without appendages). 1900–1910. IAF purchase, Acoma, 1928.

IAF 1058. Acoma bowl, Acoma Polychrome. Dough bowl with slightly incurving and squared-off rim. Six Tularosa-style scrolls in solid and hatched black paint. 8" x 14–14 ½" (warped). 1900–1920. IAF purchase, Acoma, 1928.

IAF 1062. Acoma bowl, Acoma Polychrome. Wide bowl with connected ellipse motifs around the exterior. Four-color polychrome; white-slipped inside and out. 5" x 12". 1900–1920. IAF purchase, Acoma, 1928.

*IAF 1063 (p. 159). Acoma bowl, Acoma Polychrome. Unusual straight-sided "cake-pan" form with nine exterior design units. White slipped inside and out. 3 ½" x 11". 1910–20. IAF purchase, Acoma, 1928.

IAF 1064. Acoma bowl, Acoma Polychrome. Three main panels of bold black design with three vertical divisions of split squares. 5" x 11". 1900–1910. IAF purchase, Acoma, 1928.

IAF 1065. Acoma bowl, Acoma Polychrome. Hemispherical form in four-color polychrome with bordered orange zigzag motif. 5 ½" x 11". 1900–1920. IAF purchase, Acoma, 1928.

IAF 1066. Laguna(?) bowl, Laguna Polychrome. White-slipped interior and exterior; flat, red-slipped base. Eight units of design with floral elements. Chunky paste. 7" x 13". 1910–25. IAF purchase, Acoma, 1928.

IAF 1069. Acoma jar, Acoma Polychrome. High shouldered jar; three diagonal rectangular motifs with scrolls and double arcs. 11 ½" x 14". 1900–1910. IAF purchase, Acoma, 1928.

IAF 1071. Acoma jar, Acoma Polychrome. Banded design; neck and body bands repeat. Curved split triangles form ellipses at shoulder band. 12" x 13". Ca. 1900. IAF purchase, Acoma, 1928.

IAF 1073. Acoma jar, Acoma Polychrome. Four large diamond motifs with alternating horizontal and vertical orientation. Use of black paint lends dark appearance. 9 ½" x 13". 1910–15. IAF purchase, Acoma, 1928.

IAF 1075. Acoma jar, Acoma Polychrome. Four-color polychrome; four diamond motifs with orange hatching, pendant stepped scrolls, and double arcs. 9 ½" x 12 ½". 1900–1910. IAF purchase, Acoma, 1928.

IAF 1076. Laguna(?) jar, Laguna Polychrome(?). Four-color polychrome; four orange bird motifs and two opposing unbordered flower and pinwheel motifs. 6" x 8". 1910–20. IAF purchase, Acoma, 1928.

IAF 1077. Acoma jar, Acoma Polychrome. Allover design: two diagonal rectangles with round caps, scrolls, and floral elements. 10 ½" x 11 ½". 1910–20. IAF purchase, Acoma, 1928.

IAF 1078. Acoma jar, Acoma Polychrome. Four-color polychrome; banded, with neck and body bands of repeating orange leaf motifs. Central shoulder band of stepped and triangular motifs. 12 ½" x 13 ½". 1900–1910. IAF purchase, Acoma, 1928.

IAF 1079. Acoma jar, Acoma Polychrome. Large jar with geometric banded design. Neck and body bands repeat; central shoulder band of scrolls with double dots. 11" x 13". 1900–1910. IAF purchase, Acoma, 1928.

IAF 1080. Acoma jar, Acoma Polychrome. Water jar with elaborate bird and floral design; two pair of facing birds. 12" x 14". 1910–20. IAF purchase, Acoma, 1928.

IAF 1081. Acoma jar, Acoma Polychrome. Three separate bands of design: neck band of open ellipses with unbordered red floral motifs and dots; body band of stepped elements with "eyes;" base band of triangular motifs. 9" x 11". 1910–20. IAF purchase, Acoma, 1928.

IAF 1082. Acoma jar, Acoma Polychrome. Water jar with banded design. Neck has Zuni layout; body has five panels of geometric elements with zigzag-filled vertical dividing panels. 10 ½" x 11". 1910–20. IAF purchase, Acoma, 1928.

IAF 1083. Acoma jar, Acoma Polychrome. Severe-shouldered jar with banded design; neck and body bands repeat. Shoulder band of black triangles and open white parallelograms. 9" x 12". 1900–1910. IAF purchase, Acoma, 1928.

IAF 1084. Acoma jar, Acoma Polychrome. Unusual banded design of unbordered orange-slipped triangular motifs. Black midbody framing line and rim. Four-color polychrome with deep orange base. 12" x 14". 1900–1920. IAF purchase, Acoma, 1928.

IAF 1088. Acoma jar, Acoma Polychrome. Three medallions with three areas of paired stepped triangles with open "eyes." 8 ½" x 12 ½". 1910–20. IAF purchase, Acoma, 1928.

IAF 1089. Acoma seed jar, Acoma Polychrome. Neckless form with allover design of zigzags and triangles. 5 ½" x 9". 1910–20. IAF purchase, Acoma, 1928.

IAF 1092. Acoma jar, Acoma Polychrome. Six major orange triangles with interior lobed element with triangles. 9" x 11 ½". 1910–20. IAF purchase, Acoma, 1928.

IAF 1093. Acoma jar, Acoma Polychrome. Banded design with triangles and ellipses around the neck; five panels of geometric design around the body. 11" x 12 ½". 1900–1920. IAF purchase, Acoma, 1928.

IAF 1095. Acoma jar, Acoma Polychrome. Five vertical panels of horizontal triangular elements in black and orange. 6 ½" x 8". 1900–1920. IAF purchase, Acoma, 1928.

IAF 1096. Acoma jar, Acoma Polychrome. Tall-necked form with design that looks banded but lacks framing lines. Panels of triangles with central scroll elements. 11" x 12". 1900–1910. IAF purchase, Acoma, 1928.

IAF 1097. Acoma jar, Acoma Polychrome. Banded design with repeating steps and triangles. 10" x 11 ½". 1910–20. IAF purchase, Acoma, 1928.

IAF 1098. Acoma jar, Acoma Polychrome. Allover checkerboard design in bordered orange panels filled with geometric elements. 11" x 13". 1900–1910. IAF purchase, Acoma, 1928.

IAF 1099. Acoma jar, Acoma Polychrome. Opposing pairs of stepped scroll motifs with open "eyes". 9" x 12". 1910–20. IAF purchase, Acoma, 1928.

IAF 1101. Acoma jar, Acoma Polychrome. Repeating hatched and solid elements in two design bands. Unusual treatment of line break on the rim. 8" x 12". 1910–25. IAF purchase, Acoma, 1928.

IAF 1103. Acoma jar, Acoma Polychrome. Allover checkerboard pattern with alternating panels of opposing triangles and open ellipses. 10" x 11 ½". 1910–20. IAF purchase, Acoma, 1928.

IAF 1104. Acoma jar, Acoma Polychrome. Checkerboard layout with repeating panels of four-lobed split-leaf motifs with filled corners. Strong flexure at the neck. 8" x 11 ½". 1900–1920. IAF purchase, Acoma, 1928.

IAF 1105. Acoma jar, Acoma Polychrome. Two unevenly spaced vertical dividing panels of scrolls and triangles. Major square elements have double-arc motifs. 9" x 11 ½". 1900–1920. IAF purchase, Acoma, 1928.

IAF 1106. Acoma jar, Acoma Polychrome. Zuni-style design layout with three large medallions with central band of small bird motifs. Three smaller seven-pointed star medallions. 9 ½" x 12". 1910–20. IAF purchase from Southwest Arts and Crafts, Santa Fe, 1928.

IAF 1107. Laguna(?) jar, Laguna Polychrome(?). Chalky red slip; rock in the paste. Banded design with triangular elements. 8" x 11". 1900–1910. IAF purchase, Acoma, 1928.

*IAF 1109 (p. 164). Laguna jar, Laguna Polychrome. Tall fluted-neck form with three design bands. The base band has open white space with red flowers. Red tufflike material in paste. 7 ½" x 9". 1900–1920. IAF purchase, Paguate, by K. M. Chapman, 1928.

IAF 1110. Acoma jar, Acoma Polychrome. Large storage jar with flat base. Tightly drawn design in three bands; neck and body bands repeat. 15" x 19 ½". 1900–1910. IAF purchase, Acoma, 1928.

*IAF 1111 (p. 89). Acoma Jar, Acoma Polychrome. Large jar with flat base. Three design bands; neck and body bands repeat; much open white slip. 15" x 17". 1910–25. IAF purchase, Acoma, 1928.

IAF 1114. Acoma cooking pot, Acoma utility ware. Sharp-shouldered, undecorated pot with wide open mouth. Two handles of two coils each. 8" x 10". Ca. 1920. IAF purchase, Acoma, 1928.

IAF 1115. Acoma cooking pot, Acoma utility ware. Wide open mouth with coil sections attached on the diagonal around the rim. Two handles. Undecorated. 6 ½" x 8". 1910–20(?). IAF purchase, Acoma, 1928.

IAF 1116. Acoma bowl, Acoma Polychrome. Small bowl with two design panels of double arcs and double dots. 4" x 8". 1900–1910. IAF purchase, Acoma, 1928.

IAF 1117. Acoma bowl, Acoma Polychrome. Round form with incurving rim and paneled design of repeating geometric motifs. Four-color polychrome. 5 ½" x 10". 1900–1920. IAF purchase, Acoma, 1928.

IAF 1118. Acoma bowl, Acoma Polychrome. Small bowl with orange stepped motifs, double dots, and design across base. 3" x 8 ½". 1900–1920. IAF purchase, Acoma, 1928.

IAF 1123. Acoma bowl, Acoma Polychrome. Small, flat-based bowl with bordered orange zigzag and open ellipses. 4" x 7". 1910–20. IAF purchase, Acoma, 1928.

IAF 1124. Acoma bowl, Acoma Polychrome. White interior and orange base; orange zigzag motif. 4" x 7 ½". 1910–20. IAF purchase, Acoma, 1928.

IAF 1125. Acoma bowl, Acoma Polychrome. Small bowl with slightly sculpted rim; white-slipped, black-spattered interior; exterior band of scroll elements. 4" x 7". 1910–20. IAF purchase, Acoma, 1928.

IAF 1126. Acoma bowl, Acoma Polychrome. Four panels of geometric elements with checkerboard band. Four thin vertical panels with triangles. 4" x 7". 1900–1920. IAF purchase, Acoma, 1928.

IAF 1127. Acoma bowl, Acoma Black-on-white. Slightly sculpted rim. Four diamond units with hatched and solid fill elements. Design covers the base, which has traces of purple and green pigment. 4 ½" x 8 ½". 1910–20. IAF purchase, Acoma, 1928.

IAF 1128. Acoma bowl, Acoma Polychrome. Small bowl with four diagonally arranged panels with hatched motifs. 3 ½" x 7 ½". 1910–20. IAF purchase, Acoma, 1928.

IAF 1129. Acoma bowl, Acoma Polychrome. White-slipped interior and exterior; sculpted rim. Four design panels with Zuni-style heartline deer motifs. 3 ½" x 6". 1910–20. IAF purchase, Acoma, 1928.

IAF 1130. Acoma bowl, Acoma Black-on-white. White-slipped interior and exterior, including base. Older-style design in black with hooked elements and "eyes." 4 ½" x 8". 1915–20. IAF purchase, Acoma, 1928.

IAF 1131. Laguna bowl, Laguna Polychrome. White-slipped exterior; red underbody and interior. Four-color polychrome with checkerboard zigzag element. 3 ½" x 8". 1910–20. IAF purchase, Acoma, 1928.

IAF 1132. Acoma bowl, Acoma Polychrome. White slip with red interior rim. Exterior design in four panels with rainbird. Base has "flower" with four split petals. 4" x 7". 1900–1920. IAF purchase, Acoma, 1928.

IAF 1133. Acoma bowl, Acoma Black-on-white. White-slipped interior and exterior; three spirals with "eyes" and double arcs. 3 ½" x 7". 1910–20. IAF purchase, Acoma, 1928.

IAF 1134. Acoma bowl, Acoma Polychrome. Small bowl with sculpted rim. Four-pointed zigzag in orange with geometric elements; four-petaled motif on base. 3 ½" x 6 ¼". 1910–25. IAF purchase, Acoma, 1928.

IAF 1138. Laguna bowl, Laguna Polychrome. White exterior with orange interior. Band of parallelograms with dots and hatching. 3" x 4 ½". 1910–20. IAF purchase, Acoma, 1928.

IAF 1139. Laguna bowl, Laguna Polychrome. Red interior and white exterior with four floral motifs in brown and red. No delineation of base. 3" x 4 ½". 1910–25. IAF purchase, Acoma, 1928.

IAF 1140. Acoma jar, Acoma Polychrome. Small jar; geometric design with triangles and "eyes." 4" x 5 ½". 1910–25. IAF purchase, Acoma, 1928.

IAF 1149. Acoma jar, Acoma Polychrome. Very similar in potting and painting to IAF 1206. 14" x 18". 1910–25. IAF purchase, Acoma, by K. M. Chapman, 1928.

*IAF 1156 (p. 104). Acoma jar, Acoma Polychrome. Unusual jar with seven deer motifs (one without heartline), butterflies, and floral elements (grass); row of filled triangles around base. Possible ceremonial vessel. No major signs of wear. 9" x 11 ½". 1900–1925. IAF purchase, Acoma, by K. M. Chapman, 1928.

IAF 1157. Acoma canteen, Acoma Polychrome. Round form with spout and two handles. Central medallion with opposing scrolls and many double-dot motifs. 6" (h) x 9" (l) x 6" (w). 1900–1920. IAF purchase, Old Santa Fe Trading Post, 1928.

IAF 1184. Acoma jar, Acoma Polychrome. High-shouldered jar with Tularosa-style scroll motifs (three panels of two scrolls each), solid and hatched. 10 ½" x 12". 1900–1920. According to Juana Leno, her mother, Lupita Vallo, made this jar. IAF purchase from B. A. Reuter, 1929.

IAF 1203. Acoma jar, Acoma Polychrome. Tall-necked jar with banded design; neck and body bands repeat, central band of split parallelograms. 9 ¾" x 11 ½". 1900–1910. IAF purchase from Maisel's, Albuquerque, 1929.

IAF 1206. Acoma jar, Acoma Polychrome. Large jar with flat base. Hatched and solid stepped meanders with two-headed thunderbird, heartline deer, and double arcs with rectangular "eyes." 13 ½" x 18 ½". 1910–25. Same potter-painter as IAF 1149? IAF purchase, Acoma, from Maria Cimmaron by K. M. Chapman, 1929.

IAF 1401. Acoma jar, Acoma Polychrome. Water jar in four-color polychrome; four diamond units and double-arc motifs. 9 ½" x 12". 1900–1910. IAF purchase from Hugh B. McGill, 1930.

IAF 1423. Acoma canteen, Acoma Polychrome. Unusual double canteen form with long connecting tube and tall arched handle. Floral and geometric design elements. 6 ½" (h) x 13" (l) x 3 ½" (w). 1900–1920. IAF purchase, Acomita, by K. M. Chapman, 1930.

IAF 1424. Acoma canteen, Acoma Polychrome. Three-lobed form with central spout and flat base. Orange and black geometric design. 6 ½" (h) x 11" (l) x 4 ½" (w). 1900–1920. IAF purchase, Acomita, by K. M. Chapman, 1930.

*IAF 1457 (p. 163). Laguna tile, Laguna commercial ware. Commercial glaze (Volkmar) with green double-headed stylized bird motif. Made under the direction of Josephine Foard by Yamie Z. Leeds. 6" x 6". Ca. 1910–20. Gift of Yamie Z. Leeds, Seama, 1930.

IAF 1458. Laguna tile, Laguna commercial ware. Cut commercial tile with unglazed black-and-red geometric design. Made by Yamie Z. Leeds in connection with Josephine Foard. 6" x 6". 1910–20. Gift of Yamie Z. Leeds, Seama, 1930.

*IAF 1485 (p. 69). Acoma bowl, Acoma Polychrome. Small bowl with fret meander of orange-and-black geometric design covering exterior. 4" x 7 ½". 1900–1920. IAF purchase, Acoma, by K. M. Chapman, 1930.

IAF 1591. Acoma jar, Acoma Polychrome. High-shouldered water jar with fluted rim. Allover checkerboard pattern with hatched and solid split elements. 11" x 14". 1890–1915. IAF purchase, Acoma, by K. M. Chapman, 1931

IAF 1673. Laguna jar(?), Laguna Polychrome(?). Tall-necked form, heavy construction. Brownish-red chalky slip with black in checkerboard layout: three horizontal bands, each different. 12" x 12". 1900–1910. Gift of Old Santa Fe Trading Post, 1931.

IAF 1908. Acoma jar, Acoma Polychrome. Large water jar with elaborate curvilinear design with heartline deer in Zuni layout. Red base and interior rim. 11 ½" x 14". 1910–20. IAF purchase, Acoma, 1933.

IAF 2019. Acoma bowl, Acoma Polychrome. Bowl with outflaring rim and deep red base. Four-color polychrome with six panels of geometric design. 4" x 7". 1910–20. IAF purchase from Pamela Parsons, 1934.

IAF 2053. Acoma jar, Acoma Polychrome. Four-color polychrome with banded design; neck and body bands similar, shoulder band of hatched parallelograms. Flexure at base of neck. 12 ½" x 11 ½". 1890–1910. Transfer from PX collection, 1937.

IAF 2146. Acoma seed jar, Acoma Polychrome. High-shouldered, with flat upperbody and no neck. Four design panels around body with Ako Polychrome-style feather motifs. 5 ⅜" x 8 ¼". 1910–20. Gift of Laura B. Toulouse estate.

IAF 2175. Acoma bowl, Acoma Polychrome. White exterior and orange interior with orange zigzag with checkerboard corners. 4 ½" x 7 ½". 1900–1920. Gift of Mrs. Carlos Vierra; acquired by Carlos Vierra, ca. 1920.

IAF 2209. Acoma jar, Acoma Polychrome. Allover design with three medallions and three diagonal rectangles. 9" x 12". 1900–1920. IAF purchase from Spanish and Indian Trading Co. for Mary Austin collection.

IAF 2319. Laguna bowl, Laguna commercial ware. Shallow bowl with brown zigzag motif under yellow glaze. Red-slipped exterior. Style introduced by Josephine Foard, ca. 1910. 1 ¾" x 5". 1910–25. IAF purchase by K. M. Chapman from Elizabeth Elder, 1945.

IAF 2491. Acoma basket form, Acoma Black-on-white. Square shape with squared handle. White slipped with black geometric design and four split leaves on flat base. 3 ¾" x 3 ⅜", including handle. 1910–25. Trade with Bruce Ellis for material from Seligman collection.

IAF 2832. Acoma jar, Acoma Polychrome. High-shouldered jar with typical Zuni design layout in four bands with rainbird elements and large-tailed red birds. 10" x 13 ¾". 1900–1920. Gift of Amelia E. White, 1961.

IAF 2952. Acoma jar, Acoma Polychrome. High-shouldered jar with shoulder flexure. Undulating rainbow band with scrolls, split leaves, and hatching. 10 ¾" x 11 ¾". 1900–1910. IAF purchase from Olive Rush.

*IAF 3010 (p. 159). Acoma vase form, Acoma Polychrome. Round body with tall neck and outflaring rim. Banded design with three distinct sets of motifs. 13 ¾" x 11". 1900–1915. Gift of C. Phelps Dodge, 1965 (in family for over 50 years).

SAR 1978-1-178. Acoma jar, Acoma Polychrome. Water jar; four medallions and elaborate fill elements. Red base and interior rim. 11" x 12". 1900–1920. Amelia White estate, 1978.

SAR 1981-26-6. Acoma canteen, Acoma Polychrome. Round form with two handles and central spout. Pinwheel design on top; red base. 5" x 5". 1910–20. Gift of Robert Klein, 1982.

1920 to 1940

*IAF 257 (p. 114). Acoma jar, Acoma Polychrome. Water jar; typical Zuni design layout with medallions. Narrow body band of birds; separate neck design. 12" x 14 ½". 1920–24. Gift of Ernest Seligman, Domingo, NM, 1924.

IAF 347. Acoma jar, Acoma Polychrome. Well-painted four-color polychrome with unusual gray slip in the geometric decoration. Red base and interior rim. 8 ½" x 11 ½". 1920–25. Gift of James H. MacMillan, 1925.

IAF 394. Laguna bowl, Laguna Polychrome. Open high-walled bowl with outflaring rim and commercial glaze. Red base and red interior slip (absorbed by the glaze). Black geometric design on inside rim; hatched stepped-scroll motifs around outside. 5" x 7 ½". 1920–25. IAF purchase, Encinal, 1925.

IAF 429. Acoma bowl, Acoma Polychrome. Six-pointed zigzag around the body in solid stepped elements. Red base, white interior. 5" x 8". 1920–25. IAF purchase, Acomita, 1925.

IAF 431. Laguna bowl, Laguna Polychrome. Small bowl slipped white with red interior rim band. Band of six diamonds with checkerboard motifs and scallops. 3" x 5". 1920–25. IAF purchase, Acomita, 1925.

*IAF 655 (p. 106). Acoma jar, Acoma Polychrome. Allover design with interlocking band of Tularosa-style scrolls in solid and hatched elements. 10 ½" x 13". 1925–26. IAF purchase, Southwest Indian Fair, 1926.

IAF 656. Acoma seed jar, Acoma Polychrome. Round neckless form; two repeating bands of red and black stepped elements on white slip. 6" x 9 ½". 1925–26. IAF purchase, Southwest Indian Fair, 1926

IAF 733. Acoma bowl, Acoma Polychrome. Tall walls with eight panels of simple geometric design in orange and brown-black. 6" x 10". 1920–24. Gift of K. M. Chapman, 1927; purchased by him at Seama, 1924.

IAF 742. Laguna bowl, Laguna Polychrome. Small bowl; five unbordered orange flowers linked by arcs and surrounded by triangular elements. 3" x 5 ½". 1920–25. IAF purchase, Encinal, by K. M. Chapman, 1927.

IAF 932. Laguna bowl, Laguna polychrome. Bowl has commercial glaze; wide body band of four units with split triangles and double dots; band of checkerboards around base. Interior glazed. "Queaustea #18" written on bottom. 6 ½" x 9". 1925–28. IAF purchase, Laguna, by K. M. Chapman, 1928.

IAF 962. Acoma bowl, Acoma Polychrome. Five units of geometric motifs in orange and black. White-slipped interior, red base. 7" x 15". 1920–25. IAF purchase, Acomita, by K. M. Chapman, 1928.

*IAF 1031 (p. 168). Acoma jar, Acoma Black-on-red. Copy of a Hawikuh Black-on-red jar (IAF 996). Claimed by Marie Z. Chino to have been made by her sister, Santana Sanchez. Entirely red slipped with black matte design. 10" x 13 ½". 1925–28. IAF purchase, Acoma, by K. M. Chapman, 1928.

IAF 1057. Acoma wedding vase, Acoma Polychrome. Angular body with two outflaring spouts and connecting handle. Two double-headed thunderbirds with wings. Lines painted on handle. 10 ½" x 8". 1920–30. IAF purchase, Acoma, 1928.

IAF 1072. Acoma jar, Acoma Polychrome. Water jar; allover checkerboard layout with bordered orange split rectangles and black split diamonds. 10" x 11". 1920–25. IAF purchase, Acoma, 1928.

*IAF 1074 (p. 164). Acoma jar, Acoma Polychrome. Water jar with allover checkerboard pattern of split black and red rectangles, split arcs, and triangles. 11" x 12". 1920–30. IAF purchase, Acoma, 1928.

IAF 1087. Acoma jar, Acoma Polychrome. Large water jar with Zuni-style layout: central band of unbordered orange birds and floral elements; repeating scroll-and-triangle bands at rim and base. 10" x 14 ½". 1920–28. IAF purchase, Acoma, 1928.

IAF 1108. Acoma jar, Acoma Polychrome. Water jar; banded triangle and hatched design. Top and body bands repeat; hatched triangles around shoulder. 8" x 11". 1920–25. IAF purchase, Acoma, 1928.

IAF 1120. Acoma bowl, Acoma Polychrome. White-slipped interior and exterior; four orange and black scroll motifs of feathers in a spiral. Lucy Lewis claims she made the bowl. Popouts from firing. 5" x 9". 1925–28. IAF purchase, 1928.

IAF 1121. Acoma bowl, Acoma Polychrome. Small bowl; white-slipped inside and out. Red and black exterior design covers base. 4" x 7". 1920–25. IAF purchase, Acoma, 1928.

IAF 1122. Acoma bowl, Acoma Polychrome. Alternating vertical bands of hatching and zigzag motifs. 4" x 8 ½". 1920–25. IAF purchase, Acoma, 1928.

IAF 1135. Acoma bowl, Acoma Polychrome. Red-slipped exterior and white-slipped interior with hatched triangle design. 2 ½" x 5". Ca. 1920. IAF purchase, Acoma, 1928.

IAF 1136. Laguna bowl, Laguna Polychrome. Small bowl, white-slipped inside and out. Red dots with black geometric elements on exterior. "Encinal 95¢" written on base. 3" x 4 ½". 1920–25. IAF purchase, Acoma, 1928.

IAF 1137. Laguna cup, Laguna Polychrome. Small cup with flat base and missing handle. Polished red interior; red and black geometric design on white slip. 2 ½" x 4". Ca. 1920. IAF purchase, Acoma, 1928.

IAF 1155. Acoma jar, Acoma Polychrome. Water jar with four spiral elements composed of various feather motifs. Red base and interior rim. Made by Lola Vallo. 7" x 8 ½". 1928. IAF purchase, Acoma, by K. M. Chapman, 1928.

IAF 1181. Laguna vase, Laguna Polychrome. Bottle-shaped jar; neck and body bands of hatched, scroll, and triangular elements. Reddish-brown paint with orange slip. Same potter as IAF 1182. 5" x 5 ½". Ca. 1928. IAF purchase, Laguna, by K. M. Chapman, 1928.

IAF 1182. Laguna vase, Laguna Polychrome. Bottle form; four-color polychrome with a multiple-banded geometric design. Same potter as IAF 1181. 5" x 5 ½". Ca. 1928. IAF purchase, Laguna, by K. M. Chapman, 1928.

*IAF 1368 (p. 161). Acoma jar, Acoma Polychrome. Two double-headed thunderbirds with elaborate wings and two quadrated triangle motifs. 8 ½" x 11". 1920–25. IAF purchase from D. M. Bacalski, Navajo Trading Post, Albuquerque, 1929.

IAF 1422. Acoma jar, Acoma Polychrome. Three major design elements with a diagonal rectangle and double-arc, double-dot, and scroll elements. Lopsided construction. 6" x 8". 1925–30. IAF purchase, Acoma, by K. M. Chapman, 1930.

IAF 1426. Acoma bowl, Acoma Polychrome. Shallow bowl with four panels of black and orange geometric motifs. 4" x 9". 1925–30. IAF purchase, Acomita, by K. M. Chapman, 1930.

*IAF 1428 (p. 164). Acoma canteen, Acoma Polychrome variant. Round form with two loop handles and spout. Entirely red slipped with black and white floral motifs. "Dolores Ascension, 1.00" penciled on base. 6 ½" (h) x 9" (l) x 7" (w). 1930. IAF purchase from Dolores Ascension, 1930.

IAF 1480. Acoma two-spouted vase, Acoma Polychrome. Wedding-vase form without connecting handle. Simple geometric design in red and black. 5 ½" x 5 ½". 1920–30. IAF purchase, Acoma, by K. M. Chapman, 1930.

IAF 1492. Laguna jar, Laguna Polychrome. Water jar; allover checkerboard layout with split diamonds and open ellipses with hatch-filled corners. 8" x 10". 1920–30. IAF purchase, Laguna Pueblo, by K. M. Chapman, 1930.

IAF 1574. Acoma jar, Acoma Polychrome. Checkerboard design layout with unbordered orange colcha-type elements. Made by Lucita Sanchez(?). 9 ½" x 11 ½". 1920–30. IAF purchase, Acoma, by K. M. Chapman from Lucita Sanchez, 1931.

IAF 1577. Acoma jar, Acoma Polychrome. Allover checkerboard layout with unbordered orange flowers and opposing triangles with filled corners. Marie Chino verified in 1981 that she had made it. 10" x 10". 1925–31. IAF purchase, Acoma, from Marie Chino by K. M. Chapman, 1931.

IAF 1579. Acoma bowl, Acoma Polychrome. Wide, shallow bowl with fluted rim. Interior has orange unbordered flowers connected by stems and leaves; exterior has bordered orange flowers, ellipses, and rows of dots. 3" x 9". 1920–25. IAF purchase, Acoma, by K. M. Chapman from Lucita Sanchez, 1931.

IAF 1582. Acoma jar, Acoma Polychrome. Four units of well-polished, unbordered orange slip with triangular elements. 8" x 11". 1920–30. IAF purchase, Acoma, by K. M. Chapman, 1931.

IAF 1583. Acoma bowl, Acoma Polychrome. White-slipped interior and exterior with red base. Five design panels with triangles, stepped scrolls, and three-lobed motifs. 7" x 13". 1925–31. IAF purchase from Concepcion Mariano, Acoma, by K. M. Chapman, 1931.

IAF 1584. Acoma bowl, Acoma Polychrome. Thinly slipped or unslipped yellow exterior with black, white, and orange geometric designs. 7" x 11". 1925–30. IAF purchase from Marie Chino, Acoma, by K. M. Chapman, 1931.

IAF 1586. Acoma jar, Acoma Polychrome. Allover checkerboard pattern with solid and hatched split elements and triangles. 10 ½" x 15". 1920–30. IAF purchase, Acoma, by K. M. Chapman, 1931.

IAF 1592. Acoma bowl, Acoma Polychrome. One-third of bowl is missing; molded lug handle. Four panels of geometric design. 3 ½" x 6 ½". 1920–25. IAF purchase, Acoma, by K. M. Chapman, 1931.

IAF 1702. Acoma bottle, Acoma Polychrome. Tiny opening in a squared-off bottle form. White upper shoulder and neck; red-slipped body with two medallion motifs and two diamonds with hatching. 5 ½" x 4 ½". 1925–30. Gift of Grace Fairfax, 1932.

IAF 2030. Acoma jar, Acoma Polychrome. Small water jar with four realistic flowers in orange; double feather motifs with geometric elements. 6 ½" x 9 ½". 1936. Gift of Indian Fair, 1936.

IAF 2049. Acoma seed jar, Acoma Polychrome. Round neckless form; unbordered orange band around upper shoulder, solid and hatched geometric elements around body. 7" x 10 ½". 1920–30. Gift of Mary Cabot Wheelwright, 1937.

IAF 2057. Acoma jar, Acoma Polychrome. Checkerboard layout with two rows of six casual squared spirals. 4 ¾" x 6 ½". 1935–38. Gift of New Mexico Association of Indian Affairs through Morris Burge, 1938.

*IAF 2104 (p. 162). Acoma jar, Acoma Polychrome variant. Allover red slipped; black and white bird and floral design with geometric elements. Made by Mary Histia. 8 ½" x 10 ¼". Ca. 1931. IAF purchase by K. M. Chapman from the Mary Austin collection, 1940.

IAF 2190. Acoma bowl, Acoma White-on-red. Unusual red-slipped exterior with white connected flowers; white interior. 3 ½" x 7 ¼". 1925–28. Gift of K. M. Chapman, collected ca. 1928.

*IAF 2490 (p. 167). Acoma jar, Acoma Polychrome variant. Cooking-jar form with indented coil decoration at neck. Red-slipped with black-brown and white floral, dot, and divided-ellipse motifs. 5 ⅞" x 8 ½". 1920–40. Trade with Bruce Ellis for material from Seligman collection, 1955.

IAF 2629. Acoma tile, Acoma Polychrome. Round tile with two holes for hanging. Bird motif with hatched scroll elements. ¾" x 7 ¾". 1930–40. Gift of K. M. Chapman, 1956.

IAF 2634. Laguna jar, Laguna Polychrome. Cylindrical form with two bands of geometric design. Red base and interior rim. Made by Maria (Mrs. Jose) Lucero of Mesita. 5 ¾" x 6 ½". 1920–30. Gift of K. M. Chapman, 1956.

IAF 2776. Acoma seed jar, Acoma Polychrome. Flat upper shoulder with band of six unbordered orange birds. Body has four angular geometric units. 5 ⅞" x 9 ¾". 1920–40. Gift of Amelia E. White, 1959.

IAF 2803. Acoma seed jar, Acoma Polychrome. Flat upper shoulder and small opening. Rectangle motif around opening; bar and scroll motifs on body. 6 ½" x 8 ½". 1920–40. Bequest of Margretta S. Dietrich.

IAF 2880. Acoma dish, Acoma Polychrome. White interior with Three Avanyu crests typical of prehistoric Rio Grande biscuit wares. Two white spots on the exterior, which appears to have a washy red slip. 1 ¾" x 4 ⅞". 1935–40. Gift of K. M. Chapman, 1962.

SAR 1979-6-18. Acoma jar, Acoma Polychrome. Three panels of diagonally divided repeating elements in orange and black on white slip. Orange base and interior rim. 3 ⅞" x 4 ½". 1930–40. Gift of Mabel Morrow estate, 1979.

SAR 1981-26-34. Acoma jar, Acoma Polychrome. Banded black geometric design; five design units on the body band. 5 ¾" x 8". 1920–40. Gift of Robert Klein, 1982.

SAR 1981-26-35. Laguna jar, Laguna Polychrome. Four units of stepped triangular design; yellow-slipped base with commercial vitreous glaze on interior. 11 ¾" x 7". 1920–40. Gift of Robert Klein, 1982.

SAR 1981-26-37. Acoma vase, Acoma Polychrome. Tall, narrow-necked form with unbordered orange slip around upper neck. Black geometric design with double dots on body. 6 ½" x 4". 1920–40. Gift of Robert Klein, 1982.

SAR 1981-26-38. Acoma vase, Acoma Polychrome. Tall-necked form with outflaring rim. Orange and black stylized bird motifs. 5" (h). 1930–40. Gift of Robert Klein, 1982.

SAR 1981-26-39. Acoma pitcher, Acoma Polychrome. Pitcher with spout and large loop handle. 6" x 3 ½". 1920–40. Gift of Robert Klein, 1982.

SAR 1984-4-7. Acoma jar, Acoma Polychrome. Wide body band of design: hatched and solid elements, including scrolls and triangles. Red base and interior rim. 6 ¼". 1920–40. Given in memory of Margaret Moses (collector), 1984.

1940 to 1960

IAF 2145. Acoma jar, Acoma Polychrome. Water jar with stepped triangle motifs and Tularosa-style spirals in black and unbordered polished orange. 5 ½" x 7 ½". 1935–41. Gift of Laura B. Toulouse estate, 1941.

IAF 2147. Acoma seed jar, Acoma Black-on-white. Small form with fineline square spirals connected diagonally. Made by Jessie Garcia. 3 ⅜" x 4 ½". Ca. 1941. Gift of K. M. Chapman, 1941.

IAF 2148. Acoma bowl, Acoma Polychrome. White-slipped interior; orange-slipped exterior with horizontal black zigzag with filled corners (reminiscent of Mojave pottery designs). Made by Juana Concho. 3" x 3 ⅞". Ca. 1941. Gift of K. M. Chapman, 1941.

IAF 2149. Acoma dish, Acoma Polychrome. Central pinwheel in square; four stepped sections in orange with geometric fill elements. Made by Mary Histia. 1 ¼" x 5 ⅛". 1941. Gift of Mrs. K. M. Chapman, 1941.

IAF 2150. Acoma jar, Acoma Polychrome. Small jar with checkerboard pattern of red split rectangles and split arcs and triangles. Made by Mary Histia. 3 ⅛" x 3 ¾". Ca. 1941. Gift of Mrs. K. M. Chapman, 1941.

*IAF 2451 (p. 165). Acoma dish, Acoma Polychrome. Small dish with two modeled bird heads (black with white dots) on rim. Orange and black stylized bird painted on interior. 1" x 4 ¼". Ca. 1950. Gift of Bruce Ellis, 1954.

IAF 2516. Acoma jar, Acoma Polychrome. Fineline design in checkerboard pattern. Red base and interior rim. "Acoma N. Mex." on base. 5" x 7 ½". 1950–55. Gift of Mrs. C. H. Dietrich, 1955.

IAF 2528. Laguna bowl(?), Laguna Black-on-red(?). Chunky reddish-buff paste. Six units of geometric design in brown paint. 3 ½" x 9". 1950–55. Gift of E. Boyd, 1955.

IAF 2541. Acoma bowl, Acoma Black-on-red. Small bowl with black checkerboard design around the exterior of an entirely red-slipped vessel. 2 ½" x 5 ½". 1940–45. Gift of K. M. Chapman, acquired ca. 1945.

IAF 2762. Acoma seed jar, Acoma Polychrome. Wide-mouthed jar with square drawn around the opening and four Hopi-style feather and scroll units of design. "Acoma Sky City N. Mexico. 1958" painted on base. 6" x 8 ¾". Collected at Acoma Fiesta, 1958. IAF purchase from Mrs. William J. Lippincott.

IAF 2763. Acoma bowl, Acoma Polychrome. Shallow bowl with eleven panels of repeating hatched and solid geometric motifs with double dots. Orange base. Made by Marie Z. Chino. 5 ½" x 13 ½". 1958. IAF purchase from Mrs. W. J. Lippincott, 1958.

IAF 2777. Acoma jar, Acoma Polychrome. Four Tularosa-style spiral motifs in hatched and solid elements. Orange base. Signed "Lucy M. Lewis Acoma N.M." 5 ½" x 7 ⅜". 1959. Gift of Lucy M. Lewis.

*IAF 2778 (p. 64). Acoma jar, Acoma Polychrome. Small water jar with many popouts due to steam pockets in the firing. Undulating orange-bordered double rainbow band with bird and floral motifs. 6" x 7 ¼". 1959. Made by Lucy M. Lewis. Gift of Lucy M. Lewis, 1959.

IAF 2779. Acoma bowl, Acoma Polychrome. Shallow bowl with band of hatched and solid black stepped triangles. Bottom has popouts. "Lucy M. Lewis (Sky City) New Mexico" written on interior. 5 ½" x 14" (irregular). 1959. Gift of Lucy M. Lewis, 1959.

*IAF 2780 (p. 107). Acoma seed jar, Acoma Black-on-white. Round form with small opening and Chaco-inspired "lightning" design in black. Made and signed by Lucy M. Lewis. 5 ⅞" x 8". 1959. IAF purchase from Lucy M. Lewis, 1959.

IAF 2802. Acoma jar, Acoma Polychrome. Water jar with allover design of triangles, split triangles, zigzags, and hatching. 6 ¾" x 9". 1950–60. Bequest of Margretta S. Dietrich.

IAF 2845. Acoma dish, Acoma Black-on-white. Central fish motif with black rim. Made and signed by Sarah Garcia. 1" x 4 ½". Ca. 1960. IAF purchase from Mrs. William J. Lippincott, 1962.

IAF 2867. Acoma dish, Acoma Black-on-red. Fineline design on interior. "Acoma, N.M." on base. 1 ¼" x 4 ¾". 1950–60. Gift of K. M. Chapman, 1962.

IAF 2979. Acoma jar, Acoma Polychrome. Water jar with orange and red interlocking spiral motifs and triangles with double dots. "Acoma N.M." on base. Lucy M. Lewis said she made it. 9 ½" x 12". Ca. 1940 to late 1940s. Gift of Elizabeth Davisson; purchased at Santo Domingo in the late 1940s.

IAF 3004. Acoma dish, Acoma Polychrome. Stylized bird motif in black and orange on white slip. "Juanalita G. Ortiz, Acoma" penciled on bottom. 1" x 3 ⅛". 1940–50. Gift of K. M. Chapman, 1965.

IAF 3045. Acoma bowl, Acoma Polychrome. Miniature form; red and black decoration and "ticked" rim. 1 ½" x 1 ⅞". Penciled on base, "1954 50¢". Gift of K. M. Chapman, 1965.

IAF 3046. Acoma jar, Acoma Polychrome. Miniature form with orange and black zigzag decoration on white slip. 1 ⅝" x 1 ⅞". 1950–60. Gift of K. M. Chapman, 1965.

IAF 3047. Acoma canteen, Acoma Polychrome. Miniature form with two loop handles and spout. "Acoma, New Mex." on base. 1 ⅛". 1955–60. Gift of K. M. Chapman, 1965.

SAR 1989-22-2. Acoma chicken form, Acoma Polychrome. Red and black paint delineate features on white slip. 3 ¼" x 2 ⅛". 1950–60. Gift of Barbara Latham Cook, 1989.

1960 to 1991

IAF 2781. Acoma bowl, Acoma Black-on-white. Bowl with incurving rim and checkerboard design with triangles and fineline. Made and signed by Lucy M. Lewis. 4 ¼" x 7 ¼". 1959. IAF purchase from Lucy M. Lewis, Acoma, 1959.

*IAF 2789 (p. 50). Acoma jar, utility ware. Jar with corrugated neck band entirely, slipped red and reduced in firing to brown. Made and signed by Lucy M. Lewis. 6 ½" x 6 ¼". 1960. IAF purchase, Santa Fe Indian Market, 1960.

IAF 2790. Acoma seed jar, Acoma white ware. Round form with small mouth; white-slipped, no design, fired in a reducing atmosphere to a pewter gray. Made by Lucy M. Lewis. 3 ½" x 4 ¼". 1960. IAF purchase, Santa Fe Indian Market, 1960.

IAF 2791. Acoma dish, Acoma Black-on-white. Opposing black and white sections with lizard motifs in positive and negative. Tag on base, "1960 Acoma Pueblo Lucy Lewis." 1" x 5". 1960. IAF purchase, Santa Fe Indian Market, 1960.

IAF 2801. Acoma jar, Acoma Polychrome. Allover design of two opposing sets of spiral and feather motifs. Made by Gladys Vallo. 8 ¼" x 12 ¼". Ca. 1961. Bequest of Margretta S. Dietrich, 1961.

*IAF 2831 (p. 107). Acoma seed jar, Acoma Black-on-white. Mimbres-inspired fineline design on the upper three-quarters of the vessel, forming chevron patterns. Made and signed by Marie Z. Chino. 4 ¾" x 7". 1961. IAF purchase from the maker, Santa Fe Indian Market, 1961.

*IAF 2842 (p. 107). Acoma seed jar, Acoma Black-on-white. Flat topped jar; four Mimbres-inspired grasshopper motifs. Made and signed by Jessie C. Garcia. 3 ½" x 9 ¾". 1961. IAF purchase from maker, Santa Fe Indian Market, 1961.

IAF 2844. Acoma turkey, Acoma Polychrome. Round form with modeled head and fan tail. Orange spots with black dots, feathers, and geometric motifs. Made and signed by Sarah Garcia. 3 ¾". 1962. IAF purchase from Mrs. William J. Lippincott, 1962.

IAF 2846. Acoma dish, Acoma Black-on-white. Black rim with central Mimbres-style grasshopper motif. Made and signed by Sarah Garcia. 1" x 4 ⅝". Ca. 1960. IAF purchase from Mrs. William J. Lippincott, 1962.

IAF 2913. Acoma bird bowl, Acoma Polychrome. Bowl with modeled head and looped tail. Unbordered orange flower motifs. 1 ⅝" x 2 ⅜". Ca. 1960. Gift of Clare Jones, 1962.

IAF 2923. Acoma chicken, Acoma Polychrome. Footed chicken form with red-slipped looped tail. Details of feathers in black. 5 ¾" x 3 ¼". 1950–60. Gift of Ina Sizer Cassidy, 1962.

*IAF 2936 (p. 80). Acoma jar, Acoma Polychrome. Pseudo-ceremonial jar in water-jar form with two modeled snakes and two modeled frogs at the rim. Jar and snakes are slipped white, frogs are slipped red. Snakes and frogs are detailed in black paint. Made and signed by Lucy M. Lewis. 5 ½" x 7 ¼". 1963. Gift of Lucy Lewis, 1963.

IAF 2945. Acoma turkey, Acoma Polychrome. Elaborate depiction of feathers with orange areas and black dots. Modeled head and tail. 4 ¼" x 3 ½". Ca. 1964. Gift of Laura Hersloff, 1964.

IAF 2946. Acoma chicken, Acoma Polychrome. Modeled chicken form with flaring tail. Elaborate feather designs. Made and signed Lucy M. Lewis. 4 ¾" x 3". Ca. 1964. Gift of Laura Hersloff, 1964.

IAF 2968a–2968b. Acoma drum jar, Acoma white ware. Undecorated jar with stretched deerskin over the opening and accompanying bent-stick beater. Made and signed by Lucy M. Lewis. 6 ¼" x 5 ⅜". 1964. IAF purchase, Santa Fe Indian Market, 1964.

IAF 2969. Acoma jar, Acoma Black-on-white. Miniature form with fineline design around the upper shoulder. Made and signed by Marie Z. Chino. 2 ⅜" x 1 ⅝". 1964. IAF purchase, Santa Fe Indian Market, 1964.

IAF 2970. Acoma jar, Acoma Black-on-white. Miniature with simple black geometric design. Made and signed by Carrie Chino. 1 ⅝" x 1 ¾". 1964. IAF purchase, Santa Fe Indian Market, 1964.

IAF 2971. Acoma jar, Acoma Black-on-white. Miniature with fineline design. Made and signed by Marie Z. Chino. 1 ⅜" x 1 ⁵⁄₁₆". 1964. IAF purchase, Santa Fe Indian Market, 1964.

IAF 2972. Acoma jar, Acoma Black-on-white. Miniature with vertical panels of geometric design. Made and signed by Marie Z. Chino. 1 ⅝" x 1 ⅜". 1964. IAF purchase, Santa Fe Indian Market, 1964.

IAF 2973. Acoma bowl, Acoma Black-on-white. Miniature with simple black geometric design. Made and singed by Carrie Chino. 1 ⅛" x 1 ⁵⁄₁₆". 1964. IAF purchase, Santa Fe Indian Market, 1964.

IAF 2974. Acoma rattle, Acoma Black-on-white. Clay dance rattle with modeled head at tip of handle. Black paint details. Made and signed by Lucy M. Lewis. 2 ½" x 6 ¼". 1964. Gift of Jack and Margery Lambert, 1964.

IAF 2980. Acoma jar, Acoma Polychrome. Allover pattern with four stepped units and four vertical dividing panels. 7" x 9 ½". Ca. 1964. Gift of Elizabeth Davisson, 1964.

IAF 2998. Laguna(?) bowl, Laguna Black-on-red(?). Reddish-buff clay with red slip. Two bands of geometric design; neck band of interlocking scrolls. 4 ¼" x 8". 1960–65. Gift of Sallie Wagner, 1965.

IAF 3003. Acoma dish, Acoma Polychrome. Central motif of double-headed thunderbird. 1 ¼" x 4 ½". 1950–60. Gift of K. M. Chapman, 1965.

IAF 3044. Acoma bowl, Acoma Black-on-white. Miniature with simple black geometric design. 1 ⅜" x 1 ¹³⁄₁₆". Ca. 1960. Gift of K. M. Chapman, 1965.

IAF 3072. Acoma seed jar, Acoma Black-on-white. Wide-mouthed form with two opposing Mimbres-style fish motifs. Made and signed by Jessie Garcia. 4 ½" x 7 ¾". 1966. IAF purchase from the maker. Santa Fe Indian Market, 1966.

IAF 3073. Acoma seed jar, Acoma Black-on-white. Round form with small opening; four-pointed star with hatching, open half circles and circles. Made and signed by Anita Lowden. 5 ¾" x 7 ½". 1966. IAF purchase from maker, Santa Fe Indian Market, 1966.

IAF 3102. Acoma owl, Acoma Polychrome. Black, red, and gray design on white slip. Made and signed by Mrs. C. Garcia. 5 ¼" x 3 ¾". 1969. IAF purchase, Santa Fe Indian Market, 1969.

IAF 3103. Acoma owl, Acoma Polychrome. Modeled owl form with painted feather details. Made and signed Marie Z. Chino. 4 ⅞" x 4 ¼". 1969. IAF purchase, Santa Fe Indian Market, 1969.

IAF 3104. Acoma owl, Acoma Polychrome. Owl with modeled facial features, wings, and tail. Made and signed by Rose Chino. 6" x 5". 1969. IAF purchase, Santa Fe Indian Market, 1969.

*IAF 3115 (p. 182). Acoma jar, Acoma Polychrome. Water jar with banded design. Neck has linked diamond motifs with double dots; body has solid and white zigzag panels. Made and signed by Francis Torivio. 7 ¾" x 9". 1970. IAF purchase from maker, Santa Fe Indian Market, 1970.

IAF 3123. Acoma jar, Acoma Polychrome. Round form with wide mouth. Orange-bordered zigzag with black geometric fill elements. 5 ½" x 7 ½". Made and signed by Stella Shutiva. 1971. IAF purchase from the maker.

IAF 3128. Acoma bowl, Acoma Polychrome. Small olla form with five Zuni-style heartline deer. 4 ¾" x 6". Ca. 1971. Gift of Mrs. F. W. Hodge and Helen Blumenschein, 1971.

SAR 1981-2-32. Acoma owl, Acoma Polychrome. Modeled wings, beak, and "ears." Elaborate depiction of feathers in black. Made and signed by Lucy M. Lewis. 6 ⅞" x 7 ½". Ca. 1965. Gift of Sallie Wagner, 1981.

SAR 1982-7-11. Acoma bowl, Acoma Polychrome. Two bands of alternating geometric elements. 3 ½" x 5 ¼". Ca. 1970. Gift of Sallie Wagner, 1982.

SAR 1982-7-14. Acoma dish, Acoma Black-on-white. Oval form with fishlike design in black. Made and signed by Anita Lowden. 6 ½" (l). Ca. 1970. Gift of Sallie Wagner, 1982.

SAR 1982-7-15. Acoma dish, Acoma Polychrome. Red central square with two opposing stylized bird motifs and double dots. 1" x 4 ½". Ca. 1970. Gift of Sallie Wagner, 1982.

*SAR 1982-7-16 (p. 183). Acoma chicken, Acoma Polychrome. Footed form with a slit in the back, modeled head, crest, and tail. Black depiction of feathers. 7". 1960–70. Gift of Sallie Wagner, 1982.

*SAR 1985-9-1 (p. 184). Acoma jar, Acoma Polychrome. Kiln-fired water jar with row of unbordered orange bird motifs and unique heartline deer designs; design copied from IAF 1042. Made and signed Rose Chino Garcia. 9" x 12". 1985. Purchased from Mudd-Carr Gallery, 1985.

SAR 1985-18-1. Acoma jar, Acoma Polychrome. Tall-necked form with neck band and body bands in brown and orange on white slip. Kiln fired. Made and signed by "[Loretta] Joe, Acoma". 7" x 5 ¾". Ca. 1981. Gift of Rick Dillingham, 1985.

*SAR 1986-4-1 (p. 88). Laguna jar, Laguna Polychrome. High-shouldered water jar with linked heart motifs with split leaves. Red rim. Signed Sratyuwe. Made by Gladys Paquin. 9 ½" x 11 ¾". 1986. Purchased from Mudd-Carr Gallery, 1986.

*SAR 1987-5-1 (p. 172). Acoma bowl, Acoma Polychrome. Large kiln-fired bowl with indented decoration around the rim coil. Tightly drawn geometric design in seven panels. Made and signed by Grace Chino. 10 ½" x 18 ½". 1985. IAF purchase through Rick Dillingham.

SAR 1987-5-2. Acoma jar, Acoma Polychrome. Kiln-fired jar with realistic pumpkin motifs around the body. Separate neck design is paneled in geometric motifs. Copy of older jar on the cover of Frank and Harlow's *Historic Pottery of the Pueblo Indians, 1600–1880*. Made and signed by Grace Chino. 8" x 10". 1986. IAF purchase through Rick Dillingham.

*SAR 1987-5-3 (p. 84). Acoma jar, Acoma Polychrome. Four-color kiln-fired jar made and signed by Wanda Aragon (Dzinats-ituwits's). Thinly potted with four diagonally connected units of diamonds and squares. 7" x 8 ¾". 1986. IAF purchase through Rick Dillingham.

*SAR 1987-13-4 (p. 186). Acoma plate, commercial ware. Slip-cast dinner plate with fired-on transfer decal of the Virgin Mary. Plate is bordered with handpainted geometric pattern. Signed by the painter, Mamie T. Ortiz. 9 ¾". 1987. Gift of Rick Dillingham.

*SAR 1987-13-5 (p. 186). Acoma plate, commercial ware. Slip-cast dinner plate with nine handpainted geometric motifs around the border and a fired-on transfer decal of Christ. Signed by the painter, Mamie T. Ortiz. 10 ⅛". 1987. Gift of Rick Dillingham.

*SAR 1988-13-1 (p. 87). Acoma jar, Acoma Polychrome. Kiln-fired five-color polychrome with elaborate bird and floral motifs. Made and signed by Shayatesa White Dove and inscribed "Traditional Acoma water olla with rainbow, parrot and floral motif." 11 ½" x 12 ½". Dated on base, August 9, 1988. Gift of Rick Dillingham.

*SAR 1989-7-294 (p. 185). Acoma seed jar, Acoma Polychrome. Round form with small opening; Mimbres-style scorpion motifs and geometric elements in four sections. Made and signed by B. J. Cerno (Barbara and Joe). 2 ⅝" x 3 ¼". Ca. 1977. Gift of Henry S. Galbraith, 1989.

SAR 1989-7-307. Acoma basket form, Acoma Polychrome. Small bowl form with three-coil handle; modeled bird heads on the rim. 3 ½" x 2 ¾". Ca. 1970. Gift of Henry S. Galbraith, 1989.

*SAR 1991-2-3 (p. 195). Acoma seed jar, Acoma Poly-chrome. Slip-cast spherical seed pot with ultra-fineline painted design. By Merlinda Miller. 5" x 5". 1991. Gift of Rick Dillingham.

*SAR 1991-7-1 (p. 191). Acoma commercial ware. Slip-cast Virgin Mary statuette. Made and signed by C. Concho. 12" (h). Ca. 1988. Gift of Rick Dillingham.

*SAR 1991-7-2 (p. 191). Acoma commercial ware. Slip-cast cowboy hat form. Made and signed by "K. L." 3 ¼"(h) x 9 ⅞" (l) x 8 ⅞" (w). Ca. 1990. Gift of Rick Dillingham.

References

AT&SF Railway
1928 Employee's Time Table no. 55. March 4, 1928, Atchison, Topeka & Santa Fe Railway Company, Albuquerque Division. Winslow, Arizona.

Bandelier, A. F.
1892 *Final Report of Investigations among the Indians of the Southwestern U.S.* Part 2. Papers of the Archaeological Institute of America, American Series, vol. 4. Cambridge, MA.

Batkin, Jonathan
1987 *Pottery of the Pueblos of New Mexico, 1700–1940.* Colorado Springs: Taylor Museum of the Colorado Springs Fine Arts Center.

Bloom, Lansing B.
1928 A Glimpse of New Mexico in 1620. *New Mexico Historical Review* 3(4):357–89.

Bloom, Lansing B., ed.
1937 Acoma and Laguna. In *Bourke on the Southwest,* New Mexico Historical Review 12(4):357–79.

Bolton, Herbert E.
1930 *Spanish Exploration in the Southwest, 1542–1706.* New York: Charles Scribner's Sons.

Bunzel, Ruth L.
1929 *The Pueblo Potter: A Study of Creative Imagination in Primitive Art.* New York: Columbia University Press.

Bureau of the Census
1913 *Thirteenth Census, 1910,* vol. 3, *New Mexico.*
 –14 Washington, D.C.: U.S. Government Printing Office.

1915 *Indian Population in the U.S. and Alaska, 1910.* Washington, D.C.: U.S. Government Printing Office.

Carlson, Roy L.
1985 *Eighteenth Century Navajo Fortress of the Gobernador District.* Earl Morris Papers, no. 2. Boulder: University of Colorado Press.

1982 The Polychrome Complexes. In *Southwestern Ceramics: A Comparative Review,* edited by Albert H. Schroeder, pp. 201–34. The Arizona Archaeologist 15.

Carroll, Charles H., Michael P. Marshall, J. S. Athens, G. C. Burtchard, E. Camilli, R. Hunter-Anderson, and J. R. Stein
1979 *The Public Service Company of New Mexico Seboyeta Pumped Storage Archaeological Study.* Albuquerque: Public Service Company of New Mexico.

Chapman, Kenneth, and Bruce Ellis
1951 The Line Break, Problem Child of Pueblo Pottery. *El Palacio* 58(9):251–91.

Coe, Ralph T.
1986 *Lost and Found Traditions.* Seattle: University of Washington Press, American Federation of the Arts.

Cushing, Frank
1886 *Zuni Breadstuff.* Indian Notes and Monographs 8. Reprint, New York: Museum of the American Indian, 1920, 1974.

Davis, W. W. H.
1857 *El Gringo, or New Mexico and People.* Reprint, Santa Fe: Rydal Press, 1938.

Dawson, Lawrence E.
1980 Birds, Deer and Flowers: Foreign Influence in Historic Pueblo Indian Pottery. Manuscript and catalog notes from the exhibition at the Lowie Museum of Anthropology, University of California, Berkeley.

Dillingham, Rick
1976 Nine Southwestern Indian Potters. *Studio Potter Magazine* 5(1):34–35.

1977 The Pottery of Acoma Pueblo. *American Indian Art Magazine*, Autumn, pp. 44–51.

Ellis, Florence H.
1936 *Field Manual of Prehistoric Southwestern Pottery Types.* University of New Mexico Bulletin, no. 291. Reprint, Millwood, New York: Kraus Reprint Company, 1977.

1966 On Distinguishing Laguna from Acoma Polychrome. *El Palacio* 73(3):37–39.

1974 Anthropology of Laguna Pueblo Land Claims. In *Pueblo Indians*, vol. 3. New York and London: Garland Publishing.

1979a Isleta Pueblo. In *Handbook of North American Indians*, vol. 9, pp. 351–65. Washington, D.C.: Smithsonian Institution.

1979b Laguna Pueblo. In *Handbook of North American Indians*, vol. 9, pp. 438–49. Washington, D.C.: Smithsonian Institution.

Ferguson, T. J., and E. Richard Hart
1985 *A Zuni Atlas.* Norman and London: University of Oklahoma Press.

Fisher, Nora
1979 Colcha Embroidery. In *The Spanish Textile Tradition of New Mexico and Colorado*, Museum of International Folk Art, pp. 153–67. Santa Fe: Museum of New Mexico Press.

Frank, Larry, and Francis H. Harlow
1974 *Historic Pottery of the Pueblo Indians, 1600–1880.* Boston: New York Graphic Society.

Frank, Ross H.
1991 The Changing Pueblo Indian Pottery Tradition: The Underside of Economic Development in Late Colonial New Mexico, 1750–1820. *Journal of the Southwest* 33(3):280–321.

Garcia-Mason, Velma
1979 Acoma Pueblo. In *Handbook of North American Indians*, vol. 9, pp. 450–66. Washington, D.C.: Smithsonian Institution.

Garvan, Beatrice B.
1982 *The Pennsylvania German Collection.* Philadelphia: Philadelphia Museum of Art.

Gill, Robert R.
1976 Ceramic Arts and Acculturation at Laguna. In *Ethnic and Tourist Arts: Cultural Expressions from the Fourth World*, edited by Nelson H. H. Graburn, pp. 102–13. Berkeley: University of California Press.

Gladwin, Winifred, and Harold S. Gladwin
1930 *A Method for the Designation of Southwestern Pottery Types.* Medallion Papers 7. Globe, AZ: Gila Pueblo.

Gladwin, Harold S., Emil W. Haury, E. B. Sayles, and Nora Gladwin
1965 *Excavations at Snaketown: Material Culture.* Tucson: University of Arizona Press.

Goodman, Linda J., and Daisy F. Levine
1990 The Mines of the Cerrillos District, New Mexico: Myths and Realities. *El Palacio* 96(1): 22–37.

Grammer, Maurine
1987 Mary Histia and Her Patron, Franklin D. Roosevelt. *The Indian Trader* 18(6):9–10.

Gray, Samuel L.
1990 *Tonita Peña, Quah Ah.* Albuquerque: Avanyu Publishing.

Harlow, Francis H.
1973 *Matte-Paint Pottery of the Tewa, Keres, and Zuni Pueblos.* Albuquerque: Museum of New Mexico and University of New Mexico Press.

1977 *Modern Pueblo Pottery, 1880–1960.* Flagstaff: Northland Press.

1985 Glaze-Matte Transitions in Pueblo Pottery. Acoma chapter. Manuscript.

1988 Transitional Pueblo Pottery, 1500–1700. Proceedings of lecture, concourse on Southwestern ceramics, Recursos de Santa Fe. Santa Fe, September 18–20.

Hordes, Stanley M.
1986 Ethnic Influence of the Pueblos of Acoma and Laguna: 1680–1880. Manuscript, Indian Arts Research Center, School of American Research, Santa Fe.

James, H. L.
1970 *Acoma: The People of the White Rock*. Glorieta, New Mexico: Rio Grande Press.

Jensen, Joan M., and Darlis A. Miller, eds.
1986 *New Mexico Women: Intercultural Perspectives*. Albuquerque: University of New Mexico Press.

Kenagy, Suzanne G.
1988 Made in the Zuni Style: Zuni Pueblo and the Arts of the Southwest. *Masterkey* 69(4):11–20.

Lister, Florence C., and Robert H. Lister
1976 Distribution of Mexican Maiolica along the Northern Borderlands. In *Collected Papers in Honor of Margery Ferguson Lambert*, edited by Albert H. Schroeder. Papers of the Archaeological Society of New Mexico 3:113–40.

1982 *Sixteenth Century Maiolica Pottery in the Valley of Mexico*. Anthropological Papers of the University of Arizona 39. Tucson: University of Arizona Press.

Maxwell Museum of Anthropology
1974 *Seven Families in Pueblo Pottery*. Exhibition catalog, coordinated by Rick Dillingham. Albuquerque: University of New Mexico.

McGregor, John C.
1965 *Southwestern Archaeology*. Urbana: University of Illinois Press.

Mera, Harry P.
1939 *Style Trends in Pueblo Pottery*. Memoirs of the Laboratory of Anthropology 3. Santa Fe.

Minge, Ward Alan
1974 Historical Treatise in Defense of the Pueblo of Acoma Land Claim. In *Pueblo Indians*, vol. 3, pp. 121–210. New York and London: Garland Publishing.

1976 *Acoma, Pueblo in the Sky*. Revised edition, 1991. Albuquerque: University of New Mexico Press.

Parsons, Elsie Clews
1928 The Laguna Migration to Isleta. *American Anthropologist* 30(4):602–13.

Peckham, Stewart
1990 *From This Earth: The Ancient Art of Pueblo Pottery*. Santa Fe: Museum of New Mexico Press.

Peterson, Susan
1984 *Lucy M. Lewis, American Indian Potter*. Tokyo, New York, and San Francisco: Kodansha International.

Rands, Robert L.
1974 Acoma Land Utilization. In *Pueblo Indians*, vol. 3, pp. 211–406. New York and London: Garland Publishing.

Reynolds, Terry R.
1986 Women, Pottery, and Economics at Acoma Pueblo. In *New Mexico Women: Intercultural Perspectives*, edited by Joan M. Jensen and Darlis A. Miller, pp. 279–300. Albuquerque: University of New Mexico Press.

Robertson, Donald B.
1986 *Encyclopedia of Western Railroad History. The Desert States: Arizona, Nevada, New Mexico, Utah*. Caldwell, ID: Caxton Printers.

Ruppé, Reynold J., and Alfred E. Dittert, Jr.
1952 The Archaeology of Cebolleta Mesa and Acoma Pueblo: A Preliminary Report Based on Further Investigation. *El Palacio* 59(7):191–217.

Sedgewick, Mary Katherine (Rice), "Mrs. William T."
1926 *Acoma, the Sky City*. Cambridge: Harvard University Press.

Seymour, Tryntje Van Ness
1979 *Acoma*. Salisbury, CT: Lime Rock Press.

Shelley, Donald A.
1961 *The Fraktur-Writings or Illuminated Manuscripts of the Pennsylvania Germans*. Allentown: Pennsylvania German Folklore Society.

Shepard, Anna O.
1965 *Ceramics for the Archaeologist*. Carnegie Institution of Washington, Publication 609. Washington, D.C.

Simmons, Marc
1979a History of Pueblo-Spanish Relations to 1821. In *Handbook of North American Indians*, vol. 9, pp. 178–93. Washington, D.C.: Smithsonian Institution.

1979b History of the Pueblos since 1821. In *Handbook of North American Indians*, vol. 9, pp. 206–23. Washington, D.C.: Smithsonian Institution.

Smith, Watson, Richard B. Woodbury, and Nathalie F. S. Woodbury
1966 *The Excavation of Hawikuh by Frederick Webb Hodge, 1917–1923.* New York: Heye Foundation, Museum of the American Indian.

Snow, David
1982 The Rio Grande, Matte Paint and Plainware Tradition. In *Southwestern Ceramics: A Comparative Review*, edited by Albert H. Schroeder, pp. 235–78. The Arizona Archaeologist 15.

Spicer, Edward H.
1962 *Cycles of Conquest.* Tucson: University of Arizona Press.

Stevenson, James
1883 Illustrated Catalogue of the Collections Obtained from the Indians of New Mexico and Arizona in 1879. In *Bureau of American Ethnology, Second Annual Report, 1880–81*, pp. 307–422.

Stirling, Matthew W.
1942 *Origin Myth of Acoma and Other Records.* Bureau of Ethnology Bulletin 135. Washington, D.C.: Smithsonian Institution.

Toulouse, Betty
1977 *Pueblo Pottery of the New Mexico Indians: Ever Constant, Ever Changing.* Santa Fe: Museum of New Mexico Press.

Tyler, Hamilton A.
1979 *Pueblo Birds and Myths.* Norman: University of Oklahoma Press.

Waters, Frank
1970 Foreword. In *Acoma: The People of the White Rock.* By H. L. James. Glorieta, NM: Rio Grande Press.

Weiser, Frederick S., and Howell J. Heaney
1976 *The Pennsylvania German Fraktur of the Free Library of Pennsylvania*, vol. 1. Breinigsville: Pennsylvania German Society.

White, Leslie A.
1902 *Zia, the Sun Symbol Pueblo.* Bureau of American Ethnology Bulletin 184. Washington, D.C.: Smithsonian Institution. Reprint, Albuquerque: Calvin Horn Publisher, 1974.

1932 The Acoma Indians. In *Forty-seventh Report of the Bureau of American Ethnology.* Washington, D.C.: U.S. Government Printing Office.

Picture Credits

All photographs in this book are by Herbert Lotz unless otherwise noted below.

FRONTISPIECE: courtesy Colorado Historical Society, neg. no. WHJ15275, photo by William Henry Jackson.

CHAPTER 1: Figure 1.1, courtesy Colorado Historical Society, neg. no. WHJ086, photo by William Henry Jackson; 1.2, courtesy School of American Research Collections in the Museum of New Mexico, neg. no. 16042, photo by Ben Wittick; 1.3, SAR photo; 1.6, courtesy The Southwest Museum, Los Angeles, cat. no. 421-G-210; 1.7, courtesy Rick Dillingham, photo by Herbert Lotz; 1.9, courtesy The Southwest Museum, Los Angeles, cat. no. 491-G-808.

CHAPTER 2: Figure 2.2, courtesy Museum of New Mexico; 2.3, drawing by Katrina Lasko; 2.9, courtesy Field Museum of Natural History, Chicago, cat. no. 82044, neg. no. A111776; 2.10, drawing by Katrina Lasko.

CHAPTER 3: Figure 3.1, courtesy Museum of New Mexico, neg. no. 72584, photo by Herman S. Hoyt; 3.2, 3.3, 3.4, photos by Rick Dillingham (Acoma); 3.5, courtesy Smithsonian Institution, Department of Anthropology, cat. no. 107123; 3.6, SAR photo; 3.7, 3.8, 3.9, 3.10, 3.11, photos by Rick Dillingham (Laguna).

CHAPTER 4: Figure 4.1, courtesy Museum of New Mexico, neg. no. 80022, photo by Ben Wittick; 4.3, 4.4, 4.6, SAR photos; 4.10, courtesy Laboratory of Anthropology/Museum of Indian Art and Culture, cat. no. 12017/12, photo by Herbert Lotz; 4.13, courtesy School of American Research Collections in the Museum of New Mexico, neg. no. 16194, photo by Ben Wittick.

CHAPTER 5: Figure 5.6, drawing by Katrina Lasko; 5.13, courtesy the Laboratory of Anthropology/Museum of Indian Art and Culture, cat. no. 7898/12, photo by Herbert Lotz; 5.16, Courtesy Smithsonian Institution, Department of Anthropology, cat. no. 109962; 5.17, 5.19, SAR photos; 5.22, courtesy Laboratory of Anthropology/Museum of Indian Art and Cultures, cat. no. 12016/12, photo by Herbert Lotz; 5.23, SAR photo.

CHAPTER 6: Figure 6.1, courtesy Museum of New Mexico, neg. no. 15984, photo by Ben Wittick; 6.2, private collection, photo by Herbert Lotz; 6.5, SAR photo; 6.7, courtesy Museum of International Folk Art, FA.75.28-1, photo by Herbert Lotz; 6.8, courtesy Rare Book Department, Free Library of Philadelphia, FLP 721, photo by Joan Broderick; 6.9, courtesy Philadelphia Museum of Art, acc. no. 01-116; 6.10, courtesy Rare Book Department, Free Library of Philadelphia, FLP 195, photo by Joan Broderick; 6.13, courtesy National Museum of the American Indian, Smithsonian Institution, cat. no. 17/6083, © photo by Karen Furth; 6.15, courtesy the Smithsonian Institution, Department of Anthropology, cat. no. 107139, photo by Diane L. Nordeck.

CHAPTER 7: Figure 7.1, courtesy the Southwest Museum, neg. no. 20269, photo by F. H. Maude; 7.3, courtesy Colorado Historical Society, neg. no. WHJ15030, photo by William Henry Jackson; 7.4, 7.8, 7.10, SAR photos; 7.13, courtesy Maxwell Museum of Anthropology, University of New Mexico, cat. no. 81-46-115; 7.16, photo by Laura Gilpin, SAR; 7.17, courtesy Rick Dillingham, photo by Herbert Lotz; 7.19, courtesy Evelyn Cheromiah; 7.20, courtesy Rick Dillingham, photo by Herbert Lotz; 7.21, photos by Rick Dillingham; 7.22, 7.23, SAR photos.

CHAPTER 8: Figure 8.2, photo by Rick Dillingham; 8.7, courtesy Rick Dillingham, photo by Herbert Lotz; 8.8, courtesy Verna Solomon, photo by Herbert Lotz.

Index